DIVINA QUATERNITAS

ANNA C. ESMEIJER

DIVINA
QUATERNITAS

A PRELIMINARY STUDY IN
THE METHOD AND APPLICATION
OF VISUAL EXEGESIS

VAN GORCUM ASSEN/AMSTERDAM THE NETHERLANDS 1978

The publication of this book was made possible through a grant from the Netherlands Organization for the Advancement of Pure Research (Z.W.O.)

ISBN 90 232 1567 2

Printed in the Netherlands by Van Gorcum, Assen

PREFACE

At this time, when the uses of iconography are often exercises in hyperbole and the unsupported imagination, it is doubly a pleasure to introduce the reader to a study soundly based on an understanding appraisal of monuments and sources. 'Visual exegesis' is a term finely balancing the pictorial and the verbal; and it is applied to demonstrate that as the text sometimes elucidates the picture, so the picture sometimes elucidates — or even replaces — the text. The question once put to me by a student, 'Must I always find a literary basis for an interpretation of a picture?' is conclusively answered in the negative.

The whole matter of the exegetical relationship between the Old and New Testaments, together with a broad look at programmatic intent and the origins and types of visual exegetic schemes in a particularly valuable historical survey, precedes the examination of specific images. The choice of quadri-partite schemata for intensive examination is a happy one. Such schemata pervade the middle ages, occur in diverse regions, and offer a variety of references. The three principal themes, concisely delimited as Paradise, City, and Cross, exemplify the author's method. As pictorial devices fundamental to the period they also exemplify the multiple intellectual approach and astonishing power of the mediaeval image.

Rosalie Green

CONTENTS

FOREWORD

This study deals with a number of problems concerning the relationship between word and image, a subject which, for the middle ages, has been given little attention by art historians.

Two introductory chapters discuss this relationship as seen in certain medieval representations and programmes; an attempt is made to indicate how far one can justify the conclusion that these provide a visual exegesis, a kind of exposition of Holy Scripture in which the customary rôles of word and image have been reversed, so that the representation or programme provides the Scriptural exegesis in very compressed picture-form, and the text itself is either completely omitted or else limited to explanatory inscriptions, tituli, or a very short commentary. This investigation has had to be limited for the time being to Western art. Byzantine pictorial theory and pictorial theology, in which the relationship between word and image is just as important, have been touched on only as far as necessary for a better understanding of Western pictorial theory (for example the reactions of the *Libri Carolini* to the terms of the Council of Nicaea in 787).

During the course of research it became obvious that only after studying the development of Scriptural exegesis from early-christian times onwards, from two-fold exposition (letter/history as opposed to spirit/allegory, or the typological relationship between the Old Testament and the New Testament) to an exegesis of Holy Scripture according to the four senses (historia, allegoria, tropologia, anagoge), would one be able to consider at what stage in time reference can justifiably be made to visual-exegetic representations in which the image takes over the rôle of the word by presenting an exegetic commentary capable of 2-, 3-, or 4-fold interpretation.

Although information is somewhat scant, consisting in the first place of what early-christian writers had to say not only about the equal value of word and image but also about the didactic or moralistic superiority enjoyed by the image with its more direct force, and in the second place of the relevant tituli, commentaries, poems and descriptions, there does seem to be some foundation for the hypothesis that even in early-christian art a certain programming was aimed at, in which the choice of figures or scenes could provide a 'pictorialized' exegesis. In this way a typological relationship between the Old Testament and the New Testament could be elucidated or even a visual ex-

egesis could be provided on a variety of levels of interpretation analogously to the method of multiple Scriptural exegesis.

At this point another problem arose which has hitherto been largely ignored, at least as regards medieval art. This is the question of the complementary rôle which can be played in a decoration programme by the actual observer, or — in the case of funerary art — by the deceased in the tomb. An indication of this could be provided by the orientation of the whole painted decoration towards a definite point in space.

This is followed by an initial investigation of visual exegesis as a didactic method giving instruction in the rules of Scriptural exegesis according to the four senses, and by a survey of the basic schemata used for this method.

A certain early didactic method in which appreciation of the eye's being a more sensitive instrument than the ear led to widespread use of diagrams, schemata and genealogical trees, seems to have exercised its influence on early christian instruction. This leads one *en passant* to the question of the continued existence of the 'ars memorativa' throughout the earlier middle ages, another subject on which little research has been done so far.

The use of profane school-schemata as the basis of instruction in exegesis, can be authorized by the view, which goes back to Saint Augustine in particular, that the study of the profane sciences, the seven liberal arts, should be seen as a preliminary to the higher science of exegesis. A comparison of the 3-fold division of philosophy and the seven liberal arts into *physica*, *logica* and *ethica* (which in very many academic treatises and school-books is depicted schematically, e.g. in the form of genealogical trees) with 3- or more-fold exegesis (frequently elucidated by way of the same sort of schemata) shows that school-schemata could easily be adapted for exegetic purposes.

The hypothesis that, in spite of tentative instances at earlier periods, it is not until the Carolingian era (in which for the first time one can speak of a more uniform, specifically Christian school-programme) that the beginnings of a visual-exegetic method making consistent use of adapted diagrams and schematic arrangements can be indicated, seems to be supported by the appearance in Carolingian art of multi-interpretable representations borrowing their formal elements from school-schemata. None the less, it is not until one comes to the 11th and 12th centuries that one can refer to visual exegesis as a system of more or less fixed rules. There follows a short survey of the possible causes for this noticeable preference in the 11th and 12th centuries for visual exegetic works of art (often referred to in art historical literature with the too narrow adjective 'typological'), and the hypothesis that there may have been an illustrated 'typological' compendium for patrons and artists containing relevant subjects and motifs is gone into.

Since the majority of the schematic visual-exegetic representations studied seem to have been based on quadripartite cosmic, architectonic or anthropomorphic harmony schemes going back to early school-schemata, the last three chapters are devoted to analyses of an example of each of these cate-

gories. First the cosmic paradise-quaternity with four streams is discussed, then the architectonic quaternity of the Heavenly Jerusalem, and finally the anthropomorphic quaternity of the human figure in the form of a cross with three variations, namely, holding a globe, or grafted onto a tree-scheme, or as a cosmic musical instrument.

The material assembled in these five chapters is hardly more than a preliminary reconnaissance of the hitherto scarcely examined territory of visual-exegetic representations. The hypotheses presented will have to be subjected to further tests involving comparison with sources and art historical material from the periods discussed.

The repeated premise that the eye is often more sensitive than the ear has led to the addition of a number of illustrations showing various forms of adaptation and assimilation of the basis-schemata, intended to elucidate the arguments which have been advanced.

It is a pleasure to thank professor Rosalie Green of Princeton University for her interest in this endeavour over the years and for her most kind introduction.

I am grateful to the Netherlands Organization for the Advancement of Pure Research (Z.W.O.) who made this publication possible and I wish to express special thanks to D.A.S. Reid M.A. of Utrecht University for his skill, kindness and above all patience during the various tribulations occasioned by the translation.

A.C.E.

PICTURA QUASI SCRIPTURA

Littera gesta docet, quid credas allegoria
moralis quid agas, quo tendas anagogia.[1]

This late medieval mnemotechnic poem contains, in an extremely compressed form, a summary of the content of the multiple interpretation of the Bible which, during certain periods — the early christian, and especially the so-called renaissances of the 9th and 12th centuries — played a large part not only in christian exegesis but also in christian art.[2]

Exegesis and pictorial art are in some instances so closely bound together that in the case of certain, often schematic and quadripartite compositions, or sometimes even in the case of a complete decoration programme which proves to have been carefully composed on a variety of levels analogously to the method of multiple Scriptural interpretation, we can speak of a 'pictorialized' exegesis.

The justification for this visual exegesis as a legitimate method of Scriptural interpretation is based in the long run on the same arguments concerning the analogy between image and word as were adduced in Antiquity in the discussion about 'ut pictura poesis': painting as a silent form of verbal art. These arguments play a rôle straight away when we come to early-christian art; and later on, whenever the question of religious art was raised by opponents of the image, they were to be brought in as a defence.[3] Two important functions of the image were recognized again and again: its didactic, pedagogic function, and its mystical function. The image, the representation, was highly valued for the possibilities it provided of rendering the 'historia' in a summary, compressed form, or of perpetuating the 'memoria' of saints and martyrs, and also for its power to move and inspire to imitation ('imitatio'). The use, too, of representations as mnemonic images, (already an ancient notion), involving their repeated contemplation with a view to impressing them on the memory, could be valuable as a mnemotechnic method in a didactic and pedagogical sense. For all these reasons the use of images for instruction was considered legitimate, both as regards the catechesis of the 'simplices', the simple of soul and those who could not read, and as regards the instruction in exegesis of the 'periti', those who were more advanced and could read.

But the contemplation of the image can function as a vehicle for spiritual

elevation, leading to the prototype, of which the image is a representation. In the writings of the church fathers this mystical, anagogical function of the image plays an important rôle, side by side with the didactic function.

The idea that image and word, (spoken or written, biblical text or sermon), represented parallel possibilities, together with the idea that the image could serve as a short, compact way of reproducing the word, or that it could act as a mystical means of elevation to the prototype (the Word), contributed to the birth and development of visual exegesis as an equally valid method of Scriptural interpretation.

The analogy between word and image begins to be used as early as the 4th century by the Greek church fathers – for example by the Capadocian fathers Basil, Gregory of Nyssa and Gregory of Nazianzus. When Basil (c. 330-79), at the end of a homily on the martyr Barlaam, calls in the help of painting to perfect and surpass the verbal picture of the martyr as hero of the contest in which Christ is the arbiter – because he considers the image 'more forceful, more radiant' than the word; and when, in a homily on the 40 martyrs of Sebaste (who died c. 320 A.D.), he regards painting as a 'muta praedicatio' surpassing the sober historical statement (the 'historia') of the word – because the image has the power to call up the memory of the martyrs to the eye, and thus allow their deeds to stimulate virtuous emulation more powerfully still; he is already making two points which in later arguments *pro* and *contra* the image were to be raised again and again: its power to perpetuate the 'memoria' and its capacity to exhort to 'imitatio'.

Gregory of Nazianzus (329-89), too, when he comes to compare the impression made by painters with that produced by rhetors, considers that the visual image is more convincing than the word.

If these two instances are not concerned with much more than a rhetorical comparison between verbal and pictorial art in general, Gregory of Nyssa (c. 330-95) was thinking of existing works of art with a christian theme, for example when he described the painted scenes of martyrdom in a church dedicated to St. Theodore, and valued them for being a 'speaking book'. Gregory, too, frequently accords the visual image a greater power than the word, particularly when he is describing the moving, suggestive power of a representation of Abraham's sacrifice of Isaac.

A further step in the appreciation of the visual image is represented by the idea that contemplation of the image is a stage in the approach to the divine, an argument that had already been employed by gentile defenders of image-worship. This mystical function of the image, which together with its didactic and pedagogical function played a large part in visual exegesis, goes back to platonic and neoplatonic doctrines concerning the mirroring of the invisible reality of the world of ideas in the reality which is visible, and also concerning an ascension in stages from the material to the immaterial, or from the imperfect visible world to the perfect invisible world of ideas. Ivanka, in his book on platonic philosophy in the service of christian theological thought,

directs attention to the pluriformity of platonic philosophy as a frame for the world-picture in which the proclamation of the christian revealed truth is placed. When christian thinkers began to use it, it already had a long evolution behind it and was no longer the original platonism but a more or less developed neoplatonism. (Some christian thinkers were aware of this, and in rejecting certain structures of thought erected by their contemporaries, refer back to platonism in its original form.) Even original platonism, however, contains elements of widely differing origin — for example the rational, mathematical view that the real world mirrors the numerical, ordered quality of the world of ideas *(Timaeus),* side by side with the mystical, anagogical view, as exemplified by the description of the ecstatic ascent of the soul to true beauty *(Symposium).*[4]

Both the mathematical and the mystical-anagogical views may have had their influence on representations aiming at visual exegesis, or on evaluations of the rôle of the image in visual exegesis: the first with respect to systematic fourfold visually exegetical schemata as reflections of a higher order, the second with respect to the 'contemplation' of the imperfect image (the visually exegetical representation) as 'vehiculum' to the perfect and true (cf. the examples discussed in Chapters III, IV and V). Platonic and neoplatonic notions concerning the visible form as sign of the invisible reality and of the ascent via the image to the prototype, can be found as early as the 4th century in explanations by the Greek church fathers of the rôle of images and their veneration. In so far as it is permissible to speak of adoration at all in this respect, it ought — as Basil, for example, states in *De spirito sancto,* 18 — to be directed solely to the prototype represented by the image. This argument was to be reintroduced later, during the iconoclastic controversy, when appeal was repeatedly made to the 4th-century Greek church fathers.

The latin fathers of the church are on the whole more cautious in their attitude towards the image. For example there is the criticism of Augustine (354-430) that it is easy to be misled by erroneous ways of representation in the visual arts (e.g. Paul together with Christ and Peter): 'Sic omnino errare meruerunt qui Christum et apostolos eius non in sanctis codicibus, sed in pictis parietibus quaesierunt: nec mirum, si a pingentibus fingentes decepti sunt.'[5]

But from the start the didactic and pedagogical value of images was recognized both in the east and in the west.

The 'pictura' as substitute for 'scriptura', as Ersatz for familiarizing the 'simplices', 'illiterati', 'idiotae', who could not read, with bible stories and church doctrines, occurs for the first time a little after 400 in the work of Paulinus of Nola (353/4-431), where there is talk of people 'non cassa fide neque docta legendi', who are piously deceived by the illusion of art: 'pie decepti'.[6]

Sometimes the accent is placed differently, when it is stated that the 'docti' or 'sapientes' do not need the 'pictura' since they have direct access to the

'scriptura'. Hypatios of Ephesus (c. 520-40), for example, considers representations to be an imperfect intermediate stage, a concession to the uninitiated, whereas for the initiated the word of God or the image of God in the soul is enough.[7] Gregory of Tours (c. 540-94), however, speaks both of the fact that the faithful must preserve the laws of Christ engraved on the tables of their hearts, and of the pedagogical use – as an exhortation to virtue – of His image, which can be seen both in the church and at home: 'in tabulis visibilibus pictum, per ecclesias ac domos".[8]

Eastern and western opinions about the nature and function of images gradually begin to diverge. In the east the didactic function often seems to be subjugated to a particular interpretation of the mystical function of the image with respect to the prototype, as a result of which it becomes regarded no longer as something purely intermediary but as being a real substitute. Although orthodox doctrine taught that the act of worship centering on the image – including embracing, proskynesis, the offering of light and incense – was only to be directed to the prototype (all that was permitted towards the image was 'veneratio = timè', the 'adoratio = latreia' being directed to God), in practice, inevitably, believers often found it difficult to draw a clear dividing line. The result was that the image became identified with the prototype and was worshipped accordingly, often with the additional attribution to it of magical powers and miraculous healing properties.[9] This aspect was of course enlarged upon during every polemic concerning the permissibility of images, particularly during the iconoclastic periods towards the end of the 7th century and in the course of the 8th and beginning of the 9th centuries.

The attitude of the west toward images found its chief formulator in Gregory the Great (c. 540-604). He stressed the didactic and pedagogical value of the image, especially for the unlettered, and firmly rejected the 'adoratio' of the image: 'aliud est enim adorare, aliud per picturae historiam quid sit adorandum addiscere' and 'non ad adorandum in ecclesiis, sed ad instruendas solummodo mentes'.[10] Gregory does acknowledge the mystical function of images as reflections of the higher and invisible, but although he rings the variations on the equivalent didactic possibilities of word and image: 'pictura quasi scriptura' and 'per litteras et picturas' etc., the mystical function receives only a single mention: 'per visibilia invisibilia demonstramus'.[11] Gregory sees the didactic function as being particularly valuable in the missionary field, since he considers that pagans are extra-sensitive to images: 'nam quod legentibus scriptura, hoc idiotis praestat pictura cernentibus: quia in ipsa etiam ignorantes vident, quid sequi debeant, in ipsa legunt, qui litteras nesciunt. Unde et praecipue gentibus pro lectione pictura est'. For this reason he presented the missionaries whom he sent to England at the end of the 6th century with 'imagines in tabula' containing the image of Christ.[12]

That even a conducted tour of the representations in the church could form a highly educative introduction to christianity for a pagan, leading him on from the visible to the invisible, is argued in a treatise of c. 764, entitled *Contra*

4

Caballinum, which has been attributed to the monk Joannes of Jerusalem and was directed against the Emperor Constantine Kopronymos and the iconoclastic synod of Hiereia in 754. Finally, an account of an effective conversion by means of the image is given by Paul the Deacon (c. 720-c. 800) in the *Historia Lombardorum.* Here we find the story of Count Ariulph, who was converted after seeing representations of the martyr-bishop Sabinus in the church of Spoleto. Ariulph recognized in Sabinus the person who had helped him in battle (at Camerinum, against the Romans, in 601) and protected him with his shield.[13]

In the east, as a reaction to iconoclastic tendencies, a theory of images was devised which found its principal formulation in the 'image' sermons of John of Damascus, (c. 675-*ante* 754).[14] These sermons summarize, supplement and elaborate upon the various arguments used in the polemic concerning the representation of Christ, Mary, the saints and martyrs, making use of numerous quotations from the church fathers, especially Basil and Gregory of Nyssa. The main point is an emphasis on the legitimacy of the use of images as part of the christian tradition, since the image and the spoken and written word, eikon and logos, are equivalent as means of revelation, in which connexion the topos 'ut pictura poesis' again comes up for discussion. Consequently both the gospelbook and images may be venerated with proskynesis, light and incense. The value of an object of veneration lies not in the matter but in the form in which the intended prototype ought to be optimally reproduced by means of speech, writing or painting by priest, author or painter. What has to be attended to, therefore, is the striving for truth and the good intentions of the artist. For this reason there have to be more or less established rules for representation, while attributes and tituli can be an important aid to identification.[15] The Old Testament ban on images, considered as being imposed on an immature people, is nullified by the incarnation. The public for representations can now be considered as mature in its faith. A further argument for using images was provided by the comparison between hearing and seeing, between the sensitivity of the eye as compared with that of the ear, which was decided in favour of sight. The functions of the image in the theory of images of John of Damascus can be summarized as follows. First, 'memorial' function, as sign commemorating events or deeds[16] which can and must give rise to virtuous imitation (imitatio); in this capacity the image can be Ersatz, since it conjures up the memory of what is absent and makes it, so to speak, present, a comparison being drawn with the emperor's portrait, in which the absent is present, without the portrait's being the emperor himself. Secondly, there is the didactic function: the image can give rise to questions, to an image-based instruction; in addition it can present the facts about salvation in an abbreviated form, and is thus related to the *Symbolum Apostolorum* as a concise formal statement of important points of christian doctrine. Present here are significant points of contact with what was later to be more fully worked out in the method of visual exegesis (cf. Ch. II).[17]

5

The mystical function of the image, which — like the word — can aid our imperfect senses in ascending gradually to the immaterial, the invisible, receives extensive discussion, in the course of which John of Damascus draws on Gregory of Nazianzus and Dionysius the Pseudo-Areopagite (c. 500?),[18] although he differs from the latter on one important point, since he sees the image primarily as a means of making patent what is hidden and of making it accessible to the public, while (pseudo-)Dionysius is mainly oncerned with the secret and enigmatic writings which conceal the holy truth from the mass of the people and preserve its inaccessibility. The possibility of making practical application of the theory of images in church decoration is put forward by John in his 1st and 3rd 'oratio', where a decoration programme is offered of scenes taken from the life and sufferings of Christ, a programme which at the same time can be regarded as a christological 'summarium' of orthodox doctrine in image form. John warmly welcomes church decoration and states that he is speaking from his own experience when he regards images in churches as necessary substitutes, as means to salvation. He describes how — when there are no books available or no time for reading — he goes to church and comes under the influence of the variegated splendour of the paintings (which he compares with a meadow), how his gaze is satiated and his soul transported, how he burns and, in proskynesis before the image, adores God by means of the object represented: in other words the honour paid to the image is transferred to the prototype.

Dispite revivals of iconoclastic feelings which reached their peak in the iconoclastic synod of 754, mentioned earlier, (where John of Damascus was excommunicated, only to be reinstated at the iconophile second Council of Nicaea in 787), and which had to be reckoned with throughout the 8th century right up to the end of the iconoclastic controversy in 843, the arguments and views on the theory of images formulated by John of Damascus remained valid for byzantine art to the very end.[19]

The west had nothing comparable to offer in the way of a clearly defined theory of images, perhaps because there was no need to react to either an extreme iconoclastic standpoint or an extreme iconophile one.[20] Broadly speaking the standpoint formulated by Gregory the Great remained in force: emphasis on the didactic and cautious recognition of the mystical. The didactic and pedagogical possibilities of the image were those put forward as a strong argument against the iconoclastic emperor Leo III the Isaurian in a letter from Pope Gregory II (669-731), which describes how parents make their children familiar with the Bible story by pointing out features with their fingers: 'indicatis digito historiis eos aedificant'.[21]

An acuter confrontation between east and west on the image problem was to follow, however, as a result of the second Council of Nicaea in 787 and the summary of the byzantine theory of images as contained in the Acts of the Council. The reaction to these proceedings achieved expression in the so-called *Libri Carolini,* compiled c. 791. The obvious lack of comprehension

repeatedly manifested by the *LC* may stem in part from a lack of familiarity with the background of the byzantine theory of images, since the writings of the Greeks were still virtually unknown in the west. The works of Dionysius the Pseudo-Aeropagite were not rendered more accessible until the 2nd quarter of the 9th century, by the latin translation of John Scotus Erigena (c. 810-c. 877),[22] and not until the 12th century was John of Damascus translated into latin by Burgundio of Pisa and thereby offered to a wider public. Another possible source of confusion about the Acts of the Council was the faulty translation – for example both 'latreia' and 'proskynesis' are rendered by 'adoratio'. Nevertheless both political and religious motives must also have played a part in the composition of this document which, for the first time, gave expression to an independent attitude in this matter on the part of the western, and in particular the Frankish, church towards Byzantium.[23]

The attitude of the *LC* towards the image problem can be briefly summarized as follows: 'nec destruimus, nec adoramus', neither the destruction nor the extreme adoration of images is condoned. The didactic and pedagogical function is emphasized, chiefly because the image can serve to support 'memoria'. But images can also be valuable 'ad ornamenum' or 'ob venustatem'. Here we can catch an echo of the 'prodesse et delectare' that, ever since the time of Horace, had played an essential part in discussions about the equivalence of words and images ('ut pictura poesis').

The mystical significance of images is to some extent recognized in the *LC* but the contemplation of nature and the reading of the Bible are considered better methods of ascending to God.

The *LC* ought to be regarded as a theoretical manifesto connected with a particular occasion, born of a discussion in Carolingian court circles about the problems raised by the Acts of the Council. It did not, consequently, have very much influence on Carolingian art.

At the Synod of Frankfurt in 784 the adoration of images was again condemned, but at the Synod of Paris in 825, under Louis the Pious, a much less rigid standpoint was taken. At this renewed confrontation with the east – where a ban on images had again been imposed at the Council of Constantinople (815), and where iconoclastic emperors were again in power in the person of Leo V the Armenian and his successors – 'adoratio' was again rejected. Once again there was recognition of the didactic and pedagogical function of the image – for which arguments such as the assisting of 'memoria' and the equivalence of word and image ('pro amoris pii memoria' and 'nescientibus vero pro eiusdem pietatis doctrina pictae vel fictae') were advanced – but there was now also an emphatic recognition of the mystical function of images as reflections of the relation between the earthly type and the heavenly prototype.

This meant that the view earlier held by Gregory the Great, as we have noted, was confirmed, and it continued to be followed until the 12th and 13th centuries, cf. Durandus *Rationale divinorum officiorum,* I, 3 De picturis et

cortinis et ornamentis ecclesiae: 'Pictoribus atque poetis quodlibet audendi semper fuit aequa potestas . . . Pictura namque plus videtur movere animum quam scriptura. Per picturam quidem res gesta ante oculos ponitur quasi in praesenti geri videatur, sed per scripturam res gesta quasi per auditum, qui minus animum movet, ad memoriam revocatur. Hinc etiam est quod in ecclesia non tantam reverentiam exhibemus libris quantam imaginibus et picturis'. Various arguments can be recognized here that had been put forward ever since the days of the 4th-century Greek church fathers, among them the suggestion that images might be preferable because they had a greater capacity to move people.[24]

A growing recognition of the mystical function of the image, alongside the didactic and pedagogical one, may have been promoted by the fact that from the 2nd quarter of the 9th century onwards platonic and neoplatonic writings were becoming better known in the west. This mystical function, however, can as we saw earlier) be interpreted in two ways: either as a making accessible of what is hidden and a means of ascending from the visible to the invisible, as in the case of John of Damascus, or, in the diametrically opposed sense that we find in Dionysius the Pseudo-Areopagite, of a veil or cloak to cover the holy truth, so that it remains inaccessible to the mass of the people.[25] Both interpretations may have played a part in visually exegetic representations or programmes. The view that an understanding of the deeper (mystical) significance of the image represented a higher level of insight reserved for the initiated, while the more simple souls and those who could not read could not proceed further than the 'historia' offered as a didactic and pedagogical aid, seems more obviously applicable to some of the learned programmes provided with latin tituli which were to be found in churches, since the complicated exegesis offered by the totality of word and picture must have remained a 'closed book' to the average churchgoer. (cf. the examples given in Ch. IV).

So far it has almost always been a twofold interpretation of both word and image which has engaged our attention: the letter or the 'historia' on the one hand, and the quest for deeper significance, 'mystice', on the other. But indications of a further differentiation were already present, for example in the possibility that representations could prompt virtuous imitation (moral interpretation) and in the potentiality of ascending via the representation from the visible to the invisible and to higher insight (anagogical interpretation). This forms a parallel with the development of Scriptural exegesis which, in its earliest form, also recognized only two levels of interpretation and developed as the result of further differentiation into a method operating on three, four or even more levels.

Before we ask what the earliest example of multiple visual exegesis was, and before going on to investigate the development of visual exegesis as a practice employed in schools (see Ch. II) or as a method of visually confronting the initiated with the finer points of multiple Scriptural exegesis by means of

clear, compact images (see the examples in Chs. III, IV and V), we must first briefly take a look at how Scriptural exegesis developed from a twofold interpretation into one practised on a larger number of levels.

The fourfold exegesis referred to in the poem quoted as motto to this chapter is the expanded, and also the most harmonious form (often 3 and even 5, 7, 9 etc. 'sensus' were applied) of the original twofold explanation which operated purely in terms of 'historia' and 'allegoria'. That is to say, the 'sensus historicus vel litteralis' gave the historical reality of the persons, affairs, actions or events featuring in the text, or their literal significance, as against the deeper spiritual significance: the 'sensus spiritualis, mysticus or allegoricus'.[26] 'Historia' and 'allegoria' could moreover indicate a very special, so-called typological relationship between the Old and the New Testaments, in which persons, affairs or events from the O.T. were regarded as types (also 'figura', 'umbra', etc. and other platonically tinged concepts), that is to say as O.T. foreshadowing, pointing ahead to the fulfilment in N.T. persons, affairs or actions: the N.T. antitype.

Thus various O.T. figures, such as Adam, Noah, Isaac, King David and many others were seen as types of Christ; Noah's Ark could be a prefiguration of the Ecclesia; and the raising of the Brazen Serpent could be a type of the crucifixion. O.T. scenes which had to do with water in one way or another (the crossing of the Red Sea, Moses striking water from the rock) were explained in terms of baptism, and O.T. scenes containing meals or sacrifices (Melchisedek, or the three Angels visiting Abraham) were viewed as types of the Last Supper and the Eucharist.[27]

A further differentiation of the 2nd term of comparison (the 'allegoria') into 'tropologia' and 'anagoge' led to a tri- and thus to a quadripartite exegesis which explained a particular text (person, affair, action or event) on 4 levels: namely 'historia', that is to say the literal meaning of the reality of the O.T. type, together with the 3 'sensus' which gave its deeper spiritual meaning: namely the 2nd 'sensus', the 'allegoria', which signified the fulfilment in the N.T. antitype or the explanation in terms of Christ, the Ecclesia or the sacraments; the 3rd 'sensus', or 'tropologia' ('sensus tropologicus vel moralis') which provided a moral explanation, an application to man and the salvation of his soul; and finally the 4th 'sensus', the 'anagoge' ('sensus anagogicus') which provided an eschatological explanation, or which elevated the thoughts of the exegete or his reader from visible to invisible things and to a higher truth.[28]

An example may make this clearer: Paradise can be explained by 'historia' as the Garden of Eden with its four rivers; by the 'allegoria' as Christ and the Ecclesia (the four rivers = the Gospels emanating from the single river = Christ, which water the Paradise of the Church); by the 'tropologia', relating it to man, as the Paradise of the 4 cardinal virtues; and by the 'anagoge' as the Paradise which will be restored at the end of time. Similarly Jerusalem can be historically the city situated in the Holy Land, allegorically the Ecclesia,

tropologically the soul of the believer, and anagogically the Heavenly City of Jerusalem.[29]

Methodologically speaking there is a relationship between christian exegesis and the Greek method of interpreting texts which had come down from early times, for example those of Homer. Elements considered to be absurd or awkward were interpreted in cosmic terms: by regarding gods and heroes as natural forces; or in mystical or moral terms: by explaining the adventures and wanderings of, for example, a Hercules or an Odysseus as the dangers besetting the soul. This Greek method of allegorical interpretation strongly influenced Philo of Alexandria (c. 20 B.C.-c. 50 A. D.) who explains the various events in the Septuagint — Exodus, the 40 years in the desert, the entry into the promised land, etc. — as various stages on the journey of the human soul. His main aim is to harmonize platonic philosophy with the Scriptures.[30] Traces of his method, such as the use of number symbolism and etymology, may be found in christian exegesis.[31] Alexandrian circles of learning in Philo's day, in fact, show a general tendency towards allegorization. It was at this time that the first examples began to appear of 'bestiaries' like the Greek *Physiologus,* allegorical 'lapidaries' (the forerunners of medieval 'lapidaria' and 'bestiaria'), and collections in the nature of Horapollo's *Hieroglyphica,* which anticipate the emblem books of the Renaissance.[32] Various elements from these works found their way into medieval exegesis and thence into medieval art.

The christian method of exegesis is regarded by some as a literary genre in the sense of this Alexandrian allegorization, the point being made that in early centuries gentiles, jews and christians formed part of a still fairly homogeneous culture.[33] This receives clear expression in Alexandria, for example, in the mixture of Philonic and christian exegesis in Clement of Alexandria (c. 150-c. 215) and Origen (c. 185-c. 254). Philo's influence is also traceable beyond the Alexandrian milieu, for example in Gregory of Nyssa or in the latin church fathers, especially in the commentary on Genesis by Ambrose (c. 339-97).[34]

Other modern historians of christian exegesis, however, stress the difference between the allegorical method coming down from the tradition of the ancients, in which events, figures or things are stripped of their reality and totally merged in something else, and the christian exegetic method, in which the persons, affairs, actions or events taken from the Old Testament continue to exist as realities, as history, but are also — as types ('figura' etc.) — terms in a comparison with other equally historical figures or events: the New Testament antitypes.[35]

Here again there was a precedent in jewish exegesis, which explained the words of prophets like Hosea, Jeremiah, Ezekiel and Isaiah (who themselves had often taken their examples from the historical events of Genesis and Exodus) in a Messianic sense, as types of future events. The coming Kingdom of the Messiah was awaited as a new Paradise, a new Flood, a new Exodus.

This was a point at which the earliest christian exegetes could link up, by showing that these expectations had been fulfilled in Jesus of Nazareth.[36]

This line of thought is also given expression at various places in the New Testament in the words of Christ, for example at John 3:14 'And as Moses lifted up the serpent in the wilderness, even so must the Son of man be lifted up', a passage which even the earliest christian exegetes interpreted as a reference to the crucifixion.[37]

It was in the Epistles and Acts of the Apostles that the basis was laid for an exegesis which sought in the jewish Scriptures for a christian meaning. The Old Testament was no longer regarded as a book setting forth the laws and history of the jewish people, but was now viewed together with the New Testament as a single corpus, in which the Old Testament formed the history or letter and the New Testament the allegory or spirit, or in which the Old Testament prophecy pointed forward to the New Testament truth or where an Old Testament figure or event was placed as type over against a New Testament antitype.[38]

In Paul this has already become a method, which could be used both apologetically and polemically. Apologetically because it took the ground away from the accusation that the christian religion was something new, without a history or a tradition; polemically because it could be used against jewish opponents. Moreover, interpreted in this way the Old Testament was no longer simply the history of the jewish people, and thus it could be made acceptable to a wider circle. A further gain was that the comparison between real events in the Old and New Testaments could be employed as a weapon in the struggle against gnostic sects, who tended to reject the Old Testament and to explain the New Testament in a way which fitted their special cosmic theories, denuding it entirely of real and historical meaning.[39]

The task begun by the apostles was continued by the church fathers and doctors of the church. Their autority contributed to the continuity of exegesis, as is shown by the frequent recurrence of the same quotations taken from their writings and by the way in which the images and symbols they had used continued to live on.[40]

At a very early date the original twofold division began to develop as the result of further differentiation of the second term, the allegory, into a multiple interpretation on 3 or 4 levels. That there was no question of there being an opposition between a threefold and a fourfold division is plain from the fact that they occur together in the work of one and the same author, and even in one and the same work.[41]

The use of the threefold division is thought to go back to Origen (c. 185-c. 354). In the east his bequest to posterity was soon systematically destroyed, because his orthodoxy was questioned. In the west his influence made itself felt through two channels: indirectly through quotations by the latin church fathers, and directly by way of translations into latin, for example by Rufinus

of Aquileia (c. 398). Despite the admiration felt for his work, it was often also approached with a good deal of reserve in the west (as illustrated by the medieval legends about his fall and penance), which is not to deny that a continuous Origen tradition is discernible, one strongly influencing multiple exegesis, particularly in its flowering time (early-christian, Carolingian period and 11th/12th centuries). We already find Cassiodorus (c. 485-c. 580) in Vivarium assembling a collection of Origen's works.[42] His work was also fairly well-known in the Carolingian period, as appears from the occurrence of texts by Origen in the homiliary compiled for Charlemagne by Paul the Deacon (c. 790).[43] Surviving library catalogues provide evidence of the wide dissemination of his work in the Middle Ages. In Clairvaux and in the abbey of St. Victor at Paris, Origen was read alternately with Gregory and Augustine in the refectory after the reading from the Scriptures: and in the classification of the library at Clairvaux, as we learn from a catalogue of 1186, Origen's writings followed immediately after the 'Libri textus divini' and the works of Augustine.[44] In addition to the Origen tradition, the progagation of the threefold method of exegesis is indebted to the authority of Jerome (c. 342-420), who used this mode of interpretation frequently.[45]

It is noteworthy that in threefold exegesis tropology often preceded allegory (or anagoge), which appears to be the original formula traceable back to Origen.[46] It is possible that preference was given to this formula because its accentuating of the 'sensus tropologicus vel moralis', the interpretation directed towards man, offered great pedagogical advantages for instructing and preaching.[47] Another sequence, in which the allegory precedes tropology, is however more frequent, both in the threefold and in the fourfold division, and both formulas continue to exist side by side to the end.[48] The threefold exegesis of the Scriptures is related to two other, non christian, schematic divisions of a tripartite nature, the division of philosophy, ascribed to Plato, into physica, ethica and logica, and the tripartite anatomy of the human being into corpus, anima and spiritus. This threefold division of man, which is both classical and biblical (cf. Thess. I, 5:23), had already been projected onto the Scriptures by Origen – their body, soul and spirit corresponding to the 3 'sensus' of exegesis.[49] Jerome gives this relation between threefold Scriptural exegesis and the tripartite division of man in, for example, his commentary on Ezekiel, after which it was incorporated into western exegesis.[50]

In the tripartite division of philosophy the 7 disciplines making up the 'artes liberales' were arranged so that a way (or ladder) leading upward was created, by means of which the pupil could ascend from lower to higher, from the material to the spiritual, and from the 'visibilia' to the 'invisibilia'.[51]

Again it is Origen who, in the prologue to his commentary on the Song of Songs, was probably the first to project this on exegesis, by drawing a parallel between a meditation on the Scriptures proceeding step by step (in which the writings of Solomon: Proverbs, Ecclesiastes and the Song of Songs, are compared with the three components of philosophy), and the three stages of

the spiritual life as 3 'gradus' on the soul's journey to God. This was extended by Jerome to the interpretation of the whole Bible. Eucherius of Lyons (died c. 449) discusses the comparison between the threefold division of philosophy and that of the human being in the introduction to his *Liber formularum spiritualis intelligentiae*.[52] Comparisons between the three divisions of philosophy and those of exegesis occur fairly frequently during the Carolingian period, for example in exegetes such as Christian of Stavelot and Angelomus of Luxueil. John Scotus Erigena, who goes a step further in comparing the three parts of philosophy plus philosophy itself, as 'theologia', with the 4 elements (terra = historia, aqua = ethica, aer = physica, ignis = theologia), aims by means of the comparison to show how it is possible via a threefold exegesis to reach the summits of theologia, that is to say the higher grade of christian philosophy: 'altitudinem theologiae ascendere'.[53] This comparison between the threefold philosophical division and threefold exegesis creates significant possibilities for adapting the educational curriculum of late antiquity for christian purposes — the seven liberal arts serving merely as propaedeutics for instruction in exegesis. This also made it possible to transform the visual teaching method already commonly used in late antiquity for teaching the seven liberal arts into a christian method of teaching visual exegesis, in which genealogical trees and other schemata of classical origin were adapted to the needs of teaching multiple exegesis.[54]

Fourfold exegesis derives, just like threefold exegesis, from the original twofold comparison, this time by a further differentiation of the second term, the 'allegoria'. Although it is uncertain whether Augustine ought truly to be regarded as the 'inventor' of this method of exegesis (the name of Clement of Alexandria has also been put forward)[55], his assent to the use of the fourfold method undoubtedly contributed to its spread.[56] Another influence on the propagation of this method of Scriptural interpretation may well have been a certain passage by John Cassian (c. 360-435). In the latter's *Collationes* 14:8 we are informed of four kinds of interpretation for ensuring that full justice is done to God's word, in imitation of Paul's words (I Cor. 14:6); 'De his quator interpretationum generibus b. Apostolus ita dixit: 'Quid vobis prodero nisi vobis loquar, aut in revelatione, aut in scientia, aut in prophetia, aut in doctrina'. 'Revelatio' would correspond to allegoria, 'scientia' to tropologia, 'prophetia' to anagoge and 'doctrina' to historia. Since Cassian's *Collationes* were, in accordance with the rule of St. Benedict, recommended reading in monasteries, their dissemination was extremely widespread, and this passage, which was taken over word for word by, for example, such Carolingian theologians as Raban Maurus (776 or 784-856) and Sedulius Scotus (active c. 848-58), may well have been influential.[57] In addition to Augustine and Cassian, Gregory the Great was also regarded during the Middle Ages as one of the main sources of fourfold Scriptural exegesis, although he made use of the threefold method, too, for example in *Moralia in Job,* a very important text for the 'sensus tropologicus'.[58]

The decisive factor in ensuring the continuity of the method of multiple Scriptural interpretation, both threefold and fourfold formulas, was the influence of the church fathers. The study of the same 'standard works' brought about a certain uniformity in exegesis, as is clearly shown by a comparison between commentaries from the three periods in which multiple exegesis flourished, the early-christian, the Carolingian and the 11th-12th centuries.[59] The same continuity is observable in visual exegesis. This is clearly evident, for example, from the continued existence, both in words and images, of certain examples originally taken from the Bible, which were cited by the church fathers as signifying the concordance between the two Testaments, and which continue to feature regularly with the same meaning in later exegesis.[60]

The following examples may make this clearer. The book mentioned in Revelation 5:1, written 'intus et foris', already occurs as image of the literal and the deeper sense of the Scriptures, or of the unity of the two Testaments, in the early-christian exegesis of Origen, Jerome and Gregory. The same meaning is attached to it in Carolingian exegesis, for example by Alcuin (c. 735-804), and we meet with it again in 12th-century exegetes such as St. Bernard and Richard of St. Victor. This implies that in some apocalyptically tinged representations the book held by Christ or the Lamb ought to be regarded as a visual exegesis of the concordance of the two Testaments, even where this is not made explicit by means of an inscription.

A clear indication to this effect is provided by the miniature preceding the Book of Revelation in the Carolingian Grandval Bible at London. Here we find two zones, in the upper of which the Book with the Seven Seals is being unsealed by the Lion and the Lamb, while the lower depicts Moses being unveiled by the symbols of the 4 Evangelists. These two representations provide a visual exegesis of the concordance of Old and New Testaments, which is further stressed by the inscription: 'septem sigillis agnus innocens modis signata miris mira disserit patris leges e veteris sinu novellae Almis pectoribus liquantur ecce quae lucem populis dedere multis'.[61]

A further instance of an early-christian exegetical image of the relation between the Old and New Testaments is provided by the two cherubim overshadowing the Ark of the Covenant (Exodus 25:18-22). This may therefore, be one of the meanings which have to be attached to the representation on the Carolingian mosaics in the apse at Germigny-des-Prés, which forms part of a programme contructed round the theme of the relation between the old Temple and the new.[62]

Exegetes also interpret the miracle of the changing of water into wine at the wedding at Cana both as the relation between 'sensus litteralis' and 'sensus spiritualis' and in the sense of the concordance between the two Testaments (the water of the letter changing into the wine of the spirit), and it is therefore possible that these interpretations ought to be applied to some representations of this scene. They would seem to be appropriate, for example, in the case of

14

the representation preceding the beginning of St. John's Gospel on fol. 335v of the late 12th-century Gumpert Bible in the library at Erlangen. Even the I (N principio) initial letter on the same page could be explained in the same way. Here one of the rivers of Paradise is represented as a figure with a pitcher giving water to the Eagle, the symbol of John the Evangelist. Furthermore the Eagle, like the other symbols of the Evangelists in this MS., has six wings and is standing on a wheel, a hidden allusion to the vision of Ezekiel, which further strengthens the impression that we have to do with a visual exegesis of the concordance of the two Testaments.[63] The vision of Ezekiel with its description of a 'rota in medio rotae' occurs extremely frequently in exegetical writings as an image of the concordance between the two Testaments. This is clearly what is being alluded to in the title-page of the Gospel of St. John in the 12th-century Floreffe Bible at London, containing the inscription 'et vetus et nova lex exterior velat, intelligitur rota duplex, velata secunda revelat'.[64] Sometimes the meaning is more disguised, as for example in the use of a circular composition for those Majestas Domini representations (see Ch. II) where an allusion to the 'rota in medio rotae' may be intended.

In comparisons between the Old and New Testaments the latter is also sometimes presented as being superior, for example in the image of the Old Testament as the veil covering the face of Moses which is being removed (cf. II Cor. 3:12-18). Another example is Paul's mill, which grinds the corn of the Old Testament down to the flour of the New Testament. In the case of the juxtaposition of Ecclesia and Synagoge, however, it involves a clear antithesis.[65]

A combination of all these three examples, together with two other representations elucidating the relationship between the Old and New Testaments, is found in the so-called anagogical window of Abbot Suger (c. 1081-1151) in the choir of the abbey church of St. Denis. Here we see the Ark of the Covenant serving as a chariot for Aminadab, with the four symbols of the Evangelists as wheels, and God the Father with the crucified Christ (in accordance with the Mercy-seat type), together with the example mentioned earlier of the unsealing of the Book by the Lion and the Lamb and the unveiling of Moses. This window, for which a fully satisfying reconstruction of the order of the panels still has to be made, is not only remarkable for the elaborate visual exegesis it provides of the concordance between the two Testaments, but also, in particular, because of the remark in Suger's *Liber de rebus in administratione sua gestis* that the window is in fact an anagogical one: 'una (vitrea) quarum de materialibus ad immaterialia excitans'. There is clearly a neo-platonic slant to the view being expressed here about the function of visual exegesis, which is seen not merely as a didactic, but first and foremost as a mystical method, one that can 'transport' the soul of the beholder.[66]

After this excursion into the origins and development of multiple Scriptural interpretation and into the continuity in exegesis manifested, among other

ways, by the persistence of certain examples taken from the Bible, both in word and image, we must now turn our attention to the beginnings of visual exegesis. An investigation into the earliest examples of visual exegesis will have to concentrate on two points, first the question of the earliest occurrence of a programme in which the relation between the Old and the New Testaments — which from the very beginning plays such an important part in exegesis — finds expression through the contrasting or grouping together of Old Testament and New Testament scenes or series (a typological programme), and, secondly, the question of when one can start to speak of an interpretation on various levels (corresponding to the various 'sensus' of multiple Scriptural exegesis) of a scene, series or complete pictorial programme. In addition there is the question of whether in the case of visual exegesis, too, one can point to a development from a twofold to a multiple interpretation — parallel to the development which took place in Scriptural exegesis.

The relative dearth of pictorial material, even after the addition of a number of descriptions and tituli, forbids the drawing of more that a few tentative conclusions about an evolution which appears, moreover, to have followed rather different paths in East and West. As a rule, any conclusion drawn from these scanty data will have to be treated with extreme circumspection, especially since it is only in a few cases, such as Gregory of Nyssa (see p. 2) and Paulinus of Nola (see pp. 20 ff.), that we have anything in the way of an interpretation provided for a particular representation or programme.

In the earliest christian art, that is to say in the funerary art of catacombs and sarcophagi as well as in gold glass and early engraved glasses, Old Testament scenes tend to predominate. The continually recurring theme is that of salvation, deliverance and redemption through prayer, exemplified by Susanna, Tobias, Jonah or the miracle of Moses striking water from the rock. The same Old Testament themes occur in prayers for the dead and exorcism, for example the prayers of pseudo-Cyprianus and the *Commendatio Animae*.[67] The New Testament scenes are, in contrast, very much in the minority, and nowhere do we find any suggestion of Old Testament and New Testament scenes having been grouped or contrasted, or of there being anything by way of a programme.

That such a development may well have taken place at a very early date in buildings with a special liturgical function, e.g. baptisteries, is possibly demonstrated by what has survived of the decoration of the baptistery discovered at Doura Europos on the Euphrates, which has been dated c. 230. Here both the Old Testament and the New Testament scenes: The Fall and the Good Shepherd in Paradise (in the niche behind the font) and (on the walls) David and Goliath, the Samaritan woman at the well, the healing of the lame man, Christ walking on the water and reaching out a hand to Peter, and the 3 Marys at the empty tomb, can be seen as a step in the direction of a sort of programme which, based on exegesis, portrays baptism as a victory over and a

resurrection from death, a spiritual renewal conferring the right to a life in Paradise.[68] Little from the centuries which followed has survived in the west. Examples are a number of tituli by Ambrose for the baptistery of St. Thecla at Milan (after 390), including the lines: 'Luce resurgentis Christi, qui claustra resolvit mortis et e tumulis suscitat exanimes'; the mosaic decoration of S. Giovanni in Fonte at Naples, c. 400/08, where although there are no Old Testament scenes at all, the New Testament scenes are similar to those at Doura Europos; and the baptistery of the Orthodox at Ravenna, dating from the middle of the 6th century, where a number of the same New Testament scenes and inscriptions explaining the significance of baptism are again found. On the basis of these instances it could perhaps be argued that in early-christian baptismal iconography the typological principle at least played a part in the selection of a limited number of Old and New Testament scenes for a programme that interpreted baptism as a resurrection from death.[69]

The earliest example in the west of a grouping of Old and New Testament scenes in superimposed zones is formed by the mosaics in the cupola of S. Costanza at Rome (c. 350?), known to us solely from drawings and engravings. The decoration consisted of 12 sectors, divided by candelabra-ornamentation, containing one zone with Old Testament scenes — including Adam and Eve, the sacrifice of Cain and Abel, Moses striking water from the rock, Susanna, Tobias and Elijah's sacrifice, so in part the same examples of salvation and prayer being granted that we find in funerary art; and above this a zone containing New Testament scenes. The one identifiable New Testament scene, the healing of the centurion's servant, is located above the scene with Susanna, without any clear relationship being established between the two. The lower border of the mosaic was formed by a band running all the way round and containing a river scene inspired by the Nile landscape of Alexandrian art, complete with putti fishing, crocodiles and so on. This often used to be regarded as a remnant of a pre-christian programme which had been retained when the building was adapted to a christian purpose. Nowadays there is a tendency to interpret it as having a baptismal reference, and also — more justifiably, it seems to me — as representing the biblical motif of the heavenly waters above the firmament (Gen. 1:7; Ps. 104:3). That this may well be the true interpretation is suggested by the fact that the same motif occurred in the apse of the Oratory of Monte della Giustizia at Rome, dating from the end of the 4th centry, but no longer extant, where it was placed under a representation of Christ with the 12 Apostles. One could also cite other examples where a river is more likely to stand for the dividing-line between an earthly and a heavenly zone than as referring to baptism.[70] The uncertainty existing as to the precise function of the building (mausoleum? baptistery? both of which often display very similar types of construction and decoration)[71] further contributes to the problem of interpretation. On the scanty evidence that we have it is impossible to conclude that, in the case of S. Costanza, we are dealing with a programme in which there was a clear connexion between Old and New Testament scenes.

In the slightly later sarcophagus of Junius Bassus (c. 359) at Rome, the New Testament scenes outnumber those from the Old Testament, although in the scenes enacted by lambs in the spandrels of the columns in the lower zone the numbers are equal. The large New Testament scenes are taken from the life of Paul and from the life of Christ, and the choice might suggest that Paul is being viewed here as the type of Christ. In addition to these we find examples of deliverance from death and the granting of prayer (the Three Hebrews in the fiery furnace, the raising of Lazarus) familiar to us from earlier funerary art, and scenes which could be typologically related to baptism or the Eucharist (Moses striking water from the rock; the miracle of loaves and fishes) or to Christ (Daniel, Job as 'exemplar patientiae', the sacrifice of Isaac). But there is no question as yet of anything like a clear programme.[72]

Nor do we find clear programmatic intentions in the slightly later casket, known as the Lipsanotheca of Brescia (c. 360/80). Here the Old Testament scenes are, it is true, still more numerous than those from the New Testament, but the latter dominate because of their central positioning and larger size. The decoration has been applied in 3 zones on the 4 sides of the casket (one New Testament zone between two of Old Testament scenes) the lid has New Testament scenes only, with another zone above them containing portrait medallions of Christ and the apostles. A general relationship is evident between the miracles of salvation from the Old Testament and those from the New, and moreover the latter receive particular stress as a result of their greater size, but there is no direct relationship between Old and New Testament scenes.[73]

It is possible that as early as the 4th century attempts were being made in monumental art to visualize the concordance between Old and New Testaments more systematically. The large basilicas being built at this time offered, with the long walls of their naves, an ideal opportunity for decoration. The increased amount of space available for decoration and the fact that they were designed for public worship, must have necessitated something in the nature of a planned programme. But these monuments have vanished; all we have are descriptions which provide a pointer in that direction. Statements about the kind of wall decoration that the Emperor Constantine had introduced into churches in the Holy Land ought to be treated with circumspection, as attempts made at a later date, in the face of iconoclastic tendencies, to present the decoration of churches as a tradition with its roots in early christendom. The representations mentioned by John of Damascus in this connexion all come, in fact, from the New Testament, which could be an indication of a later date. And the somewhat cryptic remark by the patriarch Nicephoros I of Constantinople (c. 758-829) that Constantine ordered symbols of the 'great "economy" of God: miracles, evidences, the Passion', to be introduced into the decoration of the basilicas, is usually taken to refer to New Testament scenes from the youth and life of Christ and his miracles. However, an unmistakable reference to a contrast between Old and New Testament

scenes is to be found in a statement made by legates sent by Pope Hadrian to the 2nd Council of Nicaea (787). Here we learn that Constantine had arranged for typologically contrasting scenes to be portrayed on the walls of the Lateran basilica: on one side Adam being driven out of Paradise, and on the other the entry of the Good Thief into Paradise. Even here, though, it seems likely that we may be dealing with an anti-iconoclastic report — attempting to suggest the existence of a long-standing tradition at Rome.[74]

Not until round about 400 do we come across more concrete information. With respect to the east this takes the form of a letter from Nilus of Ancyra (later on a monk in the monastery on Mt. Sinai, died c. 430) in which the Prefect Olympiodorus, commissioning a programme of decoration, is explicitly advised to choose one with a contrast between Old and New Testament scenes instead of the profane scenes proposed (hunting, etc.).[75] As regards the west we also have indications, dating from roughly the same time, of a more obvious attempt to programme Old and New Testament scenes. This takes the form of a number of tituli, ascribed to Ambrose (c. 339-97) and possibly connected with a programme executed at Milan, which offer a series of 18 two-line verses relating to Old Testament scenes. In a number of these verses, although not consistently, reference is made to the New Testament antitype, for example: 'Joseph manipulus Christi crux stolaque Christus. Quem sol luna decem coeli stellae quoque adorant' (verse 11).

A second series of 10 New Testament scenes: annunciation, adoration of the Magi, and the miracles of Christ, is not directly related to the Old Testament series.[76]

Compared with the above, the tituli given by Prudentius (348-c. 410) in his *Tituli Historiarum (Dittochaeon),* probably intended for a western church, display a much greater degree of programming: no longer do we find groups of individual scenes rather loosely connected together. These tituli would appear to have been designed for the walls of a large basilica, with a series of 24 Old Testament scenes on the one wall — running from Adam and Eve, the days of the Patriarchs and of Moses, Judges, Kings, the Babylonian exile up to the 'Domus Ezechiae Regis' (the house of King Hezekiah; II Kings: 20) — and on the other wall 24 New Testament scenes, running from the annunciation and the youth and miracles of Christ up to the passion, the resurrection and the ascension and scenes from the Acts of the Apostles. Now, too, for the first time a programme is given complete with titulus for the apse as well: in this case the adoration of the Lamb by the 24 Elders of the Apocalypse. Both the contrapositioning of Old and New Testament series and the inclusion of 4 scenes from the Acts of the Apostles, would seem to point forward to the programmes in the great Roman basilicas of St. Peter and S. Paolo fuori le mura dating from the middle of the 5th century.[77]

The letters and poems of Paulinus of Nola (353-431) provide us with too fragmentary information, alas, about the construction of the buildings restored and founded by him, shortly after 400, in the complex dedicated to St.

Felix at Cimitile. Nor do we learn enough about the decoration programme and the arrangement of the scenes in these buildings. Nevertheless we can derive from them a certain amount of interesting information concerning the purpose of the decoration and how it was to be interpreted.[78] To begin with there is the term 'raro more' used in connexion with decoration in *Carmen* 27, vv. 543-45. The usual explanation given is that Paulinus was implying that the decoration of churches in his time was an infrequent activity. But this is contradicted by his own correspondence with Sulpicius Severus (e.g. *Ep. 32*, dealing with precisely this subject-matter), as well as by numerous examples dating from the same time (mosaics of S. Aquilino, Milan; tituli by Ambrose, tituli by Prudentius, Augustine's warning against incorrect representations, see p. 3). The emphasis in these lines is not so much on 'raro more' — which ought rather to be read in the sense of 'in an explicit, striking way',[79] and would then refer to the markedly lively way in which the figures have been presented, 'animantibus adsimulatis' — as on the question of what the purpose of the decoration was: 'quanam ratione gerendi':

'forte requiratur quanam ratione gerendi
sederit haec nobis sententia, pingere sanctas
raro more domos animantibus adsimulatis.
accipite et paucis temptabo exponere causas'.

This gives Paulinus the chance to go thoroughly into the didactic function of the 'pictura' as replacement for the 'scriptura' in the case of the 'illiterati', and into the beneficial effect of the image on newly converted churchgoers who were still close to being heathens (vv. 548-51). He returns to this theme and plays a variation on it in vv. 580-91:

'propterea visum nobis opus utile totis
Felicis domibus pictura ludere sancta,
si forte adtonitas haec per spectacula mentes
agrestum caperet fucata coloribus umbra,
quae super exprimitur titulis, ut littera monstret
quod manus explicuit, dumque omnes picta vicissim
ostendunt relegunt sibi, vel tardius escae
sint memores, dum grata oculis ieiunia pascunt,
atque ita se melior stupefactis inserat usus,
dum fallit pictura famem; sanctasque legenti
historias castorum operum subrepit honestas
exemplis inducta piis . . . ',

where he hopes that the 'umbra' of the representation will make its way to the spirit by way of the eye. The tituli above the representations, however, cater for the more advanced churchgoers, those who can read, while, in addition, the close connexion between word and image brings about a play of words on 'esca, ieiunia, fames', the allusion being to spiritual nourishment, which the representations as 'exempla' offer for virtuous imitation.[80]

Although the author is concerned here with the didactic and pedagogic

20

function of the image with respect to the ordinary churchgoer, there are indications that he also ascribes a deeper significance to the representations, with an eye on the 'docti', and in particular on the guest of honour Nicetas, Bishop of Remesiana, whom he showed round on the feast of Felix the martyr (January 401?). This is expressed in the lines in which Paulinus addresses Nicetas directly, e.g. as early as vv. 243-87, where he courteously compares the inspiring influence of Nicetas with that of Jacob, which leads to an extensive typological comparison on the theme of Jacob's branch and David's tree (thereby suggesting a preliminary step towards representing the tree of Jesse).[81] In vv. 511-41 and 596-735, too, we can find indications of the mystical significance of the image for the initiate, who can penetrate by way of the image, the 'figura', to the 'veritas':

'qui videt haec vacuis agnoscens vera figuris
non vacua fidam sibi pascit imagine mentem'.

The representations described in *Carmen* 27 are from the Pentateuch, Joshua, Judges and Ruth. Occasionally Paulinus gives a more extensive description of scenes such as that of Joshua crossing the Jordan with the Ark of the Covenant (vv. 518-28). He also pays considerable attention to the representation of Ruth and Orpah (vv. 531-36), where the contrast between 'historia' and 'mysteria' is used to illustrate the difference between the brevity of the story of Ruth, in terms of the letter, and its extensiveness in terms of its deeper significance:

'. . . brevis ista videtur
historia, at magni signat mysteria belli,
quod geminae scindunt sese in diversa sorores . . .'

where Ruth is regarded as type of 'fides' and Orpah as type of 'perfidia'. This attention to the mystical significance of the image is also found at vv. 596 ff., where Paulinus again addresses himself to Nicetas with the request that the latter should use the themes of the representations in a prayer for the salvation of Paulinus' soul, followed in vv. 607-635 by a number of types and antitypes familiar from exegetical writings and also from funerary art: e.g. the old and the new Adam (vv. 608-09) 'ne maneam terrenus Adam, sed virginea terra nascar et exposito veteri nova former imago', and the comparison between Isaac's carrying the wood for the sacrifice and Christ's carrying the cross (vv. 616-17) 'hostia vivua deo tamquam puer offerar Isac et mea ligna gerens sequar almum sub cruce patrem', while in vv. 621-22 Jacob's rest at Bethel (Gen. 38:10-11) and the rest to be found in Christ are compared: '. . . tamquam benedictus Iacob fratris Edom fugitivus erat, fessoque sacrandum subponam capiti lapidem Christoque quiescam'. These lines seem to contain an allusion to an exegesis on three levels, since attention is drawn not only to the 'historia' (O.T.) and the 'allegoria' (N.T.) but also to the 3rd 'sensus' of tropology, with its application to man, here given in the exhortation to imitate Christ. It even looks as if Paulinus might already be playing with the

possibility of a complete quadripartite exegesis of some of the representations when, at the end of *Carmen* 28, vv. 322-25, he extends anagogically the comparison made in *Carmen* 27 between Adam, Christ and Man:

'terrena intereat, subeat caelestis imago,
et Christo vertatur Adam; mutemur et istic,
ut mutemur ibi; qui nunc permanserit in se
idem, et in aeternum non inmutabitur a se'.

Paulinus' opinion, which he elaborates on at various places, that a representation can be read by the initiated on the various levels of exegesis, the Old Testament type pointing to the New Testament antitype and vice versa is also expounded in *Epistola* 32 (c. 403?) addressed to Sulpicius Severus with a proposal for the decoration of the latter's basilicas at Primulacium (Gallia Narbonensis):

'Lex antiqua novam firmat, veterem nova complet.
In veteri spes est, in novitate fides,
sed vetus atque novum conjugit gratia Christi'.

This opinion could provide an explanation for the much-discussed lines in *Carmen* 28 vv. 175-79: 'et tribus in spatiis duo testamenta legamus,/hanc quoque cernentes rationem lumine recto/quod nova in antiquis tectis, antiqua novis lex/pingitur; est etenim pariter decus utile nobis/in veteri novitas atque in novitate vetustas'. The point is that these lines do not have to signify that the new building contained only Old Testament scenes and the old building only New Testament scenes; they simply indicate that the representations introduced in the 3 areas mentioned in the poem may have a typological significance, with the Old Testament scenes pointing to the New Testament and the New Testament ones to the Old Testament, something which had been explained clearly enough in *Carmen* 27, vv. 596-635, in connexion with the types of Adam, Isaac, Jacob, etc.

A remarkable example of coherent programming by placing Old and New Testament scenes on walls facing each other, is provided by the decoration which Bishop Neon of Ravenna (451-473/74) planned for a refectory of the palace to the south of the cathedral.

On one wall were depicted Psalm 148 'Laudate Dominum de caelis', and scenes of the Flood; on the other wall appeared the miracle of the loaves and fishes. Although no tituli were provided for these scenes (possibly through lack of space, since two walls seem to have had windows: 'Ex utraque parte triclinii fenestras mirificas struxit"), the scenes on the other two walls were provided with extensive tituli ('. . . cotidie legimus ita . . .'). On the 3rd wall ('parte frontis inferius triclinii') there was a representation of the 'mundi fabrica', which, on the evidence of the tituli must have consisted of a cycle dealing with the creation: the creation of heaven and earth, land and sea, sun, moon and stars, day and daybreak, and also the creation and animation of Adam as 'imago Dei' and his being led into Paradise and given dominion over

the earth and creatures of every kind. Possibly there was a representation of the Fall as well (nothing is said about the creation of Eve): 'Praeceptum spernens, sic perdidit omnia secum'. The opposite wall contained Peter's vision of the sheet descending with clean and unclean beasts (Acts 10:11-16), together with extensive tituli. What we find, therefore, is that, with an eye to the function of the space as a refectory, two New Testament scenes dealing with food have been chosen, but that the dominant thought in the programme as a whole is the comparison between the glory of the creation and the power and lordship over all created things enjoyed by Adam before the Fall, and the rehabilitation after the Fall: the purification by God of all created things and his promulgation of a New Law; 'legisque novae tibi dantur ab alto' in order to convert all men to 'Christicolae'.[82]

A further attempt towards refining the typological method, by way of grouping Old and New Testament scenes in pairs according to their content — something already present, in a sense, in the tituli of Ambrose and in *Carmen* 27 of Paulinus of Nola (old and new Adam,Isaac/Christ) — is found for the first time, insofar as the surviving material permits any certainty, in the wooden doors of Sta.Sabina at Rome, dating from c. 430. Although there are panels missing and others have changed places, and although there is no question of there being a coherent programme, nevertheless the existence of paired groups is demonstrable in places, for example in the central zone with the large rectangular panels on the left-hand door, where miracles performed by Moses are contrasted with others associated with Christ. On the right are miracles by Moses, occurring in four different zones: the bitter waters of Marah, then two scenes depicting the miracle of the quails and manna in the desert, and below this the miracle of the water from the rock. On the left are three miracles by Christ: the healing of the blind man, the miracle of loaves and fishes, and the wedding at Cana.[83]

A coherent typological programme, constructed on the principle of grouping Old and New Testament scenes in pairs, is provided by the tituli ascribed to Rusticus Helpidius (first half 6th century), although whether, and if so where they were executed is not known. Eight tituli contain the following pairs: the Fall/annunciation to Joseph (quod sit flagrans, salvatur honore), expulsion from Paradise/return of the Good Thief to Paradise, Noah's Ark containing all the creatures/Peter's vision (Acts 10), Tower of Babel (superbia, ora discordia)/Pentecost (consona diversas fundit praedicatio linguas ...), selling of Joseph/betrayal by Judas, Abraham's sacrifice (propria fert hostia lignum)/crucifixion, miracle of quails and manna in the desert/miracle of loaves and fishes, Moses receiving the tables of the Law/Sermon on the Mount. These are followed by a New Testament cycle, also containing 8 scenes: Martha and Mary, the centurion's servant, the wedding at Cana, the healing of the crippled woman (Luke 13:11), the healing of the woman with the issue of blood, the raising of the widow's son from the dead, Zacchaeus, the raising of Lazarus. Just as in early-christian funerary art, these 8 scenes all

depict miracles of belief, healing and raising from the dead, but there is no connexion whatsoever with the 8 typological pairs.[84]

Typological programmes of this kind, in which Old and New Testament scenes were matched for content and grouped together in pairs, must have been in vogue at Rome during the next century. This at least is what we learn from the statement in Bede (c. 673-735) *Vita s. Benedicti Biscopi,* that Abbot Benedict Biscop of Wearmouth brought back from his journeys to Rome between 653 and 684/86, books, 'picturae' and 'imagines', including a series offering a 'Concordia Veteris et Novi Testamenti' with familiar types and antitypes, such as Isaac carrying wood matched with Christ carrying the cross, and the raising of the brazen serpent over against the crucifixion. These he arranged to have grouped in pairs in his church: 'proxima super invicem regione pictura coniunxit'.[85] But we cannot conclude from this (as is frequently done) that we are dealing with an iconographic phenomenon peculiar to Rome. The surviving 7th-century material, at Rome or elsewhere, is simply too scarce to permit such a conclusion. The line of development was continued in the Carolingian period, for example in Alcuin's tituli for a refectory, with as typological pairs: the rain of manna/feeding of the multitude, Moses striking water from the rock/wedding at Cana, and in the tituli by Ermoldus Nigellus, c. 826, for frescoes in the palace at Ingelheim.[86]

Typological representations assume a particulary important rôle in the 11th and 12th centuries, so much so that it has been asked whether there may not have existed something in the nature of a typological compendium, containing a selection of subjects from which both patron and artist could choose (see Ch. II, pp. 56 ff.).

In addition, however, to the method of typological juxtaposition, there were other possibilities for expressing systematically the relationship between the Old and New Testaments. One such involved laying the stress on the historical principles of O.T./N.T. continuity in the history of Salvation, the *Heilsgeschichte.* This could be done, for example, by bringing into visual relation with each other a series of representations from the Old Testament and a series from the New Testament in one and the same programme.

In so far as the surviving monuments allow us to draw conclusions, the serialization seems to have occurred first of all with Old Testament material. This took place in monumental art towards the end of the 4th century. In the Hypogeum of the Via Latina at Rome, for example, we now find, alongside the scenes of salvation familiar from early-christian funerary art, series of representations taken from the Bible, for example the stories of Isaac and of Jacob.[87] Paulinus of Nola also describes Old Testament series taken from the Octateuch. And in the tituli of Prudentius we already find a consecutive series of Old Testament representations placed over against consecutive series from the New Testament.

The earliest surviving programmes in which the historical principle of continuity appears to have been applied are found in Roman basilicas dating

24

from towards the middle of the 5th century, for example the mosaics of Sta. Maria Maggiore,[88] which were probably started under Pope Sixtus III (432-40) and finished under Leo I (440-61). Although there is no general agreement as to the correct interpretation, it looks as if the mosaics decorating the walls of the nave and those on the triumphal arch ought to be considered as belonging to one single programme, in which a certain thematic connexion between Old and New Testaments is being aimed at. The series of Old Testament scenes in a composition consisting of two zones[89] on the walls of the nave reproduce the early chapters of the *Heilsgeschichte,* the days of the great leaders of Israel with the deeds of Abraham, Isaac, Jacob, Moses and Joshua; the scenes from the youth of Christ on the triumphal arch depict the continuation 'sub gratia' of the *Heilsgeschichte.* The hypothesis put forward in a recent study on this subject, where a three fold programme is suggested, corresponding to the three promises made to Abraham by God in Genesis 12, and based on the commentary provided by Augustine in *De civitate Dei* XVI, seems highly acceptable. The cycle on the left wall would, in that case, show the multiplying of Abraham's descendants, and that on the right wall would show the Exodus and the occupation of the Promised Land. The christological scenes on the triumphal arch would then represent the realisation of the third, Messianic, promise. A too one-sided interpretation of the scenes on the triumphal arch, viewed in the light of the dogmatic definitions of the Council of Ephesus (431) — concerning the status of the Virgin Mary as Theotokos, is no longer generally accepted.[90]

The monumental cycles of pictorial decorations initiated under Pope Leo I, towards the middle of the 5th century, in the great Roman basilicas of St. Peter and S. Paolo fuori le mura, which are only partially known to us from 17th-century drawings, show a still more consistent application of the historical principle of continuity in the *Heilsgeschichte* as the guiding idea behind the programme. The *Heilsgeschichte* which begins with the Old Testament scenes on the one wall is continued via the New Testament scenes or the story of the apostles on the other, and concluded with a series from contemporary history: the portraits of the popes.[91] It is possible that here, too, the underlying idea was influenced by Augustine's *De civitate Dei.* That just at this time and at Rome Augustine's views should find their reflection in an official, 'propagandist' art, which placed the popes as heirs to the apostles in a programme visually emphasizing the historical continuity, may be connected with the strong position of the pope and the claims to papal primacy which Leo I was energetically defending against the Eastern Empire.[92]

A variant on the principle of historical continuity is provided by representations in which Old Testament prophets and their prophecies are interpreted as anticipating the New Testament. We find this, for example, in compositions occurring fairly frequently in the 6th century where 2 or 4 Old Testament prophets, accompanied by an inscription containing their prophecy, point to New Testaments scenes forming the fulfilment of that prophecy. This

compositional scheme and its interpretation is extremely explicit, for instance, in the 6th-century Sinope fragment at Paris, in which 5 miniatures accompanying the Gospel of St. Matthew each display a zone of New Testament scenes placed between zones containing inscriptions, the lower zone being crowned by busts of prophets.

The same thing is found in the Codex purpureus Rossanensis, also dating from the 6th century, where the text — only partially preserved — is preceded by miniatures containing Gospel scenes in the upper zone with, underneath them, inscriptions crowned by prophets. The Rabula codex at Florence gives a variant of this arrangement in which the Old Testament prophets appear in a row above the canon-tables.[93]

The placing of prophets in the window zone, too, e.g. in the Old St. Peter's at Rome and the S. Apollinare Nuovo at Ravenna, may well have been done with the similar idea in mind of providing an O.T. commentary on the N.T. scenes of the programme.[94] This principle can be traced through into the Middle Ages. It is, for example, extremely effectively used in a number of programmes in stained glass, where the high windows of the nave contain prophets with text-scrolls — for instance in the five 'prophet windows' in the nave of the Dom at Augsburg.[95]

A variant on this theme consists of a composition 'ordine quadrato', in which the prophets supplying a commentary are placed at the four corners. This seems to occur for the first time during the Carolingian period, e.g. in a titulus by Alcuin which is probably meant for a representation of the Majestas Domini with 4 prophets and the 4 symbols of the evangelists, such as occurs, for example, in the Vivianus Bible at Paris.[96]

This type of composition with prophets providing a commentary from the corners can also be traced far into the Middle Ages, e.g. in the compositional scheme of the earliest copies of the 'Biblia Pauperum'. In later copies the scheme is varied by placing the prophets two by two in niches above and below the representation, a method which in its turn was followed well into the Renaissance.[97]

From what has been said above we can draw the following conclusions respecting the question of the earliest appearance of representations depicting a relation between the Old and the New Testaments. The first indications of a typological relationship between Old and New Testament scenes in an early-christian decoration programme occur round about the year 400 in the tituli ascribed to Ambrose and in the descriptions by Paulinus of Nola; the oldest surviving pictorial example is formed by the grouped pairs of scenes in the doors of S. Sabina. The earliest coherent typological programme occurs in the tituli ascribed to Rusticus Helpidius.

In so far as the scanty evidence which has survived allows of conclusions, it seems reasonable to imagine that the typological principle also had a certain part to play in the decoration of buildings with a specific liturgical purpose, such as baptisteries.

The principle of historical continuity in the *Heilsgeschichte* is first found in the tituli of Prudentius; towards the middle of the 5th century it becomes more extensively applied in Roman basilicas. A variant form of expressing this historical continuity, in which prophets are provided with texts underlining the New Testament fulfilment of their prophecies, can be traced through from early-christian times until far into the Middle Ages.

In coming to conclusions about scenes and programmes which portray the relation between the Old and New Testaments in terms of concordance, contrast or historical continuity, a certain amount of assistance is provided by the concrete nature of the representations, but the question of the earliest occurrence of a multiple interpretation of certain scenes or of a whole programme is a tougher one. Nevertheless it seems a reasonable hypothesis that the descriptions by Paulinus of Nola, made shortly after 400, are the earliest examples we have of 3-, or possibly even 4-fold interpretation of a decoration programme, even though adequate evidence is lacking.

Still greater uncertainty attends the interpretation of particular representations or programmes which have no explanatory tituli, and for which we have no elucidatory texts, and which yet lead us to think that they ought to be interpreted in a special way, namely from the human standpoint. In these instances we have to consider the possibility that the programme is focused on man, either as observer, or as recipient of baptism, or as priest at the altar. In the case of a funerary programme the standpoint might even be the postulated consciousness of the dead person.

The whole question of the complementary rôle that man can play in the programme touches on a problem with which art-historians dealing with early-christian and medieval art have scarcely concerned themselves at all.[98] A hint that this relation between man and image was in fact recognized (although the instance in question is not a particular representation or programme but a theoretical problem) is possibly what we are offered by a certain 7th-century polemic about the problem of the permissibility of images. This occurred between Bishop Leontios of Neopolis (Cyprus) and a jewish opponent, and one of the arguments produced was that an observer is always necessary if the image is to achieve the optimal fulfilment of its transcendental function.[99]

That the relation between the actual human being and the painted decor could indeed have played a part, is perhaps suggested by the fact that in some cases the programme is oriented on the spot where the human being — whether recipient of baptism, priest at the altar, dead man in his tomb, or prince in his palace chapel — was situated. In this way, a multiple interpretation of the programme — with an emphasis on the 'sensus tropologicus', exegesis in terms of man —was rendered possible.

Examples of such programmes from the Carolingian period and from the 11th and 12th centuries are known (see p. 29 and Ch. IV). The question is whether interpretation in this sense is possible at an earlier date.

27

In early-christian funerary art the scenes chosen often form a parallel with the prayers in the first person of, for example, pseudo-Cyprianus and the *Commendatio Animae:* 'libera me ut liberavis . .' (followed by Old and New Testament examples). The human being — the dead person in the tomb or the observer present in the burial chamber — could in this case, too, be regarded as a complementary element, rendering the fictitious, painted programme complete. This also makes possible an interpretation in accordance with the 3rd, tropological, 'sensus' in terms of man, and, (since we are dealing with a funerary programme) possibly even in accordance with the 4th anagocical 'sensus' concerned with the Things to come.

But this will have to remain a hypothesis, since we have no texts that could show whether this explanation of such a programme was in fact made. However, Paulinus of Nola's interpretation, in *Carmen* 27, of certain representations in the sense of an 'imitatio Christi' — a point which we discussed earlier — could serve as a pointer.

This method of interpretation would also be possible in the case of programmes in baptisteries, which are related to funerary art. The baptistery of the Orthodox at Ravenna, dating from the middle of the 5th century, provides an example. Here we find a combination offered of Old Testament and New Testament scenes and inscriptions which supply a commentary on the significance of baptism, the whole programme culminating in the mosaic of the cupola portraying the baptism of Christ. Once the candidate for baptism had placed himself in the centre of the terrestrial zone, exactly under the figure of Christ, Who forms the centre of the heavenly zone, the meaning of the programme: the 'imitatio Christi' had been fulfilled, and the explanation on the four levels of history, allegory, tropology and anagoge was complete.

This agrees entirely with early-christian exegetical texts and with the baptismal liturgy, which interpret baptism as a rising from the dead and as 'imitatio Christi', an interpretation based on the following passage from Paul's Epistle to the Romans 6:3-4 'An ignoratis quia quicumque baptizati sumus in Christo Jesu, in morte ipsius baptizati sumus?'[100] But direct evidence that the representation was actually read in this way cannot be provided here either.

Another example of the part that human beings could play in a decoration programme by their actual presence is provided by the presbytery and apse of S. Vitale at Ravenna, which dates from the fourth decade of the 6th century. The dominating theme here is the continuity of sacrifice in 3 phases: Old Testament (Abel, Melchisedech, Abraham), New Testament (represented by the picture of the 3 Magi on Theodora's mantle, and especially by the Lamb as antitype of the Old Testament sacrifices, in a medallion borne by 4 angels at the summit of the vault), and — since the Lamb is oriented on the officiating priest — the celebration of the Eucharist itself, which forms the 3rd phase in this continuity of sacrifices, and is at the same time the element of reality in the fictitious programme.

There is also a further interpretation possible in the sense of a historical

continuity on 4 levels: first Old Testament, then New Testament, next the imperial couple Justinian and Theodora with their court 'in effegy' on the side walls of the apse, and finally, the ultimate completion of the programme in the apse mosaic with Christ in the glory of Paradise, which is a recapitulation of the Old Testament Paradise with its 4 rivers.[101]

Indications of the complementary part that man (alive or dead) could play, as observer, priest or ruler, in a decoration programme, can also be found in the later periods that are of special interest to us, the Carolingian period and the 11th and 12th centuries. We find it, for example, in palace chapels[102] (sometimes two-storeyed chapels), where the ruler's throne was situated in a tribune looking onto the altar, as at Aix-la-Chapelle, and as we are told was the case in the episcopal chapel of Theodulf of Orleans at Germigny-des-Prés. In both instances the ruler or church dignitary could have played his part in a programme based on the typological relation between the earthly and heavenly Jerusalem, or the earthly and heavenly Temple. In the 11th and 12th centuries we find this principle of participation by man in a decoration programme, which is completed by his actual or ideal presence, mainly in funerary chapels or funerary churches. (see Ch. IV).

II

VISIBILES FIGURATIONES[1]

It was argued in the preceding chapter that even in the early-christian period the 'pictura', as equivalent to 'scriptura' was assigned not only a didactic and pedagogical function, but also a mystical function. It thus became possible to 'read' a decoration programme in terms of the 4 'sensus': 'historia, allegoria, tropologia, anagoge'. Whether this was actually done during the period is a question which, despite strong positive indications, will have to be left open for lack of proof.

But in any case, the application of a method of visual exegesis in the true sense of the term, often making use of quadripartite schemes, was simply not possible at this date, since it went hand in hand with the assimilation of the rudiments of the late antique system of education to a specifically christian school curriculum, and with the development of multiple exegesis as part of educational practice. Despite early signs of a move in this direction, therefore, it is quite inappropriate to speak of such exegesis as existing before the Carolingian period and the reform of education which took place then.[2]

As early as in Augustine we find the suggestion that the antique school curriculum based on the 7 'artes liberales' might be modified to serve as a basis for the study of the Scriptures. Augustine considers the various subjects in the curriculum of the trivium and quadrivium as providing a suitable pro-paedeutics for instruction in Scriptural exegesis, from which they receive, as it were, their christian brevet. The 'artes' must never, however, be studied as an end in themselves, since their only function is to exercise the spirit, 'exercitatio animi' (see *De quantitate animae* 15 (25); *PL* 32, 1049). They ought to lead: 'a corporalibus ad incorporalia ... a visibilibus ad invisibilia et a temporalibus ad aeterna' (*Epistola* 55 ad Januarium; *PL* 33, 211), and this has to take place step by step: '... quibusdam quasi passis certis vel pervenire vel ducare' (*Retractiones 1, 6; PL* 32, 591).[3]

Augustine was followed by, among others, Cassiodorus (c. 490-583), whose *Institutiones* became a handbook of the unity of profane and sacred studies, with the 'artes liberales' acting as propaedeutics for the exegesis. This work continued to serve as a school programme until well into the Middle Ages.[4]

Since instruction in the method of exegesis involved fairly complicated material, use began to be made of diagrams and schemes known from secular learning, in which the facts about the multiple interpretation of the Scriptures

at the various levels of history, allegory, tropology and anagoge could be clearly and schematically presented. This created a visual-exegetic method of Scriptural interpretation in which the image often tended to dominate, while the text acquired a secondary, explanatory rôle, or was omitted altogether, making it genuinely possible to speak of pictorial exegesis. But this tendency only began to manifest itself clearly in the Carolingian period, after a preparatory phase; it did not develop into a system with more or less fixed rules until the 11th and 12th centuries.[5]

With the aid of these schemata an extremely complex exposition which would otherwise need pages of text to set it forth could be concisely expounded and clarified. It is hardly surprising that the great didactic advantages of the visual-exegetic method should have been recognized by a number of great medieval teachers, including Honorius Augustodunensis, Hugh of St. Victor, Peter of Poitiers and Joachim da Fiore.[6]

Some visual-exegetic schemata are easily recognizable as such; in others this function is more or less disguised. Sometimes the representation precedes the text (or a portion of it) as a summary, or the text serves simply as a starting-point for a number of pictorial paraphrases on the theme of the work concerned. In such cases the representation can provide a more or less independent exegesis. Explanatory inscriptions, which need not be taken from the text, and which can again provide a largely autonomous commentary, may also play a part, one which can be expressed by their function in the composition: for example as spokes in a 'rota' scheme, or as a legend running round the outside of a representation and summarizing it. In this way related, or opposed concepts can be brought into relation with each other. Furthermore, inscriptions or scrolls connected with subsidiary figures or representations may also provide a commentary, as it were, on the principal theme.[7]

The loose relationship between a visual-exegetic scheme and the exegetical text in which it originates, simplifies transmigration to other texts, and even to quite different media, such as, for example, wall-paintings or liturgical objects.[8]

The use of diagrams and schemata for christian instruction represents the continuation of a method of teaching by illustration which had already been long in use in the schools of late antiquity.[9] As Cassiodorus says in the 'praefatio' to his *Institutiones,* there are two ways of teaching, by way of the eye and by way of the ear:

'quia duplex quodammodo discendi genus est, quando et linealis descriptio imbuit diligenter aspectum, et post aurium praeparatus intrat auditum'.[10]

But in addition to the didactic and pedagogical aspect of the visual-exegetical method there was also the mystical aspect, involving an awareness of the power of the image to lead from the visible to the invisible, to serve as a 'vehiculum' to higher things.[11] In this respect the term 'figura', frequently used for a visual-exegetic scheme,[12] is ambivalent, since it can be

31

used both in the sense of a concrete representation or illustration and in the sense of a prototype, a prefiguration of something higher.

This is clearly demonstrated by two facing pages in the Ottonian Hitda codex at Darmstadt. The titulus on the left-hand page reads:

'Hoc visibile imaginatum figurat illud invisible verum cuius splendor penetrat mundum cum bis binis candelabris ipsius novi sermonis'.

The accompanying Majestas Domini shows Christ in a mandorla, shaped like the figure 8, enthroned between the four symbols of the evangelists and flanked by the two pairs of 'rotae' from Ezekiel's vision. Through the combination of representation and titulus the rôle of the Majestas as visual-exegetic scheme (see pp. 47 ff.), capable of conducting the observer from the 'figura' to the 'veritas', and from the 'visibilia' to the 'invisibilia', is demonstrated.[13]

The value attached to both the didactic and the mystical possibilities of the visual-exegetic method for instruction is evident from passages in a dialogue between master and pupil occurring in a 12th-century MS. of the *Speculum Virginum*. That preference was often given to the image above the word when it came to elucidating a particular line of thought is clear from the following passage (fol. 114r., followed by a representation of the 'virga Jesse'):

'. . . ut melius innotescat ex pictura si quid dignum proferri potest ex scriptura. Facilior enim ad intellectum per oculos sensus est, ubi premonstrat ratio invisibilis quod ostendere vis verbis secuturis. Fabricemus ergo . . . Attende igitur' (followed by the representation).

In another passage (fol. 83r., followed by a cruciform scheme of the HOMO TOTUS, which provides in abbreviated form the contents of the chapter entitled 'De fructu carnis et spiritus') the emphasis falls on the mystical function of the image, which is explained here in the sense of an 'imitatio': 'ut vigeat in eis (Christi virginibus) interius quod figuraliter videtur expressum exterius'

Peregrinus: 'Quod ut apertius clareat rursus figuram ponamus . . . Sepe enim aliud per aliud consideratur et per rerum imagines visibilibus obiectas intellectus acuitur. . . . sic Christi virgines quaecunque rerum similitudine vel collatione visibilia possunt invisibilibus conferri, ipsae quae per hoc ad profectum virtutum excitari gratanter intuentur, coniectantes maiora de minoribus sed quandam veritatis soliditatem in figuralibus speculantes rationibus'. *Theodora:* 'Ordinatissimis rationalibus premissas posuisti figuras, visibiliter imprimens pagine quod considerandum est mentis ratione, omnibus hoc modis persuadens Christi virginibus ut vigeat in eis interius quod figuraliter videtur expressum exterius. Pone itaque figuram quam promittis in qua colluctatio carnis et spiritus suis exhibeantur triumphis alternantibus'.[14]

The lesson is then continued with reference to the scheme (fol. 83v.), and introduced by a question from Peregrinus (written round the drawing): 'Videsne quid pretendat huius ratio formulae?'.

Sometimes we even seem to find hints that the contemplation of the 'figura' could be regarded as a meditation technique. An oblique pointer in this direction may occur in a passage in the work by John Scotus Erigena (815?-877?) entitled *Periphiseon id est de divisione naturae*, where, in another

of these discussions between master and pupil using images as a starting-point, there is talk of a visual-exegetic circular scheme which possibly ought to be thought of as a revolving scheme.[15]

The formal origins of many visual-exegetic schemata used for conveying knowledge of the fourfold interpretation of the Scriptures for teaching purposes have to be sought — as we have said earlier — in school diagrams and schemata which had already been long in use for secular learning and had been adapted for the purposes of visual exegesis.[16] This use of secular schemata was sanctioned by the acceptance of the 'artes' as propaedeutics for exegesis by Augustine and the pedagogically-minded writers who followed him, such as Cassiodorus, Isidore of Seville, Alcuin and Raban Maurus, etc.[17]

The material underlying the visual-exegetic schemata was provided, how-ever, by a fairly constant supply of images and comparisons going back to the Bible, which exegetes had used from earliest days and which had continued to be used in Scriptural commentaries throughout the centuries. There is a noticeable preference for quadripartite cosmic or architectonic symbols, e.g. the Paradise garden with 4 streams, the four-sided city of Jerusalem, the cross reaching out to the four points of the compass. Exponents of visual exegesis, too, make use of these examples regularly found in the commentaries, employing them as symbols of the harmony brought about by the application of the 4 'sensus', and adapting quadripartite, cosmic schemata long in use for school instruction, such as the 4 winds, the 4 elements, microcosmos, macro-cosmos, 'mappa mundi', Annus and the seasons, etc. (figs. 1-7, 19b).

In this way quadripartite visual-exegetic schemata came to be created on the theme of Paradise, city, cross, in which room could be found for all the finer points of multiple exegesis. These 3 principal categories: Paradise quaternity (paradisus quadruplex), city quaternity (Hierusalem quadrata), anthropomorphic quaternity (cross as 'machina mundi'), will be dealt with separately in the following chapters.

The use of cosmic schemata for visual exegesis may have been stimulated by the parallel, frequently drawn by exegetes, between the Creation and the Holy Scriptures, a parallel hingeing on the doctrine that the harmony of the Cre-ation was disturbed by the Fall, which necessitated a second Creation by means of a second revelation of the Word, the Scriptures. This concept of God's twofold revelation, in the Creation and in the Scriptures, was extremely widespread. Scriptures and Creation, 'scriptura / creatura' and 'lex / mundus' are like two books. The letters of the Creation were written by the finger or the pen of God. The heavens of the Scriptures were unrolled like a second firmament.[18]

Diagrams and schemata which had long been used in secular learning for illustrating the inner cohesion and harmony of the cosmos, could obviously be fairly easily adapted to expound the harmony of the Scriptures, all the more so

since cosmos and Scriptures, as image and word, offered equivalent possibilities for illustrating platonic views about the way in which number and order in the cosmos reflected the world of ideas, or for serving as 'vehiculum' to transport the mind from incomplete, visible things to reality and truth.

This is no doubt why it was mainly cosmic school diagrams and schemata explaining antique, platonic subject-matter dealing with the creation, construction, composition and harmony of the world, that were adapted.[19]

The recognition of Plato as an authority within the 'doctrina christiana' was largely due to the influence of Augustine, who did not consider the platonic world view to be irreconcilable with christian dogma.[20]

Graphic illustration was probably a fairly early feature in commentaries on Plato's works; its use is already suggested in the platonic dialogues themselves.[21] In particular, illustrations to commentaries on the *Timaeus* may have been influential, since the passage dealing with the creation of the world[22] had already been incorporated into early-christian exegesis — for example in the commentaries of Ambrose, Basil and Augustine on the book of Genesis.[23] A comparison between the platonic creation with its elements, their mixture on the basis of common properties, and the relation between the elements and numbers,[24] and, on the other hand, the christian creation, which was also based on number and measure *(Sapientia* 11:21 'omnia in mensura et numero et pondere disposuisti') became part of exegetical procedure, largely because of Augustine.[25]

It seems unlikely, however, that the illustrations in commentaries on the *Timaeus* had any influence on the development of visual-exegetic schemata. So far as is known, MSS. of Chalcidius' 4th-century commentary on the *Timaeus,* to take a case in point, contain, even in 11th- and 12th-century examples, solely technical diagrams explaining the text, but no harmony schemata.[26]

There were other sources, however, from which the Middle Ages could derive their knowledge of the platonic doctrine concerning the elements. One important source for the conception of a world created in terms of number and measure, and also for the idea of the mixture of the elements, the 'syzygiae elementorum', was the commentary by Macrobius (c. 400) on the *Somnium Scipionis* of Cicero. In this work emphasis is laid, in connexion with the creation of the universe, on the important function of the number 4, by means of which the Creator united the 4 elements: 'per tam iugabilem competentiam'.[27] The Macrobius text was illustrated from its earliest appearance, and the text repeatedly refers the reader to 'figurae' for enlightenment: '. . . quia facilior ad intellectum per oculos via est . . .'.[28] As in the case of Chalcidius' *Timaeus* commentary, however, what we find are for the most part simple diagrams illustrating the text. One exception is an 11th-century Macrobius MS. at Copenhagen, presumably French, where on fol. 25 r. we find a circular cosmic scheme of the terrestrial globe surrounded by 7 planetary spheres and

the zodiac, with a clear division into 4 parts by means of 4 caryatid-like figures supporting the scheme at the corners (fig. 8).[29]

A late Macrobius MS., at London, dating from the first half of the 13th century, contains an even more elaborate scheme. At the start of the MS., by way of summary of the cosmological and philosophical subject matter, a school scheme of the 'syzygiae elementorum', with the relations between elements, qualities, numerical series and (as sole representative of the platonic forms) the 'tetragonus cubus', is placed under a circular scheme of the 'Triplex Anima'. The origin of this scheme is, however, obscure. It might have been added to later commentaries on Macrobius to elucidate a relatively difficult passage where words proved inadequate. It could equally well, however, have transmigrated to the Macrobius text from some other context (fig. 9).[30]

Another source of platonic cosmological material for teaching purposes was the allegorical encyclopedia of Martianus Capella (410-39) *De nuptiis Philologiae et Mercurii,* in which the mixture of elements acquires a poetical garb with the image of Hymen who, summoned to reconcile the elements, binds the warring particles of primary matter together in a mystical tie and indissolubly unites the contrarieties. (I, 3, 4).[31]

As a school text Martianus Capella's encyclopedia was particularly influential in connexion with the study of the 7 liberal arts. It frequently served as a basis for teaching, and Gregory of Tours (c. 540-94) praised it as a compendium of all educational wisdom.[32]

Of the surviving copies made between 900 and 1200, there are four containing illustrations of the Martianus Capella text, but from the research done on this material so far there is no evidence of any uniform pictorial tradition connected with the transmission of the text. So far as we can tell, cosmic school schemata do not occur. Most of the illustrations take the form of initial letters or elucidations of the text in which the liberal arts are represented as standing or enthroned, or occasionally as teaching.[33] Only in two instances it is possible to trace an attempt at schematic representation. In a late 11th-century miniature in a MS. at Paris (fig. 10) containing elements taken from the Martianus Capella text and accompanying a poem about Sapientia and her daughters, the 7 'artes' (fol. 60 r.), we find Sapientia-Philosophia enthroned (cf. the inscription on the scroll 'Initium Sapiencie timor Domini' Ps. 111 : 10) between Dialectica and Grammatica above a structure in the form of an arcade, in which the other 5 'artes' are standing. This must be a case of transmigration from another context, since in the poem Sapientia is presented as the 'nourishing mother' of the 7 'artes', which she is not in the illustration.[34] It is doubtful, however, whether this has really been taken from a Martianus Capella MS. The representation reminds one in some ways of the visual-exegetic schemata of Ecclesia and her court in, e.g., *De civitate Dei* MSS., and in the *Hortus Deliciarum.* In both cases the choice of the architectonic scheme is undoubtedly linked with the comparison to the House of Wisdom and its 7 pillars (Prov. 9 : 1).[35]

35

On the other hand a 12th-century drawing in the collection of R. von Hirsch at Basle, which possibly comes from a Martianus Capella MS., shows a sort of tree scheme with Philosophia at the top and streams running from her to the 7 'artes', which she is feeding.[36] Here, again, the provenance is not at all certain (fig. 11).

Certainly of no less importance than the text itself were the commentaries on Martianus Capella, e.g. by John Scotus Erigena and by his pupil Remigius of Auxerre (c. 841-908), whose commentary was entirely inspired by that of his master.[37] Remigius's work was a particularly important link in the teaching of theories about the elements.[38] The passage dealing with the mixing of the elements, however, was not, so far as we can tell, schematically elucidated in any of the Martianus Capella commentaries, although Remigius of Auxerre takes the phrase 'Complexumque sacro dissona nexo foves' (I, 3) as the starting-point for an extensive discussion of the elements, their 'qualitates' and the 'syzygiae elementorum', and although his exposition of the texts 39:21 'Quaeque elementa ligat dissona nexo' and, especially, 44:18 'Et habetur ipse quaternarius quadratus', seems to have been written with a school scheme in mind of the 'syzygiae elementorum', the 4 winds and Annus and the 4 seasons.[39]

The examples of illustrated Remigius commentaries that have come to light so far, however, contain — with one exception — purely textual illustrations, and not what could be called independent schemes. The exception is a Martianus Capella MS. with marginal glosses incorporating the Remigius commentary. This work, which is in the library at Berne and dates from the end of the 9th or the beginning of the 10th century, contains at the start and finish a number of diagrams added in the 11th and 12th centuries. It is not known, however, from what context these diagrams have come, or whether they occur elsewhere in Martianus Capella commentaries.[40]

In view of the important part played by Boethius' (480?-524) *De consolatione philosophiae* as a school text,[41] in particular as regards the transmission of platonic cosmic ideas, it will be necessary to investigate the extent to which the Boethius tradition could have contributed to the development of visual-exegetic schemata. Particularly important texts were *Consolatio* III, m.9:

'O qui perpetua mundum ratione gubernas
Tu numeris elementa ligas . . .'

and IV, m. 6: 19: 'Haec concordia temperat aequis . . .',[42] which were read with the respect accorded to classical texts handing down ancient wisdom. Metrum 9 was recognized to be an adaption of the first part of *Timaeus* and was therefore read with a certain veneration.[43]

In numerous medieval commentaries on Boethius' *Consolatio* III, m. 9, this difficult passage was elucidated by means of what were apparently widely known school schemata of the mixture of elements and their geometrical proportions, coupled with a comparison between macro- and microcosmos.

36

There were two ways of doing this, involving either a circular scheme of elements or a linear one. Both schemata probably played their part in the development of visual-exegetic schemata. Both, however, transmigrated from another context.

The circular scheme may have derived from Isidore of Seville (560-636) *De natura rerum*.[44] In his encyclopedic works, *Etymologiae* and *De natura rerum*, Isidore puts together everything that was still known in his time about the secular learning of late antiquity, but — in imitation of Augustine — he placed this at the service of 'doctrina', as is shown by the prologue to *De natura rerum*: '. . . Neque enim earum rerum naturam noscere superstitiosa scientia est, si tantum sana sobriaque doctrina considerentur'. This may have facilitated the adaption of scholarly schema to visua-exegetic scheme.

For Isidore, number was of fundamental significance in the structure of the universe: 'Tolle numerum in rebus omnibus et omnia pereunt. Adime saeculo conputus, et cuncta ignarantia caeca conplecitur . . .' (*Etym*. III, iv, 4).[45] To the information he had gleaned on this subject from writers of late antiquity such as Nicomachus of Gerasa (c. 100 A.D.), whom he had come across in Boethius and Cassiodorus, he added the etymology of numbers. The important thing for our present investigation is the rôle he ascribes to numbers in exegesis, influenced in particular by Augustine's view that the study of numbers can serve as an aid to biblical exegesis.[46] This numerological emphasis by Isidore led to extensive discussion of numbers by medieval exegetes, and in particular of the number 4, which was analysed repeatedly at various levels.[47]

In his discussion of the 4 elements in *De natura rerum* XI. 1, 'de partibus mundi'[48] Isidore clearly incorporates material from various sources, this being further elucidated with the aid of 2 different schemata. Although the first of these, the 'figura solida' (see p. 38) is announced in the text, its connexion with the latter is minimal; the second — a circular scheme of the elements — is used to elucidate the 'syzygiae' theory from Ambrose's *Hexaemeron*. This scheme is introduced in the text as follows: '. . . quae latine elementa vocantur, eo quod sibi conveniant et concinant. Quorum distinctam communionem subiecti circuli figura declarat', and it brings chapter XI to a close. By means of an ingenious system of circles and segments of circles it portrays the idea of a harmoniously concordant cycle of elements and their 'qualitates', linked to a comparison between the macro- and the microcosm in which the 4 seasons and the 4 humours, positioned, together with the 4 elements, on an orthogonal cross, participate in this cycle of 'mundus-annus-homo' (fig. 12.).[49]

The circular scheme of elements, elucidating Ambrose's version of the 'syzygiae' theory, may well have formed part of the text from the very beginning, since it is mentioned in the earliest known MS. of *De natura rerum*, now in Paris, dating from the end of the 7th century: '. . . quorum distinctam communionem subiecti circuli figura declarat'.[50]

The circular scheme of elements became incorporated in the medieval scholastic tradition and can frequently be met with in school books containing

compilations of cosmological texts.[51] It also occurs fairly often — as we mentioned earlier — in commentaries on Boethius' *Consolatio* at passage III, metrum 9, 'Tu numeris elementa ligas'.[52] Some medieval commentaries on Boethius, however, (fig. 13)[53] elucidate the same passage by means of a completely different, linear scheme of the 'syzygiae elementorum', in which expression is given to the interconnectedness of elements, 'qualitates' and numerical series (8, 12, 18, 27), and the harmonious nature of the universe. This scheme can also be found in various medieval school texts (fig. 14).[54] Its origin is uncertain, but there may have been an influence from a school scheme of the elements, also linear, which occurs in an Appendix to various MSS. of Cassiodorus' *Institutiones*, including some from the 9th and 10th centuries (fig. 15). Here it accompanies a short discussion entitled 'Excerptum de quattuor elementis . . .' and portrays the elements, their 'qualitates', the 4 platonic forms (pyramid, sphere, icosahedron, cube) and the numerical series 12, 24, 48, 96 as an image of the closely knit bonds by which the world is held together: 'hoc illud nexibile mundani foederis vinculum, haec elementorum colligativa cognatio'. But again, the origin (and incidentally also the age) of this linear scheme of the elements is unknown.[55]

The first of the two schemes which, as we mentioned earlier, Isidore used in his *De natura rerum* XI.1, 'de partibus mundi' to elucidate the theory of the 'syzygiae elementorum', appears to be a variant on the linear scheme of the elements. Like the circular scheme of elements, this so-called 'figura solida' probably dates back to the original version of Isidore's work, or may even — the possibility cannot be excluded — have been designed by Isidore himself (figs. 12, 16, 17, 18).[56]

This scheme, too, is introduced in the text, as follows:

'. . . Terra autem et ignis a se separantur sed a duobus mediis aqua et aere iunguntur. Haec itaque ne confusa minus colligantur subiecta expressi pictura'.

There is no real connexion between the scheme and the text. It is more likely to have been simply a graphic representation in which a number of different ingredients were united, such as details from Plato's *Timaeus* dealing with the 4 elements, their 'qualitates' and — as residue of the relationship between the elements and geometrical forms — the cube and traces of the triangle and the circle. The latter pair, however, are more decorative than functional: the main emphasis falls on the cube. This gives rise to the question whether the platonic material found here has not been grafted on to a passage borrowed from Macrobius' *Comm. in Somn. Scipionis* (lib. 1, v. 9)[57] concerning the construction of the cube and the number 8. Isidore's 'figura solida', which bears the inscription 'haec figura, est secundum geometricam proportionem', might be an attempt to link ideas of Macrobius with the platonic data on the elements and their 'qualitates'. The scheme is additionally interesting in that it attempts to create the impression of being a 3-dimensional 'figura'.[58]

The 'figura solida' in Isidore's *De natura rerum* is not only an early example

of the relatively loose connexion between image and text characterizing the compilation method used in school books; in another light it would appear to play a part in the development of school schemes into visual-exegetic schemes. As early as the 8th century we find various figurative elements being added to the 'figura solida', such as a peacock, a human figure, or both. These are not directly related in any way to the text, nor is it likely that they are traceable back to the archetype of Isidore's work: they must have been added at a later stage in the history of the illustrative material of the Isidore texts. It is possible that the first example of these additions must be sought in Spain, in a visigothic prototype.[59] As early as in the oldest known MS. of *De natura rerum*, at Paris, we find figurative additions (mainly heads) to the diagrams of months, climatic zones, and winds, as well as to the circular schemes of the elements.[60] The 'figura solida', however, was not ornamented, so in this respect the MS. in question could not have functioned as prototype for later MSS. (fig. 16). In an 8th-century Northern French MS. at Paris, however, (Chelles? St. Denis?), the text of which (and therefore probably the illustrations as well) also goes back to a visigothic model, we find the 'figura solida' accompanied by both a peacock and the human figure (fig. 17).[61]

The 'figura solida' complete with human figure and peacock found in a MS. of Isidore's *De summo bono* at Munich, possibly originating c. 800 in southern Germany (Salzburg?), is somewhat similar to the previous example.[62] However it looks as if the relationship between the human figure and the bird might have to be interpreted in terms of the representations of the elements mounted on beasts that go back to antiquity: in this case the element would be air, and the cube would stand for the element of earth (fig. 18).[63] This adding of figurative details to what were originally non-figurative scholastic diagrams — something that is particularly noticeable in early Cassiodorus MSS. for example (see pp. 44 ff.)— is obviously a phase in the development of scholastic into visual-exegetic schemes.

School schemata could be used in various ways — e.g. by incorporating them, unaltered, into a representation or programme, or by adapting them to a visual-exegetic scheme for multiple exegesis, in which case the school scheme remained more or less recognisable.

An example of both possibilities is provided by the linear scheme of elements of the 'syzygiae elementorum' found in the Boethius commentaries. This must have been such a well-known scheme that it could transmigrate beyond the territory of scholarly discussion and commentary to, for example, the field of monumental painting. Thus we find it incorporated in its entirety in an encyclopedic theological programme of church decoration (in the crypt of the cathedral of Anagni) dating from the end of the 12th or the beginning of the 13th century.[64] Here the northernmost four of the seven bays bordering the west wall (fig. 19a, see compartments 15, 16, 17, 18) form, in a sense, a connected whole, both on account of the quadripartite composition of their

decoration, and as a result of the contents of the programme, in which encyclopedic, cosmological and exegetical elements are combined.

The representations portrayed in the various compartments are as follows. In 15: the zodiac; in 16: the microcosm of man, together with the 4 humours and the 4 ages of man;[65] in 17: the 4 symbols of the evangelists; in 18: 4 angels supporting a medallion bearing the cross. The whole provides a visual exegesis of the unifying force of the number 4 in the cosmos and in the Scriptures. On the back wall of compartment No. 16, where the vault portrays man as microcosmos (fig. 19b), the linear scheme of the elements has been added, together with the two great physicians of antiquity, Hippocrates and Galen, probably because they were authorities for the theory of the 4 humours in relation to the 4 elements (fig. 19c).[66] Here the linear scheme of elements has been added as a sort of learned footnote to the visual-exegetic programme contained by the four compartments, a programme which somewhat vaguely, portrays the connexion between creation, cross and gospel, ruled over by the number 4.

Another programme, from the 2nd quarter of the 12th century, and known only from a description of lost paintings in the monastery of St. Ulrich and Afra at Augsburg, must have formed an analogous case. We read of a circular composition with astronomical data, including the 'aequinoctialis linea', and also of representations in which the 'Concordia Veteris et Novi Testamenti' is expressed.[67] So this, too, may have exemplified the adoption, without alteration, of a cosmological school scheme, and the combination of originally pagan cosmological subject matter and exegetical elements within one and the same decoration programme.

Although in the instance of the crypt of the cathedral of Anagni the linear scheme of elements was adopted unchanged, in other cases the details of the scheme were taken as a starting point and worked into a visual-exegetic scheme in a way that makes the source less easily recognisable. This is what happened for example, with a group of IN (principio) initial letters for the book of Genesis which, thanks to the researches of Bober, may safely be viewed as a visual-exegetic commentary on the creation, with a linear scheme of elements as its basis. Formally these initials go back to the IN principio initials at the start of St. John's Gospel, which often feature in Ottonian miniatures from the Rhine and Meuse areas. They are quadripartite schemata related to a particular scheme used for the Majestas Domini, with, for example, in the middle the Lamb of God with a cruciform nymbus surrounded by the 4 symbols of the evangelists at the ends of two axes, and with the letters IN in the inner field (fig. 20).[68] The first use of this composition was perhaps on a Genesis initial in the great bible from St. Hubert at Brussels, dating from c. 1070. The use of a pictorial scheme that had long been associated with the beginning of St. John's Gospel, suggests an attempt to portray in a visually exegetic fashion the relationship between the beginning of Genesis and that of St. John's Gospel which had received extensive exegetical cover-

age.[69] The centre of the representation is occupied by a medallion of Christ. The material belonging to the linear scheme of elements is worked into the medallions with the 4 elements and into the inscriptions surrounding them, which explain the relationship between elements and numbers, namely, fire: 8 $(2 \times 2 \times 2)$; air: 12 $(2 \times 2 \times 3)$; water: 18 $(3 \times 3 \times 2)$; earth: 27 $(3 \times 3 \times 3)$. The whole provides a commentary on the creation 'in pondere, numero et mensura' (fig. 21).

As a visual exegetic scheme of the created world this scheme could transmigrate from the bible text to other texts. We find it, for example, at the beginning of some MSS. of Flavius Josephus' *Antiquitates Judaicae* e.g. in a MS. originating in the Meuse area round about 1170/80, now in the Musée Condé at Chantilly. Here it has been converted into a scheme of the six days of creation and enriched with typological representations (fig. 22).[70]

In another MS. of the *Antiquitates Judaicae* at Paris, also dating from the 12th century, the initial at the start of the first book (INcipit liber primus) has been made into a visual exegetic scheme of the creation, ruled over by a large figure of Christ as creator, forming the vertical of the I, with the inscription: 'constitutio mundi et elementorum' on either side. The days of creation are depicted on the letter N, and at the point where the axes cross there is a medallion containing a female figure, who may stand, depending on the level of multiple exegesis chosen, for Mary, Ecclesia, or the individual soul.[71]

The circular school scheme of the mixture of elements can also be adapted to the purpose of a visual exegetic scheme. The most ingenious example of the use of wheel schemata, including the circular scheme of the elements, is provided by the great rose-window of the cathedral at Lausanne (fig. 23).[72]

In addition to the circular and linear schemes of elements, there was a third important school scheme which could be adapted for visual exegetic purposes, namely the tree or ladder scheme.[73] Here again, there has been no systematic investigation of the material of the tree schemata used as illustrations for school texts, so we shall have to rest content with a few remarks and examples.[74]

The development of these tree schemes seems also to have progressed, by and large, from a simple linear scheme in which concepts were linked by lines, to a more or less figurative scheme which, through the addition of vegetative elements, began to look more and more like a proper tree, and which also by the addition of exegetical elements, could be elaborated into a visual exegetic scheme.

The following school schemata, among others, could have served as points of origin: graphic representations of the interrelations between logical principles, serving as an aid to the study of logic; the graphic reproduction of the 'divisio philosophiae', which indicated the interrelations between the 'artes' and 'disciplinae' in the system of philosophy; the 'stemma' or 'arbor iuris', deriving from roman law, which gave a survey of the degrees of consanguinity

and which had been taken over by the canon law, e.g. for determining objections to marriage on grounds of consanguinity.[75]

Graphic representations resembling genealogical trees and dealing with the interrelations between various principles in writings on logic, probably go back to their use in commentaries on the *Isagoge* of Porphyry (d. 305), e.g. in that by Ammonius (5th century A.D.). The handing-down of this practice to the Middle Ages probably took place via Boethius' writings on logic.[76]

The logical diagrams could transmigrate from this context. One example of such transference is found in the 12th century MSS. of Honorius Augustodunensis' *Clavis Physicae* at Paris and Vienna, where similar tree diagrams have been used to illustrate the 'divisio naturae'.[77] The text of the *Clavis Physicae* is based on John Scotus Erigena's *Periphiseon id est de divisione naturae,* but is a somewhat simplified version. In addition, the need was felt to provide graphic elucidation, such as the two simple linear tree diagrams (Paris, fols. 2 r. and 2 v.; figs. 24a, b), which possibly go back to Honorius himself, or to a pupil, and which at all events are closely connected with his teaching.[78]

The first tree diagram (fig. 24a) presents the fourfold 'divisio naturae', leading from 'Deus' via the 'primordiales causae' to the world brought into being by the action of the latter: 'effecta causarum, elementa', and back to 'Deus'. The second tree diagram (fig. 24b) displays the fivefold ladder of nature, with the creatures divided into 5 categories from bottom ('corpora motu carens') to top, the highest rungs being 'homo' and 'angelus'. To these a 6th rung has been added: 'archetypus mundi' and 'causae omnium' (Bonitas, Essentia, Sapientia, Vita) which according to the inscription exist in the Word: 'In Filio cause omnium'. The 7th and highest rung of all is formed by 'Deus' (anarchos, since principio).[79]

While the Vienna MS. is illustrated throughout by means of linear tree-diagrams or ladder-shaped diagrams, the Paris MS. also contains two extremely complex, figurative, exegetic schemata. These occur on fol. 1v., where we find a scheme of the TRIPLEX ANIMA MUNDI as a 'syndesmos' figure,[80] where a figurative visual exegetic scheme appears, worked out to the last detail, in which the ingredients of the linear tree-diagrams of the fourfold 'divisio naturae' (fol. 2r.) have been reworked, now in a scheme with four zones, quite unlike the logical tree diagram from which it originated. The scheme on fol. 3v. seems to be more inspired by a cosmic school scheme, for example one exemplifying the climatological zones.[81]

An adaption of the logical tree-diagram is also to be found in a French Miscellany at Darmstadt, dating from c. 1140 and containing the *Isagoge* of Pophyry, Aristotle's *Logica Vetus* in the translation by Boethius, and the latter's writings on logic.[82] At the beginning of this work, and serving, so to speak, as a concise survey of the material to follow, is a miniature depicting 'Dialectica domina', standing on a footstool,[83] bearing her customary attribute, a snake, in one hand, and in the other, as a sort of sceptre, an adaption

of the tree scheme of logical principles: a fivefold division of nature, and of the relationship homo – deus – animal (fig. 25).[84]

That the logical diagram has been converted into a tree-schema is clear from the addition of vegetative elements. Dialectica is at the centre of a quadripartite composition, at the four corners of which four philosophers – Plato, Aristotle, Socrates and Magister Adam – are portrayed in the act of teaching. The fourth figure was probably intended as a portrait of Adamus de Parvo Ponte, 'magister' of the Parisian school on the left bank of the Seine, and a great champion of Dialectics as an end in itself and as the essence of all activity.[85] Dialectica has obviously replaced Philosophia here, as also appears from the adoption of the current quadripartite composition of Philosophia with 4 philosophers (fig. 26).[86]

Graphic representations of the 'divisio philosophiae' likewise exemplify a development from linear diagram, where the concepts are linked by lines, to figurative scheme and thence to visual exegetic schema.

There were two possibilities for the 'divisio philosophiae': one based on Aristotle's binary division into 'inspectiva (theoretica) et actualis (practica)'; the other a tripartite division – incorrectly ascribed by classical authors to Plato – into 'physica, ethica, logica'.[87] The relation between this tripartite division and multiple exegesis has already been discussed in Chapter I. The bipartite division, too, however, could be applied to exegetical ends by equating it with 'vita activa et vita contemplativa'.

The two-part division into 'inspectiva et actualis' was followed by Cassiodorus in his *Institutiones* (II, iii, 4, De dialectica).[88] He provides a linear diagram to which, in the original version, Greek terms were added. As regards the systematic arrangement of the 'artes' he followed, not the Latin school tradition of the 7 liberal arts, which already had a long history behind it in Rome (cf. Cicero, Varro, Quintillian and Martianus Capella, and, among the christian authors, Augustine in particular), but the late-Greek Alexandrian tradition. This is shown by the fact that the Greek terms correspond to those in a diagram included by Ammonius in his prologue to a commentary on Porphyry's *Isagoge*. Cassiodorus borrowed either directly from Ammonius or from Boethius.[89]

Elsewhere in his writings, too, Cassiodorus makes repeated use of graphic information, but he seems to have restricted himself in the *Institutiones* to linear diagrams (linealis descriptio).[90] However, he is known to have added visual exegetic schemata to his *Codex grandior* and these very likely survive in the *Codex Amiatinus* (see figs. 27a-d, 62, 63).[90a] The value which he attached to the pictorial method of teaching may have influenced school practice at a later period.[91]

As early as in pre-Carolingian and Carolingian MSS. we can see the simple, informative diagrams concerned with the systematic arrangement of the sciences or of various concepts (see fig. 28)[91a] making way, as the result of the

addition of all sorts of heterogeneous elements, for figurative schemata — for example in a MS. at Bamberg from the second half of the 8th century, and in the 9th-century MSS. at St. Gall and Paris. The schemata now issue from pillars, chalices and 'flower' ornaments, and also frequently from fishes, animals or half-figures. Thus in the MSS. at Bamberg and Paris we find the threefold division of music issuing from a half-figure and a chalice, while the threefold division of musical instruments issues from a fish (figs. 29a-b). The 'rhetorica argumentatio' issues from a halffigure with the inscription 'Domnus Donatus eximius grammaticus', while a 'lily' from which emanates the scheme of the division of philosophy bears the inscription 'Calix domni Donati grammatici'. In the St. Gall MS. a quadruped is standing above a scheme of the 'divisio mathematicae' (fol. 276 r.) and a kind of peacock above the 'divisio totius numeri' (fol. 287 v.). The relation of these figurative elements to the schemata is still as problematic as the matter of their origin (figs. 30a-c).[92]

But it has to be asked how far these details are, in fact, 'irrelevant', and to what extent there may be a link with, for example, the methods of the 'ars memorativa' recommended by teachers of rhetoric, one of the basic rules of which was that the 'imagines', the memory images allocated as *aides memoires,* to the 'loci' (the memory places), had to be 'imagines agentes', or in other words, they had to be striking and active, cf. Cicero, *De oratore,* II, lxxviii.[93] It seems, however, as if this 'clothing' of diagrams and schemata represents a general tendency, one which can also be signalled in other school books, for example in Isidore's *De natura rerum* (figura solida) and *Etymologiae* (stemma).[93a]

Like Cassiodorus, Boethius recognizes the bipartite division of philosophy into 'theoretica' and 'practica': 'est ... philosophia genus, species vero duae, una quae theoretica dicitur, altera quae practica.' But he simply mentions the subdivisions of the disciplines, and he translates Ammonius' terms of classification differently from Cassiodorus.[94]

However, for Boethius' influence on the development of the bipartite philosophical scheme into one of a visual exegetic nature, we have to turn to another passage by him, in *Consolatio* I, pr. I, 4, where the twofold division of philosophy is visually represented as the ladder leading from Π to Θ (from 'philosophia practica' to 'philosophia theoretica') on the garment worn by Philosophia when she appeared to Boethius in his dungeon:

'Harum in extrema margine ·π· graecum, in supremo vero. ·Θ· legebatur intextum. Atque inter utrasque litteras in scalarum modum gradus quidam insigniti videbantur, quibus ab inferiore ad superius elementum esse ascensus.'[95]

Commentaries on Boethius nearly always explained the rungs of this ladder as representing the 7 liberal arts, the mounting difficulty of which was thus indicated.[96] This graduated ascent had already been termed the 'gradus ad summum culmen philosophiae' at the end of Chalcidius' commentary on the *Timaeus.*[97]

That Boethius was not exclusively concerned with profane studies, and thus with the growth of understanding, but also with spiritual and moral growth,

which could lead from 'vita activa' to 'vita contemplativa', is clearly expressed in the Boethius commentaries. It is also graphically represented by means of the illustrations to Boethius.

In these illustrations the ladder on Philosophia's garment is seen to develop from pure ornament to a scheme of the twofold division of philosophy with the order of the 7 liberal arts, and thus to a visual exegetic scheme which, by the addition of the 4 cardinal virtues or the 7 gifts of the Holy Ghost,[98] portrays the idea of preparation and of the growth of 'vita activa' to 'vita contemplativa', leading finally to 'illuminatio' (cf. *Consolatio* I, pr. I, 18: 'gradus quidam . . . Hoc igitur . . . ascensi . . . inluminent'), or in other words, to an insight into true wisdom, the 'Sapientia Dei'.

In an 11th- or 12th-century MS. from Salerno, now at Madrid, in which Philosophia appears to Boethius in his prison as if in a vision and elevated on a pedestal, the ladder has a purely ornamental function. But a miniature in a 10th-century Boethius MS. at Sélestat shows Philosophia bearing a ladder, each rung of which carries the name of one of the gifts of the Holy Ghost, the representation being accompanied by a poem on the 7 liberal arts (fig. 31). In an early 12th-century MS. at Vienna, Philosophia is depicted in a highly schematic fashion as carrying a blossoming sceptre and with her ladder leading from π to θ by way of the 4 cardinal virtues: temperantia, fortitudo, iustitia and prudentia (fig. 32).[99]

Effective though the bipartite philosophical scheme may have been, the tripartite scheme — with a division into 'physica, logica, ethica' — offered still greater possibilities of development for visual exegesis, since the elements of the division of philosophy could be compared, point for point, with the 3 (or more) 'sensus' of Scriptural exegesis (see pp. 12 ff.).

The originally linear diagram of the threefold division of philosophy also underwent a development in a figurative direction. There is an unpublished 11th-century MS. at Cambridge, entitled *Tractatus de quaternario* — and incidentally containing numerous other interesting schemata, mostly quadripartite (cf. the title) — in which we find a complicated tree-scheme with a number of vegetative elements (fig. 33).

From this scheme it is possible to extract both a bipartite division ('practica / theoretica') on the right — here attributed to Boethius — and a tripartite division into 'logica, physica, ethica' on the left, attributed to Macrobius. The various concepts have been written more or less in the shape of leaves, which clearly indicates that we are dealing with a tree.[100]

A miniature in an early 13th-century MS. at Leipzig portrays an anthropomorphic tree scheme of the threefold philosophical division, this time born by Philosophia, who calls herself 'scientiarum ego mater omnium'. The elements of the division of philosophy are placed as follows:

p h y s i c a	e t h i c a
(quadrivium)	(4 virtues)
l o g i c a	
(trivium)	(fig. 34)[101]

45

There are indications suggesting that as early as in Carolingian times a complete, figurative, visual-exegetic scheme of the 3 divisions of philosophy had been realized, in an 'arbor philosophiae'. This is hardly surprising if we bear in mind the rôle that the system of the 7 liberal arts played in the educational revival which took place during this period. Continuing the impetus provided by Augustine, Boethius, Cassiodorus and Isidore, the 7 liberal arts were viewed as preliminary studies to the practice of exegesis. This is examplified in the writings of Alcuin, who, as the 'auctor intellectualis' of the programme for Charlemagne's Palace School may be regarded as the outstanding authority on education during this period.[102]

Commentaries on Boethius had been divided from earliest times on the question whether the figure of Philosophia represented a pagan or a christian allegory. Alcuin opted for the latter possibility, equating Philosophia with 'Sapientia Dei'.[103] In his *De grammatica* the pedagogical implications of the ascending rungs of the ladder link the 'septem gradus philosophiae' to the 7 gifts of the Holy Ghost and to the 7 pillars of the House of Wisdom.[104]

Alcuin refers simultaneously to the philosophic material of the *Consolatio* and to the Scriptures, and creates the possibility of rising by means of Boethius' 'gradus' (*Consolatio* I, pr. I, 18) to 'illuminatio'.[105] He also stresses the moral value of secular studies as propaedeutics, and interprets the 'gradus' of Philosophia (= the 7 'artes') as a means of arriving at the 'perfectio evangelica'.[106] In addition to his reference to the ladder image, implicit in the term 'gradus', he also touches, in passing, on the tree image, by quoting the saying (already of ancient standing): 'radices litterarum esse amaras, fructus autem dulcis'.[107]

This high estimate of philosophy, together with the comparison frequent in Carolingian exegesis between the tripartite division in philosophy and multiple Scriptural exegesis, make it likely that a visual exegetic scheme of the 'arbor philosophiae' came into being at this time.

The information we have from the Carolingian period concerning subjects occurring in the monumental art of that time is rather scanty.[108] But there is a relatively high occurrence of references to representations of the liberal arts. On the whole, however, these are snippets of information relating to, for example, wall-paintings at Aix-la-Chapelle and in other palaces.[109] A marked contrast is formed by the poem entitled 'De VII liberalibus artibus in quadam pictura depicta' by Theodulf, Bishop of Orleans (d. 821), which possibly describes a representation in his own villa at Germigny-des-Prés.[110] The impression of the composition and meaning of the representation one gets from the description, makes it reasonable to imagine that the poem supplies the programme of a visual-exegetic tree scheme of the tripartite division in philosophy, into which has been woven a covert suggestion of the parallel with multiple Scriptural exegesis.

In Theodulf's 'arbor philosophiae' the 7 liberal arts are presented as personifications with attributes going back, in part, to Martianus Capella,

together with the 4 cardinal virtues and the tripartite division of philosophy into 'logica, ethica, physica'. From the opening lines of the poem we can deduce that the representation portrayed a combination of a circular cosmic scheme (a disc) with a tree scheme, at the root of which was Grammatica, the starting-point of all learning, accompanied by 'sensus bonus' and 'opinatio'. The remaining liberal arts were portrayed higher up the tree, along with the 4 virtues: prudentia, vis = fortitudo, iustitia, moderatio = temperantia. The 4 cardinal virtues were represented as personifications like the 'artes'. The tripartite division of philosophy into 'logica, ethica, physica' mentioned in the poem was, however, in all probability not portrayed by means of personifications, as is usually assumed, but only hinted at by a division of the scheme into three zones with 'physica' at the top (fig. 35).[111] That we are concerned with a visual-exegetic scheme, which in addition to conveying the basic facts of the intellectual system also had the aim of purveying information at a deeper level of significance, is evident, it seems to me, from the contrast at the end of the poem between the 'folia = verba' and the 'poma = sensus' on the one hand, and between the 'venustas' and the 'mystica plura' on the other.[112] It seems reasonable to assume, therefore, that a figurative visual-exegetic scheme of the 'arbor philosopiae', adapted from the long-standing school diagram of the division of the 7 liberal arts, was already in existence in the Carolingian period.

The instance we have been dealing with is by no means the sole example of the adaption of school schemata for visual exegesis during the Carolingian period. After a preparatory phase in the pre-Carolingian period, there now came into being a fairly constant formula for the Majestas Domini[113] in the shape of a quadripartite cosmic harmony scheme with a strong emphasis on the centre and with an orthogonal or diagonal system of axes. This makes a visual exegesis possible of the following exegetically familiar significances:

historia (or Old Testament prototype):
 4 rivers of Paradise from one source (Gen. 2:10)

 4 cherubim and 4 'rotae' (Ezek. 1:1-28)

 4 major prophets

allegoria (or New Testament antitype):
 4 evangelists or 4 Gospels spread over the whole world

 4 mysteria Christi

tropologia:
 4 cardinal virtues

anagoge:
 vision of the Throned Being amid the 4 living creatures (Rev. 4)

The ingredients of the representation derive from the exegesis of the church

fathers, especially that relating to Genesis 2 and Ezekiel 1.[114] Ambrose (*De paradiso* 3:14) compares the 4 rivers of Paradise to the 4 virtues, Phison equalling prudentia; Geon, temperantia; Tigris, fortitudo; and Euphrates, iustitia.[115] Although Philo, who was probably Ambrose's source,[116] calls the spring feeding the 4 rivers 'virtus', Ambrose himself names 'Sapientia Dei' and Christ as the source of eternal life (after I Cor. 1:24 'Christus Dei Virtus et Dei Sapientia'). This became an established component of the exegesis of Gen. 2:10, usually side by side with the interpretation of the 4 rivers as the 4 evangelists.[117] Ambrose takes this even further (*o.c.* 3:19) by comparing the virtues to the 4 ages of the world: Abel, Enoch, Noah — prudentia; Abraham, Isaac, Jacob — temperantia; Moses and the prophets — fortitudo; Christ up to the present-day — justitia.[118]

The borrowings from the exegesis of Ezekiel's vision derive chiefly from Irenaeus, Ambrose, Jerome and Gregory.[119] Irenaeus sees the relation between the tetramorphic cherubim in the vision of Ezekiel 1:4 and the Throned Being of Revelation 4 as one between the creative Logos and the operations of the latter. He explains the vision of the cherubim entirely in cosmic terms: the 4 evangelists are compared to the 4 regions of the world, the 4 principal winds, and the Ecclesia spread over the whole earth. There is a strong emphasis on the centre, from where the Gospel, the pillar and support of the Church, is propagated. The creator of the universe, the Logos, who is seated above the cherubim, has given us the Gospel 'tetramorphon' (in 4 forms). The four faces of the lion, the bull, man, and the eagle are equated with the 4 evangelists, who as messengers are turned towards the cardinal points of the universe, which is the field of action of Ecclesia.[120]

Ambrose provides a new interpretation of the vision of Ezekiel by explaining the 4 beings as the motions of the human soul, which are compared to horses: 'animam autem describit propheta, cuius sunt motus quattuor velut equi ...', while the soul itself is interpreted as a chariot, with reference to the 'currus Aminadab' of Song of Songs 6:11: ('anima mea conturbavit me propter quadrigas Aminadab'). The bad horses are the 'passiones corporis' (iracundia, concupiscentia, timor, iniquitas) and the 'boni equi' are the 4 virtues (prudentia, temperantia, fortitudo, iustitia).[121] Here we find the origin of the concept of the 'quadriga virtutum' so beloved of Carolingian exegetes.

Jerome's contribution was to add the comparison between the 4 evangelists and a quadriga, and also the representation of the 'rota in medio rotae', taken from Ezekiel 1:16.[122] For the possible influence of the latter concept on the composition of Majestas representations as a system of circles, see pp. 53 ff.

Finally, there is the significant enrichment contributed by Gregory the Great to the exegesis of the Ezekiel passage through his interpretation of the faces of the 4 beings as: ... the Gospels since the beginning of time; the 4 virtues; the 4 'mysteria Christi', Who is at the same time: man through His birth, bull through His death, lion in His resurrection, eagle in His ascension.[123]

Irenaeus' interpretation may well have become known immediately in the west, since Latin translations were circulating at an early date.[124] But his exegesis, and also those of Jerome and Gregory, were also of influence on the liturgy.[125] Western theologians and artists had thus at their disposal an extremely varied exegesis, the Majestas Domini being the graphic reproduction of this in a concentrated form.

Up to a point, therefore, the origin of the representation will probably have to be sought in the formula of the apocalyptic vision of the Throned Being with the 4 living creatures grouped centrifugally round Christ in the order set forth in the vision of Ezekiel: man, lion, bull, eagle, but arranged anti-clockwise:

<div style="text-align:center">

man eagle

Christ

lion bull[126]

</div>

Nor must one forget that in the east this was a favourite theophany theme for decorating the apse (and one which must have been exported to the west at an early date). But, the western Majestas formula, more emphatically schematic and offering a more complex visual exegesis, is more likely to have been created in western miniature art — by adaption of cosmological school schemata and in close connexion with the sacred texts they were designed for and with the exegesis of these texts.[127]

It was from this context that the Majestas transmigrated into western monumental art and persisted well into the romanesque period in portal sculpture or as apse theme.[128]

That the development of the Majestas, as visual exegetic scheme, was closely linked to the presentation of the Gospel text, appears to be confirmed by the fact that most western examples of the Majestas as a strict quadripartite scheme — and these include the earliest surviving instances — are found in miniature art and not in monumental art.[129]

The placing of these representations — as frontispiece to an evangeliarium or on the cover of a Gospel book[130] — becomes of particular significance if we regard the Majestas as a visual exegetic scheme of the expositions of Ambrose, Irenaeus, Jerome and Gregory on the unity of the 4 Gospels. The creation of the Majestas as a quadripartite visual exegetic scheme to be placed at the beginning of the Gospels may well have owed something to certain elements from 7th- and 8th-century Irish exegesis. The Irish exegetes, whose mode of exposition was by and large heavily oriented towards number symbolism, often began their commentaries on the Gospels with a prologue in which their commendation and justification of the number 4 was illustrated by means of a summary of various quartets (evangelists, cardinal virtues, the 4 rivers i.e. the 4 Gospels irrigating the Ecclesia). One example of this is provided by the

Expositio IV Evangeliorum of pseudo-Jerome, which was composed in Ireland or in an Irish centre on the continent. This must have been a popular work, since roughly 49 MSS. from the 8th and 9th centuries have come down to us. It seems therefore to have been a very widely used handbook in the Carolingian period, and one which influenced, among other exegetes, Paschasius Radbertus, Abbot of Corbie (d. 860), and Christian of Stavelot (d. 880).[131]

In this prologue by pseudo-Jerome all the exegetical stops are fully pulled out. Paradise with its 4 rivers is compared with the 4 Gospels and with 'cor nostrum', watered by the 4 virtues. The 14 generations in the genealogical tree of Christ (Matt. 1:17) are interpreted as the 10 Commandments + the cardinal virtues. The calling of the first 4 disciples (Matt. 4:18) is compared with a quadriga, and thus leads on to a further comparison between the Ecclesia and the 'arca Noe' in which the 'bini et bina animalia, quattor virtutes significant: justitia, prudentia, fortitudo, temperantia'.[132] Various elements are found here which were to become translated into the Majestas Domini which, together with the prologue, was placed by way of introduction at the beginning of the Gospels.

As regards its form, the Majestas scheme, like many other visual-exegetic schemata, is an adaption of cosmic harmony schemata. The justification for assuming this can be found in the very earliest examples of exegesis, e.g. in Irenaeus's comparison of the 4 evangelists with the 4 regions of the world, the 4 principal winds and so forth. Various extremely well-known schemes, such as those of the winds, of Annus and the 4 seasons, and of the 'mappa mundi' may have exerted their influence.[132a]

A variety of compositions are possible, by means of which particular aspects of the exegesis can be underlined. An emphasis on the centre, for example, together with an orthogonal or diagonal division, enables particular stress to be laid on the flowing forth of the Gospels as 4 rivers from a single source and their spreading to the 4 points of the compass. An early example of composition with an orthogonal cross is to be found in a representation at the beginning of an evangeliarium in the treasury of Trier cathedral, produced at Echternach round about 730 (fig. 36).[133]

Roughly twenty years later this quadripartite composition with its accent on the centre and its orthogonal cross was already being regarded as a more or less established formula for the visual exegesis of certain cosmic and theological aspects of the relation between the 4 Gospels and the single source. This is evident from the transmigration of the formula in question to another context, distinct from the Gospel text. In a mid-8th-century MS. of Paulus Orosius' *Historiarum ad paganos libri VII*, in the library of Laon,[134] we find this quadripartite scheme (now with the Lamb in the centre) used as title-page at the beginning of a history of the world from the time of Adam up to the year 417. The scheme could be read as a visual exegesis of the unity of the beginning and the end of the history of the world, which unfolds from the

50

creation at the beginning of time (the 4 rivers of Paradise, and the plants, fish, birds and quadrupeds[135] in the 4 fields and the surrounding border) via the coming of Christ and the spread of the Gospel up to the moment of Christ's second coming, which is indicated by the apocalyptic Lamb in the centre and by the Alpha and Omega (fig. 37).

In another pictorial formula, the use of circles as basis for the composition may be designed to stress Jerome's interpretation of the 4 evangelists as a quadriga, as, for example, in an evangeliarium from St. Maria ad Martyres, dating from the 1st quarter of the 9th century, now at Trier (fig. 38). Here the circular composition is repeated four times, at the beginning of each Gospel, in the form of a half-length figure of Christ above a square with 4 circles, resembling to some extent a birds-eye view of a vehicle with 4 wheels. The only thing that varies is the location of the symbols: the appropriate evangelist's symbol is placed each time in the top left corner, i.e. to Christ's right.[136]

In the titulus on fol. 1v. of an 8th(?)-century evangeliarium in the British Museum at London, which runs as follows: 'Haec est speciosa quadriga luciflua a(n)i(m)ae sp(iritu)s gratia per os agni (e)i inlustrata in quo quatuor proceres consona voce magnalia D(e)i c(antant)', the quadriga is called 'luciflua'. This gives expression to yet another interpretation of the 4 Gospels, namely as the 4 rivers from the one source of Light (Christ or the Lamb). Their unity is also implied in the term 'consona voce'. These ideas must have been visualized in a representation of the Majestas of the Lamb now no longer extant, on the facing page. This undoubtedly took the form of a quadripartite composition, with an orthogonal cross (as on the title-page of the Paulus Orosius MS. at Laon), or with a diagonal cross (like the representation on fol. 1v. of the lectionary at Aschaffenburg (fig. 39) dating from the end of the 10th-century), or possibly even as a composition with a lozenge in the centre and 4 medallions in the corners (after the fashion of fol. 3v. of the so-called Arnaldus evangeliarium, dating from the 1st half of the 9th century, now in the treasury of the cathedral of Nancy (fig. 40).[137]

The idea of an equivalence between the quadriga of the 4 rivers of Paradise and the 4 Gospels as 'vehiculum' receives clear expression in another composition — obviously related to the Majestas — on a book cover, dating from the middle of the 12th century, in the Musée de Cluny at Paris (fig. 41). The rectangular openwork copper plate shows a quadripartite scheme with a medallion containing the Lamb of God at its centre and the 4 rivers of Paradise in the compartments. The marginal text running round the composition reads: 'FONS PARADISIACUS / PER FLUMINA QUATUOR) EXIT / HEC QUADRIGA LEVIS TE XRE PER OM(N)IA VEXIT GYON. PHISON. TIGRIS. EUFRATES'.[138]

The same conception of the quadriga as a sign of harmony and as 'vehiculum' to higher things, is implicit in representations of the 'quadriga virtutum'. These are to be found on a number of Incipit pages of Ottonian and Romanesque evangeliaria and sacramentaria. Their composition is clearly related to

that of the IN-initials discussed earlier, which, positioned at the start of Genesis or of St. John's Gospel, comment on the harmony of the creation. The quadripartite composition of the 'quadriga virtutum' can thus also be interpreted here as a scheme of the harmony brought about by the virtues, one related to the various levels of multiple Scriptural exegesis, i.e. to Christ or the Ecclesia (allegory), or to Man (tropology), while the anagoge is implicit in the idea of the quadriga as 'vehiculum' to the higher realm of Christ or the Lamb. The same exegesis is probably applicable to the scheme occurring in the Ottonian Hitda codex at Darmstadt (on fol. 173 r., preceding St. John's Gospel). This is a quadripartite scheme of the 'quadriga virtutum', containing 4 medallions with the 3 theological virtues — fides, spes and caritas, to which humilitas has been added in the bottom medallion — arranged round the Lamb in the central medallion, and clearly grafted onto the harmony scheme of the IN-initials.[139]

In the application of the 'quadriga virtutum' to a portable altar, we again find a very close connexion between its exegesis and the symbolic meaning of the altar. The latter's cosmic significance is expressed in the interpretation of the 4 corners of the altar as the 4 regions of the world redeemed by Christ's sacrificial death, with the centre of the altar corresponding to Jerusalem, the centre of the world.[140] Connected with this is the interpretation in terms of the Ecclesia, spreading out to the 4 corners of the world.[141] But the commonest interpretations, however, are those based on Christ (cf. Rupert of Deutz, De div. offic. V, 30: 'altare significat Christum, quia sic illud in templo, quomodo Christus toto corpori Ecclesiae dignitate et honore praeeminet'),[142] and the explanation already found in early-Christian exegesis, in terms of the human heart (cf. Augustine, De civ. Dei, X: 3: '. . . eius (Dei) est altare cor nostrum . . .').[143] The 'quadriga virtutum', when it appears on a portable altar, can thus be interpreted with reference both to Christ and to the human soul, as we see, for example, in a group of 11th-century South German portable altars such as that at Munich (fig. 42), where the 'quadriga virtutum' is grouped round a medallion portraying Christ, with the text: 'Hic Pater et Logos necnon Paraclitus Agios'.[144]

The representation of the 'quadriga virtutum' together with a crucifixion, found on the underside of a mid-12th-century portable altar from the Meuse area, now at Augsburg, allows of a wide variety of interpretations (fig. 43). The crucifixion in the central medallion emphasizes the cosmic interpretation of the centre of the altar in terms of Jerusalem (Golgotha) as the centre of the world. The text in the border of the central medallion — 'In precibus fixus stans praesul et hostia Christus — Virtutes donat, animas beat et sacra manat' — provides an exegesis in terms of Christ as priest and also as sacrifice at the cross, whence the virtues flow that lead to salvation.[145]

In one group of Majestas representations Christ is shown enthroned within a double circle on which are 4 medallions containing the evangelists. The question arises whether this is an attempt to reproduce schematically the

difficult idea of the relation between the Old and the New Testaments as the 'rota in medio rotae' (from Ezekiel's vision). This variant on the Majestas scheme occurs on fol. 18r. of the Codex Aureus of Lorsch, dating from the beginning of the 9th century (fig. 44).[146] The space between the two circles contains, in addition to the medallions with the 4 evangelists, 8 winged and nimbed figures in square compartments. These could perhaps be explained as the 8 beatitudes,[147] as the 'sacra munera' alluded to in the inscription: 'Quatuor ergo viros animalia sancta figurant/Sacra salutiferi narrantes munera Christi'.

That this was in fact intended as a formula for reproducing the 'rota in medio rotae' as the relation between Old and New Testaments, tends to be confirmed by a much later Majestas representation with the same composition, contained in a 12th-century lectionarium in the Musée Condé at Chantilly, where the zones of the outer and inner circles are respectively indicated by means of inscriptions as the Old Testament (sub lege) and the New Testament (sub gratia). Moreover the outer circle is dark and divided into 10 compartments (the 10 Commandments), while the inner circle is light and divided in 4 (the 4 Gospels). In addition the outer circle bears the inscription: 'Extima legis Dogmatibus plenis rota prominet', where 'extima' can be read both in the sense of 'outer' and as signifying 'having finished' (fig. 45).[148]

So far, in our investigation of the way in which the visual-exegetic method took shape, we have tried to show that even in the early-christian period there was an awareness of the didactic, pedagogical and mystical potentialities of this method, but that it was not until the Carolingian period that more consistent use began to be made of visual exegesis and that the potentialities of order and harmony schemata began to be more fully exploited, (cf. 'arbor philosophiae', Majestas formula). There are a number of possible reasons for this. In the first place there is the fact that multiple Scriptural exegesis, after reaching a peak of development in the early-christian period, was now flourishing again during the Carolingian period.[149] Secondly, there was the growth of familiarity with pictorial teaching methods, which could also be applied to instruction in exegesis. The use of the long-existing school diagrams and schemata as order and harmony schemata for the purpose of visual exegesis, was sanctioned by the view of the unity of all sacred and profane knowledge and of the 7 liberal arts as propaedeutics for the study of the Scriptures, a view which received its clearest expression in the equivalence set up between the divisions of philosophy — 'physica, logica, ethica' — and the various 'sensus' of multiple Scriptural exegesis.

The educational reforms of the Carolingian period, striving as they did towards a uniform, specifically christian school programme, intensified the need for schoolbooks as the basis of education. These schoolbooks were very often compiled by stringing together excerpts, which could contain both

profane and exegetical subject matter. In applying this method, long-existing school diagrams and schemata with, and often without, the accompanying explanations were incorporated.[150] As a result of this disappearance of the link between text and image, mathematical, cosmological, juridical and philosophical schemata could be given a new content in a new context. There is moreover something else which suggests that school schemes were becoming increasingly independent. This is the tendency, observable as early as the 7th century and possibly related to the 'ars memorativa', for the originally sober, businesslike diagrams to become more and more decked out with all sorts of figurative or vegetative details, which often have no connexion whatsoever with the text.

The dominating rôle of the image, and the fact that it was often preferred to the word, may also be connected in some way with the intensification of platonic and neoplatonic tendencies in the 9th century.[151]

With the passing of the Carolingian period the use of visual exegetic schemata increased, hand in hand with the refining of the method of multiple Scriptural exegesis. The development reached its peak in the 11th, and even more, the 12th century. Nor was it simply a quantitative development: the schemata themselves become more varied and more complex, as is shown by a comparison between the Carolingian Majestas formula and the much more subtle 12th-century example in the museum at Chantilly.

Questions as to why this blossoming in the 11th and 12th centuries took place have usually been raised in connexion with so-called 'typological' works of art (i.e. those with a programme presenting a contrast between the Old Testament type and the New Testament antitype).

The term 'typology' is too restrictive here, however, since a number of these works of art have programmes which are amenable not only to a strict twofold exegesis (contrast between Old and New Testaments) but also to multiple interpretation. This is illustrated by those compositions with circles and quatrefoils, very common in the Meuse area, in which various Old Testament types are contrasted with New Testament antitypes but which as a whole can also be subjected to multiple interpretation, for example the quatrefoil of the Remaclus retable of Stavelot, the miniatures of the Floreffe Bible, and numerous other instances.[152] It would seem more appropriate in this context, therefore, to speak in general of visual-exegetic works of art.

Various hypotheses have been put forward to explain the popularity of such programmes during this period. Most of the arguments are valid for both strictly typological and visual-exegetic works of art. For example, we are reminded that the use of types ('umbra, figura') and antitypes fits into a platonic and neoplatonic pattern of thought, and that the 11th and 12th centuries saw a fresh blossoming, after the 9th century, of medieval platonism.[153]

However, the idea often met with, particularly in older literature, that there was something in the nature of a spontaneous birth of so-called typological art

at a particular spot or through the influence of some particular person or another (the art of the Meuse area and the activities of Suger at St. Denis being quoted as typical examples),[154] needs some qualification. By the 11th and 12th centuries, typology and exegesis in terms of the 4 'sensus' already had an honorable tradition behind them, rooted in the Bible and the writings of the church fathers, the same sources, in fact, as were used by contemporary exegetes. In addition, the method of visual exegesis was — as we have tried to show — under development long before the period in question.

Of course there must always have been patrons at one place or another who encouraged the use of visual-exegetic methods, and certain types or compositions may well have been disseminated from such centres. But since the activity involved was usually a matter of pictorially realizing images already long familiar in exegesis, apparently new motifs were quite capable of appearing, independently of each other, at different geographical locations.[155]

Generally speaking, there seems to have been a greater concentration of visual exegetic works of art at particular times and particular places, while elsewhere no great interest seems to have been shown. The main centres of interest appear to have been in Southern Germany and Austria, and also in the Meuse area, the Alsace and Rhineland, France and England. Italy seems to have been less active in this respect.[156] A systematic enquiry into the contacts between centres of visual exegetic activity, and into the part played by schools and religious orders in disseminating ideas of this sort, could well be fruitful.[157]

Other hypotheses put forward to account for the flourishing of 'typological' art, claim that mysticism may have played a part in the relation between exegesis and art.[158] Although there are innumerable points of contact, it is impossible to say more than that mysticism was a stimulating factor in the long-standing tradition of visual exegesis.[159] The same holds, with even more reservations, for the hypothesis concerning the influence of the medieval theatre — the prophet plays, for example — on some themes of 'typological' art, such as the contrast between Ecclesia and Synagoge. Here, too, we are dealing with themes which had a long tradition behind them.[160]

Nor can the suggestion that the Benedictines should be regarded as the preservers of a typological tradition be accepted in its entirety. Although it is undoubtedly true that most of the surviving visual exegetic works of art derive from a Benedictine milieu, which would indicate that they were extremely interested in this method of elucidating exegetical problems, it would seem to be going to far to regard the Benedictines as having a monopoly in matters of this sort. Which is not to say that the general attitude towards art in Benedictine circles, and the Benedictines' defence of its practice, did not have an important part to play. The hypothesis concerning the rôle of typology as a weapon used by the Benedictines in Southern Germany (Bavaria and Austria) in their struggle against the Cathars — the origin of the *Biblia Pauperum* (with

its convenient arrangement of Old Testament types round a New Testament antitype) being sought in the need to produce a handbook to assist preachers of anti-heretical sermons — is in some ways an extremely attractive one, but it fails to carry complete conviction.[161]Although the pictorial material of the *Biblia Pauperum* was undoubtedly developed as an additional help to preachers, in dealing not only with ordinary churchgoers but also with heretics, it cannot have been originally created for an anti-heretical purpose. It simply forms a link in a chain of development that long antedates the exegetical procedures of the late Middle Ages; an evolution characterized by an increasingly systematic ordering of the relevant material by means of grouping principal motifs and auxiliary motifs, which in their turn were again divided and subdivided.[162] Moreover, there were various precursors of the *Biblia Pauperum,* both illustrated and unillustrated (see pp. 57 ff.).

Already in Künstle we find the hypothesis of the existence of a typological compendium which patrons and artists could draw on for ideas. In his opinion the *Glossa Ordinaria* (which he thought to be Carolingian) must have served as such. But the *Glossa Ordinaria* was not written with this purpose in mind, and it can only have partially served in such a rôle.[163]

The same holds for the works of, for example, Honorius Augustodunensis, Rupert of Deutz, Hugh of St. Victor, and others. Even though their writings may in many cases have contributed to the compilation of programmes for particular works of art, and although as teachers Honorius and, more specifically, Hugh of St. Victor often made use of the visual exegetic method,[164] it is stretching matters much too far to see their writings as a sort of vademecum for commissioners and executants of visual exegetic programmes.

On the whole, it again seems more reasonable to trace the uniformity noticeable in the choice and execution of subjects back to a continuous tradition in exegesis, stemming from the church fathers. In dealing with typological and visual-exegetic works of art we are normally concerned with the pictorializing of a fairly limited number of themes, which every theologian who had been trained in exegesis could avail himself of.

It was only at a fairly late stage that the tradition which had come into being in the way we have described, began to crystallize out into compendia, often illustrated, which might have served as iconograhic model books for patrons and artists.

One move in this direction is represented by the collection of tituli published by Schlosser.[165] But it is really only when we come to the tituli written by Ekkehard IV (d. 1031) for Archbishop Aribo and his plans for the cathedral of Mainz that we can begin to talk of anything properly resembling such a compendium. Here for the first time we are confronted with a collection of subjects offering the possibility of choice: 'Eligantur qui picturis conveniant'.[166]

An early attempt at an illustrated compendium, which deals, however, with

one theme only, the cross, is offered by the South German *Laudes crucis,* with its visual exegetic 'paraphrases' on the cross.[167] The first manuscript that can genuinely claim (even though it is not illustrated) to be considered a compendium, is the *Pictor in carmine,* an extremely extensive cycle of 138 antitypes and 508 types which came into being in England round about the year 1200. One reason for accepting it as a genuine compendium is the fact that the writer motivates his work (which was intended as an inspiration for painters) by referring to the frequently senseless monstrosities found in church decoration. The antitypes with which we are confronted cover not only the life and sufferings of Christ but also the life of John the Baptist and the history of the apostles; there is no Apocryphal material, however, nor do we find any respresentations from the Apocalypse. The types are taken not only from the Old Testament but also from the liturgy and the *Physiologus.* There is a close connexion between the *Pictor* and English monumental cycles from the end of the 12th and the beginning of the 13th century.[168]

A further link in this series is provided by the 7 folios, complete with miniatures, in a MS. at Eton College entitled *Figurae bibliorum.* This MS., which dates from the 3rd quarter of the 13th century, gives evidence of a strong influence from the *Pictor in Carmine,* but is also related to the continental tradition. The latter is also true of the composition, which consists of a central medallion containing the principal subject, surrounded by medallions containing auxiliary representations, something which is met with frequently in the 12th century in, for example, the Meuse area, Northern France and Southern Germany, as well as in the early copies of the *Biblia Pauperum.*

The series starts with illustrations from the beginning of Genesis to the death of Abel (fol. 1v.; 2r.). These are followed by 10 groups, each consisting of an antitype, 4 types, 2 prophets, one virtue and one of the 10 Commandments. The noteworthy rôle played by the prophets, with their prophecies relating to the New Testament antitypes, is paralleled in the later development of the art of the Meuse area, for example in the retable at Klosterneuburg by Nicolas of Verdun, dating from 1181, and in the *Biblia Pauperum.* The Eton MS. also contains types derived from the *Physiologus.* On fol. 5v., for example, the New Testament antitype of the 'women at the tomb' (standing for the resurrection of Christ), is surrounded by 4 medallions containing the following scenes:

Jonah being spewed out by the whale	the lion resuscitating its young
Job and Jonah (as Old Testament prophets) with inscriptions from Job 19:26 and Jonah 2:7	Samson in Gaza.

The central medallion is supported by a crowned virtue in the 'Atlas' posture, while the Seventh Commandment is mentioned in the inscriptions (fig. 46).[169]

The *Figurae bibliorum* are also related to English pictorial cycles, as appears, for instance, from the iconography of the windows of the cathedral at Worcester and the paintings at Bury St. Edmunds.[170]

An Austrian development closely related to the English *Pictor in carmine* was the *Rota in medio rotae*, also unillustrated, which came into being towards the end of the 13th century and survives in MSS. dating from the 14th and 15th centuries. Unlike the *Pictor* with its 138 groups, the *Rota* only contains 68, and the work as a whole is more concise and displays a stricter typological conception than the other, but the *Physiologus* examples have been retained and, in fact, expanded.[171]

A work which came into being at approximately the same time as the *Rota* was the *Biblia Pauperum*. This work, most copies of which are illustrated, stems from Bavaria or Austria, probably from Benedictine circles. It is demonstrably connected with the *Rota*.[172] The *Biblia Pauperum* (figs. 47a-d) makes a consistent application of the typological principle of contrast between Old and New Testament to a fairly extensive christological cycle (in its most extensive form, in the second half of the 15th century, 175 groups are involved),[173] and supplements this with the regular introduction of 4 prophets, who draw attention by means of gestures and text to the antitype. Explanatory texts have been added, the so-called 'lectiones', indicating the relationship between the representations and mentioning the Old Testament texts which served as source material. Previous to this such explanations had been restricted in scope to tituli and inscriptions.

The popularity of the *Biblia Pauperum* was most widespread in the 14th century, and its particular moralistic, didactic approach to the laity matched the general tendency of the later Middle Ages.

The fact that the *Biblia Pauperum* was one of those works which benefited from the earliest spread of printing, contributed to the considerable influence it had on art. This influence is traceable, as regards both content and composition, until well into the Renaissance. Examples are provided by the windows of one of the Utrecht churches, the Mariakerk, which were designed by Jan van Scorel,[174] and especially by a series of tapestries at La Chaise Dieu, created round about 1500.[175]

The further development of typological compendia in the 14th and 15th centuries, involving, among other works, the *Speculum humanae salvationis*, the *Concordantia caritatis*, and the *Defensorium Virginitatis Mariae*, wholly devoted to Marian typology, falls outside the scope of the present investigation, which is concerned with the visual exegetic method as used up to 1200-50.[176]

It is interesting to note, however, that as typology and multiple exegesis decreased in importance for theology and became a sort of hermeneutic art-form,[177] the rôle of the typological and visual exegetic compendia was taken over by the emblem-books, in which a number of the old themes continued to survive for a long time, and to exert an influence on art.[178]

PARADISUS QUADRIPARTITUS
AND PARADISUS QUADRUPLEX

As we pointed out earlier,[1] school diagrams and schemata provide the framework within which elements of multiple exegesis could be accommodated. This is particularly evident in the case of visual-exegetic schemata used to clarify the multiple interpretation of Paradise, a favourite concern of exegetes. This multiple exegesis of Paradise was directed both to the comparison of the quaternity of Paradisal rivers in the 'quadripartitus paradisus' with many other quartets (the 4 Gospels, the 4 virtues, etc.),[2] and to the fourfold exegesis of the 'paradisus quadruplex' on the 4 levels of history, tropology, allegory and anagoge. The texts setting out to explain the 'paradisus quadripartitus' provide a good example of the continuity in exegesis running on from the days of the church fathers through the Carolingian period right up to the 11th and 12th centuries. This continuity can also be found in the exegesis of the 'paradisus quadruplex', although it is probably not until one comes to the 12th century that there can be any talk of fully-fledged fourfold exegesis proper — for example in the work of Honorius Augustodunensis. Finally, we have Pope Innocent III (1161-1216), who in his *In comm. de evang.*, 3, De quadruplici acceptatione paradisi, combines in the one text both the quadripartite and the fourfold interpretations of Paradise.[3]

The Paradise quaternity is the first of the three examples to be discussed here of the adaption for visual exegesis of quadripartite harmony schemata belonging to a tradition reaching far back into the past.

The rectangular or circular field with a diagonal or orthogonal division into four parts symbolising the harmony of the cosmos or the cosmic building (see Ch. IV), is, for example, one of the very earliest cosmic symbols to have come down to us.[4] The idea of the Old Testament Paradise as a garden with 4 rivers emanating from a single source (Gen. 2:8-14) also goes back to this ancient Eastern tradition.

The symbol of the 4 rivers occurs as a pictogram for Paradise in medieval maps of the world — for example in the *Beatus Apocalypse,* cf. the MS. dated 1086 in the cathedral of Burgo de Osma (fig. 49).[5] In an unpublished MS. at Munich, which may have come into being at Regensburg, possibly under Irish influence, and which is datable before 824, we find the same Paradise pictogram — with the names of the rivers Euphrates, Gheon, Phison and Tigris added, but standing now as 'pars pro toto' for the whole cosmos (fig. 50).

This MS. gives us a good idea of what Carolingian collections of school schemata were like, in that the latter were borrowed from various sources (Isidore of Seville, Martianus Capella, etc.), usually without acknowledgement. In between computistic tables, genealogical tree schemata of the 'divisio philosophiae' (folios 68r., 68v.) and of multiple Scriptural exegesis (69r.: tropology, allegory, anagoge), and 'rotae' of the sun, moon and zodiac (folios 71r.-73v.), we find on fol. 74v. the Paradise pictogram under an anthropomorphous many-headed animal, the 'ratio septi zodi', together with a chessboard scheme of Annus, the names of the 7 planets and the first 7 letters of the alphabet (fig. 50), in a curious representation which may be intended to show the influence of the 7 planets on the cosmos.[6]

The Paradise pictogram as image of the cosmos appears in various representations at the feet of Christ as cosmocrator, for example in the lower part of the Frankish stele from Moselkern, dating from c. 700, in the upper zone of which the crucified Christ is depicted as cosmocrator in syndesmos posture (fig. 51).[7] In a Cologne ivory, datable c. 980, the pictogram is reproduced at the feet of Christ enthroned amid the congregation of the apostles (fig. 52).[8] That it was here intended as a symbol of the harmony of the 4 Gospels, as well as being a cosmic symbol, is suggested by an earlier, related composition of Christ among the apostles, in a 5th/6th century ivory in the museum at Dyon, where instead of the Paradise pictogram there is a scrinium with 8 bookrolls (4 Old Testament and 4 New Testament books?) at Christ's feet.[9]

In addition to this Paradise pictogram going back to an age-old tradition, there are a number of well-known school schemata which, as harmony schemata, were adapted for visual exegesis.

This is the case, for example, with the quartered scheme of the 4 elements or the 4 humours which occurs very frequently as a scheme picturalizing the harmony between the micro- and macrocosmos. It features, for instance, in the earlier mentioned *Tractatus de quaternario* at Cambridge, dating from about 1100.[10] The scheme of the 4 'regiones: oriens, occidens, aquilo, meridies', the initial letters of which words, in Greek, form the name ADAM (a fact already worked into Augustine's *Comm. in Ps. 95*,[11] could also be adapted for visual exegesis (fig. 53). The windrose — the diagram of the 4 principal winds and 4 or 8 secondary winds (fig. 54) which together create harmony in the cosmos — was also influential, as appears, for example, from the representations of the rivers of Paradise as horned wind-gods (figs. 56a-c), and from the 8- or 12-part composition of some Paradise schemata (figs. 55a-b).[12] The scheme of Annus and the 4 seasons was no doubt also of influence, particularly in those cases where a central figure rules the Paradise quaternity (fig. 57b).[13]

The adaption of these school schemata was made possible by the comparison, discussed earlier, of the cosmos to the Scriptures, which we meet with in a large number of texts.[14] Irenaeus, *Adv. haer* 3, 11, 3, compares the 4 Gospels

with the 4 corners of the world; Origen, *In Joh. 1,* 14,6, talks about the redemption of the universe, in which the 4 new elements are the 4 Gospels; and Jerome compares the elements to the 4 evangelists and their symbols.[15]

The comparison of the 4 rivers of Paradise to the 4 cardinal virtues — of great importance for the Paradise quaternity — has already been discussed in connexion with the creation of the Majestas formula.[16] That there was no fixed attribution of particular virtues to particular rivers is evident from the various combinations met with: for example in Ambrose, *De Paradiso* on the one hand and in Augustine, *De Genesi* on the other,[17] as well as in the examples of visual exegetic Paradise quaternity still to be discussed. Gregory the Great, *Hom. in Ez.* 1,3,8, pushes the comparison a step further by comparing the 4 principal virtues, from which all the other virtues proceed, with the 'quattuor partes mundi', the 4 quarters of the world.[18]

An important text by Julianus Pomerius (fl. end of 5th century), *De vita contemplativa,* already groups together various cosmic and exegetic quaternities which later visual exegetic schemata were also to use: such as Paradise with its 4 rivers, the 4 Gospels, the 4 'divini currus rotae', the 4 'animalia', the 'dignitas' and 'perfectio' of the number 4, as well as the 4 cardinal points, Adam-macrocosmos, the 4 elements-microcosmos and the 4 'animae affectationes'.[19] This relation between cosmos and Scripture was also dealt with in Carolingian exegesis, for example by Christianus Druthmarus of Corbie (c. 850), who, in his *Expos., in Matth. Evang.,* makes a comparison between the elements, Gospels, evangelists and their symbols, the 4 letters of the name ADAM, and the 4 cardinal points. An even more exhaustive treatment is given by John Scotus Erigena in the text already mentioned from his *Prol. in Joh.,* where he works out an extremely complex comparison between the Bible as quadripartite 'mundus intelligibilis' with 4 elements, and the 4 'sensus' of Scriptural exegesis, which also stand for the 'divisio philosophiae'.[20]

For Radulfus Glaber (d. 1044) the number 4 provides a revelation of the 'divina quaternitas', the order of the earthly and the heavenly worlds.[21] But it is in 12th-century exegesis, in particular, that the relation between cosmos and Scripture is worked out in all kinds of quaternities, resulting in an extremely varied picture of the operations of this 'divina quaternitas'. The extension of the 'quadripartita praedicatio evangelii' to the quartered cosmos leads to the creation of a new cosmos in the 'ecclesia quadripartita'.[22]

In addition to quartered cosmic school schemata, a quadripartite logical diagram, in which various concepts requiring to be compared were arranged crosswise, may also have exerted some influence. The use of this logical diagram may have been transmitted from late antique educational practice to the Middle Ages by Ammonius or Boethius for example; or it may have come down via Martianus Capella, who provides a similar diagram, complete with extensive commentary, in his *De nuptiis Philologiae et Mercurii* III, De arte dialectica.[23]

Both school schemata could have influenced the formation of the quad-

ripartite visual exegetic Paradise quaternity as a scheme for ordering various quartets linked with each other through exegesis.

The hypothesis that the exegetic elements of both the 'paradisus quadripartitus' and the 'paradisus quadruplex', while going back to the church fathers and belonging to a continuous exegetical tradition, were only clearly combined in an exegetical formula in the 12th century, is supported by the fact that only then do we find a complete visual exegesis of these two aspects of Paradise combined in one scheme (although earlier steps in that direction, for example in the Majestas Domini scheme, can be observed).

One of the clearest examples of such a visual exegetic scheme, in which various adaptions of school schemata have been incorporated, is the Paradise quaternity found in two closely related representations (figs. 56a, 57b): the Southern German *Speculum Virginum,* of 1145/50, in the British Museum at London,[24] a didactic tract of a mystical nature concerned with the teaching of nuns; and the *Laudes S. Crucis* at Munich, dating from c. 1170/85 and originating at Prüfening, which is devoted to one single theme: the all-dominant cosmic and mystical power of the cross from the beginning of time.[25]

Both MSS. are in the form of a dialogue between a teacher and a pupil, and in both the visual exegetic schemata display a considerable measure of independence *vis-à-vis* the text. In the *Speculum,* however, the high value attached to the image as didactic, pedagogical, and even mystical aid, is also expressed in the text, and representations and text form a unity insofar as the image can function as the starting-point for a question and answer dialogue. Compare, for example, the question put by Peregrinus: 'In huius igitur figurae descriptione scisne notaverimus?' and Theodora's answer: 'quid alius nisi . . .'. From the teacher's approval which follows: 'Vigilantissime notasti proposita . . .', it is clear that we have to do here with a dialogue based on images, where the image makes a recapitulation of the text possible. In the *Laudes crucis* on the other hand, the connexion between text and image is either extremely loose or non-existent.

Comparison of the Paradise quaternities in the two MSS. brings out similarities and differences, both as regards their application of the method of visual exegesis and with respect to their way of adapting school schemata (figs. 55a and b).

The Paradise quaternity on fol. 13 r. of the *Speculum Virginum* has been analysed in detail by Greenhill,[26] who also refers to the influence of school schemata; all we need to do here, therefore, is provide a brief summary. The representation depicts a mystical Paradise (florens mistice paradisus). This, the 'Hortus Ecclesiae', takes the form of a Paradise with 4 rivers, containing in the centre a crowned figure, the Ecclesia,[27] with a medallion figuring forth Christ as 'fons totius sapientiae' and bearing a book with the inscription 'Si quis sitit, veniat ad me et bibat' (John 7:37), which represents pictorially one of the fundamental themes of mysticism and of the Imitatio Christi'.[28] The 4

horned Paradisal rivers, which are located on an orthogonal cross, bear in their raised hands medallions featuring the 4 symbols of the evangelists (right hand) and the 4 principal fathers of the church, Augustine, Gregory, Jerome and Ambrose (left hand). The 4 cardinal virtues are placed at the extremities of a diagonal cross in medallions above trees bearing fruit, at the foot of which are 4 × 2 'beatitudines'. Text and image (fol. 12v., 13.) form a unity, partly because there are frequent allusions in the text to the picture; for example:

'. . . Verum licet in omni pictura vel artificio ratio praestet operi, et sit maior qui facit quam quod facit, volo tamen quendam paradisum speculatorium prae oculis tibi in pictura ponere, ubi fons cum suis fluminibus quadripartito meatu procurrentibus . . .',

whereupon follows a representation of the paradise quaternity.

Nevertheless there are discrepancies. For instance the exegesis of Paradise in the text is threefold, but the representation allows of a fourfold interpretation:

'. . . Porro trifaria significatione notari cognosce: paradisum primum quidem terrenum . . .; secundum presentem ecclesiam scimus paradisum per primum significatum certisque suis ordinibus, id est coniugatorum, doctorum, continentum . . . fructibusque virtutum diversarum in gradibus istis exornatum; tercium celestem paradisum ad vitam praedestinatis eternam certissimum praemium . . .'.

The 4th 'sensus' of tropology, though not expressly mentioned in the text, is implicit in the allusion to the 'fructus virtutum diversarum in gradibus . . . istis exornatum' and to the 'iiii virtutes principales (in qua disciplinae ratio consistit . . .)'. The visual exegetic representation expands this into a fully-fledged fourfold interpretation in which the 4 cardinal virtues are placed at the end of the arms of a separate cross.[29]

Various writers consider that, on the strength of the discrepancies between the text and the images (discrepancies which also occur in the other representations in this MS.), the representation in the London MS. (the earliest known MS. of the *Speculum Virginum*) must have made its way over from some other text, although no-one seems able to point to any particular archetype.[30] Greenhill does indicate relationships between the *Speculum* text and the exegetical works of Hugh of St. Victor (and incidentally suggests that the writer could have been a pupil of Hugh's, who died in 1140). Furthermore, in discussing the relationship between image and text, she draws attention to the parallels with the pedagogical method of Hugh of St. Victor, and even goes so far as to consider the possibility that representations such as those of the trees of virtues and vices on folios 28v. and 29r. derive directly from designs by Hugh himself.[31]

This discrepancy between text and image need not in itself form a conclusive argument against the originality of the representations in the London *Speculum,* since the visual exegetic method allows of far greater freedom with respect to the text than would be permitted to an illustration proper. On the whole, however, it looks as if the representations in this *Speculum* MS. may

well have been adapted from other contexts: there is something clumsy and incomplete about them, and they often seem to have been fitted into a space that is too large or too small for them (cf. *Speculum* folios 2v., 13r., 28v., 29r., 34v., 46r., 100v., 114v.); only the miniatures on folios 13v., 57v, 70r. and 93v. appear to fit more or less into their frames.[32] It is impossible to say, however, whether we are dealing with adaptions made from school schemata or from already existing visual exegetic schemata. At all events, there would appear to be a demonstrable influence by various school schemata on the Paradise quaternity on fol. 13r.: note, for example, the central figure who dominates the scheme, as it were, and the horned rivers of Paradise lifting up two medallions, which would seem to derive from the scheme of the winds and that of Annus and the seasons (fig. 56a).[33]

It is generally agreed that the representations on folios 5v., 6r. and 8v. of the *Laudes crucis* MS. (figs. 57b, c, d), which came into being roughly 25 years after the *Speculum,* go back to the earlier work.[34] But although the underlying idea is certainly related, and despite the presence of numerous formal similarities, there are nevertheless certain basic differences, for example in the composition of the Paradise quaternity, and in the arrangement of the various quaternities within this scheme. Moreover the *Laudes crucis* illustrator uses the possibilities of the visual exegetic method in quite a different way: the 3 representations mentioned are wholly independent of the text, and in addition, they form, together with a representation of the crucifixion on fol. 5 r. (fig. 57a) an independent commentary on the theme of the cross with which the treatise is concerned (see pp. 69 ff.).

The representation of Paradise doubling as paraphrase of the cross, on fol. 5v., is something unmatched by any special text in *Laudes crucis,* although, of course, the underlying idea is provided by texts such as 'sanguis Christi paradysum reseravit' and 'plus in novo Adam accipimus quam in vetusto perdidimus'. What is striking, in comparison with the *Speculum* representation, is the omission, alteration or substitution of certain elements, − for example the omission of the 8 'beatitudines' − as a result of which the 'rota' aspect of the scheme becomes clearer and more easily grasped.[35] A particularly noteworthy feature is the replacement of the Christ medallion by one containing the Lamb of God with a cruciform nimbus, and bearing the banner of the cross, which has the effect of stressing the anagogical meaning. Moreover the inscription PARADYSUS has been added to the central figure, indicating that this figure ought to be viewed as a Paradise personification, while the illustration in the *Speculum* interprets the same figure as Ecclesia or Mary.[36] The placing of the letters A.D.A.M. in the form of a cross represents an enriching of the cosmic aspect of the scheme, in the first place by orienting it on the four cardinal points, and in the second place by introducing the comparison between microcosm and macrocosm, which also emphasizes the typological comparison between Adam Vetus and Adam Novus.

Another important addition is formed by the inscriptions relating to the 4

'mysteria Christi' (incarnation, passion, resurrection, ascension) accompanying the symbols of the evangelists.[37]

The circular, closed form of the Paradise scheme in *Laudes crucis* (unlike its counterpart in the *Speculum*, which tends to be squareshaped and is hemmed in by the text, as it were) has a special significance, since the scheme is placed as cosmos under the feet of Christ 'Rex Gloriae', appearing as judge at the end of the world.[38] The 'rota' form is also more pronounced here because of the fact that the 'spokes' are clearly indicated.

The *Speculum* illustrator has kept closer to the original form of the scheme of the winds, cf. the type represented by the rivers of Paradise with their wild appearance and horns, while the *Laudes crucis* adopts a freer approach. The Lamb of God in the central medallion of this 'paraphrase' on the theme of the cross in the *Laudes crucis* MS. is the key-figure, from which the emphasis on the anagogical interpretation can be deduced. The temporal unfolding of the history of redemption is indicated by the rivers of Paradise, 'mysteria Christi', symbols of the evangelists, church fathers, and second coming of Christ.

A striking feature is formed by the divergences between *Speculum* and *Laudes crucis* in the way they group the various quartets relative to each other (see figs. 55a-b). There are obvious differences in the way the church fathers are combined both with the rivers of Paradise and with the symbols of the evangelists and the virtues.[39] Moreover, in all the *Speculum* MSS. the 4 rivers of Paradise (together with the medallions with the 4 symbols of the evangelists and the 4 church fathers) form an orthogonal cross, while the 4 cardinal virtues form a diagonal cross. In *Laudes crucis*, on the other hand, the rivers of Paradise (together with the medallions of the church fathers) form a diagonal cross, while the combination of the symbols of the evangelists and the virtues form an orthogonal cross. In addition, the *Speculum* appears to have adapted an eight-pointed windrose and the *Laudes crucis* one with 12 points.

These differences would seem to argue against the assumption that the *Speculum* scheme was straightforwardly copied. In fact they support the view that, although the *Laudes crucis* illustrator may have known the *Speculum* schemata.[40] he made independent use of them and also drew upon other cosmic school schemata.

In the Paradise quaternity on fol. 5v. of *Laudes crucis* the emphasis is laid, in accordance with the fact that the programme was designed to indicate types of the cross or of the form of the cross, on the cruciform and quadripartite nature of Paradise, which in addition to being a 'paradisus quadripartitus' is also a 'paradisus quadruplex'. The Paradise with four rivers coincides here with the quadripartite cosmos designated by the four letters A.D.A.M., the placing of which on a cross indicates the orientation of the scheme towards the 4 points of the compass. At the typological level this provides the comparison between a cruciform 'Adam Vetus' and the crucified 'Adam Novus'. Anagogically, there may also be a reference to the idea of Adam's eventual return to Paradise.[41] Finally, the placing of the letters A.D.A.M. (in the cosmic

sense of 'Adam Sparsus')[42] on the same axis as the quaternity of the 4 virtues makes a comparison possible between macrocosmos and microcosmos, but with respect to the microcosmos not of the human body but of the human soul. This provides at the same time the tropological exegesis of the Paradise scheme.

The 4 cardinal virtues are depicted as female figures, their faces turned to the centre of the 'rota' and, in their hands, scrolls bearing inscriptions. Reading clockwise these figures are: temperantia (inscr. 'discretus in istis'), fortitude (inscr. 'fortis'), prudentia (inscr. 'prudens') and justitia (inscr. 'iustis eris'). The symbols of the evangelists are on the same axis as the letters A.D.A.M. and are linked to the medallions containing the quaternity of virtues. This signifies the spreading of the 4 Gospels from the one single source in Paradise to the 4 points of the compass.

An enrichment, by comparison with the *Speculum* representation, is formed by the introduction of the christological quaternity, which can be read from the inscriptions on the book held by John's eagle and on the scrolls held by the other symbols of the evangelists. These are: 'carne dei' (incarnatio)/ Matthew; 'morit' (mors)/ Luke; 'mors mortis' (resurrectio)/ Mark; 'ad alta levatur' (ascensio)/ John, which together form the 4 'mysteria Christi'.[43]

The personifications of the 4 rivers of Paradise are placed on the diagonal cross. They hold mèdallions depicting the 4 principal fathers of the Latin church: Augustine, Gregory, Jerome and Ambrose. By the direction of their gaze, the rivers of Paradise and the church fathers are linked with the symbols of the evangelists and the cardinal virtues on the orthogonal cross; the four streams of water link them with 'Paradysus' and the Lamb. By putting the quaternity of the 4 principal church fathers on an equal footing with the 4 rivers of Paradise, harmony is assured within the Paradise of the Church. By comparing the 4 streams of explication in accordance with the 4 'sensus', with the 4 streams from a single source, the 'rota' can also be seen as the Paradise of the Scriptures, in which harmony is achieved by the method of fourfold exegesis, with the aid of the 4 church fathers, each of whom was pre-eminent in one of the 'sensus'.[44]

In view of the striking composition of the scheme, which systematically groups items in sets of four within circles (or wheels) at the ends of the arms of a cross and unites them into quaternities, the question has to be raised whether or not this is an attempt to express figuratively the idea of the quadriga as a heavenly chariot bearing the soul upwards and assisting the flight of the contemplative soul. We do find the term quadriga used in exegesis for each of the quaternities separately, so that we arrive successively at a quadriga of the 4 rivers of Paradise and the 4 church fathers; a quadriga of the 4 Gospels, driven by Christ as 'Verus Aminadab' through the 'quadratus orbis' in order to found the Ecclesia; and lastly, the 'quadriga virtutum, the wheels of which — prudentia, justitia, fortitudo and temperantia — convey the soul to Heaven.

Finally, this forms the quadriga of the 4 'sensus', round which the whole Bible turns: 'quatuor rotis tota divina scriptura volvitur'.[45]

In addition to the analysis in terms of the various quaternities, it is also possible to make a fourfold interpretation of the whole representation on the basis of the 4 levels of exegesis. According to the first of the 4 'sensus' (historia) what we see is a representation of the Old Testament earthly Paradise, with 4 rivers emanating from one source, which is also an image of the world (cf. A.D.A.M. = 4 cardinal points) in which the spread of the Gospel takes place.

According to the second 'sensus' (allegoria), however, this cosmic Paradise is also the Paradise of the Scriptures, divided by the 'quadripartita Evangelii praedicatio', and the Paradise of the Ecclesia, rendered fruitful by the 4 streams of explication emanating from the church fathers. The third 'sensus' interprets it as also being the Paradise of the human soul with the quaternity of the 4 cardinal virtues, which, as 'quadriga virtutum', conveys the soul 'ad aeternam patriam'.

The fact that the quaternity of the virtues is linked to a quartet of evangelistic symbols bearing texts mentioning the 4 'mysteria Christi': (incarnatio, mors, resurrectio, ascensio) allows an additional emphasis to be placed on the third 'sensus' of tropology since the 'mysteria' had been interpreted by Augustine in his *Enchiridion* 14, 53, as the 'interioris hominis sacramenta'.[46]

Finally, the heavenly, restored Paradise of the fourth 'sensus', that of anagoge, is represented by the Lamb in the centre and by the appearance of Christ at the end of time, in the upper zone of the miniature.

It is very noticeable that in the 'illustration' of the *Laudes crucis* MS. various possibilities of the visual exegetic method have been experimented with, using as a guideline the programme set out in the elaborate title:

'Dyalogus de eo, quod dominus ait: ego si exaltatus fuero a terra, omnia traham ad me ipsum. Et quod agnus occisus sit ab origine mundi. Qui et convenienter de laudibus crucis intitulatur',

a programme which, — from the fall of Adam on — searches through the whole *Heilsgeschichte* for types of cross and crucifixion, further specified by the author as follows:

'Quomodo mysterium crucis ante legem, sub lege, usque ad gratiam de typicis adumbrationibus quasi gemma quaedam lucidissima de mundi tenebris traluxisset, succinte notabimus.

In the forty-seven little representations at the beginning of the MS. (folios 1r.-4v.) the artist has remained fairly close to the text, although in the case of some of the pictures there is no matching text, and conversely, not all the sections of the text are illustrated. Obviously he was not aiming at an illustrative cycle so much as at a pictorial survey of the main types of the cross, usually with the accompaniment of a framed, brief typological explanation as titulus.[47] However, when the author, basing himself on the New Testament, starts on a long moralising interpretation running on for pages, the illustrator

goes his own way. From fol. 5r. onwards he changes to a pure form of visual exegesis, paraphrasing the text freely, and, though extracting relevant ideas from his source material, refashioning and deepening them.

The crucifixion on fol. 5r. (fig. 57a) belongs in a way, since it is a composition in two zones, to the preceding series of historical representations (folios 1r.-4v.) and rounds off this series of Old Testament types of cross and crucifixion with the New Testament antitype. On the other hand this crucifixion introduces the series of 4 paraphrases on the programme of the 'Dyalogus', the text of which begins on fol. 9r. The representation can itself be interpreted on 4 levels, as is apparent from the *Leitmotif* of 'piercing', which occurs four times here with different meanings: first as the historical event on Mount Golgotha, then allegorically as the birth of the Ecclesia resulting from Longinus' lance thrust, then tropologically by the victory of 'humilitas' over 'superbia' at the foot of the cross (to which may be added a christological interpretation on the basis of the inscription: 'Superbia diaboli vincitur humilitate crucis Christi'), and finally, as anagoge, by the piercing of the snake with the point of the cross, coupled to the text taken from Ps 90 (91): 13: 'Super aspidem et basiliscum ambulabis, et conculcabis leonem et draconem', which is regularly explained as a triumph motif.

The next miniature — the Paradise quaternity (fol. 5v.) and its fourfold exegesis — have been discussed above.

The 'paraphrase' of the cross which follows — the ladder scheme of the HOMO TOTUS (fol. 6r. fig. 57c), which Boeckler has called 'Menschen-kreuzigung' — has been fully analysed by Greenhill, in connexion with its appearance in the *Speculum*.[48] In this last work the theme is introduced at the end of Chapter 7 and discussed in Chapter 8, which is entitled: 'De fructu carnis et spiritus'. *Laudes crucis* adopts portions of the latter in a text enclosing the representation, but departs from it at certain points (fig. 57c). The representation is introduced as follows:

'HOMO TOTUS subscriptae formulae ratio haec est Homo stat ex carne et spiritu quod alterum causa pugnare alterius est . . .'.

This has clearly been influenced by the *Speculum,* but the basic material has been independently treated. Significant features are the additions found in *Laudes crucis* and not in the *Speculum,* such as the inscriptions with the 4 dimensions of the cross and the letters A.D.A.M., giving the relation between macrocosmos and microcosmos, not however, in terms of the body but of the soul. Another difference is that in *Laudes crucis* only one figure representing 'Spiritus' occurs, in contrast to the two figures of 'caro' and 'spiritus' in the *Speculum.*

This representation, too, can be apprehended in terms of the 4 'sensus'. Apart from the historical (literal) interpretation (which is obvious), there is a marked tropological content, as has become clear in the previous paragraph, while an allegorical interpretation is latently present in the text enclosing the

representation, i.e. in the exegesis of the text of the Song of Songs 1:3 'trahe me post te', usually explained in terms of a comparison between Sponsa and Ecclesia.[49] The anagogical interpretation can follow either from the terms 'trahere' and 'sublevatus', used in respect of the 'Spiritus' on the cross (and also clearly pictured in the raising and drawing up), or from the implication of the crucifixion and redemption of the 'vetus homo', as in Rom. 6:6-11.[50]

The idea of a victory over the devil and Death is emphasized here by the triumphant transfixing of the snake, the 'draco versutus',[51] with the point of the cross. Finally, this visual-exegetic representation is exceptionally important for another reason still, namely on account of its visualization of the fundamental idea of mysticism: man as 'imago et similitudo Dei' and the 'imitatio Christi'.[52]

In the fourth 'paraphrase' of the cross, the representation on fol. 8v. (fig. 57d) of a tree scheme with syndesmos ideogram (circles with head, hands and feet at the extremeties of a cross), the allegorical exegesis, in terms of Christ and the Ecclesia, is dominant. The course of the history of redemption from patriarchs to apostles finds expression in the tree as a scheme of growth, while the partial revelation of salvation to the types (figurae) of the Old Law, is graphically expressed by the syndesmos ideogram, in which only the head, hands and feet of the crucified figure appear.[53] The anagoge is implicitly present in the allusion to the cross, with the tendrils sprouting from it, as the 'lignum vitae in medio paradisi' (i.e. in the restored Paradise), and in the idea of growth from earliest times to the end of the world. The tropology, too, is only latently present here, for example in the text (fol. 6r.): 'verum quia omnis spes et salus redempti hominis in cruce Christi constat'.

The illustrations of *Laudes crucis* have been chiefly studied in connexion with research into the possible existence of a typological compendium. Much attention has consequently been paid to the forty-seven small representations, which have been evaluated as the oldest surviving typological cycle and also, for example, as a forerunner of the *Biblia Pauperum* and as contemporaneous with the Klosterneuburg retable.[54] The 4 large miniatures on folios 5r., 5v., 6r. and 8v. have never, so far as I know, been dealt with together as a coherent group.[55] And yet they represent a special form of visual exegesis, in which a number of miniatures provide their own commentary on the text, while remaining independent of it.[56] In the case of *Laudes crucis,* the 4 large representations form 4 'paraphrases' of the cross, each accenting one of the 4 'sensus' of multiple exegesis according to which the cross can be interpreted. These are:

fol. 5r. (historia)	crucifixion of Christ
fol. 5v. (anagoge)	Christ as judge of the world, with the cruciform Paradise quaternity at his feet
fol. 6r. (tropologia)	HOMO TOTUS, cruciform ladder scheme
fol. 8v. (allegoria)	Christ and the Ecclesia, cruciform tree scheme and syndesmos ideogram.[57]

Each representation has a key-figure at the centre: respectively Christ (5r.), the Apocalyptic Lamb (5v.), Man (6r.), Ecclesia / Mary (8v.).

This hypothesis, that the 4 large miniatures of *Laudes crucis* form a coherent series visually rendering the programme of the treatise is supported by the existence of an analogous case — one which, moreover, uses two visual exegetic schemata also occurring in *Laudes crucis,* namely the Paradise quaternity and an anthropomorphic scheme.

The schemata on folios 9v., 10r. and 10v. of a 12th-century Lectionary from Zwiefalten, now at Stuttgart, can be regarded as forming a coherent whole, the purpose of which is to reproduce pictorially the essence of the book containing the lessons or portions of Scripture to be read at divine service (figs. 58a, b, c).[58] In succession we find Christ, the Lamb and Paul at the centre of schemata adapted from cosmic school schemata such as that of the 4 winds, the scheme of Annus and the seasons, and anthropomorphic macrocosmos — microcosmos schemes. The first representation (fol. 9v.) contains a rectangular scheme of the vision of Christ enthroned between the 24 elders, with 'fulgura et voces et tonitrua' issuing from the throne (cf. the inscription Apoc. 4:5), indicated by the 3×5 heads, variously depicted, in the oval mandorla (fig. 58a). At the four corners of the inner field we see, above, 'tenebrae' and 'lux', and below, 2 seasons, 'hiems' and 'aestas', suggesting the grafting of a representation of the creation onto the scheme of the 4 seasons.[59] Christ is seated in the House of Wisdom, indicated by the text 'Sapientia aedificavit sibi domum, excidit columnas septem' (Prov. 9:1) and by the architecture. The representation has been adapted from at least two well-known schemata — that of Annus and the seasons, and the scheme of the winds — and there are also obvious points of resemblance to Majestas Domini compositions.[60]

The miniature on fol. 10r. (fig. 58b) is clearly related to the Paradise quaternity of the *Speculum* and *Laudes crucis,* but the field is now square instead of round, and contains in the centre the Lamb of God bearing a cross, in a medallion. At the ends of the 4 arms of the cross (orthogonal, as in the *Speculum)* are the horned personifications of the 4 rivers. In the 4 compartments are the 4 evangelists with their symbols, while medallions at the 4 corners of the frame (placed diagonally, as in the *Speculum)* contain personifications of the 4 cardinal virtues: prudentia, iustitia, temperantia, fortitudo. The following text runs round the border:

'Quattuor virtutes cardinales in quibus omnes virtutes velut ianua in cardine
pendent et quattuor flumina paradisi figuram tenent. IV evangelistarum qui tamquam columnae celi sustentent
orbem terrarum et sua doctrina replent et rigant universum mundum
Ex eorum quippe Scriptis septem signacula libri signati referantur. Id est Christi incarnatio baptismus passio descensio ad inferos resurrectio ascensio sancti spiritus descensio'.[61]

The two representations (9v., 10r.) taken together provide a visual exegesis of the *Heilsgeschichte* with Christ as creator and ruler of the cosmos (lux and tenebrae; Paradise as 'pars pro toto' for the cosmos) and of time (allusion to

70

the scheme of Annus and the seasons). Furthermore, the history of redemption from the beginning to the end of time is visually presented through the 4 rivers of Paradise seen as the 4 Gospels permeating the cosmos, while the writings of the evangelists are compared to the 7 seals of the book (Rev. 5:1) and the 'mysteria Christi' (from incarnation to descent of the Holy Ghost at Pentecost).

The number 7 is repeated in the representation on the facing page, where we find the 7 pillars of the House of Wisdom, which, like the 4 evangelists in the rôle of 'columnae coeli', support the House of Wisdom in which Christ is seated. The relation between the beginning and the end of the world is adumbrated by the Apocalyptic Lamb in Paradise, and by Christ the creator and ruler of the cosmos being adored by the 24 elders of the Apocalyptic vision. Finally, the tropological exegesis based on man and his hope of salvation is summed up in the comparison of the 4 cardinal virtues with the 4 rivers of Paradise in the inscription (fol. 10r.).

The representation of Paradise itself (on fol. 10r.) is clearly related to a particular type of Majestas Domini composition, as becomes evident from a comparison with, for example, the earlier mentioned bookbinding in the Musée de Cluny at Paris (fig. 41), with its depiction of a Paradise quaternity.[62]

Finally, the miniature on fol. 10 v. (fig. 58c) shows an anthropomorphic scheme with Paul as syndesmos figure[63] in the initial D of the text 'Deus pacis sanctificat vos per omnia ut integer spiritus (I Thessal. 5:23), which begins the reading for Advent Sunday. In the inner field the representation is rigidly divided by a system of 4 quatrefoils containing the half-length figures of Peter, John, James and Luke. The border shows 4 medallions at the corners and 6 lozenges, in which are placed prophets such as Daniel, Solomon, Moses and Esther (who qualifies as Old Testament prophet on the strength of the text in Esther 13:9, 'Domine, rex omnipotens'). All of them are provided with text scrolls bearing texts taken from the lessons.[64] The representation in its entirety can be understood as a visual exegesis of the texts of the lessons taken from the Old and New Testaments, incorporated in an anthropomorphic basic scheme which shows Paul, as linking figure, bringing together the elements presented by these texts.

Although this representation has a greater measure of independence than the two which precede it, it is still possible to view the 3 miniatures as forming one programme, emphasizing successively the anagogical (Christ and the 24 elders), tropological (Paradise quaternity), and allegorical (Paul) exegesis of the text given in the book. To this extent, they together form an analogous case to the 4 miniatures in the *Laudes crucis MS*.

What we have tried to show so far is that, of the three visual-exegetic schemata adapted from quadripartite school schemata which we proposed to discuss, the first, the Paradise quaternity, is capable of providing a visual exegesis in accordance with the 4 'sensus'. We have also contemplated the possibility that some of these Paradise quaternitiès, together with other

quadripartite visual-exegetic schemata in the same MS., form a coherent series, in which a summary is given of the programme contained in the accompanying text.

HIERUSALEM URBS QUADRATA

A second basic visual exegetic scheme is formed by the cosmic-architectonic quaternity going back to the antique tradition of a cosmic building or cosmic city with a square, rectangular or circular ground-plan divided orthogonally or diagonally into four.[1]

Traces of such a quaternity can be found in the architectonic symbols used in the Bible, both in the Old and in the New Testament. Examples are the ark of Noah, the tower of Babel, the Tabernacle, the Temple of Ezekiel, the Temple of Solomon, the House of Wisdom and the Heavenly City described in Revelation (figs. 59, 60).[2] Exegetes make remarkably frequent use of these architectonic symbols as a starting-point for multiple exegesis. Perhaps the most popular subject of all interpretation according to the 4 'sensus' of history, allegory, tropology and anagoge, was the city of Jerusalem. This preference can probably be traced back to the twofold interpretation, already found in Origen, of Jerusalem as, on the one hand, 'civitas Dei' and Ecclesia − the architect of which was Christ − and, on the other, as the dwelling He constructed in the heart of each believer. Such an interpretation already carries a suggestion of the 4 'sensus'. It was in common use in the early-christian period (partly due to the great influence of Augustine's *De civitate Dei),* and was passed on to the Middle Ages by, for example, Cassian's *Collationes.* Representative figures from the Carolingian period who used this interpretation were Raban Maurus and Walafrid Strabo, while later on it became almost a cliché, cf. the *Glossa ordinaria,* Honorius Augustodunensis and Hugh of St. Victor.[3]

One of the above mentioned architectonic symbols from the Bible was used as a basic scheme, with the addition of one or two elements to facilitate visual exegesis, in two related drawings, made almost at the same time, which are only known from later copies of them. These two drawings are that of the Tabernacle as cosmic building (fig. 62) in Cosmas Indicopleustes' *Topographia Christiana* (c. 540), and the design by Cassiodorus, possibly made for his *Codex grandior* (fig. 63). It is quite possible that these examples go back to an Alexandrian prototype, since it was Philo of Alexandria who first attached a cosmic significance to Temple and Tabernacle in a way which opened up possibilities for multiple exegesis. The possible existence of a link with Alexandria is supported by the fact that the *Codex Amiatinus* in the Laurenziana at

73

Florence (from Yarrow-Wearmouth, and dating from before 716), which goes back to the *Codex grandior*, contains in addition to this scheme of the cosmic Tabernacle, early examples of adapted genealogical schemata (figs. 27a-d), e.g. the 'divisio scripturae divinae', which, as we have seen, may well derive from Alexandrian originals. As presented by Cosmas Indicopleustes, the Tabernacle is drawn in elevation, while in the drawing in the *Codex Amiatinus* going back to Cassiodorus, we have a purely schematic representation. That the two are related, however, is suggested by, among other things, the fact that of all known later examples of the Court of the Tabernacle in medieval MSS. from the west, it is only in these two that we find an orientation to the 4 cardinal points.

Cassiodorus himself mentions the drawing of the Tabernacle in his *Comm. in Ps. 14* (*PL* 70, 109a) and in the *Institutiones* I, v.: '... tabernaculum templumque domini ad instar caeli fuisse formatum: quae depicta subtiliter lineamentis propriis in Pandecte latino corporis grandioris competenter aptavi'. On folios 2v./3r. of the *Codex Amiatinus* is a large rectangular schematic drawing of the Court of the Tabernacle (fig. 63). Around the outside of the Court are the names of the 12 Tribes of Israel, and in the Court itself we find the names of the 4 cardinal points: ANATOLE, DYSIS, MESEMBRIA, ARCTOS. Over the entrance to the Tabernacle is a cross. The addition of an orientation on the four points of the compass makes possible a visual exegesis in terms of, for example, a comparison between the cosmic Adam Vetus and Adam Novus, or the assembling of the 12 Tribes from the 4 cardinal points at the Day of Judgement.[4]

Nevertheless it is the architectonic symbol of the City of Jerusalem — represented by a cosmic-architectonic quaternity with a circular or square ground plan and either an orthogonal or a diagonal division — that visual exegesis makes chief use of, as basic scheme for the 'quadrifaria expositio'.

This city quaternity was frequently employed in medieval monumental painting. In most cases the symbolism appears to have been chiefly centered on the vault, where the introduction of a city scheme with a clear quadripartite division made possible a visual exegesis starting out from the comparison between the earthly and the Heavenly Jerusalem and the Ecclesia.[5]

It is worth noting that in a number of instances the building involved is a funerary chapel or church, and that the programme of decoration was planned to commemorate a particular person, for example the patron. The content of this programme is the hope of redemption and the final attainment of the 'visio pacis' in the Heavenly Jerusalem. Understandably enough, there is a strong emphasis on the 4th 'sensus', anagoge, although the other 3 'sensus' are always more or less latently present.

An example of a programme of this sort is to be found in the little church of S. Pietro in Monte belonging to the Benedictine abbey of Civate, and situated in a relatively inaccessible part of the mountains between Como and Lecco (figs. 64a-c). The decoration of this church is nowadays usually ascribed to the

Lombardic school active at the end of the 11th century,[6] when Civate played a part in the struggle between the papal and the imperial factions. It was here that Arnolfo III di Porta Argentina, who had been elected Archbishop of Milan in 1093, sought a temporary shelter and − as the sources put it − 'sanctissime vixit' for two years, when shortly after his election he was deposed as the result of political intrigue. The choice of Civate may have been determined partly by the inaccessibility of the place, partly by the fact that the Abbot of Civate possessed special powers of absolution. Going to S. Pietro − which had also possessed important relics since Lombardic times (including St. Peter's key) − was like going to Rome: 'et dominus abbas potestatem habet absolvendi illos visitantes, ut supra vel allius solvens loco illius' and 'ita quod qui per tres annos illam ecclesiam talliter visitaverit et absolutus, sicut tempore jubilei Rome', as an early source puts it. In addition, the level of cultural activity at the abbey, which possessed a library and a scriptorium, must have been high.

In 1095, at the council held in Piacenza, Pope Urban II reinstated the archbishop, who was reordained by three German bishops: Dimo of Salzburg, Ulrich of Passau and Gabardus of Constance. Arnolfo died two years later, in 1097, and was buried at Civate. Since archbishops of Milan were usually buried in that city, and since there was no threat of war or other form of unrest at the time in question, the reason for this departure must be sought elewhere. It is tempting to speculate that Arnolfo had already conceived the plan of being buried at Civate during his exile, and that during his stay there, or perhaps during the two years following his reinstatement as Archbishop of Milan, he drew up the programme of decoration for the little church and had the work executed. The striking alterations made to the original church, which had a single nave oriented to the east, by the construction of a new apse to the west (containing the high altar and a ciborium modelled on that in the cathedral of St. Ambrogio at Milan), the bricking up of the triumphal arch in the east, and the conversion of the eastern apse into a sort of narthex with three naves, must at all events have taken place at this time.[7] It is not beyond the bounds of possibility, therefore, that these radical alterations were connected with Archbishop Arnolfo's plans for a sort of memorial chapel in S. Pietro, where the services he wished to be held for his soul[8] could be performed.

The resulting little three-naved 'chapel' consists of three bays (one square-shaped between two rectangular) with cross-ribbed vaults, and centrally behind them a square space (containing the entrance), flanked by two small apses with altars, one of them dedicated to St. Peter, and the other to Philip and James.[9] Within this space a fairly coherent programme has been realized. As for the rest of the church, none of the decoration has survived. It may possibly have resembled the roughly contemporaneous decoration of the church of S. Calocero di Civate (belonging to the same abbey and governed by the same abbot) in the valley below, where − on the evidence of surviving

fragments of wall-decoration above the stone vaults introduced later — the programme had a typological character, with well-known themes such as the fall of Jericho and the crossing of the Red Sea, and possibly other scenes of salvation. In the 'chapel' of S. Pietro it seems as if we have to do with a more personal programme, one with a specifically eschatological slant, befitting a funerary or memorial chapel for the Archbishop of Milan, whose memory was held in honour by the monks.[10]

The hypothesis that the programme was a special one, specifically intended for this 'chapel', is strengthened by the fact that it is not designed to be read by someone entering the church (i.e. from the entrance looking towards the altar), but from within the church itself, from the high altar, with the decoration (contemporary) on the inside of the altar ciborium serving as a starting-point. The series of radical alterations to the church which preceded the making of the 'chapel', also go to suggest that special value was attached to a situation in the east, something which we also find in other funerary or memorial chapels (cf. the funerary chapel of the bishops, the Allerheiligen-kapelle, on the east side of the Cathedral at Regensburg).[11] It is also possible that the dead archbishop was conceived of as playing a part in the programme through his fictive presence, by an imagined temporal extension of his consciousness during the Mass for the Dead, when he must have lain before the altar with his gaze directed away from it,[12] and thus towards the east. There are other, admittedly later examples — occurring in mortuary churches and chapels — of programmes where the dead are imagined as playing a part.

For instance, in the so-called Karner, the cemetery chapel at Perschen, near Nabburg, the decoration only becomes fully meaningful when one is aware of the presence of the dead in the mortuary under the chapel, which is connected with the space above it by an opening in the floor (see pp. 89, 91).

In two-storeyed churches and chapels, too, built as final resting places for their founders the placing of the tomb in the centre of the lower church (connected by an opening in the middle with the upper church) can be meaningfully related to the design of the programme (see Schwarzrheindorf).

The way the eye is guided in programmes of this sort suggests, at the same time, their essential purpose, namely to 'elevate the soul'.[13] But the direction need not always be a vertical one: it can also be horizontal, in two areas placed one behind the other, as for example in the Bishop's Chapel of the cathedral at Gurk.[14] In Civate, too, where motifs taken from Revelation can be followed in chronological order, moving in an easterly direction from the ciborium over the high altar, one can speak of a horizontally developing programme. This starts with the painting of the inside of the altar ciborium, where the passage from Rev. 7:9-17 is depicted in a quaternity scheme. In the centre we see the Lamb, with a cruciform nimbus, being worshipped by the multitude represented by eighteen saints holding branches of palm. At the corners four angels have been placed as caryatids, supporting the winds, which are depicted as birds.[15]

In the 'chapel' itself different stages of the programme can be distinguished in the following locations:

— zone over the arcades of the entrance wall (originally wall with triumphal arch)

— the three vaults

— left and right apse, walls to left and right of the door, lunette over the door

— vault in front of the door.

The first representation, on the wall containing the bricked up triumphal arch, follows Rev. 12 fairly closely, and has a semicircular inscription (only fragmentarily preserved) running like a frame round the top: 'Homo dolet sene (scens) sed munera gaudet (rufus) draco. (Salv)ator ad Dñm raptus, patria iam sede ... (glor)iat(ur?) in excelsis. Deiectus inde superbis cum quibus Michaelis cuspide fossus de ...'.

In the lower zone are the Woman and Child, being threatened by the Dragon, and on the right (barely visible) the fall of the Bad Angels: 'And they prevailed not, neither was their place found any more in heaven' (Rev. 12:8). The transition to the upper zone is provided by the gesture made by an obscure figure (a monk?) depicted as elevating the child who is in orant posture. Various writers have pointed out the resemblance to the gesture of the midwife in Byzantine representations of the bathing of the Christ Child,[16] where, moreover, the bath is often in the form of a baptismal font. The wresting of the child from the Dragon is consequently often interpreted in terms of baptism and penance, which would fit in very well with the programme.

The upper zone depicts Michael and the Angels fighting against the Dragon, and what followed this battle, as recounted in Rev. 12:5- 'and her child was caught up unto God, and unto his throne'. One curious feature is that the child being presented by an angel to the enthroned Christ (the remains of a cruciform nimbus are still visible) has darker coloured skin than the child being threatened by the Dragon in the lower zone, a difference which might be explained by the fact that this child is supposed to represent the soul of Archbishop Arnolfo.[17]

This representation, like the other sections of the programme in the 'chapel', can be read on various levels: allegorically the child is Christ; tropologically it stands for the human being 'fortis in penitentiae contemplatione'; and anagogically it shadows forth the saved soul, in this case that of Archbishop Arnolfo.

The programme of the interior of the 'chapel' (fig. 64b) provides in its entirety a graduated version of Heaven's joys becoming manifest to this saved soul, the culmination being the 'visio beatae urbis Jerusalem'. This idea of an introduction to heavenly bliss by way of a number of steps or stages, occurs frequently in medieval visions of heaven and hell. Usually the visionary is

transported, via an anteroom (sometimes again divided), which often has the characteristics of the earthly Paradise, to a place where he can catch a glimpse of the ultimate 'visio pacis', a locality which he is allowed to view from afar but not enter. In the majority of cases this last and highest stage is described as a city having the characteristics of the Heavenly Jerusalem as described in Revelation, enriched with various elements taken from the ideal city of the classical antique and eastern traditions — and later on from the medieval city as well.[18] In Civate, too, what we have is a sort of anteroom, from which the Heavenly City can been seen but not entered.

The programme of the interior of the chapel must have been meant to be read starting with the representations on the walls. But all that has survived of the latter are fragments on the wall of the left-hand, the north, apse, possibly depicting a martyrdom of St. James. Since we know from a 16th-century source that the altars of the 'chapel' were originally dedicated to Peter, and to James and Philip, the altar dedicated to the last two apostles probably stood in this north apse, the altar to Peter being in the south apse. The 16th-century source mentioned also states that behind this last altar there was a representation of St. Peter, which was removed on the orders of S. Carlo Borromeo, who as Archbishiop of Milan also had the two altars dismantled.[19]

The representations on the wall on either side of the door have survived. Here we find depicted, on the north side, Pope Marcellus[20] addressing the multitude with the words: 'Audite filii et inluminamini', and on the south side, Pope Gregory,[21] also addressing the multitude, this time with the words: 'Venite filii audite me, timorem Domini docebo vos'. Both figures have been placed under arches, which creates the impression that they are receiving the multitude in a porchlike anteroom. The promise of 'inluminatio' and the incitement towards 'timor Dei' form an introduction to the rest of the programme, in other words they prefigure the joys of heavenly bliss.

The quaternities in the three rib-vaults each direct attention to the space behind them. The middle quaternity, with 4 rivers of Paradise round a monogram of Christ, alluding to the restored Paradise on earth, goes with the representations in the space lying behind it, i.e. Abraham with 3 souls in his bosom (lunette above the door)[22] and the ultimate vision of the Holy City of Jerusalem (vault before the door)). The quaternity of the 4 symbols of the evangelists in the rib-vault on the north side, a schematic representation of the spread of the Gospel to the four points of the compass, leads on naturally to the representation in the north apse, where Christ is shown in mandorla with triads of saints, of whom there are 18 in all: martyrs, popes, and anchorites, representing the various ranks in the Ecclesia. The quaternity with 4 angels blowing trumpets in the vault on the south side, which together with the 3 angels[23] round the window on the south wall represent the 7 angels with trumpets in Revelation 8:2, leads on to the representation in the south apse, where Christ is depicted in mandorla between 2 seraphs and in the midst of the heavenly host, represented by 24 angels grouped in triads.

All these representations form an introduction to the vision of the Heavenly City on the vault before the door (fig. 64c). This, like visions of the life to come, is painted so as to create the illusion that the brilliance and the intensity of the light increase the higher the eye travels. The description of the City given in Revelation (Rev. 21 and 22) has been fairly closely followed here: we see Christ with the golden measuring-rod (Rev. 21:15), the Lamb in the middle (Rev. 22:3).[24] the two trees (Rev. 22:2), the throne like an emerald (the globe on which Christ is seated is emerald-green),[25] and finally the square shape of the City, with its 12 gates containing 12 figures, their gaze turned inward to the centre.[26] The gates also contain inscriptions conveying the names of the precious stones with which the foundations of the City were adorned (Rev. 21:19 ff): jasper, sapphire, chalcedony, emerald, sardonyx, sardius, chrysolite, beryl, topaz, chrysoprase, jacinth and amethyst.[27] The text, 'Qui sitit veniat (et qui vult accipiat aquam vitae gratis)', (Rev. 22:17) on the book in Christ's hands, together with the fact that the river of the Water of Life flows from the throne, out of the City, and on to the vault with the 4 rivers of Paradise, form the connexion with the representation on the entrance wall of the 'chapel', which we discussed earlier as being concerned with the redemptive power of baptism.[28] The Heavenly Jerusalem is depicted as a city quaternity divided diagonally, the four corners of which are accented by inscriptions with the names of the 4 cardinal virtues: justitia, fortitudo, temperantia, prudentia.[29] The result is a complete visual exegesis of the multiple interpretation of Jerusalem: historically − the cosmic city with quadripartite division; allegorically − the Ecclesia formed by Christ and the living stones of which the City is built: tropologically − the 4 virtues as cornerstones of the Jerusalem of the human soul; and anagogically − the 'beata pacis visio'.

The whole programme in the 'chapel' seems too subtle and personal to have been intended as instruction for the faithful. For one thing, if it had been designed to instruct, one would expect to find didactic and moralistic features, but they are totally absent. The note of admonition so often introduced by the visualization of Judgement and Hell, the darker side of the coin (we find it dwelt on at length in the medieval visions of heaven and hell), is missing here. The fight with the Dragon has been decided, the soul is already being raised 'ad patriam sedem'. The hope of attaining to heavenly bliss has here become almost a certainty.

Archbishop Arnolfo's long, enforced stay in Civate, combined with his exalted position and the fact that it was his wish to be buried in Civate, make the hypothesis that it was he who commissioned the work carried out in S. Pietro towards the end of the 11th century by no means an unlikely one.

This is not the only example of a personal, non-didactic programme, in which admonition and threat have been replaced by an emphasis on the hope of final admission to the joys of Heaven. Various analogous cases also make use of the city quaternity to image forth the 'ultima visio'.

Such programmes are often found in private chapels or other spaces barred to the laity, so that the contents could be attuned to initiates, who could be expected to understand the frequently complicated line of thinking. The essence of most of these programmes is the 'ascent of the soul', use being sometimes made of an actual physical guiding of the eye from lower to higher. In a number of cases the building or the space containing the programme functions as a sort of anteroom, from which the joys of Heaven − the Heavenly City of Jerusalem, with Christ and the Lamb or the hierarchy of Heaven − can be contemplated as in a vision. This feature can sometimes be linked with the special function of the church, or part of it, concerned. This function may have been that of serving as memorial or burial chapel for the commissioner of the programme, or as bishop's or abbot's chapel (e.g. Brioude, Allerheiligenkapelle Regensburg, Brixen, Gurk), or as cemetery chapel (St. Plancard, Perschen).[30] Occasionally the space in question is cut off from the rest of the church by a wall through which there is only a single narrow entrance (St. Gabriel's Chapel, Canterbury; Hardham).[31]

It is striking that in many cases we have to do either with buildings on an elevated site, e.g. St. Michel d'Aiguilhe (where, moreover, the Heavenly Vision is in the sanctuary), or with areas in the upper storey of the westwork (Brioude, Regensburg St. Leonhard), or on the upper storey of a tower-like construction near the choir or the crossing (St. Chef), or in a double-storeyed choir (Windischmatrei).[32] Sometimes this space is also called the Angel Chapel (Hersfeld), or Chambre St. Michel (Brioude), or the altar is dedicated to the Archangels (Le Puy, cathedral; St. Chef).[33]

In the programmes of the churches mentioned one frequently meets with the same themes. But whether they are related in any way cannot be established − partly on account of the scarcity of such monuments and the extremely wide variations in their dates. There are only one or two instances where such a relationship is clearly present, for example in the case of Gurk and Matrei. The problem is rendered still more difficult by the fact that we know so little about how particular church decorations came to be created. The people who commissioned them are often anonymous, and the artists themselves almost always so. The contents of a programme were naturally the business of the patron or his adviser. Its execution may have been influenced by the personality of the artist, or by model books. And in some cases the patron could step in again at a later stage to give inspiration, or to restrain or correct.[34] We do know that the artists who executed these commissions were ambulatory, and that the model books had a part to play in transmitting iconographic themes.[35] But what rôle contacts between learned patrons of these works may have played in disseminating programmes containing specific theological subtleties, is extremely uncertain. Possibly councils and synods provided an opportunity for the exchange of ideas, and also for recommending artists.[36]

It is curious, incidentally, that almost all the examples due for discussion

come from a Benedictine ambiance, although the point ought not to be stressed too heavily, since ultimately the origin of every single programme lay in the continuous exegetical tradition running from the church fathers to contemporary commentators, and the 'standard works' of this tradition must have been available in every library of any size.

There are a number of programmes — most of them in France — which are roughly contemporaneous with Civate, or a little earlier, and which display similar features. In the Benedictine Abbey of Fleury (St. Benoit s. Loire) there were paintings with apocalyptic motifs, known to us only in the form of tituli. These paintings were situated on or in the tower-like westwork, two storeys high, in which the upper chapel was dedicated to Michael. Among the 18 subjects we know to have been represented are the fight between Michael and the Dragon, and the New Jerusalem. The paintings were probably made at the same time as the tituli, which originated with Abbot Gauzelin (c. 1020-40).[37] Possibly we ought to imagine them as resembling the apocalyptic scenes in the narthex of the Benedictine Abbey Church at St. Savin (Vienne), which are dated c. 1100 and are thus roughly contemporary with Civate. We again find the battle between Michael and the Dragon, the apocalyptic Woman and Child 'raptus ad thronum', and the triumph of the Heavenly Jerusalem.[38] The examples, also French, in St. Michel d'Aiguilhe (Le Puy) and more especially in St. Chef (Dauphiné), however, would appear to be more closely related to Civate. Their situation, for instance, is largely the same (sanctuary on a height; chapel with its own programme, independent of the rest of the church). The dating of the two monuments, however, is a matter for argument. In the case of St. Michel the dates proposed run from the 10th to the 12th centuries, in that of St. Chef, from the 11th to the 12th.

The programme of the sanctuary of St. Michel d'Aiguilhe (figs. 65a-b) agrees at certain points with that of Civate. On the basis of what has survived we can arrive at the following reconstruction: the west wall contained saints, and the north and south walls apostles — all in zones. The upper zone of the east wall contained angels, and in the lower zone we find, to the left of the window, the gatehouse of the Heavenly Jerusalem (with a soul being led there by an angel, while other souls already 'in bono' look down from the windows), and to the right of the window, Hell. Insofar as restorations carried out at various times make an estimate possible at all, these last representations would appear to date from the 12th century, so that no conclusions can be drawn respecting the original programme. Whether we ought to regard them as restorations of earlier paintings, or as a later attempt to create a didactic whole, is impossible to say.

The ceiling, which is considered to belong for the most part to the original 10th-century scheme of decoration, contains a cosmic quaternity composition with Christ and St. Michael (the patron saint of the chapel) as the principal figures (fig. 65b). As in the 'chapel' at Civate and at St. Chef, the decoration of the walls of the sanctuary points to an interpretation of the sanctuary as a sort

of anteroom, from which the vision of heavenly bliss on the ceiling could be viewed. Apart from the representations of Heaven and Hell (which may well be of later date) and the possible allusion to the Last Judgement in the figure of St. Michael (whom I am more inclined to think of here as belonging to the Heavenly Host), this programme is again one which has to be interpreted entirely in positive terms. The observer's eye is led, via the representations of saints, apostles and angels on the walls, upwards to the 'ultima visio' in the vault, which is portrayed in a quaternity composition, surrounded by a 'cloud collar' motif to indicate that what is depicted must be thought of as located in the heavenly spheres (cf. the system of 9 circles). The principal axis contains the Majestas Domini and St. Michael, while the horizontal axis contains the sun and the moon and 2 angels, St. Michael being flanked by 2 seraphim. The 4 symbols of the evangelists are placed at the ends of a diagonal cross.

The composition of this vault displays — without being precisely a city quaternity — a striking resemblance to what we find at Civate. Specifically this involves the employment of a schematic quaternity composition with the 4 symbols of the evangelists at the ends of the arms of a cross (in Civate the 4 virtues), combined with an axial positioning of Christ. In addition there is the fact that in both cases we are dealing with a separate area, with its own programme designed for initiates. From his place in the nave the ordinary member of the congregation could only see the paintings on the walls, and not the 'ultima visio'.

The question whether the chapel and its paintings originally had a commemorative function seems to have a positive answer. There is evidence that Truannus, coadjutor of the bishop of Le Puy, decided in 962 to found a chapel-cum-oratory on the top of Mount Aiguilhe, in imitation of Mount St. Michel, where, to the end of time, prayers could be offered for his soul and that of Bishop Godescalc of Le Puy. According to later documents the first stone was laid in 962 by Bishop Godescalc, and the consecration was carried out in 984 by Guy II of Anjou, Godescalc's successor. Although nothing is known for certain, Truannus could therefore have been responsible for commissioning the original decoration.

Various commentators have drawn attention to the late-Carolingian elements of the ceiling decoration; all of them agree, however, that little is left of the original paintings, particularly where the walls are concerned, and that most of the decoration in its present state consists of 11th- to 13th-century restorations.[39]

A date in the 10th century for the ceiling is supported by the occurrence of a related programme in the crypt of the church at Ternand (fig. 66).[40] Here, too, we find a quaternity scheme on the vault, with an accentuating of the principal axis, on which Christ and Mary/Ecclesia, like Christ and Michael in St. Michel, are oriented towards differently positioned observers.[41] Once again the dates put forward range very widely from the 9th to the 11th/12th

centuries. Deschamps/Thibout assign a date in the late-Carolingian period, which seems reasonable.

Another programme resembling the one at Civate is found in the onetime Benedictine abbey church of Notre Dame at St. Chef (Dauphiné). On the north side of the transept there is a tower-like structure containing, below, the Chapelle St. Clément and, above it, the Chapelle St. Michel (fig. 67). The two are connected with each other by a spiral staircase in the wall, and both have arcades on their south sides opening onto the nave. Again there is disagreement about when the decoration was applied (11th to 12th centuries). But a date close to the middle of the 11th century, when the church was restored, seems not improbable.

There are strong indications that the programme of both chapels has to be considered as one single whole. In both the Majestas Domini is depicted in the east apse, but the representation in the lower chapel is accompanied by only two of the four evangelist's symbols, the lion and the bull, the two complementary symbols, namely the angel and the eagle, being found in the upperchapel, accompanying the Majestas. Various other elements in the programme of the lower chapel also serve to indicate that this has to be regarded as a preparation for the upper chapel. This programme starts with annunciation scenes: in the lunette in the west (entrance) wall is the angel informing Zacharias of the birth of a son, and on the two sides of the window in the north wall we have the annunciation to Mary, with the dove in a segment of heaven above the window. On the arch of the window we find God the Father handing scrolls to figures on either side of Him (Moses and Elijah?). The window of the east apse contains 2 martyrs and the inscription: 'contemnantes aulam regiam pervenerunt ad celestia regna', which holds out the promise of finally achieving heavenly bliss. Lastly, the vault itself contains a medallion with the dove of the Holy Ghost and the inscription: 'Spiritus Domini replevit orbem terrarum et hoc quod continet omnia . . .'. Round this medallion is a garden quaternity with personifications of the 4 rivers of Paradise, each standing on three chalice-shaped flowers which they are watering. Since in visions of Heaven and Hell, for example, the garden of Paradise with the 4 rivers is usually rated a degree lower than the City Paradise, this may also be preparatory in intention.

The programme is continued in the upper chapel with the depiction of the 'celestia regia' announced by the inscription accompanying the martyrs. Along the walls we see portrayed the various ranks of the Ecclesia: knights, clerks, monks, prophets, and finally the apostles, the 4 evangelists and angels. The archangels Michael, Gabriel, Raphael, and also St. George, to whom the altar in the upper chapel was dedicated, are found on either side of the window in the east apse, below the Majestas Domini. The programme of the upper chapel culminates in the vault containing the heavenly vision, reproduced by means of a quaternity composition (fig. 67).[42] Here we see in the western segment, the gatehouse of the Heavenly City (in the usual form of the

medieval city-pictogram);[43] the walls each have three crenels (4 × 3 = 12) and the towers at the corners are guarded by 2 angels, while the Lamb is in the centre. The motif of the souls 'in bono' looking down is once again present. Two nimbed figures (the souls of the martyrs in the lower chapel?)[44] are being conveyed by angels to the gatehouse,[45] and on the extreme right, still expectant and somewhat chilly, are two little naked souls towards which one of the angels is pointing (founders?). In the eastern segment we see Mary, with hands uplifted in prayer, pictured between angels. The other segments of the vault are filled with the heavenly host of angels (one of whom has a scroll with the inscription: 'Gratias agimus tibi, Domine', while two seraphim are provided with the inscriptions: 'SCS.SCS.SCS.DNS DS SA(bao)T(h)' and 'Pleni ... S(unt) T(er)RA').

Finally, at the centre of the scheme and serving as culmination of the whole programme, we see Christ enthroned and in mandorla, with his raised hands displaying their wounds, and in his lap a book with the inscription 'Pax vobis ego sum'.[46]

It has been suggested that the upper chapel was used for admitting novices,[47] but there is nothing to confirm this. More probably, as in Civate, we are dealing with a personal programme of an eschatological nature. The chapel may commemorate the two martyrs depicted in the lower chapel dedicated to St. Clément. The suggestion has also been put forward that the figure in the narrow zone on the wall of the east apse of the upper chapel, who is raising his eyes to Christ, could represent the founder himself. The interpretation offered by Cahansky (who nevertheless denies the connexion between the programmes of the lower and upper chapels — wrongly, it seems to me) that we have to do with an angel's chapel and a choir gallery, would fit in with this. The combination of memorial chapel and choir gallery in an upper chapel occurs elsewhere as well.

A comparison of the idea underlying this programme with what we find at St. Michel, and even more at Civate, brings out certain clear points of similarity: for example the relatively enclosed nature of the areas involved, and the fact that the programme, instead of being didactic, is one in which the 'ascent of the soul' is emphasized by the gradual intensification of the degrees of blessedness until the 'ultima visio' is reached in the form of the Heavenly Jerusalem, reproduced as a city quaternity.

Comparison of Civate with the abovementioned French examples shows — insofar as the vagueness of the dating permits — that the idea of the 'ascent of the soul' inherent to these programmes may have been depicted earlier and more frequently in France than in Italy. But in Civate a more consistent use has been made of the interpretation according to the 4 'sensus', e.g. by the addition of the 4 cardinal virtues in the city quaternity of the Heavenly Jerusalem.

Insofar as the surviving monuments allow us to draw any conclusions at all, related programmes only make their appearance a hundred years later,

mainly in Southern Germany and Austria, and again for the most part in a Benedictine milieu. Ever since the Ottonian period the miniature art of Regensburg had shown a preference for summarizing complicated theological material by means of visual exegetic quaternity and circle compositions. There may have been a Carolingian influence at work here, the impetus having been possibly provided by the study of Carolingian MSS., for example during the restoration of the Codex Aureus of St. Emmeram. This may have been further stimulated by the increased influence of neoplatonic ideas round about the middle of the 11th century, stemming from a renewed interest in the writings of pseudo-Dionysius Aeropagita together with the disputed possession of the body of St. Dionysius by the Abbey of St. Emmeram.[48] This could have brought about a renewed interest in the possibilities and powers of the image as an introduction to higher reality and thus in the visual exegetic method.

Although little has survived, there are indications that the Benedictine monastery of St. Emmeram may have had an important contribution to make in this respect. Unfortunately all we now have of the ceiling of the abbey church of St. Emmeram, which must have provided a classic example of visual exegesis by means of a composition comprising circles and squares with a quadripartite division, are details of the programme derived from tituli surviving from the 16th and 17th centuries. These details do, however, make it possible to arrive at a reconstruction (fig. 68).[49] The tituli give an idea of the ceiling as it must have appeared after the great fire of 1166. Whether this, in its turn, still incorporated anything of an earlier ceiling, presented by Emperor Henry II in 1052, and about which nothing more is known,[50] is a question which cannot be answered with any cetrainty. But in view of the fact that such circle compositions are known to have existed at least as early as the Ottonian period, a positive answer is by no means precluded.

The programme, which ran from west to east, was divided into three cycles: 'ante legem, sub lege, sub gratia'. The west choir, which formed, as it were, the entrance hall to the whole area designated for decoration, contained the stages preparatory to salvation — a quaternity composition with the 'antiquus dierum' between the 4 beasts of the vision in Daniel 7:22, which represented the 4 terrestrial kingdoms of the Chaldaeans, Persians and Medes, Macedonians and Greeks, and Romans.[51] It is noteworthy that the ceiling decoration above the west choir — executed after the fire of 1624 — still contains a quaternity composition, which gives rise to the question whether here, too, something of the earlier scheme might not have survived. The first cycle is completed by representations of the ark of the covenant and prophets in nine compartments (partially preserved) on the arch dividing the west choir from the west transept.

In the west transept itself the decoration continued with Christ's work of redemption in historical and typological scenes in 10 circles, while finally, above the nave, also in a system of circles, was the fulfilment of the work of

redemption in historical and typological scenes, together with the 'status ecclesiae Christi' and the 'curia pacis', the Heavenly Jerusalem. The apse contained the Majestas Domini between the 4 symbols of the evangelists.

One striking feature is the mention of a large quaternity composition: 'magnus quadrangulus circulus' with a 'spera, quae est in medio corporis crucis', with semicircles at the four ends of the cross and smaller circles in the four corners of the ceiling. Both this composition with circles and semicircles and some of the scenes mentioned in the tituli — the 'duae molentes', the 'Christ in the winepress', and the Leviathan — are reminiscent of compositions and themes in use in the Meuse area, Nothern France and Alsace at this time.[52]

The documents also mention a chandelier hanging from this large circle. It, too, must be regarded as an image of the Heavenly Jerusalem descending from the heavens, as part of the 'sub gratia' programme.[53]

One or two examples of the use of a city quaternity as visual exegetic scheme in church decoration have also survived in the Regensburg milieu, for example in the Benedictine monastery church of Prüfening (figs. 69a-c).[54] Here only part of the originally very elaborate programme has come down to us. These surviving fragments are in the three apses on the east side: the main choir, the so-called George's choir, and in the subsidiary choirs, the St. John and St. Benedict choirs.

Only the two side apses have remained unaffected by restoration, the paintings in the central apse having been completely reconstructed at the end of the 19th century. The original decoration came into being round about the middle of the 12th century, under Abbot Erbo I (1127-62), who had earlier been at St. George in the Scharzwald and before that at Admont. Endres holds the view that the Prüfening programme is entirely based on the sermon by Honorius Augustodunensis entitled *De omnibus sanctis* (*PL* 172, c. 1013 ff.), but this is a large claim to make when so little of the decoration has survived. From what has come down to us it is evident that use was made of a number of ideas occurring fairly widely in exegesis, and admittedly also in the work of Honorius, and that these were arranged in a visual exegetic programme which also incorporated the well-known scheme of the city quaternity.

The apse of the main choir depicts Christ and the apostles, while the vault contains an architectonic scheme with a clear quadripartite division in which the four corners are accentuated by tower-like constructions bearing the symbols of the 4 evangelists. At the centre of this scheme of the House of Heaven or the Heavenly City, is a large medallion encircled by the marginal text: 'Virtutum gemmis prelucens Virgo Perennis Sponsi juncta thoro Sponso conregnat in evo', within which the Ecclesia Imperatrix is enthroned. The latter, we learn from the inscription, is both Mary = Virgo perennis and Sponsa Dei,[55] with banner and disc, the attributes of Ecclesia. The virtues mentioned in the inscription — continentia, mansuetudo, fides, caritas — have been painted on the inside of the triumphal arch. These virtues are considered

to be ornaments both of Ecclesia herself and of her members: the prophets (left: 'prophetarum laudabilis numerus''), martyrs (right: 'te martirum candidatus laudat exercitus'), and confessors, whose figures are depicted on the side walls of the choir. In addition they must have applied to the spiritual ruler, Bishop Otto of Bamberg (d. 1139), who founded the monastery, and the worldly ruler, Emperor Henry V, whose figures are depicted in the bottom zone of the side walls, on the right and the left respectively.[56] These virtues provide, alongside the allegorical interpretation (Ecclesia) and the anagogical interpretation ('conregnare in evo'), the tropological exegesis of this part of the programme. The scrolls which the martyrs and confessors in the two upper zones of the side walls are holding in their hands, and which form a continuous horizontal line, originally contained the words of the Ambrosian hymn (fig. 69a).

The large part played by informative and supplementary inscriptions in the composition is characteristic of all works from the Regensburg milieu from the 11th century onwards.[57] The most extreme example is the Allerheiligenkapelle at Regensburg, still to be discussed, where the inscriptions seem to spread out like a spider's web over the walls of the whole chapel, leading the eye on and binding the various elements of the programme together (figs. 71a-b).

In the subsidiary choirs at Prüfening the vision of the Lamb in the Heavenly City is depicted twice as a city quaternity, a duplication for which no satisfactory answer can be provided. That the shape (rectangular or round) of the traditional scheme of the cosmic Heavenly City used here was anything but rigidly established, is evident from the fact that in the St. John choir (left) the Lamb is depicted in a square Heavenly City with towers at the corners and gates in the middle of the walls (fig. 69b), while the Lamb in de St. Benedict choir (right) is at the centre of a circular Heavenly City with 3 gates in each segment of the circular wall and 3 apostles above each set of gates (fig. 69c).

In both cases there is a marked stress on the anagogical exegesis, which may be connected with and intended as a culmination to the history of the patron saints of these subsidiary choirs, whose history had been illustrated on their walls.

About 40 years later the following scenes were added to the piers of the crossing:

NE: St. Peter as vicar of Christ, SE: 3 prophets.
conferring the highest
terrestrial power on Pope and
Emperor.

NW: 3 female saints bearing lily- SW: Annunciation (?).
sceptres.

However, we cannot say for certain whether these 4 scenes had any connexion with each other, or what their relation was to the programme as a whole.[58]

Of a somewhat similar nature to the Prüfening city quaternity is a representation of the Lamb in the Heavenly City in St. Leonhard (once a church belonging to the Knights of St. John) at Regensburg. Karlinger dated the remains of this programme — which has been very badly damaged by restoration — at c. 1155. On the vault of the central bay of the room on the upper storey of the western gallery, there was a city quaternity with a circular crenellated wall pierced in each segment by three gates surmounted by busts of angels (cf. Prüfening) and culminating in the 'ultima visio' of the Lamb of God with the banner of the cross in the central medallion.[59]

Dating from roughly the same time or a little later is the decoration of the Allerheiligenkapelle at Regensburg, a small building with a centralized lay-out and an octagonal dome supported by squinches, probably founded orig-inally as a funerary chapel for Bishop Hartwig II, Count Ortenburg (1155-64). The programme in this chapel, although culminating not in a city quaternity but in a 'rota' scheme with Christ Pantocrator, surrounded by 8 radially placed angels, is so closely related to the eschatological programmes we have been discussing, in which expression is given to the 'ascent of the soul', that it calls for discussion here. Unlike the related western programmes with their strict schematic arrangement, we here find a marked byzantine influence in the use of a radiating composition in the dome, but in other respects the arrangement of the programme, and the fact that the whole area is activated by means of a system of explanatory inscriptions — a typical product of the learned milieu found at Regensburg in the 12th century — makes a total western impression (figs. 71a-b).

The theme is the beginning of the Last Judgement (based on the Office of All Saints). The principal figure is the Angel of Judgement, standing on the sun-symbol in the east apse. From here scrolls with inscriptions go out to the 2 × 2 angels in the east and west squinches of the dome, who, as the 'quatuor angeli stantes super quatuor angulos terrae' (Rev. 7:1) give a cosmic definition to the representation and form the recipients, via the inscriptions, of the Angel's comment: 'Nolite nocere terrae et mari neque arboribus' (Rev. 7:3).

The programme has to be read starting from the walls above the socle zone (with a drapery motif), where 8 ecclesiastical (north side) and 8 secular (south side) figures are linked by horizontal scrolls. Continuing upwards, we find beside and above the windows the figures of saints who are being raised up by their hands (a 'raptus' motif, which can indicate both physical and spiritual 'exaltation').[60] Next, in the arch of the east apse, we have the sealing of the 12 tribes of Israel (Rev. 7:4-8). In the dome we find, repeated 8 times, fides, spes and caritas pointing upward and forming, by means of this gesture, the link between the lower zone and the centre of the dome, where 8 angels are ranged round Christ. The following multiple exegesis of the programme is possible:

allegory: the spiritual and the secular kindom of Christ on earth, the Church suffering — cf. also the scenes of St. Lawrence's martyrdom — militant and triumphant, the 12 sealed tribes representing the O.T. prototype.

tropology: the doves (7 gifts of the Holy Ghost) in medallions above the windows of the dome; the virtues of fides, spes and caritas repeated 8 times between the windows.

anagoge: the 24 elders in adoration and the 'rota' of Christ with 8 angels.[61]

The programme is adapted to the function of the chapel — namely the provision of a suitable place for the dead bishop to lie in state and for the funeral rites to be performed — and its elements are all positive, there being no negative references to the Last Judgement (neither the damned nor the punishments of hell are present). The dead bishop lying in state hopes to enter into the company of the saints and the elect. Demus cells it: 'eine beschwörende Verbildlichung der Hoffnung auf Erlösung". Once again we seem to be dealing with an instance in which the dead person, by his actual presence, plays a part in the programme, the latter having been determined in this case by the text of the liturgy of the All Saints Mass.[62]

The supplementary rôle which the dead could play in a programme is still more clearly illustrated by the so-called Karner, the cemetery chapel at Perschen near Nabburg (Oberpfalz). The paintings in this chapel, with its circular ground-plan and dome, have been dated in the 3rd quarter of the 12th century (fig. 72). Like the Allerheiligenkapelle at Regensburg, the composition on the dome reflects a certain amount of influence from the byzantine radiating system, but again the treatment is thoroughly western.
The decoration is buit up of five zones. The lowest is, as in Regensburg, ornamented with a drapery motif. In the next we find saints standing, above which is a mandorla with Christ enthroned upon a rainbow and surrounded by the 4 symbols of the evangelists. This mandorla connects the two uppermost zones, which contain, under arcades, the 12 apostles, and above them 5 wise virgins and 5 angels. Finally, at the top of the vault is a female figure with a lily-sceptre bearing three flowers, which in the light of the remains of an inscription 'Nato Facta Perennis' very probably represents Mary — Ecclesia — Virgo Perennis. This Ecclesia figure is located exactly above the round opening in the floor of the chapel, and is thus oriented on the corpse lying in state in the mortuary on the lower floor. This dead person thus, by his actual presence, plays a part in the programme, which in this case is based on the liturgy of the Mass for the Dead, the 'orationes' of which were originally inscribed on the scrolls.[63] The importance attached to the inscriptions — now largely obliterated — if not so far-reaching as in the Allerheiligenkapelle, where the scrolls serve both to accentuate the architecture and direct the programme, could point to connexions with Regensburg. Although in this case no individual patron was involved and the programme as a whole is simpler, this is certainly

not illustrative or didactic art aimed solely at the layman.[64] Here, too, the contents of the programme, leading from the terrestrial zone via the community of the saints in the lower zone to the heavenly Ecclesia in the upper zone, express the hope of ultimate admission to heavenly bliss.

This imaging of the soul's elevation to higher spheres would also seem to lie at the heart of the programme connecting the lower and upper churches in Schwarzrheindorf.[65] Founded by the Archbishop of Cologne, Count Arnold von Wied, this building was consecrated in 1151, in the presence of Conrad II and numerous dignitaries. It is not known whether the founder originally intended the church, which was designed from the start as a two-storeyed church with a ground-plan in the form of a four-armed cross, to serve also as a funerary church. At all events it was there that he was buried after his sudden death in 1156. Various parallels exist to this particular form of funerary church, in which a tomb in the lower church is placed centrally under the opening forming the connexion with the upper church; one instance is the Ulrichskapelle at Goslar. Before he died Arnold had made over the church to his sister Hedwig, who in the years that followed had extensions added to the west side for the benefit of a planned Benedictine nunnery.

The paintings in the lower church were made while Arnold was still alive, being possibly completed by 1151; those in the upper church must date from after the extension. It seems very likely, however, that the programme for both the lower and the upper churches had been designed as one whole, but it may not have been completed until later (c. 1170/75). Arnold von Wied, Conrad III's chancellor, (although not unlettered: we know that he studied at Liège, and even that he collected manuscripts and books) was more of a politician than a scholar. The chances are, therefore, that he turned to others for the design of the ambitious programme in his church. In this connexion the name has been suggested of Otto von Freising, who was present at the consecration in 1151 and who himself consecrated the altar of the upper church. But comparison with Otto's own writings, and especially with his *Chronicon,* fails to provide more than partial support for this hypothesis. There is perhaps a better case to be made out for Wibald of Stavelot, who was also at the consecration in 1151 and was in regular correspondence with both Arnold and his sister, and who moreover is thought to have possibly studied together with Arnold at Liège. This learned Abbot of Stavelot was responsible for the programmes of various works executed by artists from the Meuse area — for example the Remaclus retable, which survives only as a drawing —, so he certainly had experience of this kind of material.[66]

The programme of Schwarzrheindorf is dominated by the idea of the destruction of the old Jerusalem and the founding of the new, taken from Ezekiel 's vision (fig. 73). Here, again, we are confronted with a highly specialized programme, one that was certainly directed not at laymen but at theologically trained initiates, as the frequent use of explanatory texts in Latin

underlines. The large representation of the vision of the prophet Ezekiel on the vault of the lower church finds its New Testament fulfilment in the 4 christological representations in the arms of the cross, which are oriented to the 4 cardinal points. The scene in the west, depicting Christ driving the money-changers from the temple, faces the Majestas Domini in the east apse; the crucifixion in the north is placed over against the transfiguration in the south. The four kings seated in the niches may represent the 4 kingdoms of the world present in the vision of Daniel.

The way in which the vision of Ezekiel has been interpreted could derive from Rupert of Deutz, for example from his *De Trinitate*, finished at Siegburg in 1117, in which he interprets the book of Ezekiel as a prefiguration of the life and teaching of Christ, and provides each of the prophet's visions with an explanation in terms of the Gospel and apostolic history. The central motif in Rupert's exegesis — the building of the new Jerusalem on the ruins of the old, symbolizing the establishing of a new kingdom of God after the destruction of the old, in a new plan of salvation — agrees broadly with the programme of Schwarzrheindorf.

Abbot Wibald of Stavelot was a pupil of Rupert's at Liège, so it is possible that he advised using the latter's Ezekiel exegesis as the starting-point of a programme which could offer both religious and political aspects, and would thus be appropriate as decoration for a church commemorating the chancellor to the German Emperor.[67]

In this programme, dedicated to the ascent from the old to the new Jerusalem, a part may have been played by the positioning of the founder's tomb (now missing) in the centre of the lower church. It is even possible that the programme in the upper church has to be interpreted from this standpoint.

In the east apse of the upper church we find, above a zone containing 10 saints, a large mandorla with Christ enthroned between the 4 symbols of the evangelists and being adored by Arnold and Hedwig, who are stretched out at Christ's feet. In the vault a medallion portraying the Lamb with the banner of the cross forms the centrepoint of a quaternity, the four compartments of which contain Christ and Mary / Ecclesia in the choir of the blessed, apostles, martyrs and confessors.[68] It is possible that the whole programme of the upper church was originally designed to culminate in the vault over the open octagon, thus directly over the tomb. This vault is now empty (after suffering war damage at the end of the 16th century the church appears to have remained roofless until 1605). It may once have contained a representation of the Heavenly City of Jerusalem, since architectonic elements and quadripartite divisions play a part elsewhere in the programme. But there is not sufficient evidence to base this hypothesis on, and the question will have to remain open for the time being.

City quaternities continue to appear until well into the 13th century, as part of late-Romanesque programmes in Germany and Austria.

A particularly good example has survived in the Nikolauskirche at Matrei (Eastern Tirol; figs. 74a-c), dating from c. 1250.[69] In the choir, which has two storeys connected on either side by staircases, the lower and upper rooms are linked by a single programme devoted to, respectively, the Creation and Fall, and the propagation of the Gospel and salvation, culminating in the 'ultima visio' portrayed by means of a city quaternity. The two spaces complement each other, as is also the case in St. Chef.

The vault of the lower choir contains a representation of the terrestrial realm, following the scheme of a garden quaternity formed by the 4 rivers of Paradise and containing four scenes from Genesis in the segments: the creation of Adam and Eve, the Fall, the expulsion from Paradise, and Adam and Eve at their labours. The occurrence of arcades in the representations of the Fall and the Expulsion shows that the scenes must have been adapted from another context (posibly miniatures, or modelbooks).[70] The triumphal arch bears a representation of the Lamb between two archangels. On the walls of the lower chapel fragments survive of angels, trees and flowers, and also of a number of scenes possibly taken from the life of St. Nicholas, the patron saint of the church. Various elements suggest that the lower choir ought to be seen as an 'anteroom' to the joys of heaven. The connexion between the lower and the upper spheres is made by means of the − here remarkably appropriate − motif of Jacob's ladder painted on the inner side of the triumphal arch of the upper choir. At the start of the arch, to left and right, are portrayed the dream of Jacob and the anointing of the stone, while on each side 2 angels rise upwards to the figure of Christ at the top, Who with outspread arms holds the topmost rungs of the ladder.[71]

The decoration in the upper choir is made up of four zones (fig. 74b). It has to be read starting from the lower zone with its drapery motif, via a zone running round the north, east, and south walls and containing 3 × 7 figures of saints, bishops, deacons, etc., in a rectangular frame, up to the zone on both sides of the windows, which contains prophets with scrolls. The decor suggestive of a garden, with plants and large-leaved trees, probably implies that these figures, too, are to be imagined as in an 'anteroom' to the heavenly regions − visualized as a garden −, a familiar motif in medieval visions of Heaven and Hell. In the spandrels of the vault stand the 4 elements, represented as naked figures bearing their attributes in their raised hands. They form a cosmic quaternity which finds its counterpart in the vault above, where we find portrayed a city quaternity, surrounded by a wall richly ornamented with precious stones and broken by 4 × 3 gates, above each set of which are 3 apostles under arcades resembling baldaquins. At the 4 corners are towers bearing the symbols of the 4 evangelists, which in their turn support, in Atlas posture, a round medallion in which Christ is enthroned (fig. 74c).

Whereas the lower choir is entirely devoted to the earthly paradise, the upper choir portrays the joys of heaven (reachable via Jacob's ladder), analogous to

visions of Heaven and Hell, again with a gradual ascent from the paradisal garden to the 'ultima visio', a duplication of the paradisal scene which we also find in some visions of Heaven and Hell.

The bishop's chapel in the west gallery of the cathedral at Gurk, dated c. 1260/70, provides a horizontal variant of the programme at Matrei, but much more richly and elaborately decorated (figs. 75a-b).[72] Here, too, the programme includes both the earthly paradise as a garden quaternity and the Heavenly Paradise as a city quaternity, and again the connexion is formed by the Jacob's ladder on the arch between the two bays of the chapel. This time, however, the movement is not vertical but horizontal. The programme unfolds from east to west, and, since the entrance is at the west, is thus obviously not designed for people entering the chapel but for those already inside the building.[73] The scenes to the east allude to the anticipation and prefiguration of redemption; those to the west prefigure triumph and fulfilment. In the southern lunette is portrayed the annunciation to St. Anne, and in the northern lunette the annunciation to Mary. The east wall contains an exceptionally richly elaborated representation of Solomon's throne: 'Ecce Thron. Magni Fulgescit Regis et Agni'.[74] In the vault is the garden quaternity of the terrestrial paradise, the four segments of which display:

east: Adam being led into Paradise

south: God talking with Adam and Eve

west: the Fall

north: the expulsion from Paradise (no longer extant).

As in Matrei the diagonals of the quaternity are formed by the 4 rivers of Paradise, which flow from vessels held by 4 crouching figures in a medallion at the top of the vault. Again as in Matrei, the 4 elements are standing in the spandrels (now as winged figures with attributes in their hands),[75] this time together with the 4 evangelists. The Jacob's ladder on the arch dividing the eastern from the western bay is interpreted as the 'porta coeli', which is reasonable enough, but nevertheless somewhat forced as an explanation due to the fact that the interconnected areas lie one behind the other and not above and below each other.

In the western bay and facing each other in the lunettes of the south and north walls we find the triumphal journey of the three Magi and the triumphal entry of Christ into Jerusalem. Of the male saints in medallions on the north wall and the female saints on the south wall, little survives. The west wall shows a representation of the transfiguration. This has been created in such a way that the light from the windows plays its part in the representation.[76]

In the vault we find the 'ultima visio' of the Heavenly Jerusalem reproduced by means of a circular city quaternity, the diagonal divisions of which are formed by the 4 corner towers surmounted by the 4 symbols of the evangelists.

The walls, which are set with precious stones, are broken in each segment by a gatehouse with 3 gates, each time surmounted by 3 apostles[77] flanked by angels. The prophets in the spandrels make reference by means of inscriptions to the city seen as in a vision and to its circular form, and also to the 'porta civitatis', which could support the interpretation of Jacob's ladder as 'porta coeli'.[78]

In the decoration of the Karner in Pisweg (Carinthia), which is allied to that of Gurk, the motif of the Jacob's ladder with angels going up and down is worked into the diagonals of the quaternity. Here the garden and city quaternities have been combined with the Jacob's ladder and the throne of Solomon in one single scheme. The 4 compartments contain the following scenes: God speaking to Adam and Eve in Paradise, the Fall, Expulsion, throne of Solomon.
The angels on the Jacob's ladder lead to the medallion with the Lamb in the centre of the quaternity (fig. 76).[79]

In Matrei, and also in Gurk, the city quaternity still forms an integral part of a late-Romanesque decoration programme, the iconography of which has been modernised here and there. This is possibly due to the somewhat remote nature of these sites, as a result of which new architectural developments, which were of far-reaching importance for monumental painting, could take a long time to arrive.

The same may well hold for the occurrence of the city quaternity in the programme of the presbytery of the chapel of the Knights of St. John in Taufers (Tubre), dated c. 1200/20 (fig. 77). The south wall contains a representation of Moses giving the Law and a row of busts of prophets, together with an elaborate depiction of the baptism of Christ. The paintings on the north wall have gone, with the exception of a large St. Christopher. The east wall contains a fragment of a transfiguration.[80] The vault provided a picture of heaven, inspired by the city quaternity. The diagonal divisions are formed by crowds of half-length figures: saints, bishops, abbots, martyrs, holy virgins — which possibly ought to be interpreted as building-stones of the city. In the centre under a triple arcade, is the Deesis. The segments of the quaternity contain church fathers (of the western and eastern churches) seated on thrones and writing; they are on both sides of a lectern on which the 4 symbols of the evangelists are resting. The quaternity is supported by 4 Atlas-figures. The various components, familiar to us from other representations of the city quaternity — Atlas-figures, evangelists, church fathers, architectural details — have been combined here with a Deesis, which may have been chosen because of the part played by the church's patron saint, John, in this scene.[81]

The argument of a relatively remote setting, suggested as a possible explanation of the somewhat archaic nature of the programmes in the monuments discussed above, is certainly not applicable to the decoration of the church of

St. Blasius (now a cathedral) at Brunswick, where the city quaternity forms part of a very extensive programme displaying a number of later features (figs. 78a-b). One possibility is that the city quaternity, which here appears to be simply an anachronistic detail, found its way into the programme via the model books of an atelier active in Brunswick during the third or fourth decade of the 13th century.[82] Another possibility is that this scheme preserves traits of the original decoration of the building, which was founded as a funerary church by Henry the Lion in 1173. Although there is no convincing proof of this hypothesis, the fact that city quaternities frequently occur in the programmes of funerary or memorial churches could point in this direction.[83] But nothing is known of any late-12th-century decoration from the time of Henry the Lion or immediately after his death, except for the stained glass windows — decorated with figures of saints — now in the museum at Brunswick. These, which can be dated c. 1190, may also have come from the church of St. Blasius. The chronicles have little to tell us. Henry is mentioned in 1173 as the donor of works of art to the church and glass windows to the monastery, and again in 1194, when there is a reference to the gift of a floor, and also to the gift of paraments and relics in costly settings after Henry's return from the Holy Land. On the other hand it is difficult to explain how such an important building could have had to wait 50 years for its decoration.

Another matter which is not quite clear is the extent of the fire which broke out a few days before Henry's death (1195), and how far advanced the building was at that moment.

An argument in favour of the hypothesis of an already existing decoration scheme is the fact that Henry the Lion was praised as 'novus Salomo', and that the church of St. Blasius was called 'Novum Templum'.

A programme for this 'Novum Templum' could have been based on a comparison between the earthly and the heavenly temples, the earthly and the Heavenly Jerusalem. Such a programme could include both the 7-branched candelabrum, which is now in the choir of the church and was possibly intended for the tomb of Henry and Mathilde, and the extremely elaborate representation of the tree of Jesse in the vault of the choir (a comparison between candelabrum and tree of Jesse, via the comparison of the 7 flames to the 7 gifts of the Holy Ghost from the Isaiah text, is very common).[84] The city quaternity of the Heavenly Jerusalem in the vault of the crossing would also fit in with such a conception. If we add to all this the fact that the programme is an 'old-fashioned' one for the 2nd quarter of the 13th century, the surmise that we are dealing with an earlier decoration (possibly damaged by the fire) which has been 'modernized', would appear to be strengthened.

Despite the 19th-century restorations, which even after a recent thorough cleaning could no longer be eradicated, the representation over the crossing appears to be largely undamaged. The city quaternity forming a part of it has been used without much understanding of the original significance of the scheme, which could indicate the incorporation of an archaic element from a model book, or the adaption of an already existing decoration scheme.

The four compartments depict the following scenes: S: birth of Christ and his presentation in the Temple; W: angel and the Three Marys at the empty tomb; N: the journey to Emmaus and the meal at Emmaus; E: Pentecost.

The content of these representations appears to bear no clear relation[85] to the Heavenly Jerusalem, which is pictured as an encircling wall with 4 × 3 gates in which the 12 apostles are standing and with the Lamb of God with the banner of the cross at the top of the vault. The inscriptions with texts from the Creed which the apostles are holding, and the inscriptions of the 8 prophets, who are grouped two by two in the spandrels, do however bear a relation to the representation of the Heavenly City, a fact which could indicate that these figures belong to the (hypothetical) earlier design (fig. 78b).

In following through, with the aid of the examples discussed, the various ways in which the city quaternity was used in the decoration programmes found in churches, what emerges most clearly is its origin in the age-old cosmological tradition of the quadripartite cosmic building, whereas in the final versions of the city quaternity it has often become little more than an arbitrary scheme of ceiling decoration.

What has also become clear is that other cosmological school schemata were often grafted on to the scheme of the cosmic city, for example the scheme of the winds, the scheme of Annus and the seasons, and the 'mappa mundi'. The introduction of various elements such as the 4 rivers of Paradise, the 4 elements, as well as the 4 evangelists (or their symbols), the 4 virtues, etc., makes possible a fourfold exegesis of the scheme according to the 4 'sensus', based on the relation between the earthly and the heavenly Jerusalem.

It is striking that city quaternities often occur in the programmes of funerary churches or chapels which, like the idea of heavenly blessedness contained in various medieval visions of Heaven and Hell, often present an 'ascent of the soul' from garden paradise to city paradise and thence to the 'ultima visio' of heavenly bliss. The programme may follow either a vertical or a horizontal path, depending on whether the areas involved are superimposed one above the other or situated one behind the other.

CRUX QUADRIFARIA
AND CONCORDIA DISCORDANTIUM

The anthropomorphic quaternity which we now have to discuss incorporates, as did the garden and city quaternities, certain of the school schemata mentioned earlier in connexion with them, such as the schemata of the elements and qualities, the scheme of the winds, Annus and the seasons, the 'mappa mundi' and the macrocosm/microcosm scheme, with, in addition, variations on the tree and ladder schemes. The anthropomorphic scheme depicts Christ or a substitute figure (usually an Old Testament type such as Adam or David) in the syndesmos posture: the all-embracing gesture with hands outspread, by which harmony is established. By means of the syndesmos gesture, which can be interpreted here as cosmogonic gesture of creation 'in mensura et in numero et pondere', the harmony of the quartets is brought about: 4 rivers of Paradise, elements and their qualities, winds (in the system of 4 principal winds and secondary winds). As posture of the crucified Christ and sign of the crucifixion the syndesmos restores the balance destroyed by sin. The main text bearing on this is the following passage from St. Paul's Epistle to the Ephesians (3:18): 'ut possitis, comprehendere cum omnibus sanctis, quae sit latitudo, et longitudo, et sublimitas, et profundum . . .', which had already been interpreted by the earliest Christian exegetes in terms of the cross reaching out to all the points of the compass, and of Christ's power, by means of this cross (as syndesmos, vinculum), to bind the cosmos, hold it together and restore it.[1]

Finally, the syndesmos posture is also a gesture of 'recapitulatio', thought of in terms of both space and time: the assembling of the faithful both from the cardinal points and at the end of time. An influential factor in this connexion was the text and exegesis of Ephesians 1:10: 'in dispensatione plenitudinis temporum instaurare omnia in Christo, quae in caelis, et quae in terra sunt, in Ipso.'[2]

There are a number of possible variations on the anthropomorphic quaternity scheme, depending on which particular exegetical aspect is stressed. In the present discussion we shall deal with the following three variants: the syndesmos figure 1) embracing a sphere, 2) grafted on to a tree scheme, 3) as cosmic musical instrument.

Turning to the first group (the figure with a sphere or disc), we can discern

influences from various well-known 'rota' schemata, such as the scheme of elements and qualities and the scheme of the winds. There is a good example of the syndesmos figure with the elements scheme in the *Tractatus de quaternario* mentioned earlier, which is dated c. 1100. The elements and their associated qualities have been placed on an orthogonal cross. The text repeatedly mentions the 'concordia, armonia, symphonia' achievable if the proportions between elements and qualities are right, and this is elucidated by means of a visual exegetic harmony scheme.[3]

The same meaning can be attributed to the syndesmos figure with the scheme of the winds. Numerous texts make a comparison between the 4 extremities of the cross and the 4 cardinal points of the compass. Firmicus Maternus, for example, who died at some time after 360, was even at that early date stressing the capacity of the cross to sum up and give stability; and Jerome in his commentary on the Epistle to the Ephesians, declares that this comparison between the 4 points of the compass and the 4 ends of the cross can serve as means to elevate oneself 'de corporalibus . . . ad spiritualia'.[4]

An example of the syndesmos figure with the scheme of the winds in its arms can be found at the beginning of some MSS. of Petrus Pictaviensis, *Compendium historiae in genealogia Christi* (fig. 79), where it provides a visual exegesis of the crucifixion in terms of a cosmogonic gesture, signifying the maintenance of harmony and the 'recapitulatio' at the end of time.[5] Christ, standing on a pediment embraces the creation in syndesmos posture. The 4 principal winds (quatuor imperiales) are placed on an orthogonal cross. The 4 points of the compass are indicated by the names 'anatole, dysis, mesembria, arctus', the initial letters of which make up the name ADAM. The 4 × 2 secondary winds (8 ministeriales) are placed on a diagonal cross. The blowing of the winds resounds through the 5 zones of the world, as the marginal text informs us: 'flatibus. orbe tonant. hii quator imperiales: + : Horum quinque volant. sunt octo ministeriales.' In the centre is the 'mundus' circle with the inscription: 'Quatuor a quadro exsurgunt limine venti. Hos circum gemini dextra levaque iugantur atque bisseno circumstant flamine mundum.' The A and Ω on either side of the head of the syndesmos figure could be there to provide an exegesis of the syndesmos posture as 'recapitulatio' of the gesture of creation, at the end of time. In addition, the partial covering of the figure by the cosmic sphere enables expression to be given to the idea that the 'invisibilia Dei' can only be understood from the 'visibilia', from God's works, as Petrus Pictaviensis again says, this time in his *Sententiae:*

'(Quod Deus sit): invisibilia Dei a creatura mundi per ea que facta sunt intellecta conspiciuntur (ut ait Ambrosius . . .). Videns itaque homo hanc mundi machinam tam magnam et spatiosam a nulla alia posse fieri creatura, alium esse intellexit qui tam pulchrum et spatiosum opus fecit, et sic optime, ductu rationis firmissime Deum comprehendit.'[6]

The text subjoined to the scheme points out the pedagogical possibilities of the visual exegetic scheme for the 'studium sacrae lectionis'. By means of the 'figura' a mass of difficult material can be easily memorized to the reader's

benefit and pleasure '. . . quod et fastidientibus prolixitatem propter subiectam oculis formam animi sit oblectatio et a studiosis facile possint pro oculis habita memoriae commendari et omnibus legentibus utilitas conferri . . .'. We are dealing, therefore, with a pure form of visual exegesis: the miniature does not constitute a true illustration of the text which follows it (the prologue to a survey of biblical history in the form of a genealogy of Christ), but provides by way of introduction a brief pictorial summary of the period to be dealt with, from creation via crucifixion to 'recapitulatio' at the end of time, and simultaneously gives an insight into the part played by the cross and the crucifixion posture as a principle of harmony. This fits in perfectly with what we know of the teaching-methods employed by Petrus Pictaviensis, who used to hang up genealogical trees in the classroom, in which the material of the lesson was presented visually.[7]

Instead of the scheme of the winds, it may be the 'mappa mundi' or terrestrial globe that is being held by the syndesmos figure, or ruled by the syndesmos ideogram (a cross with, at the extremities, circles containing the head, hands and feet).

The adaption of the 'mappa mundi' to visual exegesis could go back to texts like the passage in Honorius Augustodunensis' *De inventione S. Crucis,* in which two different ways of explaining the world-embracing power of the cross are given.[8] The first concerns the reaching out of the arms of the cross to the four cardinal points and the 'signing', as it were, of the four parts of the world with the sign of the cross of Christ. The graphic translation of this interpretation is found in, for example, the Ebstorf map of the world, which reproduces in elaborate detail the extent of geographical knowledge at the time (c. 1235), with at the periphery, the syndesmos ideogram of head, hands and feet (fig. 80a).[9] In the continuation of Honorius' exegesis the cross is seen in spatial terms. The symbolical explanation given is that by means of the cross earthly things are restored and heavenly things renewed, the left and right extremities of the horizontal arm being interpreted as the Judgement directing the good to the right and the wicked to the left. This relationship between the syndesmos posture (the extending of the arms) and the Last Judgement is linked to the 'mappa mundi' in the map of the world of Richard Haldingham in Hereford Cathedral,[10] made c. 1290, at the top of which, in a triangular tympanon, is a representation of Christ syndesmos coming forth on the Day of Judgement with the blessed at his right hand and the damned at his left hand (fig. 80b).[11]

A syndesmos figure with a 'mappa mundi' in its arms and standing on two dragons occurs in an English psaltery in the British Museum, dating from c. 1200/50. The 'mappa mundi' is in the form of a T-map (Asia at the top, Europe left, Africa right) incorporating a written text. The posture of standing on two animals is not uncommon as a triumphal motif in christian art, and goes back to Psalm 90 (91):13 'super aspidem et basiliscum ambulabis, et conculcabis leonem et draconem'. This miniature (fol. 9v.) is found on the

back of a leaf containing a variant on the same formula, in which Christ is depicted with raised hands (the right in benediction the left bearing a disc = world) between adoring angels with censers above a circular 'mappa mundi'. This is again T-shaped, but Jerusalem is now in the centre, there are figurative indications of the various geographical particularities, and the whole is contained in a frame, in which we find the phases of the moon and the principal winds. Although this time Christ's feet have not been reproduced, the motif of standing on two beasts is hinted at. The two miniatures complement each other. It is possible that the leaf was incorrectly bound and that the miniature with the complete syndesmos figure (who has no cruciform nimbus here, unlike the one on fol. 9r.) was originally intended to come first. It is perhaps significant in this respect that the series of miniatures preceding it (folios 3v.-8r), which contain representations from the life of Christ, are also slightly out of order (figs. 81a-b).[12]

The syndesmos posture, as sign of the establishment of harmony in the cosmos and as sign of the cosmoscrator, can also be adopted by other figures regarded as harmonizing principles, for example Sapientia, Philosophia and Saturnus.[13] It can even be taken over by a secular ruler, as is shown by a 16th-century representation of Elizabeth Regina with the 'sphaera civitatis'.[14] An unique instance is provided by the MS. of Opicinus de Canistris, dating from c. 1320-40, in which highly personal use is made of the syndesmos scheme and the map of the world for incorporating all manner of theological, historical, geographical and autobiograhical facts.[15]

An important step in the evolution of the anthropomorphic quaternity into a complete visual exegetic scheme of explanation according to the 4 'sensus' of multiple exegesis, was the adaption of the harmony scheme of macrocosmos and microscosmos. This scheme — in which on analogy with the correct distribution of the 4 elements, 4 qualities and 4 principal winds in the macrocosmos, the harmony of the 'little cosmos', i.e. man, is reproduced by means of a quadripartite scheme — had extremely varied antecedents.[16] Influences can be traced from the stories found in many eastern creation myths which deal with a prehistoric man of gigantic proportions stretching out to the four corners of the world. He has also been interpreted as 'Adam Vetus', created from 4 pieces of earth taken from the different points of the compass, or as 'Adam Sparsus' stretched out to the points of the compass.[17] The interpretation of this old Adam as the type of Christ, the 'Adam Novus', lies at the basis of various anthropomorphic quaternity schemata for visual exegesis. A possible further influence on such schemes was the harmony scheme of the perfect man, the ancient proportional figure in a circle or square, of the type represented by the 'home circularis' and 'homo quadratus' in Vitruvius' *De architectura* III, 1.[18] The attraction of this last scheme was that it enabled a connexion to be made with the syndesmos posture of the crucified Christ.

An example of the adaption of the microcosm scheme to visual exegetic

ends, in combination with a scheme of the winds, is provided by a miniature in a late 12th-century collection of chronological and astronomical writings from Prüfening, now at Vienna. The leaf (fol. 29r.; fol. 30r. gives a scheme of elements)[19] is included in a discussion 'De planetis' (folios 26v.-30r.) in which the other astronomical diagrams are all non-figurative (fig. 82).

An exclusively orthogonal division into four has been applied in this case, with the 4 principal winds on the main axes, each of them accompanied by two secondary winds in the form of winged heads. The inscription gives their names and qualities. This system of winds rules the macrocosmos square, which is indicated by the 4 points of the compass, with, as in most medieval maps of the world, the east at the top.[20] The 4 elements are also distributed orthogonally, these being placed at the points where the macrocosmos square cuts the microcosmos diamond, in the following order: oriens-ignis, meridies-aqua, occidens-terra, septemtrio-aer.[21] The microcosmos figure is a 'homo quadratus' (the diagonals of the square into which he can be fitted cross at the navel). The incorporated text, which carefully defines by its arrangement the diamond round the microcosmos figure, links the 4 elements with the 4 Gospels, which were propagated by the 12 Apostles and their successors:

'. . . IIII elementa significant IIII evangelia quae per IIII partes mundi ad salvationem totius generis humani per XII apostolos et successores eorum episcopos et presbyteros praedicantur".

Only the 'homo exterior' is shown as a cosmic quaternity of the 4 elements: the quaternity of the 4 cardinal virtues of the 'homo interior' is lacking.[22] Mankind does, however, experience the beneficent influence of the 4 Gospels, disseminated to the 4 points of the compass by the system of 12 winds, which are compared with the 12 apostles.[23] The term 'ad salvationem' points forward to the future salvation which this will bring about.

Another MS. from Prüfening, dating from between 1158 and 1168, comprises a variety of texts (including the so-called *Glossarium Salomonis*). This MS., which is now at Munich (Clm. 13002), originally had, by way of introduction, a miniature of the microcosmos man (now fol. 7v.). Here again we find a quaternity scheme being used to express the relation between microcosmos and macrocosmos, or in other words the influence of the 4 elements and their qualities on the 5 senses of man (fig. 83). Within the encircled head, which is 'instar celestis sphere', the influence of the 7 planets on the 7 openings of the head (eyes, ears, mouth, nostrils) is pictured. The microcosmos representation is surrounded by a marginal text indicating the relationship between the elements, their qualities and the 5 senses. Each element is assigned 3 qualities. The 4 elements are placed in the corners of the scheme, with ignis and ear at the top and aqua and terra below. Bands bearing inscriptions lead from them to the microcosmos, where the relation with the 5 senses is established (hearing and smell are together assigned to 'aer', which in its turn is divided into 'aer superior' and 'aer inferior'). The relation between macrocosmos and microcosmos is worked out further in the following in-

scriptions: 'ut pedes molem corporis terra sustentat omnia' and 'os lapides', 'ungues arbores', 'dat gramina crines'; the breast and the belly are crossed by transverse bands carrying the inscriptions: 'Pectus aer in quo flatus et tussis ut in aere venti et tonitrua', 'Venter mare, in quo confluunt omnia ut in mare flumina'. Of the many inscriptions forming an integral part of the scheme and serving to guide the eye, some are taken word for word from Honorius Augustodunensis' *Elucidarium* (*PL* 172, 1116 B-C), 'De hominis formatione et quomodo sit parvus mundus: de substantia corporali.'[24]

Closely related to the above is the microcosmos scheme appearing on fol. 16v. of the *Hortus Deliciarum* by Herrad of Landsberg. The text of the *Hortus* includes a short tract, 'De substantia spirituali', which also goes back to Honorius' *Elucidarium*, and which provides the materials for the scheme, contained in a dialogue between a teacher and a pupil, as well as supplying the mnemotechnic verses found on the scrolls.[25]

Folio 16v., which contains the microcosmos scheme, originally preceded the representation of the creation of Adam. In addition there used to be another microcosmos figure, only known from a description, on fol. 255v., between the representation of Hell on fol. 255r. and the final symbolic scenes of the MS. (folios 258r.-263v.: Babylonian whore, Apocalyptic Woman, Abraham's bosom). This figure was standing on two allegorical monsters, and could be interpreted as signifying the regeneration of fallen man who had been afflicted by his vices (the beasts).[26]

If in the examples mentioned so far an exegetic element is conferred somewhat hesitatingly on a collection of cosmological data, a later adaption of the microcosmos scheme makes possible a highly elaborate and complete exegesis according to the 4 'sensus'. Two facing pages in a MS. of Thomas of Cantimpré's *De naturis rerum* at Munich,[27] dating from c. 1295, present us with two quaternity schemes, ruled by Adam Vetus and Christ respectively, and requiring to be read together (figs. 84a-b). The two miniatures must originally have been intended as an introduction to the first book, 'De partibus et membris corporis humani', and specifically as an elucidation of the prologue to that book, in which an explanation is given of how the world is held together by the fact that the elements which compose it are in the proper relationship to each other: 'Aliter enim machina mundialis stare non posset . . .'.[28] The scheme on fol. 104v. portraying the microcosmos man subjected to the influence of the planets, elements and seasons, goes back to earlier prototypes and to schemata with a central figure, such as that of Annus and the seasons. It is related to the scheme of Clm. 13002, and to that of the *Hortus*, with the 4 elements at the corners related to the 5 senses of man, and with the separately circled head influenced by the 7 planets. To this has been added the quaternity of the 4 seasons — ver, aestas, autumnus and hiems — taken from the Annus scheme. The two lighter elements, aer and ignis, are placed at the top. Aer is on the left, seated on an eagle (?) and holding in the right hand a sort of a four-petalled flower, and in the left the inscription: 'ex superiori aere

flatū'. On the right is ignis, seated on a lion and holding a dish containing fire in one hand, and in the other the inscription: 'ex aere inferiori calorem'.[29] Aer, ignis, ver and aestas form a separate quaternity, the midpoint of which is the head of Adam; the heavier elements of terra and aqua, and the darker seasons of autumnus and hiems, also form a quaternity, centering on Adam's feet and bearing the inscription: 'Ut pedes molē corporis sic terra sustinet omnia'. Over the breast runs a band connecting the circles of aer and aestas, and containing the inscription: 'in quo flatus, tussis, ut in aere venti et tonitruna', while the hands are connected by another band running over the belly and displaying the text: 'in quo liquores confluunt. ut in mare flumina'. Below left is terra suckling a centaur, with the inscriptions: 'Ex terra carnem' and 'Ex terra tactus'. On the right is aqua, seated on a fish, and carrying a fish in the right hand and the inscription 'Ex aqua sanguinem' in the left. The terrestrial zone, under the figure's feet, is still further differentiated, perhaps with the aim of making reference possible to the various subtitles of Thomas of Cantimpré's encyclopedia. The vegetation on the right, for example, with the inscriptions 'ex herbis et germinibus mollitiei veniunt' and 'ex holeribus ungues', could refer to the 12th book of *De natura rerum,* which bears the title 'De herbis aromaticis'. The rock on the left, with the inscription 'ex lapidibus duritiam ossium', may allude to the 14th book, 'De lapidibus . . .', while the tree-like plant under the feet of the figure could stand for books 11 and 12, 'De arboribus communibus' and 'De arboribus aromaticis & medicinalibus'. This could also explain the rather old-fashioned way of presenting the elements as mounted on beasts, since it made reference possible to the titles of some of the books: 5. 'De avibus', 4. 'De animalibus quadripedibus' and, in the case of aqua, to both 7. 'De piscibus' and 6. 'De monstris marinis', while the centaur of terra could allude to book 3. 'De monstruosis hominibus orientis'.[30] The marginal text summarizes once again the relation between the macrocosmos and the microcosmos, with the elements and humours: 'gustus et olfactus humor est et sanguinis usus. Ex terra carnem. tactum trahit et gravitatem. Aer huic donat quod flat sonat audit odorat. Ignis fervorem visum dat mobilitatem. Aeris. ignis. aquae. terrae. levitas gravitasque. Dum circum-venere (?) mycrocosmum constituere'. On the facing page appears the scheme of 'Adam Novus' as counterpart to the complicated harmony of the 'Adam Vetus' at the beginning of the creation. A system of circles and squares figures forth the rôle of Christ as 'vinculum mundi' holding the creation together. Here the syndesmos posture is open to various interpretations, for example as cosmogonic gesture or as the cross being, as it were, stamped on to the creation from the very beginning by way of anticipation; cf. the inscription round the central square: 'omnia de nichilo fecit manus omnipotentis mundum con-stituens in quator hiis elementis', and the marginal text to the large circle: 'Ut quadrua (sc. imagine) mentis et corporis elementis. / Vivus (?) ab eterno fuit in sermone superno. Archetypus mundus sensibilis iste fecundus. Est homo terrigena microcosmus ymagine plena'.

The syndesmos posture also forms, however, an allusion to the death on the cross of the 'Adam Novus', who restores the harmony disturbed by the fall of the 'Adam Vetus'.

The Christ syndesmos comprises the 'mundus' circle (= macrocosmos). Interwoven with this circle is a large square (with the names of the elements and their qualities as marginal text), in which the harmony brought about by the systems of the 4 principal winds, each with its two secondary winds, and by the 4 elements, is demonstrated. The winds are placed diagonally, whereas the elements — depicted as holding hands (the 'syzygiae elementorum'!) — are placed orthogonally. They support the central square containing 'celum' and the various spheres.[31] The large rectangle cut by this system of circles and squares provides, as counterpart to the material quaternity of the body, a spiritual quaternity with the four cardinal virtues in the corners. Above left is Prudentia, with a snake and the inscription: 'Provida sincera semper prudentia vera'. Above right is Justitia with her balance and 'Libram iusticie dat gracia sola sophye'. Below left is Fortitudo with a lion and the inscription: 'Mens superat fortis quecumque pericula mortis'; and below right is Temperantia with jug and basin and the text: 'Iusta maiorem bonum temperat ista rigorem'.[32]

The examples of anthropomorphic schemata mentioned above, which provide a visual exegesis of the all-embracing, harmonizing power of the cross, mainly use compositions built up of circles and squares, influenced as they are by such adapted schemata as the 'mappa mundi', the scheme of the harmonized winds, elements and qualities in the macrocosmos and the microcosmos. The adaption of other forms of cosmic harmony schemata, for example the tree or ladder schema, or the universal scheme in the form of a musical instrument — cithara or psaltery — led to other basic forms.

Various instances occur in the Bible of the cosmic tree at the centre of the world, which reaches out to the 4 corners of the universe and is so large that it connects the higher and the lower spheres as a 'scala coeli'. The 'lignum vitae', (Genesis 2:9) planted by God in the middle of Paradise belongs to this category.[33] The identification of this tree stretching out to the 4 corners of the world with the cross and the crucified Christ[34] — one which is already found in early exegetical works — finds its visual exegetic counterpart in an anthropomorphic tree scheme. The tree is usually represented as a cross with twining tendrils, the syndesmos posture being suggested by the ideogram of head, hands and feet at the extremities of the cross. This is a rich field for visual exegesis. It creates possibilities for representing, among other things, the unity of the Old and New Testaments, or the fulfilment of the Old Testament in the New, or the sign of the cross stamped on the creation from the very beginning — which cross also, as syndesmos or 'vinculum', holds together the 'machina mundi' — , or the assembling of the faithful from the 4 corners of the world at the end of time.

104

The tree scheme was not only regarded as depicting spatial harmony but also as representing the harmonious regulation of time. Due to the inherent association of trees with growth, this scheme, is also capable of accommodating the idea of universal history in visual terms — either in accordance with the periods 'ante legem, sub lege, sub gratia', or as the succession of ages or generations on earth, which permits the scheme to become a genealogical tree of the human race *en route* to its ultimate salvation.[35] Finally, the tree scheme can give shape to a particular hierarchy, for example of the various ranks within Ecclesia in terms of an ordered system, or on the basis of desert, as a result of which the tree becomes capable of anagogical exegesis as 'scala coeli'.[36]

The miniature on fol. 8v. (fig. 57d) of the *Laudes crucis* MS. discussed at length in Chapter III provides a very good example of visual exegesis making use of a tree scheme. The ideogram of the syndesmos posture — circles with head, hands and feet at the extremities of a cross — has here been grafted onto the tree of the cross which permeates the whole cosmos. The cosmos seen in terms of salvation is also explicitly meant here. The cross is not a barren piece of wood, but active, alive and putting forth shoots which roll themselves up into medallions containing figures which, according to the inscriptions, represent the various ranks of the Ecclesia in the course of time, both in the Old and in the New Testament. These figures are, from bottom to top: patriarchs, prophets, martyrs and apostles. At the point where the axes cross is a female figure, commonly interpreted as being Mary,[37] but which here also stands for Ecclesia since the beginning of time. This is the same Ecclesia as is pictured on fol. 1r. of the same MS., also with a budding cross, which she embraces in the syndesmos posture and which has an inscription alluding to the continuity of Ecclesia since the fall of Adam.[38]

The meaning of the tree scheme on fol. 8v. is elucidated by the inscription to left and right of the foot of the cross:

'figura praesens hoc pretendit, quod omnes sancti ab exordio mundi, usque adventus Christi in fide crucis pependerunt / crucifixum per figuras quasi ex parte videbant unde facies manus pedes apparent'.

The syndesmos ideogram is explained here as the partial revelation of Christ's death on the cross in the centuries before his arrival on earth.[39] The term 'pependerunt' has to be taken both literally, as hanging from the tree of the cross, like fruit, and in the sense of being dependent on a belief in a final redemption by means of the cross. A figure's position in the tree also indicates its ranking: Old Testament figures are at the bottom, and virgins, martyrs and apostles on successively higher steps.

The emphasis we find being laid, in this representation in the *Laudes crucis* MS. on the significance of the fact that the syndesmos figure is only partially visible, suggests that in the case of other visual exegetic anthropomorphic schemata as well, special importance ought to be attached to the partial

concealment of the figure. It seems plausible to imagine that interpretations were provided both in terms of the incomplete revelation of the power of the cross in Old Testament times and types, and in terms of the possibility of raising oneself from the incomplete 'visibilia' to the complete 'invisibilia Dei'.

The ideogram of the syndesmos posture employing circles with head, hands and feet, is found in a whole group of monuments, especially liturgical objects (a cross reliquary, a portable altar, a paten). In all of these part of the figure has been omitted, and an actual object (e.g. a fragment of the True Cross, or the eucharist) has to be imagined as supplementing the syndesmos ideogram; only then is the representation complete.[40]

The earliest example is a cross reliquary, dating from c. 1130 and probably of Southern German origin, in the treasury of the former abbey church at Zwiefalten (fig. 85). According to Ortlieb's chronicle of the monastery of Zwiefalten (which runs from 1135 to 1145, and incorporates information provided by Abbot Ulrich, 1095-1139, about the acquisition of relics), the fragment of the Cross contained in the reliquary was brought back from Jerusalem by Bertold von Sperberseck the Younger, and was mounted at the expense of Salome von Dettingen. The work is attributed to a goldsmith's workshop operating in St. Emmeram at Regensburg, which — in view of the Regensburg tradition with respect to visual exegetic works of art — is not improbable.[41]

The same method of using the syndesmos ideogram with the suggestion of an imaginary or actual complement (in this case the eucharist) is found in a portable altar (?) from the first half of the 14th century, in the castle chapel at Albrechtsberg a.d. Pillach, where it has been incorporated into a pillar. Round the edge runs an ornament made up of tendrils and rosettes; at the ends of the axes of an imaginary cross is the syndesmos ideogram of head, hands and feet; and at the corners are the symbols of the 4 evangelists. The field in the centre is empty (fig. 86).[42]

This idea of supplementing the syndesmos ideogram with an imaginary or actual element, prior to which it remains an incomplete representation, is also found in a number of Swedish silver patens from the 14th century, e.g. in a silver-gilt paten in the church at Vårdsberg (fig. 87). Here the syndesmos ideogram has been placed on the border, which is otherwise unadorned; in the centre of the dish is a quaternity scheme of the 4 symbols of the evangelists with, in the middle, Christ in an oval mandorla appearing at the Day of Judgement, seated on the rainbow and showing his wounds. This version is less pure than the others mentioned, since the central field has not been left empty.[43]

One group of late medieval representations display an ideogram related to that of the syndesmos, namely the 'quinque vulnera', containing, in the centre, the heart with the wound, and at the 4 corners, the pierced hands and feet. This representation, which has affiliations with the worship of the Sacred Heart, and which is particularly frequent in popular art, was propagated

mainly by means of woodcuts to which indulgences were attached (fig. 88).[44] This 'five-wounds' scheme also provides a good example of the survival of a visual exegetic scheme in religious emblems of a later date. For example, in Johannes David, S. J. *Paradisus Sponsi et Sponsae in quo messis myrrhae et aromatum ex instrumentis ac mysteriis passionis Christi colligenda . . .,* Antwerp, 1607 (fig. opposite p. 182), during the course of a discussion based on St. Bernard's 43rd sermon on the Song of Songs: 'Haec mea sublimior philosophia: scire Jesum et hunc crucifixum', there is a print showing the ideogram of the 'quinque vulnera' held by a syndesmos angel with the inscription above its head: 'omnes sitientes venite ad aquam', implying an interpretation of the heart as the source of the 'aquae vivae'. The hope of salvation is contained in the lines: 'in manibus, pedibusque tuis scripsisse redemptos, magnum erat; at maius cordis in aere tui'.[45] As in the case of medieval visual exegetic representations the image is given preference here above the text, and again, as in visual exegesis, the image has been rendered potentially capable of pluriform interpretation, the function of the text being merely a supporting one.

In addition to serving as a sign of the all-embracing power of the cross, and as a cosmic scheme for establishing a hierarchy of desert, the tree scheme with the syndesmos ideogram can also be used as a visual exegetic scheme for periodizing various ages of the history of salvation — an idea which goes back to St. Augustine. There is a unique example in a MS. of Augustine's *De civitate Dei* at Schulpforta, made in Northern Germany at the end of the 12th century. The only two miniatures in the MS., on folios 2v. and 3r., which depict the 'civitas dei' and 'civitas terrena', precede the actual text as an explanation of the programme.[46]

The 'civitas dei' is rendered by means of a tree-scheme consisting of the syndesmos ideogram grafted onto the tree of the Cross; this provides a visual exegesis of the periodizing of the history of salvation (fig. 89). The tree permeates the scheme of sacred history, which is divided into 6 compartments corresponding to the 6 ages of the world first linked by St. Augustine with particular biblical figures. In *De civitate Dei*, 22:30, Augustine defines the ages as follows: from Adam to the Flood; from Noah to Abraham; from Abraham and Isaac to Moses; from Moses to the years of the Babylonian exile; from the latter to the birth of Christ; and, 6th and last, the age after Christ's appearance on earth (represented here by John,[47] and Peter with a key and a model of a city or church, and beneath them St. Martin of Tours between the two martyrs, Stephen and Agnes of Rome). Below and in the middle is an angel writing, usually interpreted as the angel of Matthew, writer of the sacred history, as opposed — in the miniature of the 'civitas terrena' (fol. 3r.) — to Varro, the writer of secular history.[48] An odd feature of this tree scheme is that, unlike what we find in *Laudes crucis* for example, the growth is from top to bottom instead of from bottom to top.[49]

In addition to conveying the periodization of the *Heilsgeschichte*, with the

syndesmos ideogram also conveying the partial nature of the revelation of that history)[50] this scheme is also capable of incorporating an allegorical comparison between the 'civitas Dei' and the ark as 'corpus Christi'. St. Augustine refers to Noah's ark as an image of the 'civitas Dei' here on earth and compares it with the cross of Christ and the proportions of the human body. So the architectonic frame round the 'civitas Dei', with its 20 medallions, containing various beasts, could also be interpreted in terms of Noah's ark with its compartments for different categories of beasts, and also, moreover, allows of a tropological exegesis in which these beasts correspond to different categories of souls.[51] An anagogical interpretation would then take the form of that exegesis of Noah's ark which derives from I Peter 3:20-21, 'in qua pauci id est octo animae salvae factae sunt per aquam', emphasizing baptism as a means of salvation.

This representation could have come about through the influence of tree schemes familiar to the artist, of the kind represented by the *Laudes crucis* miniature with the Christ syndesmos, and the various ranks within Ecclesia throughout the ages; or it could have been influenced by other tree schemes, for example genealogical trees such as the 'arbor consanguinitatis', which is due for discussion now. Nevertheless it remains an extremely personal adaption of the tree scheme.

The history of how the genealogical scheme of the 'arbor consanguinitatis' came into being provides a good example of the adapting of what was originally a school scheme. Originating in roman law, it was taken over by the canon law as a scheme for determining blood relationships in connexion with marriage impediments, and in this way could become a scheme for use in visual exegesis according to the 4 'sensus'. Since no systematic investigation has as yet been conducted into the development of these genealogical tree schemes, we shall have to examine them a little more closely here.

It is possible that even in roman juridical texts the passage dealing with degrees of relationship in connexion with the law of succession was illustrated with a linear scheme. One would imagine that this was architectonic rather than vegetative in its presentation, but we cannot tell, since no relevant material has survived.[52]

It is not until we come to the text of the *Sententiae,* Lib. IV, Tit. XI 'De gradibus', by Julius Paulus (2nd century), in which the relationship is defined and eleborated down to the 7th degree, that we hear of a comparison being made with a 'scala' and terms being used such as 'superior linea, transversa, recta linea, supra ... infraque', which could indicate the existence of an explanatory scheme − but, again, the scheme itself is missing.[53]

For a clearer references to a graphic illustration of the degrees of relationship (as far as the 6th degree), we have to wait until Justinian's *Institutiones,* III, 6, 9, 'De gradibus cognationis', where we read:

'Sed cum magis, veritas oculata fide quam per aures animis hominum infigitur, ideo necessarium duximus, post narrationem graduum etiam eos praesenti libro inscribi, quatenus possint et auribus et inspectione adulescentes perfectissimam graduum doctrinam adipisci',

and where, incidentally, the emphasis is again laid on the didactic advantages of graphic presentation as opposed to verbal instruction. However, we cannot be certain whether the schemata which appear in later MSS. of the *Institutiones* which have come down to us are original, or whether they have transmigrated from another context.[54]

What is certain is that a genealogical tree scheme existed of the 'arbor iuris legis romanae', designed to clarify the degrees of relationship in connexion with succession rights under roman law. This scheme was adapted, as 'arbor consanguinitatis', to the purposes of indicating degrees of relationship in connexion with marriage and the possible objections to it on grounds of affinity, and as such passed into the canon law. That there was an awareness that the 'arbor' represented an attempt to provide a concordance between roman law and the church's laws relating to marriage, is evident from the following passage in the Acts of the 2nd Council of Douci, held in 874, where the scheme is described as follows:

'... et arbor iuris legis Romanae, ecclesiasticis concordans legibus, a praecedentibus et subsequentibus, dextra laevaque, usque ultra septimum gradum neminem nemini legaliter sociari permittit ...'.[55]

The expansion of this into a visual exegetic scheme for didactic ends is what we find in an 11th-century collection of canons at Rome (Vat. lat. 1352). For didactic reasons the author only provides half an 'arbor', in which a comparison is also implicit between the 'stemma cognationum' and the ark in which 7 generations were saved. The distinction is also drawn between 'parvuli' and 'perfecti' (with reference to Hebrews 5:13-14, '... qui lactis est particeps, expers est sermonis iustitiae: parvulus enim est. Perfectorum autem est solidus cibus ...') as an argument in favour of the visual teaching method, since images make it easier for beginners to approach the subject: '... hanc propter parvulos subdividere curavimus, quatinus in parte media ludentes lactis discant experiri dulcedinem, donec ad solidum cibum valeant pervenire'.[56]

It seems likely that, where adaptions of genealogical tree schemes are concerned, the rôle of Isidore of Seville as a link between the late antique tradition and the Middle Ages was of considerable importance. In his *Etymologiae* (ix, vi, 4-7 'De agnatis et cognatis') he provides three 'figurae' (figs. 90a, b, c) to illustrate the restrictions on marriage imposed by the law relating to marriage in his time. These illustrations do not faithfully reflect the text, however; nor, on the other hand, are they copied from the schemes used by Julius Paulus or Justinian.[57] An important source for the adaption of such schemata to visual exegetic purposes is possibly to be found in exegetic digressions such as we find in *Etymologiae* IX, vi, 8: 'Quatuor autem modis in Scripturis divinis fratres dici: natura, gente, cognatione, affectu", where a

quadruple interpretation of the word 'fratres' is supplied, and where the final term, 'affectus', is subdivided into 'spiritale et commune' with the addition of a variety of examples taken from the Old and New Testaments.

The introduction (*Etym.* IX, vi, 28) to stemma I and stemma II, where reference is made to the secular origins of the scheme (. . . quod advocati . . .) runs as follows:

'Stemmata dicuntur ramusculi, quod advocati faciunt in genere, cum gradus cognationum partiuntur, ut puta ille filius, ille pater, ille avus, ille agnatus, et ceteri, quorum figurae haec: (followed by stemmata I and II).

Stemma I (fig. 90a) has the shape of a truncated pyramid, interesected at the level of the 4th degree by a transverse beam and furnished with steps (gradus) descending from left to right. The line of movement from 'Ipse' to the 6th degree is from up to down, but the growth in chronological order from 'triavus' to 'Ipse' is upwards. The term 'ramusculi' used in the Isidore text makes possible an expansion to a genuine tree scheme.

Stemma II (fig. 90b) resembles in some ways a schematic tree. The compartments of the 'gradus' are square or rectangular. 'Ipse' is placed a little below centre. The numbers of the degrees indicate that the growth is centrifugal, but going by the chronology it runs from 'tritavi pater' via 'Ipse' to the latter's 'trinepotis nepos': i.e. from the top of the principal axis to the bottom. This scheme includes the 7th degree of relationship, unlike stemmata I and III, which only deal with 6 degrees of relationship.

Between stemma II and stemma III a short text has been inserted (*Etym.*, IX, vi, 29) in which the 6 degrees of relationship are compared with the 6 'aetates mundi':

'Haec consanguinitas dum se paulatim propaginum ordinibus dirimens usque ad ultimum gradum subtraxerit, et propinquitas esse desierit, eam rursus lex matrimonii vinculo repetit, et quodam modo revocat fugientem. Ideo autem usque ad sextum generis gradum consanguinitas constituta est, ut sicut sex aetatibus mundi generatio et hominis status finitur, ita propinquitas generis tot gradibus terminaretur.' (followed by stemma III).

This has been turned to visual exegetic use by providing an exegesis in terms of Adam and the generations which succeeded him.[58]

Stemma III (fig. 90c) is in the form of a circle, and thus comes closest to the original meaning of stemma, namely a garland. The scheme is built up of concentric rings, working out from the centre ('Vox filii utriusque sexus') to the 6th degree ('grad: F. a cuius voce incipitur').[59]

The development of stemma I to a tree scheme was already complete in the 9th century. In a 9th-century MS. of the *Etymologiae,* possibly from the Loire region, now at Berne, the scheme appears in the form of a trapezium, with architectonic details such as socle, shaft, cornice and cruciform pinnacle to indicate the place of 'Ipse' at the top of the scheme.[60] In another French MS. (Fleury?), of slightly later date, also in the library at Berne, architectonic detail in the form of socle and shaft has been incorporated, but the scheme itself has

110

become a pointed tree with vegetative shoots, the 'ramusculi', and is crowned by a fleuron (the name 'Ipse' is missing). At the foot, to left and right, an inscription has been added which does not derive from Isidore. This speaks of the 'arbor iuris', on which the 'nati hominum' hang (like fruits), and of its application to the law of succession (heredes):

PER VERSICULI DE ADFINITATE VEL GRADUS HOMINUM
(left) 'Aspice pendentes ex iuris arbore natos
 Hominum per pulchra genus indagine lucra
 Recta linea immobiles manere propinquos'
(right) 'A latere semper masculino cedere gradu
 Et femine longius per lege manere heredes
 Decreta per evum cessabunt hominum lites.'[61]

In another 9th-century MS. at Paris, with a scheme to which the same verses have been added, the socle and shaft have also acquired vegetative ornamentation, and the 'ramusculi' have become branches and leaves (fig. 91).[62]

An intermediate form between stemma I and stemma II has survived in a MS. of the *Breviarium* of Alaric at Paris, dating from the end of the 9th or the beginning of the 10th century. The scheme covers two pages and is clearly architectonic, although shoots at the corners betray an urge to develop in the direction of a tree scheme. The trapezium form relates it to Isidore's stemma I, but the designations of the degrees have been placed in medallions and, as in Isidore's stemma II, arranged centrifugally, although in this case they only go to the 6th degree (as in Isidore's stemma I). Another noteworthy detail, one which frequently occurs in illustrations of this sort of adaption of roman law, is the figure of one or more law-givers, here 'Theodosius rex' (fig. 92).[63]

In a further, 9th-century, example of tree scheme in a MS. of the *Breviarium* of Alaric, also at Paris, we again find — as in stemma I in the Isidore MSS. — a development towards a pointed tree shape with branches and leaves, although, once again, the degrees of relationship are only followed through to the 6th, and the data are arranged centrifugally, as in Isidore's stemma II (fig. 93).[64]

Stemma III, which does not occur in earlier MSS.,[65] seems to have been the least popular. Nor — so far as I know — did this circular scheme ever develop into a figurative scheme or become elaborated into a visual exegetic scheme. An example of stemma III as a sober linear scheme is to be found — although there are others of course — in the MS. at Baltimore containing a collection of school texts and schemata, which was discussed earlier.[66]

The stemma II of the Isidore tradition (the triangular, stepped scheme reaching to the 7th degree) is the most interesting for our present investigation, not least because it was the most popular of Isidore's three 'figurae' and has survived in numerous MSS., usually with acknowledgement to Isidore and accompanied by the passage, *Etym.* IX, vi, 29: 'Haec consanguinitas . . . tot gradibus terminaretur' (although mention is only made of 6

degrees, whereas stemma II usually has 7). In addition, so far as I know, this is the only one of the three stemmata which was worked into an anthropomorphic scheme for visual exegesis.

Like stemma I, stemma II began at an early stage to display tree-like details illustrative of the 'ramusculi" — for example, in the sole miniature occurring in the earliest known MS. of the *Etymologiae* at Wolfenbüttel.[67] In another early example at Brussels, possibly a production of the school of Corbie, c. 800, and which belonged to the monastery of St. Hubert in the Ardennes, all the degrees are adorned with flowering twigs, while the whole scheme is crowned by the half-figures of 'Pater' and 'Mater' (fig. 94).[68] The miniaturist of an early 9th-century MS. at Berne, possibly made at Strasbourg, decorated the 'gradus' with twigs and also provided the top with ornamentation suggestive of foliage, but placed the figures of 'Pater' and 'Mater' where they belong, at the heart of the scheme.[69]

The presence of figures, both at the top (Ipse or Pater and Mater) and at the heart of the scheme, and also to right and left of the trunk (Pater and Mater to indicate the male and female lines of descent)[70] becomes accepted as part of the stock equipment of stemma II.

Birds, too, were added to this stemma with its tree-like characteristics endowed by the twigs it appears to have put forth; in a 10th-century MS. of the *Etymologiae* at Paris, for example, the scheme is crowned by a bird.[71] In a related scheme in a late 9th-century Lombardic edict in the library at Modena, the representation is entirely surrounded by birds: two peacocks and two birds of prey, with their catch. Whether this is simply the result of the passion to ornament, or whether it is an attempt to apply the priciples of the 'ars memorativa' (association between tree with birds and genealogical tree) is uncertain (fig. 95).[72]

The development towards a visual exegetic scheme, helped perhaps by passages from Isidore such as *Etym.* IX, vi, 8 (Old and New Testament examples) and IX, vi, 29 (6 aetates mundi) achieves expression in, for example, the addition of the name Adam to the scheme, or the substitution of biblical names for the names of the degrees of relationship. Such schemata can again transmigrate from the Isidore context to purely juridical texts such as the *Codex Justiniani.*[73]

However, because it was shaped like a tree and stood on a socle, stemma II was suggestive of a human figure with outstretched arms, and full advantage was taken of this for visual exegetic purposes. An anthropomorphic tree scheme came into being, in which various exegetical subtleties could be visually rendered. Peter Damian, writing half way through the 11th century, discusses in his *De Parentelae Gradibus* c. 11 (*PL* 145, c. 193) the calculation of blood relationships to the 6th degree with the help of a schematic drawing in the form of a human figure, and even at this early date he writes as if the idea was an established custom.[74] The earliest anthropomorphic example of stemma II known to me also dates from the 11th century and is found in a

Spanish MS. of Isidore's *Etymologiae* at Paris (fig. 96), which was completed at Silos in 1072. The accompanying texts have been copied from *Etym*. IX, vi, 28 and 29 and the 'Versiculi de adfinitate ...' (see p. 111).[75] The visual exegesis aimed at in this scheme by the indication of the cruciform posture of the figure and by the syndesmos ideogram of head, hands and feet, that is to say the origin and fulfilment of the human race from 'Adam Vetus' to 'Adam Novus', receives clearer expression in the anthropomorphic 'arbor consanguinitatis' in a MS. of the *Etymologiae* at Munich (fig. 97), made at Prüfening c. 1150/65. The degrees of relationship are presented both by the numerals I-VII plus captions and by the figures of the relatives involved, depicted singly or in pairs beneath arcades. A striking feature is formed by the two circles with texts in the upper corners and the two inverted triangles, also complete with texts, below left and right. These texts explain how the scheme is to be interpreted: 'Adam Vetus', the origin of all human races, extended through matter and time, carries the 'arbor consanguinitatis' as type of Christ, the 'Adam Novus', in whom the circle is completed. This is set forth in the marginal text running round the whole representation:

'Porrigit in latum se linea posteritatum
Incipiens ab Adam cursum complebit in Adam.
Omnis homo fit Adam, quoniam generatur in Adam
Omnes ex uno nati moriuntur in uno';

in the texts round the circles: :Mundus in etates sex et consanguinitates in gradus sex dividuntur' and 'Tendit ab exortu renovando sicut in ortu', and in the text 'Haec consanguinitas ... terminaretur', taken from *Etymologiae* IX, vi, 29, which is contained in the circles above left and above right and then in the triangles below left and right.[76] A relation with anthropomorphic macrocosmos/microcosmos schemata is offered by the comparison between 'mundus' and 'homo', both in the Isidore quotation and in the marginal texts not deriving from Isidore. As a visual exegetic scheme this 'arbor consanguinitatis' can also provide an interpretation according to the 4 'sensus': historia — the succession of the races and the 6 'aetates mundi'; allegoria — exegesis in terms of 'Adam Novus'; tropologia — 'omnis homo fit Adam'; and anagoge — the idea of 'recapitulatio' and 'renovatio'.[77]

The Isidore text also served as basis for discussions of blood relationships as hindrances to marriage in collections of canons, such as that by Burchard of Worms (written c. 1008/12) and the *Decretum Gratiani* dating from c. 1140. The anthropomorphic scheme of the 'arbor consanguinitatis' participated in the transmigration. The earliest example known to me, located in an 11th-century MS. at Paris, consists of an anthropomorphic tree scheme (following Isidore's stemma II) accoanying Burchard's *Decretum* VII, 10 'De incestu', where family relationships are discussed in terms of a tree with 'radix, truncus et ramusculi'. The peculiar 'branches' on either side of the figure's head (fig. 98) suggest a crossing between this scheme and some other genealogical

scheme, for instance the tree of Jesse in the *Speculum Virginum* tradition, or the genealogical scheme of Noah and Terah in the *Laudes crucis* MS.[78] But it is especially in MMS., of the *Decretum Gratiani* that we meet with a wide variety of anthropomorphic genealogical tree schemes (fig. 99-104).

In his *Concordia discordantium canonum,* of c. 1140, Gratianus, a jurist and theologian from Bologna, applies the same method to the canon law as theologians had applied to biblical texts in order to arrive at a harmonizing interpretation of texts apparently conflicting with each other.[79] In pars 11 causa 34, qu. IV of tis *Concordia* Gratianus quotes Isidore as an authority on the 'vinculum matrimonii', in connexion with the marriage law. This passage is accompanied in most MSS. by an anthropomorphic genealogical tree scheme, which may have been taken over together with the passage quoted from Isidore, or may have come from earlier collections of canons of the kind resented by the MS. of Burchard of Worms mentioned above. All kinds of variations are possible; cruciform schemes, or (especially in later MSS.) pointed 'arrowshaped' schemes, or schemes with loosely drooping branches. The rectangular compartments of the 'gradus' are now often replaced by medallions, which is seen as an Italian innovation,[80] but which in fact is a casting back to the use of medallions in juridical schemes as early as the 9th centrury, as we saw, for example, in Alaric's *Breviarium* (cf. Paris, B.N. lat. 4410, fol. 2; see fig. 93). The scheme is usually borne by a syndesmos figure, who is sometimes standing on a lion and a dragon or holding tendrils.[81]

In later (14th-century) examples, especially, the figure — now interpreted as a crowned king — holds in his raised hands birds, or a globe and sceptre. In one isolated example the figure is depicted seated, holding the scheme in front of him (fig. 100). A cruciform scheme with rectangular compartments, borne by a standing syndesmos figure characterised as an old man in priestly (?) garments, occurs in a MS. of the *Decretum Gratiani* at Auxerre, possibly emanating from Pontigny c. 1170 (fig. 101).[82]

Perhaps the earliest example of the type with raised hands, standing on a lion and a dragon, is to be found in a MS. from Prüfening, now at Munich, which may have originated at Salzburg c. 1160/70. Here the scheme in fact appears twice, with one or two variants, on two facing pages (figs. 99a-b). In both miniatures the tree details are strongly accentuated at the corners by in-curling shoots in which beasts are climbing, while in both cases the compartments are rectangular. On fol. 308v. the relatives are depicted 'in effigy', while in addition, the frames contain simply numerals and indications of degrees of relationship. At the top is the half-figure of 'Adam Vetus' as an old man with white hair holding the topmost shoots of the 'trees', in which various animals are climbing: dogs (?), hawks (?), doves, hares, bears. In the scheme on the facing page, fol. 309, all the compartments have been assigned numerals and inscriptions with the degrees of relationship, while the figures of 'Pater' and 'Mater' are depicted in the middle. The 'Adam Vetus' is here much more clearly related to Christ as 'Adam Novus' because of the uplifted hands

and the fact that he is standing on a lion and a dragon.[83]

Another type of genealogical tree, comprising a pointed tree-like scheme with medallions, borne by a figure with priestly characteristics, may originally have come into being in Austria during the 1st half of the 13th century, under Italian influence; cf. examples in Admont (fig. 102) and Munich.[84]

The genealogical tree type with an 'arrow-shaped' scheme, behind which a figure with kingly characteristics is depicted, holding in his raised hands shoots or beasts (birds, dragons), or with sceptre and globe and two beasts (usually dragons) under his feet, is found in a number of 13th-century French MSS. of decretals, e.g. in a loose vellum leaf in the Glazier collection at New York (fig. 103). This also appears to be the commonest type in the 14th-century MSS. as well.[85]

The scheme with the loosely drooping branches, held by a standing figure, can also be traced back at least to the last quarter of the 12th century.

It occurs, for example, in a MS., now in the H. P. Kraus collection at New York, (fig. 104) which may have originated in France (Sens). Although the figure is here still characterized by a nimbus, in later MSS. the bearer of the scheme — as in the other types mentioned — has become a crowned king; cf. the *Decretum Gratiani* from S. Croce in the Laurenziana at Florence.[86]

Seated figures with the 'arbor consanguinitatis' are far rarer. In an example dating from the 2nd half of the 12th century, contained in an Austrian MS. in the Stiftsbibliothek at Admont, the figure has the characteristics of a priest (fig. 100). On the other hand, in a remarkable pen-exercise on the inside of a book cover of a miscellany from Salzburg (?), 2nd half of the 12th century, containing *inter alia* the *Vitae patrum*, we find that the seated figure with the 'arrow-shaped' scheme containing medallions is described in an inscription as 'Antiquus dierum'.[87]

The types mentioned above could have transmigrated from the *Decretum Gratiani* to other 13th- and 14th-century collections of canons, decretals and summa.[88] A remarkable adaption of a seated Christ syndesmos with genealogical scheme occurs in an early 14th-century North-Italian MS. of the *Aurea Summa* by Henricus de Segusio (d. 1271), now at Admont (fig. 105). Under the titulus 'De bigamis non ordinandis' (X.1.21) the author mentions 11 points to show how the marriage bond everywhere ensures unity and stability, and lists in succession the following marriages: Adam and Eve, God and Mary, Christ and the Church, Peter and the priesthood, bishop and church, sacrament of baptism and the true believer, God and the believing soul, mercy and the believing soul. The text frames an 'arbor bigamiae', in which Christ holds with His right hand that part of the scheme illustrating His relation with the faithful, while with His left hand he rejects the unbelievers (as in the last Judgement). The genealogical scheme proper consists of medallions connected by lines and bearing inscriptions referring to the divine 'matrimonia' (to the right of Christ) and the infernal 'vincula' (to the left of

Christ). Christ's feet are resting on a basilisk or cerberus, next to which is the mouth of hell, where devils are busy with the unbelievers.[89]

There are some striking examples of the transmigration of the anthropomorphic scheme of the 'arbor consanguinitatis'. In a MS. of *Der Naturen Bloeme* by Jacob van Maerlant, dating from the 1st half of the 14th century and now at Brussels, Aristotle is depicted with a book in his left hand, and in his right an 'arrow-shaped" scheme containing the names of the writers drawn upon by the author of *Der Naturen Bloeme*.[90]

Another example is provided by a 13th-century Spanish MS. at Madrid by Fuero Juzgo (which includes a translation of Julius Paulus *Sententiae* tit. XI 'De gradibus'). It contains a representation of a recumbent Jesse holding an 'arrow-shaped' scheme with the inscription: 'Este es Jesse donde nascio el linage de la vergine Sancta Maria', and an outline of the degrees of relationship to the 7th degree.[91]

The concept of 'concordia discordantium' summarized in these collections of decretals and canons by means of the visual exegetic scheme of the syndesmos figure with the 'arbor consanguinitatis', is closely related to the concept of harmony in musical theory. From earliest times terms derived from music had been employed in explaining that harmony was the fundamental idea behind exegesis.[92] This resulted in the creation of visual exegetic schemes such as an anthropomorphic quadripartite harmony scheme in the form of a musical instrument. The ideas behind this had a long prehistory, both in early christian exegesis and, prior to that, in the views on music and harmony held by the ancients.

The idea of universal harmony being created by a musical instrument goes back to the Pythagorean tradition. The musical harmony of the 7 planets, the harmony of the spheres, was compared to that produced by a heptachord with 7 strings.[93] The harmony of all terrestrial things, which were also governed by number, was in sympathy with this heavenly harmony. The human soul, too, was compared to a properly tuned musical instrument when all 'affectus' were in harmony.[94]

For Philo of Alexandria the heavens provide an archetype of all musical instruments, the terrestrial image being the 7-stringed lyre. He, too, thinks of the harmony of the soul as analogous to that of the universe. In addition, he is the first to introduce the image of God as musician who plays on the human soul like a well-tuned lyre.[95] In this connexion he devotes a great deal of attention to ecstasy as the only means of participating in the transcendental: every wise and virtuous man is a prophet, an instrument to be made use of by the spirit of God.[96] The church fathers, too, in their exegesis, make repeated use of music as a means towards the highest insight. It also forms part of the Rule of St. Benedict:

'. . . cantantes et psallentes in conspectu sanctae Trinitatis et sanctorum angelorum . . . devota mente, amore supernorum, spiritus ardore, intimo desiderio accensi, ut per verba, quae

pangimus, ad coelestia elevati, coelites effecti, arcana contemplantes ... iubilemus Deo creatori nostro, ut tandem inter Sanctos resuscitati mereamur eum, qui nos vocavit'.

The curative powers of music, too, which result in catharsis, made their way through various stories about the power of music — deriving partly from the Pythagorean tradition — into christian thought, which added the classical biblical example of David playing to Saul on a harp.[97]

Very early on, christian exegetes linked the quadripartite world harmony (of the 4 elements, 4 winds, etc.) to the all-embracing, harmonizing function of Christ's cross, regarded as a world instrument.[98] The cithara, the psaltery, and also the organ, lyre and lute, were termed world instruments, and there are numerous texts in which the cross and passion, or even the 'corpus Christi', were compared to one of these musical instruments. By comparing the Ecclesia, as 'corpus Christi', with a musical instrument, the unity in diversity of the various members could be effectively presented in terms of the strings of one, single instrument. This comparison was also appropriate, however, to each individual member of the church. Man as microcosmic reflection of the world-instrument could only be truly in tune when the virtues created the proper harmony.

It follows that a matter of the utmost importance for exegesis was the christian interpretation of the 'moral' implication of music — an idea that had already made its presence felt in the musical theories of the ancients. Without 'caritas', the claim went, it was impossible for man to produce true music; cf. 1 Cor. 13:1 'Si linguis hominum loquar, et angelorum, caritatem autem non habeam, factus sum velut aes sonans, aut cymbalum tinniens'. Only those who made music with the right motives and in a state of inner harmony were capable of attaining to God: the 'moralitas artis musicae' became a fixed ingredient of exegesis.[99] Psaltery and cithara were often compared with one or more of the virtues, for example 'fides' or even more commonly 'caritas', or with a symphony of virtues. Man ought to be like an 'organum virtutum, quod sancti Spiritus plectro pangens propheta venerabilis coelistis sonitus fecit in terris dulcedinem resultare' (Ambrose). The cithara also occurs as an image for good works. We find as early as St. Augustine (In Ps. 149:3) the statement that men ought not to praise God with their voices only but also with their deeds: 'Cantate oribus, cantate moribus'; and Augustine goes on to name the acts of charity: feeding the hungry, clothing the naked, giving shelter to the stranger.[100]

Musical harmony terms were often used for indicating harmony in the exegesis of the Scriptures. The idea of a 'concordia dissimilium' was used for reconciling passages from the Old Testament and the New Testament which at first sight appeared irreconcilable, the resulting unity being seen as a 'concordia discors'. Above all, the correspondence between the 4 Gospels was seen as a musical harmony, as a 'concordia'; cf. Ambrose, *De concordia Matthaei et Lucae in genealogia Christi,* and Augustine, *De consensu Evangelistarum.* On occasion the Scriptures as a whole were called a musical instrument.[101]

117

This idea also received expression in the symbolic interpretation of the cithara and the psaltery, which, on the basis of Psalm 32:2, 'Confitemini Domino in cithara; in psalterio decem chordarum psallite illi. Cantate ei canticum novum', were regarded as contrasting with or complementing each other. This interpretation was usually based on the difference in construction, the psaltery being considered superior because it contained no curved or bent lines and because its 'soundboard' was not at the bottom, as in the cithara, but at the top.[102] The two instruments could also be viewed as the 'consonantia' of the two Testaments, whose harmony produced 'nova cum veteribus'; in this case the cithara usually stands for the Old Testament and the psaltery for the New.[103]

By using an anthropomorphic musical instrument as a scheme for visual exegesis, various of the aspects mentioned above could be given expression — for example the 'concordia discors' of the Old and New Testaments, or the Gospels, or the unity in diversity of the various members of Ecclesia seen as one body of which Christ is the head; the 'moralitas artis musicae' could also be expressed, as could, finally, the anagogic power of music.

In a 12th-century MS. of Peter Lombard's commentary on the Psalms, probably from Southern Germany and now in the Chester Beatty collection, there appears on fol. 1r. — thus as introduction to the text and as aid to reading it — a visual exegetic scheme of the 'psalterium decem chordarum', which is both played on and formed by David as type of Christ in syndesmos posture (fig. 106). In addition to the caption 'David', there is also an inscription beside the head of the figure: 'Christus caput ecclesiae'. This could be an allusion to, for example, Eph. 1:22 Et omnia subiecit sub pedibus eius: et ipsum dedit caput supra omnem Ecclesiam quae est corpus ipsius et plenitudo eius, qui omnia in omnibus adimpletur'. The text to the left of the head, 'in psalterio dechachordo psallat tibi', could have come from a number of psalms. Psalm 32:2 is the most likely source, however, because of its continuation of this text: 'cantate ei canticum novum'.[104]

The texts which explain the scheme provide in compact form an extremely varied exegesis involving not only theories dealing with the harmony of the world and the world instrument, but also exegetical subtleties relating to the harmony of the two Testaments as the 'concordia' of the 'canticum vetum et novum', and an interpretation in terms of the 4 levels of historia, allegoria, tropologia and anagoge. The texts incorporated in the scheme itself are (as so often in visual exegetic schemata) not taken only from Peter Lombard's commentary. But the ideas contained in the latter are exegetical common-places. The main emphasis lies on the harmony of contrasts, the 'concordia discors' achieved in macrocosmos and microcosmos by means of the cruci-fixion posture and the cross as 'vinculum'. This concord embraces the whole history of the Ecclesia in the Old and New Testaments, and also points

forward to future salvation, of which the harmonious melody produced by the instrument is a prefiguration.

The 'psalterium decem chordarum' is a quadripartite scheme, and the music which is produced has the perfection of 'musica quadrata'.[105] This division into 4 is given by the system of axes formed by the figure and the 'crossbeam' of the instrument, and is further accentuated by the allusion to the symbolic interpretation of the 4 dimensions of the cross, which starting from the text Eph. 3:18 'ut possitis comprehendere cum omnibus sanctis, quae sit latitudo et longitudo et sublimitas et profundum', forms the basis for the exegesis of the cross as syndesmos, 'vinculum' or 'machina mundi'.[106] From the originally cosmological idea of a 'vinculum' reaching out to the 4 cardinal points of the 'spatia mundi', the cross developed into a 'mysterium'; cf. Augustine: 'Crux magnum in se mysterium continet, cujus positio talis est, ut superior pars coelos petat, inferior terrae inhaereat, fixa in infernorum ima contingat, latitudo autem ejus partes mundi appetat'.

Even in early-christian times the 4 dimensions of the cross were made the subject of extensive exegesis, in which a connexion was often made with the centrifugal working of 'caritas'. We come across this in *Hom.* 50 (*PL* 341) of Maximus of Turin (c. 580-662), and later on in, for example, the *Glossa Ordinaria,* Ep. ad Ephes. III, 17, 18 (*PL* 114, 595), and Peter Lombard, *Collectanea in Epp. Pauli* (*PL* 192, 193).

A matter of great importance for later exegesis was the exegesis of the 4 dimensions of the cross in terms of the virtues and / or good works, something we first meet with in St. Augustine. Raban Maurus, *De laudibus s. crucis,* speaks in this connexion of the 'quadriga virtutum quatuor cornibus sanctae crucis decenter aptate'. The ascription of virtues to the various dimensions of the cross can vary. Usually one finds: 'latitudo = bona opera caritatis', 'longitudo = perseverantia' or 'longanimitas (tolerantia)', 'altitudo = spes coelestium praemiorum'. 'Profundum', in particular, tends to receive (as in our scheme) an extensive exegesis, for example in Augustine: 'Profundum autem quod terrae infixum est, secretum sacramenti praefigurat'. In a sermon by pseudo-Augustine which has been ascribed to Quodvultdeus it is interpreted as 'fides christiana' ('in profundo crucis occultum est quod non vides sed inde exsurgit hoc totum quod vides: adsit fides christiana'). For Peter Damian, 'profundum crucis' is both 'fides' and 'fortitudo'.[107]

The text appended to 'profundum' in the scheme — 'fides est sperandarum rerum argumentum non apparentium' — contains a further exegetical subtlety. It can refer literally to that part of the cross which is hidden in the ground, but it can also allude to the possibility of raising oneself, with the aid of the scheme, from 'corporalia' to 'spiritualia'.[108] Similarly, when a psaltery is played, the music can transport the listener from lower things to higher, from 'profundum' to 'sublimitas', or from 'praesens vita' to 'vita aeterna' and from 'vita activa' to 'vita contemplativa'.

The text, 'Et factum est principatus eius super humerum eius', to the right of

the head of the syndesmos figure, could be interpreted with reference both to Christ's carrying the cross and to the 'imitatio' of that action.[109]

Only 2 of the 4 'dimensiones crucis' are explicitly mentioned in the scheme: 'sublimitas crucis' and 'crucis profundum' as ends of the vertical axis; but on the horizontal axis and to the left (the right from the viewpoint of the figure) is the text: 'caritas distenditur usque ad inimicos',[110] where the 'distendere' plays on the syndesmos gesture of the outspread hands, and thus on the 'latitudo crucis'. In the text at the right-hand end of the horizontal axis, too, 'Latum mandatum tuum nimis' (from Psalm 118:96), there is a punning allusion to 'latitudo'. 'Longitudo', as an indication of the vertical axis, is embodied in the text 'longitudo crucis. Deus a longe venit', which appears on the body of David.[111]

The 3 theological virtues, 'fides, spes, caritas',[112] are assigned respectively to the extremities of the cross corresponding to 'profundum, sublimitas, latitudo'. It is interesting to note that, since there are only 3 virtues to be distributed, the left-hand side of the cross — i.e. the unfavourable one — has been discriminated against.[113] This switch to a tripartite arrangement within a quadripartite scheme made it possible to exploit the exegetical possibilities of the 'numerus ternarius',[114] and indirectly to invoke the symbolism of the numbers 7 and 12 as well. There may have been some cross-fertilization from the practice of dividing music into three kinds: 'musica mundana' (macro-cosmos), 'musica humana' (microcosmos: harmony of body and soul), and 'musica instrumentalis',[115] or from the threefold division of the psalter into 3 × 50 psalms, as exemplified by Honorius Augustodunensis, for example, in his commentary on the psalms, where he arranges them according to the periods: 'ante legem' (Abel), 'sub lege' (Moses), and 'sub gratia' (Christ).[116] But in fact, the commonest exegesis of the tripartite division, in terms of the Trinity, must surely have also played a part.[117] For example, one inspiration for the scheme could have been the following text from the commentary on the psalms by Honorius, mentioned earlier:

'tanta mysterii virtus inesse videtur (in the musical intervals) . . . in veteris ac novi testamenti collatione, vel quae aliarum pulsus in cithara, quae mentem, rerum consonantiae. postremo, quid sit coelestis harmonia . . . vox in choro, flatus in tuba, pulsus in cithara quae mentem, spiritus, corpus significant, quae trinitatem semper laudibus concelebrant, reor hinc posse agnosci: . . . omnes sancti per caritatis concordiam, quasi per diapason, unum resonant unum sapiunt'.

In the scheme, the emphasis on the tripartite division derives primarily from the text at the bottom, outside the frame: 'In modum etiam *delte letterae* formatus est, que figuram habet sancte crucis. Nos enim gloriari oportet in cruce domini Ieu. Christi'. And indeed it is noticeable that the space left by the text to the left and right of the body of David / Christ is more or less in the form of a triangle. The delta-shaped instrument (usually called a psaltery, and occasionally a cithara) is associated by exegetes not only with the Trinity but also with the 'corpus Christi'.[118] The miniaturist has tried to convey both

120

aspects: the quadripartite cross-shape by means of the horizontal 'crossbeam' of the instrument and the vertical position of the body of David/Christ; and the (inverted) delta shape by means of the boundaries formed by the texts incorporated within the scheme.[119]

The emphasizing of the favourable side (right) and the unfavourable side (left) is continued in the figures of Martha (left) and Mary (right) and the texts assigned to them, taken from the Song of Songs 2:6: 'Leva eius sub capite meo' and 'dextera illius amplexabitur me', to which the words 'Teta', on the left, and 'Bita', on the right, have been added. These have to be read as the letters Θ (= θάνατος) and β (= βίος), life and death. They strengthen the indication of the favourable and unfavourable sides, and can be compared with, for example, the figures of 'vita' and 'mors' which appear at the corresponding places in the visual exegetic crucifixion — also elucidated with the aid of details taken from musical harmony — in the evangeliarium of the Abbess Uta of Niedermünster, discussed earlier, which was produced at Regensburg, c.1002/25.[120] Martha and Mary, who appear to left and right above the 'cross-beam' of the instrument, may stand exegetically for the 'vita activa' and the 'vita contemplativa'. The incorporation, via these two figures, of the abovementioned concepts into the scheme, is something that anyone trained in the finer points of exegesis — and they were the people the scheme was intended for — could not fail to register. This particular line of interpretation was already of considerable antiquity. Even before Philo, music formed part of the preparatory study for philosophy. It elevated the life of the senses to a transcendental plane, which Philo symbolizes by the contrast between Hagar and Sarah,[121] one of the pairs of figures used in exegesis to illustrate the duality of the two 'vitae'; among the other pairs regarded as exemplifying the same idea were Rachel and Leah, Peter and John, and Martha and Mary. Sometimes, in further digressions on the two 'vitae', we find the two sorts of vocal music — psalms and canticles — being taken as images of the active and the contemplative life; and the contrast between instrumental performance and unaccompanied song is also met with.[122] The texts from the Song of Songs quoted as being assigned to Martha and Mary, can also — in addition to underlining the relation between left and right — be interpreted in a more general sense as the Sponsus/Sponsa relationship of Christ to the Ecclesia and to the individual soul.[123]

The various inscriptions on the 'cross-beam' ought to be read as one single text: 'Psalterium Decem corde. Decem sunt praecepta in quibus pendent tota lex et prophetae'.

The 'pendere' is intended both literally and figuratively, since the 10 strings (the 'in concavitate desuper fila pendentia' of the incorporated text on the left) have to be interpreted according to the rules of number symbolism as the 10 Commandments, on which the whole law and the prophets are dependent.[124] The 10 'pendant' strings bring about the connexion with the '5 nodi chordarum' situated left and right on the 'body' of the instrument. This body is both

the body of the syndesmos figure and, in the microcosmos sense, the human body; it is also both the body of the psaltery ('Musicum instrumentum obesum habens ventrem', cf. the incorporated text on the left) and the mystical 'corpus Christi' = Ecclesia, as indicated by the inscription at the top, just below the 'cross beam': 'Ecclesia venter'.[125] The '5 nodi' are compared with the '5 sensus hominis', and these in their turn with the Pentateuch: '5 libri moysi per quos 5 sensus hominis reguntur', as the writing to left and right of the body, and within the triangular area constituting the musical instrument, tells us.[126]

Within the 'Ecclesia venter' the number 12 is dominant, an unusual situation in exegesis employing musical concepts. The $2 \times 6 = 12$ 'fenestre' are intended to represent sound-holes of a sort, and are identified with the 12 apostles: 'XII sunt apostoli'. These also have to be seen as typologically related to the prophets named above them on the centre of the 'cross beam'.[127]

The designer of the scheme was well aware that his material was anything but easy: 'totum habet mysticum sensum. et ab imperitis non intellegitur', as we learn from the conclusion of the incorporated text below left.[128]

This text on the left gives a description 'after Jerome' of the shape of the psaltery: 'obesum habens ventrem. in concavitate desuper fila pendentia'. The illustrator obviously found this all rather unhelpful, but then the main point was the 'mysticus sensus', and the inscriptions provided more than enough material for this. The incorporated text on the right informs us of the number of the psalms and the names of their authors, and also of the division into 5 books. Even the translators are mentioned: 'septuaginta interpretes' each of whom carried out his task as best he could, although none of them could match Jerome: 'Beatus . . . Hieronymus optime transtulit'.

As we can see from the above, the anthropomorphic scheme of the 'psalterium decem chordarum' makes possible a great number of different exegeses. In the incorporated text on the left the psaltery is called a wooden instrument: 'Quidquid in hoc psalterio ligneo instrumento reperitur totum habet mysticum sensum', which, in addition to punning on the cross as 'lignum', allows the contrast between the wooden instrument and the strings to be viewed as one between the 'sensus litteralis' and the 'sensus spiritualis'. This forms a parallel with a passage in Hugh of St. Victor's *Didascalicon*, where the cithara is submitted to a triple exegesis (historice, allegorice, tropologice), in which a comparison is made between the Scriptures and the cithara, the wood representing the literal sense and the sound of the strings the spiritual sense. The author speaks of the wood of the cithara as embracing, establishing and assembling, thus employing terms connected with the idea of syndesmos, or vinculum, and implying a reference to the cross and the crucifixion posture.[129]

A complete exegesis of the scheme according to the 4 'sensus' is also possible. To the first 'sensus', historia, belong the types taken from the Old Testament: David as type of Christ, the Sponsa of the Song of Songs as type of

Ecclesia, the prophets as type of the apostles, and the 10 Commandments as counterparts of the Gospel. The 'cross beam' of the 'cross' is especially the zone of the Old Testament and of historia. The 2nd 'sensus', allegoria, is chiefly concerned with the body of the instrument, the vertical beam of the cross. This stands for 'corpus Christi = Ecclesia', with Christ as head, 'XRS caput ecclesiae'. Numerous texts present the relation between the universal harmony established by God and the harmony between the various members of the One Church, as the musical harmony produced by a well-tuned instrument.

The 3rd 'sensus', tropologia, is included in the moral duty of the individual human being to keep the 10 Commandments 'in quibus pendent tota lex et prophetae'. Man, as 'organum virtutum', as harmony of virtues and deeds, can be guided by the music from 'vita activa' to 'vita contemplativa', and consequently this life can become a prefiguration of the life to come.

This brings us to the level of the 4th 'sensus', anagoge. Music, singing and playing, can be seen as the supreme means of acquiring an understanding of the perfect harmony awaiting man, by means of which we: 'ad coelestia elevati, coelites effecti, arcana contemplantes ... iubilemus Deo creatori nostro, ut tandem inter Sanctos resuscitati mereamur eum, qui nos vocavit', as it is phrased in the passage from the rule of St. Benedict quoted earlier.

More or less at the same time as the South-German visual exegetic scheme of the 'psalterium decem chordarum' came into being, the prototype must have been created of the visual-exegetic scheme of the psaltery by Joachim da Fiore (c. 1130-1202).[130] In a simpler form it occurs already as a textual illustration in Joachim's treatise on the *Psalterium decem chordarum*.[131] As a more elaborate visual-exegetic scheme it is incorporated in the so-called *Liber Figurarum*,[132] a group of diagrams and visual-exegetic schemata explaining the principles of Joachim's system (the underlying idea of which is the operation of the Trinity in history). This group of 23 schemata was probably composed as an introduction to his ideas after the completion of his principal works: *Concordiae Veteris et Novi Testamenti, Expositio in Apocalypsim* and *Psalterium decem chordarum*. The collection of 'figurae' apparently achieved its final form c. 1200 and it undoubtedly derives from prototypes designed by Joachim himself to serve as teaching aids.[133] The main schemata are: 'figurae' of the '7 aetates' and '3 status'; tables of concords between Old and New Testaments; pair of Tree-eagles; red dragon with 7 heads; three Trinitarian Circles; 'Psalterium 10 chordarum'; 'Rotae' (Ezekiel I: 15-16); 'Dispositio Novi Ordinis'; 'mysterium Ecclesiae'.[134] At present three 13th-century MSS. are known containing a more or less complete series of 'figurae',[135] but for centuries 'figurae' continued to appear in MSS. and printed editions of texts written by Joachim himself or by his followers. In the preface to the *Expositio in Apocalypsim* and the *Psalterium decem chordarum* printed at Venice in 1527, it is even stated that Joachim's work cannot be understood without these figures,

and that they have to be regarded as the 'universalia' or 'generalia' of Abbot Joachim: 'Quia (teste Aristotele in prologo physicorum) oportet ex universalibus in singularia procedere: ita et Abbas Joachim volens circa Romanam ecclesiam et alias particulares ecclesias ac nationes populosque diversos quedam singulariter ex sacro eloquio prenuntiare quedam generalia premittit'.

The schemata, like Joachim's whole work, are permeated with the principle of 'concordia', which connects the history of Israel with that of the Church: his commentary on the sacred text is 'secundum coaptationem concordiae'.

That Joachim did in fact make use of the visual exegetic method in his teaching is evident from his phraseology at various places where he refers to 'figurae': '. . . que ut fidem inquirentibus facerem, iamdudum in figuras converti.' In his *Liber concordiae novi et veteris testamenti* he shows that the 'figura' can help where words are inadequate: '. . . ecce in subiecta figura speculari poterit super hoc sacrum archanumque mysterium, quod vis verbis congruentibus plene sicut est, dici potest' (V, 106a), and in the same work he talks about the usefulness of an explanatory tree scheme: 'Et hec quidem clara satis, sed quia mentis occupate circa multe sepe obtunditur intellectus, opere pretium credimus ipsarum de quibus agimus spiritualium arborum presentare figura, ut per ea que exterior cernit oculus interior acies illustretur . . .' (II, 1, 23). Again, in his *Expositio in Apoc.* he prefers 'visibiles figurae' to words: '. . . id ipsum quod mentis oculis contemplandum dicimus, etiam in subiecta pagina visibilibus ostendimus figuris . . . quod potius figuris ostendi quam lingua exprimi potest . . . (38r.).

The psaltery scheme seems to have had a special significance for Joachim. In the praefatio to his *Psalterium 10 chordarum* he tells us how the 'figura' of the psaltery was, as it were, revealed to him: '. . . nec mora occurrit animo modo forma psalterii decachordi et in ipsa tam lucidum et apertum sacrae mysterium Trinitatis . . .' (227).

That the 'figurae' derive in principle from Joachim himself is also supported by the story that he was received by Richard Lionheart when the latter was passing through Sicily on his way to the Holy Land in 1190. Joachim proceeded to explain his Apocalypse to the king with the help of the scheme of the 'draco magnus et rufus; (Rev. 12:3). Some of his 'figurae' were thus already familiar in his own day to English chroniclers accompanying Richard.[136]

In later times, too, Joachim's figures were considered to be his own creation, as appears from the protocol of the sitting of a commission which met at Anagni in 1255, on the orders of Pope Alexander IV, to enquire into Abbot Joachim's doctrine, and which subjected all his writings to an investigation, after some of his views had been condemned at the 4th Lateran council of 1215. The protocol speaks for the most part about tree schemes and 'figurae'

made by Joachim himself, and special mention is made of the scheme of the 'psalterium':

'Inde habetur per inspectionem arborum et figurarum inde confectarum ab ipso Joachim . . . Haec extracta sunt de libris Joachim . . . in eis plurima curiosa, inutilia et inepta . . . sicut est illud de tribus cornibus psalterii musici decacordi per quod intendit astruere fidem trinitatis aproprians illud cor . . .'.[137]

Even in the middle of the 14th century we find Giovanni di Rupescissa in his prologue to a *Commentum in oraculum beati Cyrilli,* written c. 1348/50, praising Joachim as a meritorious artist.[138]

Of the 23 different schemata in the *Liber Figurarum* we shall only deal with one here, the 'Psalterium decem chordarum'. That the idea and the original execution were Joachim's seems certain; but whether the original scheme was anthropomorphic is anything but certain.

The psaltery scheme – as already mentioned – had a very special meaning for Joachim, and its form was revealed to him in a vision. In the 'forma psalterii'[139] he attempted to represent the 'invisiblia Dei' by a visible image, expressing his religious experience in musical terms. In doing so he introduced different elements from his exegesis of the three principal musical instruments mentioned in the Bible: the psaltery, the cithara and the tuba. Thus some suggestive anthropomorphic notions in his exposition of the symbolism of the cithara as the 'homo novus', its three strings designating fides, spes and caritas (cf. *Expos. in Apoc.,* f. 172r. and *Lib. Conc.,* f. 5v.) were transferred to his exegesis of the psaltery, equating this instrument with the 'novus homo' in the double meaning of Christ and his body the Church (cf. *Psalt.* f. 230r.).

The first, simple, version of the scheme of the psaltery (as given in the textual illustration on f. 288r. of the 1527 printed edition of the *Psalterium*) is however strictly non-figurative.

The earliest known, more elaborate, visual-exegetic scheme of the psalterium – which is generally accepted as the nearest to the archetype – occurs in a MS. of the *Liber Figurarum* at Oxford,[140] dating from c. 1200 (fig. 107). However, this does not show any anthropomorphic details either.

A comparison between the two schemes shows clearly the development of Joachim's exegesis over the years, the most marked feature being the increasingly important rôle assigned to man as a well-tuned instrument, aspiring to the celestial harmony. There are however no indications that this idea of 'concordia' was expressed by way of the syndesmos-figure, though transformations of the scheme, occurring in Joachite works of a later date present it as such.

The miniature in the Oxford MS. (f. 8r.) shows a strictly non-figurative scheme in the form of a triangle, the upper part of which is truncated, with, at the top, the inscription 'Pater', in the bottom left corner 'Filius' and in the bottom right corner 'Spiritus', to which a threefold 'Sanctus' is added. The three sides of the triangle are assigned to the three persons of the Trinity, which is emphasized by the colour symbolism: Pater/light green, as the

life-giving colour (blunt top and left side); Son/red, as the colour of blood (base); Holy Spirit/blue, as the colour of air (right side). The inscriptions along the three sides — to be read in an anti-clockwise direction — provide the division of the Psalms into three groups of 50, corresponding to the three 'ordines' of the Ecclesia: left, coniugati (assigned to the Father); below, clerici (assigned to the Son); and right, monachi (assigned to the Holy Ghost). The triangularity of the psalterium represents the Trinity, whereas the three concentric circles of the 'rose' in the centre symbolize the unity of the Godhead.[141] This is emphasized by the central captions: 'Dominus Deus Omnipotens. IEUE. Sancta Trinitas. Unus Deus.' Below and above, the following inscriptions have been added: 'Una Sancta Ecclesia' and 'Psalterium decem chordarum', which may stand respectively for the unity at the human level and for the unity of the celestial harmony.

So far the psaltery has been mainly interpreted, as in the textual illustration of the *Psalterium,* as a Trinitarian symbol of unity in diversity. When we come to the interpretation of the strings a new element is introduced. In the textual illustration the 10 strings, stretched horizontally over the instrument, were simply numbered and interpreted as the 9 angelic choirs, in a descending order from the highest to the lowest, with man being added to complete the number 10 and assigned to the lowest 10th string.[142] In the visual-exegetic scheme of the psaltery in the *Liber Figurarum* the strings are attached on the left side to the 9 angelic hierarchies, but now in an ascending order, while 'Homo' is now exalted above the 9 choirs and assigned to the topmost string. This in accordance with the doctrine that through Christ's incarnation man surpasses the angelic choirs. On the right side the strings are attached to the 7 Gifts of the Holy Spirit — timor Domini, pietas, scientia, fortitudo, consilium, intellectus, sapientia —plus the three theological virtues: fides, spes and at the top, caritas. Here man's gradual ascent on the ladder of perfection is visualized.[143] The scheme thus offers a complete pictorial exegesis of the psaltery as the concordia of the 'novus homo' at the different levels of multiple exegesis. At the level of allegoria: by an allusion to Christ and his body the Ecclesia; at the level of tropologia: by an allusion to man's striving for moral perfection, and finally at the level of anagoge: by an allusion to the mystical ascent of man, culminating in the achievement of perfect celestial harmony.

By means of a cautious non-figurative approach the artist has escaped the difficulties of the instrument's double meaning: on the one hand as the Godhead in its Trinity (the triangularity of the instrument) and its unity (the central 'rosa'), and on the other hand as man himself as a well-tuned musical instrument. Despite all this the papal commission of 1255 numbered it among Joachim's 'curiosa, inutilia et inepta . . .'.

A selection from the collection of the *Liber Figurarum*, among them the psaltery scheme, often served as an introduction, the so-called 'Praemissiones', to MSS, of pseudo-Joachite works such as, e.g. the *Comm. super Esaiam.*[144] In an South Italian MS. of this pseudo-Joachite Isaiah commen-

tary, at Vienna, dating from the first half of the 14th century (fig. 108),[145] the psaltery is now represented as an anthropomorphic scheme. The musical instrument itself, however, is more like a trapezium than a triangle. The top is indicated by the inscription 'Pater', the left-hand corner by 'Filius'; the right-hand inscription (Spiritus Sanctus) is missing. The 7 Gifts of the Holy Ghost and the 3 theological virtues have changed places with the 9 choirs of angels + man, and in the middle, instead of a round sound-hole, there is simply the inscription 'Una et perfecta substantia Trinitatis'. At the top we find the figure of Christ in syndesmos posture, providing a visual represen- tation of the text to the right of the instrument: 'Nota quod Christus praelatus est omnibus ordinibus angelorum per verbum patris humanam carnem assu- mens . . .', This is a variant on the inscription 'Homo praelatus est omnibus ordinibus angelorum etc.' which occurs in the earliest known MS. of the *Liber Figurarum* at Oxford (see fig. 107).

It is characteristic that the unknown artist — nothwithstanding his clumsi- ness and his many mistakes and omissions in adapting the scheme — has grasped the basic idea of 'concordia' conveyed by the visual exegetic scheme of the 'psalterium 10 chordarum' and has expressed this by adding the syn- desmos figure, which embodies this 'concordia' in many other visual exegetic schemes.

This would raise the question whether there existed at any time a draft in Joachim's own hand for an anthropomorphic psaltery scheme showing the syndesmos figure, though apart from the scheme discussed and another 14th-century miniature with anthropomorphic additions[146] there is nothing to corroborate this hypothesis.

A relation with the 12th-century Southern German 'David'-scheme, dis- cussed earlier — though the fact that it occurs in a commentary on the psalms by Joachim's opponent in the Trinitarian controversy, Peter Lombard, would appear to be suggestive — also seems unlikely. Not only is there a difference in the exegesis of the instrument (e.g. the emphasis on the David-syndesmos and the prominent part played by the 10 strings as the 10 Commandments) but there is also a conspicuous difference in the form and the position of the instrument. The 'David'-scheme shows the correct playing-position,[147] the instrument pointing downwards, but the vertical position of the strings — though in concordance with patristic exegesis —[148] bears no resemblance to their positioning in the actual medieval instrument. In the miniature of the psaltery in Joachim's *Liber Figurarum* and in the Joachite *Super Esaiam,* on the other hand, though the blunted top of the instrument and the fact that it is shown pointing upwards are manifestly incorrect — the horizontal position of the strings indicated by the positioning of the inscriptions is correct.

Joachim da Fiore comes at the end of a long evolution in the methods of visual exegesis. In his work the method has been pushed as far as it could go. Smalley, who calls his commentaries 'A *reductio ad absurdum* of the spiritual

exposition so skilful and subtle that no summary can do justice to it. All the old conceptions are brought out and marvellously distorted . . .', admits that this whole structure so cunningly constructed was to collapse rapidly under the influence of Aristotelianism: 'the real exploder of Joachim's method was Aristotle'. The all-pervading influence of Aristotle's writings and the growing interest in and knowledge of nature led to a weakening of the symbolic vision in every field of the arts and sciences. Nor did exegesis prove an exception: the quest for the literal meaning of the Scriptures imposed severe restrictions on a method of symbolically interpreting texts which frequently recognised virtually no bounds whatsoever.[149] From then onwards visual exegesis was in decline.

The method of visual exegesis, however, based as it was on a special relationship between words and images, in which the latter, when susceptible to pluriform interpretation, were preferred to the text with its function of explaining and commenting, continued to live on in the emblematic tradition, which in many ways became its heir.[150]

NOTES

Notes Chapter I

1 This extremely popular poem (sometimes with variations such as 'quid speres anagogia') which occurs, among other places, in the prologue by Nicholas de Lyra to the *Glossa ordinaria*, goes back to the *Rotulus Pugillaris* (as a summary of the first chapter 'De introductoriis scientiae theologicae') by Augustine of Dacia (d. 1285, pupil of Aquinas). Cf. F. Chatillon, 'Vocabulaire et prosodie du distique attribué à Augustin de Dacie sur les quatre sens de l'écriture', *L'Homme devant Dieu. Mélanges offerts au Père Henri de Lubac*, II, Lyons, 1963, 17-28.

2 M. D. Chenu, 'Les deux âges de l'allégorisme', *Recherches de théologie ancienne et médiévale*, 18, 1951: 'dans le moindre des textes . . . tout un univers mental était contenu . . .'; H. de Lubac, *Exégèse médiévale. Les quatre sens de l'écriture*, 4 vols., Paris, 1959-64, Vol. I/1, 17: 'c'est "la trame" de la littérature chrétienne et de l'art chrétien . . .'.

3 For the theory, theology and adoration of images, and for iconoclasm, see: G. Lange, *Bild und Wort. Die katechetischen Funktionen des Bildes in der griechischen Theologie des 6. bis 9 Jrhts,* Würzburg, 1969 (246-63: extensive bibliography, also covering these problems in the West; for a good survey see also the article 'Bild' by Kl. Wessel (not mentioned in Lange's bibliography) in: *Reallexikon zur Byzantinischen Kunst*, I, Stuttgart, 1966, 616-62).

4 E. von Ivánka, *Plato Christianus.* Übernahme und Umgestaltung des Platonismus durch die Väter, Einsiedeln, 1964, 70 ff.

5 *De consensu evangelistarum*, 1, 10, 16 (*PL* 34, 1049).

6 For Paulinus of Nola's interpretation of a decoration programme designed by him, see pp. 20 ff.

7 Lange, *o.c.*, 44 ff., 51, 55 ff.

8 *In Gloriam Martyrum*, 21 (*PL* 71).

9 For an extreme form of the magical identification of image and prototype see, e.g., E. Kitzinger, 'The cult of images in the age before iconoclasm,' *Dumbarton Oaks Papers* VIII, 1954, 148: healing by means of a drink in which fragments of a fresco of Cosmas and Damian had been dissolved.

10 *Ep.* 11:13 (*PL* 77, 1128).

11 *Ep.* 9:52 (*ibidem*).

12 Some writers consider that the representations from the life of Christ in the evangeliary which Augustine of Canterbury took from Rome to England (Cambridge, Corpus Christi College; F. Wormald, *The miniatures of the Gospel of St. Augustine*, Cambridge, 1954) may have served this purpose, cf. P. Riché, *Education et culture dans l'Occident barbare VIe-VIIIe siècles,* Paris, 1962, 543.

13 Lange, *o.c.*, 153 (*Contra Caballinum*); H. Schrade, *Vor- und Frühromanische Malerei*, Cologne, 1958, 189 (conversion of Duke Ariulph).

14 Lange, *o.c.*, 106-40.

15 For the significance of inscriptions and tituli see: Schrade, *o.c.*, 108, 156, n. 83; Lange, *o.c.*, 233-45 (Exkurs III: Epigraphè).

129

(pp. 5-9)

16 Lange, *o.c.*, 182-200 (Exkurs II: Anamnèsis und Mnèmè Theou).

17 There is an interesting example from Byzantine literature of the visual method of teaching, in the story of the philosopher Syntipas (Sindbad), the oldest known version of which dates from the 11th century. Syntipas takes it upon himself to teach philosophy to a somewhat backward prince in six months. He does so by means of pictures painted on the walls of his house, together with ten 'kephalaia' (short didactic summaries); see Lange, *o.c.*, 105. For the part played by image-based instruction in the visual exegetic method see, e.g., Ch. II, pp. 31 ff.

18 For the problem of the dating of the writings of Dionysius the Pseudo-Areopagite, see Ivánka, *o.c.*, 228-30: 2nd half 4th century or beginning 6th century?

19 See, e.g., *Reallexikon zur Byzantinischen Kunst*, I, 662 ff. (Bildprogramm) and the painter's manual of Mount Athos (*Dionysios von Phurna, Malerbuch . . .*, G. Schäfer ed., Treves, 1855 (reprint Munich 1960).

20 Exceptions are the an-iconic pronouncements of the Synod of Elvira (Spain), c. 306/12: 'Picturas in ecclesia non debere, ne quod colitur et adoratur in parietibus depingatur', the an-iconic attitude of Claudius of Turin (*PL* 105, 459), and the iconoclastic schemes of Bishop Serenus of Marseilles, who was mildly reprimanded for the same by Pope Gregory the Great: 'pro lectione pictura' (*PL* 77, 128-30).

21 *Ep. ad Leonem* (*PL* 89, 521D).

22 R. Klibanski, *The continuity of the platonic tradition. Outlines of a corpus platonicum Medii Aevi*, London, 1939, 22 ff.: the Greek text of Dionysius the Pseudo-Areopagite was in a Byzantine monastery at Rome at an early date; among the Greek books that Pope Paul I sent to Pepin were the works of peuso-Dionysius, presumably for incorporation in the library of St. Denis; Louis the Pious received a copy from the Byzantine emperor Michael II. The rather inadequate translation by Abbot Hilduinus of St. Denis was followed by that of John Scotus Erigena. There was a renewal of interest in the work of pseudo-Dionysius in the 11th, and even more in the 12th century, which was partly a result of the versions brought out by Honorius Augustodunensis and Hugh of St. Victor.

23 H. Schade, 'Die Libri Carolini und ihre Stellung zum Bild', *Zeitschrift für kathol. Theologie*, 79, 1957, 69-78; G. Haendler, *Epochen Karolingischer Theologie*, Berlin, 1958.

24 J. Sauer, *Symbolik des Kirchengebäudes und seiner Ausstattung . . .*, Freiburg i. Br., 1924², 221; Durandus, Rationale Divinorum Officiorum . . ., Antwerp, 1614, 13.

25 Origen (*De Principiis, PG* 11, 49) had already formulated an analogous idea with respect to exegesis, by regarding the letter of the text as the veil concealing the deeper meaning from the 'simplices' while initiates could penetrate to higher things: 'per litteram simplices et per spiritualem intelligentiam perfectiores instruunt spiritualem intelligentiam sub velamine litterae . . .'; see, too: H. J. Spitz, *Die Metaphorik des geistigen Schriftsinns . . .*, Munich, 1972, 23-37: Deckmetaphorik-Gewebe-Hülle.

26 For exegesis on 5, 7 and 9 levels see Lubac, *o.c.*, I/1, 129-38 (sens multiples). For 'historia' see Lubac, *o.c.*, I/2, 425-38.
 St. Paul uses the terms 'allegoria' and 'mysterium' (mystical sense), e.g. in Gal. 4:24 (Sarah and Hagar). 'Allegoria' was then a new word. About 60 B.C. Phidomenes of Gadara speaks of what the ancients called 'hyponoia' and what was by his time called 'allegoria', meaning one of the figures of grammar. This was originally used for interpreting Homer, later it was applied to all older poets and to mythology. Exegesis of this sort could be cosmic, moralistic, psychological or metaphysical. This form of allegorical interpretation was still called 'exegesis' or 'hyponoia' at the time of the Apostles. See: Lubac, *o.c.*, I/1, 373 ff., 493-537; II/2, 125 ff., 188 ff.

27 L. Goppelt, *Typos. Die typologische Deutung des Alten Testaments im Neuen*, Gütersloh, 1938; E. Auerbach, 'Figura,' *Archivum Romanicum*, XXII, 1938, 436-89; C. Spicq, *Esquisse d'une histoire de l'exégèse latine au moyen âge*, Paris, 1944; E. Auerbach,

'Typologische Motive in der Mittelalterlichen Literatur,' *Schriften und Vorträge des Petrarca-Instituts Köln* II, Krefeld, 1953; J. Daniélou, *Sacramentum futuri. Études sur les origines de la typologie biblique,* Paris, 1950; B. Smalley, *The Study of the Bible in the Middle Ages,* Oxford, 1952²; M. D. Chenu, *La théologie au XIIe siècle,* Paris, 1957, 159 ff., 191 ff.; J. Pépin, *Mythe et Allégorie. Les origines grecques et les contestations judéo-chrétiens,* Paris, 1958, 247-75.

28 'Sensus tropologicus', see Lubac, *o.c.,* I/2, 549-618. 'Trope, tropus, tropos, conversio (turn) sermo conversus, conversiva locutio'; at first often synonymous with 'allegory' or 'anagoge'. 'Typus, allegoria, figura, schema' were used in addition to 'tropus' as grammatical and rhetorical terms. For a detailed investigation of the meaning of the term 'figura' see: Auerbach (1938).

G. B. Ladner, 'Some recent publications on the classical tradition in the middle ages and the renaissance and on Byzantium,' *Traditio,* 1954, 578-94 (583) points out that as with the tropes of medieval grammar and rhetoric, 'tropology' often chose moral examples from historical or mythological material in classical literature. However, the roots of the relation between 'tropology' and ethics would seem to lie in Philo and not to be purely rhetorical. Philo uses 'tropoi' together with 'ethè' for spiritual attitudes which he regards as being symbolized by allegories in the Old Testament. Consequently the 'sensus tropologicus vel moralis' was later on used generally in connexion with the salvation of the soul.

'Sensus anagogicus', see Lubac, *o.c.,* I/2, 621-46 and II/1, 429 ff. The term 'anagogia' is a barbarism and was a late substitution for 'anagoge' (possibly in an attempt to bring it into line with the other terms in the series: 'historia, allegoria, etc.'). An equivalent term is 'sursumductio'. In the tradition influenced by Dionysius the Pseudo-Areopagite and neo-platonism the distinction is often made between scriptural 'anagoge' referring to the 'futura' (eschatological) and scriptural 'anagoge' dealing with 'invisibilia' (spiritual and higher things) as a result of which 'anagoge' could become purely mystical ecstasy (cf. Lubac, *o.c.,* I/2, 640-42) and every link with 'historia' (including sacred history) could disappear (cf. Chenu, *Théologie au 12e s.,* 133, 186 ff.).

29 For the fourfold visual exegesis of Paradise see Ch. III, and for the same exegesis of Jerusalem see Ch. IV.

30 Smalley, *o.c.,* 6 ff.; for the Philo influence on east and west see Daniélou, *o.c.,* 258 and Lubac, *o.c.,* I/1, 207 ff.

31 Smalley, *o.c.,* 5 ff. (number symbolism and etymology); Lubac, *o.c.,* II/2, 7-40 (symboles numériques).

32 Auerbach (1938), 470; E. Iversen, *The myth of Egypt and its Hieroglyphs in European Tradition,* Copenhagen, 1961, 48.

33 For criticism of this view, see: Lubac, *o.c.,* I/2, 377, 384-85; II/2, 127 ff.

34 Cf. Smalley, *o.c.,* 20: Ambrose responded to the influence of Philo with a certain reserve, e.g. he remarks that a christian exegete ought to supplement him by finding types of Christ and his Church.

35 Cf. Auerbach (1938), 468: 'Die Figuraldeutung stellt einen Zusammenhang zwischen zwei Geschehnissen oder Personen her, in dem eines von ihnen nicht nur sich selbst, sondern auch das andere bedeutet, das andere hingegen das eine einschliesst oder erfüllt. Beide Pole der Figur sind zeitlich getrennt, liegen aber beide, als wirkliche Vorgänge oder Gestalten, innerhalb der Zeit . . . sie ist jedoch von den meisten anderen uns sonst bekannten allegorischen Formen durch die beiderseitige Innergeschichtlichkeit . . . klar geschieden'.

36 Daniélou, *Sacramentum futuri,* 131 ff., 257.

37 Daniélou, *ibidem,* 144.

38 Auerbach (1938) passim; (1953), 9; Daniélou, *Sacramentum futuri,* 21 ff.

39 Auerbach (1938), 465 ff.; Smalley, *o.c.,* 7, 9.

131

40 Smalley, *o.c.*, ch. I (The Fathers); Lubac, *o.c.*, I/2, 377 ff. We cannot go more deeply here into the opposition, real or not, between the 'historical' exegesis of Antioch and the 'allegorical' interpretation of the Alexandrians. See, e.g., Smalley, *o.c.*, 13 ff., 19 ff.

41 Lubac, *o.c.*, I/1, 40, 139 ff., 158 ff.; Isidore of Seville recognised 3 modi as well as 4, as did Bede and Raban Maurus. Guibert de Nogent states that Anselm taught his pupils in Le Bec both the threefold and the fourfold formulas (*De Vita Sua*, I, c. XVII; *PL* 156, 874B).

42 For the dispersion of the books of Vivarium − e.g. in part to the Lateran, the library of which was the largest source of MSS. from the 7th to the 9th centuries − see Riché, *o.c.*, 400.

43 For the Origen tradition see Lubac, *o.c.*, I/1, 207 ff., 221 ff., 245 ff., 254 ff., 290 ff.; Chenu, *Théologie au 12e s.*, 174, 178, 282-283.

44 Lubac, *o.c.*, I/1, 194 ff., 198 ff.

45 E.g. *In Ezech.* V, xvi (*PL* 25, 147-148), see also note 50.

46 Lubac, *o.c.*, I/1, 144 ff.

47 For the relation between multiple exegesis and preaching see, e.g., H. Caplan, 'The 4 senses of scriptural interpretation and the medieval theory of preaching,' *Speculum*, IV, 1929, 282-90. See also: Urs Kamber, *Arbor Amoris der Minnebaum. Ein Pseudo-Bonaventura Traktat*, Berlin, 1964, which also includes mnemo-technical tree schemes.

48 Lubac, *o.c.*, I/1, 157 ff., 166.

49 These three were then again applied to the 'simplices', to those at a more advanced level, and to the 'perfecti' (*De principiis*, IV, c. 2, 4), see Spitz, *o.c.*, 16 ff.

50 See note 45; see also Jerome, *Ep.* 120, c. 12 (*CSEL* 55, 513 ff.) with quotation from 1 Thess. 5-23, and the preface to Eucherius of Lyon's *Liber Formularum spiritualis intelligentiae* (*CSEL* 31, 4), where the comparison between the threefold division of the human being and the Scriptures occurs, again with reference to 1 Thess. 5:23, and also with a comparison to the Trinity.

51 *Reallexikon f. Antike und Christentum*, V, s.v. Enkyklios Paideia.

52 Cf. Lubac, *o.c.*, I/1, 194, 205. Origen, *In Cant.* prol. 75-80. Jerome, *In Eccl.* (*PL* 23, 1012C) extends the comparison to include the 3 grades of perfection in the spiritual life: 'incipientes, proficientes, perfecti'; for Eucherius see note 50.

53 See Lubac, *o.c.*, I/1, 75; John Scotus Erigena, *Hom. in Prol. Jo.* (*PL* 122, 291 BC); Jean Scot, *Homélie sur le prologue de Jean*, E. Jeanneau ed., Paris, 1969 (Sources Chrétiennes, 151).

54 See Ch. II.

55 Lubac, *o.c.*, I/1, 170-76 goes into this question thoroughly and concludes that Clement has to be left out of consideration.

56 Medieval exegetes from Bede and Raban Maurus up to Thomas Aquinas regarded the passage from *De genesi ad litteram*, c. 11, n. 5 (*PL* 34, 222), where reference is made to 'historia, allegoria, analogia, aetiologia' (although according to modern writers these concepts do not exactly match the quadripartite division of the by now classical medieval system) as an example of the 'quadriformis ratio'; so that one is entitled to say that Augustine at least prepared the way; cf. Lubac, *o.c.*, I/1, 177 ff., 190 ff.

57 *Collationes* 14:8 (Sources chrétiennes 54, 189-92); Lubac, *o.c.*, I/1, 190 ff.; even as late as the 12 th century Cassian was still being read every day in the monastery of St. Victor at Paris.

58 For Gregory's influence on medieval exegesis see Lubac, *o.c.*, I/2, 537 ff.

59 Lubac, *o.c.*, I/1, 219, 238.

60 For a detailed discussion of the texts concerned see: Lubac, *o.c.*, I/2, 328-41 (concorde des deux testaments) 341-55 (les symboles de la concorde) and Spitz, *o.c.*, who has classified various of these 'Metaphorische Grundvorstellungen' (Deckmetaphorik, Verwandlungs-, Stufungs-, Struktur-metaphorik).

61 London, Br. Mus. Add. MS. 10546, fol. 449 r. F. van der Meer, *Majestas Domini.*
Théophanies de l'Apocalypse dans l'Art Chrétien, Rome-Paris, 1938, 161 ff.draws atten-
tion to a commentary on Revelation by Victorinus of Pettau (d.c. 304) in which the lion
of Judah — predicted in Gen. 49:8-9 — rising from death as from a sleep, is linked up
with the scene of the unsealing of the Book and also with the unveiling of Moses: '. . . hic
ergo aperit et designat quod ipse signaverit Testamentum. Hoc sciens et Moyses . . .
velavit faciem suam'. For the significance of the bookroll in exegesis see also: Spitz, *o.c.,*
41-46.
62 P. Bloch, 'Das Apsismosaik von Germigny-des-Prés Karl der Grosse und der alte Bund,
Karl der Grosse, III, Düsseldorf, 1965, 234-61. Cf. also the slightly later tituli by Sedulius
Scotus for Archbishop Gunthar of Cologne (849-63). These were designed for a large
Majestas Domini, flanked by cherubim with vessels and censers, and were possibly
intended as a decoration for the old cathedral of Cologne (J. von Schlosser, *Schrift-
quellen zur Geschichte der Karolingischen Kunst,* Vienna, 1892, 315 ff.).
For a highly complex explanation of the wings of the cherubim see: Spitz, *o.c.,* 246, n. 53.
63 Erlangen, Universitätsbibliothek 121, fol. 355 v. Gumpert Bible, before 1195 (G. Swar-
zenski, *Salzburger Malerei,* Leipzig, 1908- 13, 135, Pl. xlviii; see also Spitz, *o.c.,* 142-54:
Verwandlungsmetaphorik, Wasser und Wein).
Other frequently occurring possibilities for interpreting this scene are: in terms of the
eucharist (e.g. in the catacombs), in terms of baptism (cf. Tertullian: Christ displaying
his power over water), or in terms of the 6 ages of the history of salvation (Augustine).
64 The most influential text is probably that by Gregory the Great, *In Ezech.,* I, 6, 15 (*PL*
76, 835B): 'Rota intra rotam est Testamentum Novum . . . intra Testamentum Vetus,
quia quod designavit Testamentum Vetus, hoc Testamentum Novum exhibuit', cf. also
ibid., I, 7 (844-48): 'Et vetus et nova lex intelligitur rota duplex: Exterior velat, velata
secunda revelat . . .'. See Spitz, *o.c.,* 77, 231-33 (Rad im Rad).
London, Br. Mus. Add. MS. 17737/38 title-page St. John's Gospel Floreffe Bible, 2nd
volume, Meuse region, c. 1150-70. (W. Neuss, *Das Buch Ezechiel in Theologie und
Kunst,* Münster i.W., 1912, 118 ff., 234 ff., fig. 45, points to the possible influence of the
Ezekiel commentary of Rupert of Deutz; cf. also Gretel Chapman, 'The Bible of
Floreffe. Redating of a romanesque manuscript,' *Gesta,* X/2, 1971).
65 For texts dealing with St. Paul's mystic mill, see Lubac, *o.c.,* II/2, 680 ff.; Spitz, *o.c.,* 77 ff.
(Kornmahlen). For the opposition of Ecclesia to Synagoge, see, e.g., W. Seiferth,
Synagoge und Kirche im Mittelalter, Munich, 1964.
66 For the significance of the 'anagogicus mos' in Suger and neo-platonic influences via the
works of pseudo-Dionysius Areopagita and John Scotus, see: E. Panofsky, in: *Gazette
des Beaux Arts,* 1944, II, 106-14; idem, *Abbot Suger on the Abbey Church of St. Denis and
its Art Treasures,* Princeton, 1946; idem, 'Postlogium Sugerianum,' *Art Bulletin,*
XXXIX, 1947, 119-21; K. Hoffmann, 'Sugers "Anagogisches Fenster" in St. Denis,'
Wallraf Richartz Jahrbuch, 1968, 57-88 (which provides a new reconstruction and
considers that the representation of the Unsealing of the Book and the Unveiling of
Moses could have been restored in imitation of the same representations in the Vivianus
Bible, which was exhibited in the Musée des Souverains at Paris 1852/72. Hoffmann
does not, however, rule out the possibility that Suger may himself have been familiar
with 9th-century compositions of this representation). For the motif of the 'velatio-
revelatio', see extensive discussion by Spitz, *o.c.,* 27 ff.
67 K. Michel, *Gebet und Bild in frühchristlicher Zeit,* Leipzig, 1902.
68 A. Grabar, *Christian iconography. A study of its origins,* London, 1969, 19 ff., figs. 40-44.
69 P. Lundberg, *La typologie baptismale dans l'ancienne église,* Lund, 1942. For the early-
christian baptistery programme see: L. de Bruyne, in: *Miscellanea liturgica L. C.
Mohlberg,* I, 1948, 191-220 (where the writer concludes that there is no question of there
being a fixed programme); H. Stern, in: *Actes du 5e congrès internat. d'archéologie*

chrétienne, Aix en Provence 1954, Rome-Paris, 1957, 381-90; J. L. Maier, *Le baptistère de Naples et ses mosaiques. Étude historique et iconographique*, Fribourg, 1964; Spiro K. Kostoff, *The Orthodox Baptistery of Ravenna*, New Haven-London, 1965. See also: *Reallexikon zur byz. Kunst*, I, Stuttgart, 1966, 460 ff. (s.v. Baptisterium); 662 ff. (s.v. Bildprogramm III: Baptisterien).

70 H. Stern, 'Les mosaiques de l'église Sainte-Costance à Rome,' *Dumbarton Oaks Papers*, XII, 1958, 157-218 (188-89); Grabar, *o.c.* (1969), 137.

A. Hermann, 'Der Nil und die Christen,' *Jahrbuch für Antike und Christentum*, 2, 1959, 66 ff., 69, n. 274 regards the Nile, by and large, as an image of the 'locus amoenus', but he also considers an interpretation of it as the crystal sea (Revelation 4: 6-11) possible, e.g. in the detail representing the Lamb adored by the 24 elders, occurring in the 'fons vitae' representation in the evangeliary from St. Médard de Soissons (Paris, B.N. lat. 8850, fol. 1 v.

However, Elis. Chatel, 'Scènes marines des fresques de St. Chef,' *Synthronon, Bibl. des Cahiers archéol.* II, Paris, 1968, 181, fig. 4, sees in this representation a continuation of the motif of the 'waters above the firmament'. Christa Ihm, *Die Programme der Christlichen Apsismalerei vom vierten Jhr. bis zur Mitte des achten Jhr.*, Wiesbaden 1960, 15 ff., 149 ff., fig. 1, interprets the representation in the Oratorium of Monte della Giustizia in terms of baptism.

The mosaic-fragments in the cupola of a mausoleum (?) at Centcelles, near Tarragona (mid 4th century?), form the nearest parallel to S. Costanza. Here the lower zone contains hunting scenes instead of a Nile-landscape. Between the christian themes higher up in the cupola (e.g. Jonah thrown to the whale, Noah and the ark, Three Hebrews in the fiery furnace, Daniel in the lion's den) appear personifications of the 4 seasons (H.P. L'Orange & P. J. Nordhagen, *Mosaics. From Antiquity to the Early Middle Ages*, London, 1966, 49 ff. Pl. IXb).

71 R. Krautheimer, 'Iconography of Mediaeval Architecture,' *Journal of the Courtauld and Warburg Institutes*, 1942, 20 ff.

72 Rome, Vatican Grottoes (E. Panofsky, *Tombsculpture. Its changing aspects from ancient Egypt to Bernini*, New York, 1964, 41 ff., fig. 157).

73 Brescia, Museo Civico, North Italian, c. 360-80 (R. Delbrueck, *Probleme der Lipsanothek in Brescia*, Bonn, 1952; Grabar, *o.c.* (1969), 138, figs. 333-37).

74 *Reallexikon zur byz. Kunst*, I, s.v. Bildprogramm. Moreover no parallels to the representations mentioned can be found in the earliest Christian art; they only begin to appear later, for example in the 6th-century tituli of Rusticus Helpidius, see pp. 23 ff. and note 84.

75 *Epist. LXI to Olympiodorus Eparchus* (*PG* 79, 577 ff.)

76 J. von Schlosser, Quellenbuch zur Kunstgeschichte des Abendländischen Mittelalters, Vienna, 1896, 30-32.

77 In: *Prudentius*, H. J. Thomson transl., London-Cambridge (Mass.), vol. II, 1961, 346-71.; Christa Ihm, *o.c.*, 136 thinks that it may be connected with a Spanish church.

78 Schlosser, *o.c.*, 13-30; R. C. Goldschmidt, *Paulinus' Churches at Nola*. Texts, Translations and commentary, Amsterdam, 1940; A. Weis, 'Die Verteilung der Bildzyklen in der Basilika des H. Paulinus in Nola,' *Römische Quartalschrift*, LII, 1957, 1-17.

79 W. Elliger, *Die Stellung der alten Christen zu den Bildern in den ersten vier Jahrhunderten*, Leipzig, 1930, 83, also arrives at this interpretation of 'raro more'.

80 For the Scriptures as food, cf. the texts in Lubac, *o.c.*, I/i and Lange, *Bild und Wort*, 83, n. 30 (Philo's idea that contemplating an image is like attending a banquet, and an Armenian example of this comparison from the 7th century); possibly the same explanation of 'esca' as spiritual food occurs in the poem on the 'arbor philosophiae' by Theodulf of Orleans, see my article in: *Album Amicorum J. G. van Gelder*, The Hague, 1973, 102-13.

81 There is a possibly related, early representation in the apse of the Basilica Suricorum at Capua Vetere (c. 430) with Mary and Child seated in the branches of a tree (cf. Ihm, *o.c.*, 56, 178, fig. 10 reconstruction).

82 Schlosser, *o.c.*, 102-04; F. Wickhoff, 'Das Speisezimmer des Bischofs Neon von Ravenna,' *Repertorium für Kunstwissenschaft*, 17, 1894, 10-17; A. Weis, 'Der römische Schöpfungszyklus des 5. Jrhts. im Triclinium Neons zu Ravenna,' *Tortulae. Festschrift J. Kollwitz = Römische Quartalschrift*, Suppl. H. 30, 300-16 (detailed analysis of the creation scenes and their relation to 5th-century roman cycli, e.g. in the Old St. Peter's and S. Paolo fuori le mura). The programme expresses ideas related to Rom. 5:12ff. (parallel between Adam and Christ) and 1 Cor. 15:22, 45-49 (Christ has brought a new creation and annulled the consequences of the Fall).

83 Grabar, *o.c.* (1969), 142 ff., figs. 338, 339. The factor linking these representations could possibly be an allusion to the sacraments.

84 Schlosser, *o.c.*, 34-37.

85 Schlosser, *o.c.*, 47-49.

86 J. von Schlosser, *Schriftquellen zur Geschichte der karolingischen Kunst*, Vienna, 1892, 323 ff.

87 Grabar, *o.c.* (1969), 138.

88 H. Karpp, *Die frühchristlichen und mittelalterlichen Mosaiken in Sta Maria Maggiore zu Rom*, Baden-Baden, 1966.

89 Grabar, *o.c.* (1969), 46 ff., figs. 126-31 thinks that the composition in two zones may have been influenced by the two columns which the emperor Arcadius erected at Constantionople c. 400 in honour of his father Theodosius I (a 'renovatio' of late-antique examples like Trajan's column of c. 106-13; cf. also E. H. Swift, *Roman sources of christian art*, New York, 1951, 50-69: christian symbolism and narrative style). It seems more likely that we are dealing with the possible influence of early narrative Old Testament illustrations with compositions in zones. See for this extremely complex problem e.g.: *Reallexikon zur deutschen Kunstgeschichte*, II, 478-80, s.v. Bibelillustration; K. Weitzmann, *Illustrations in Roll and Codex. A Study of the origin and method of text illustration*, Princeton, 1970² (Addenda, 229, 232 ff., 242 ff.); idem, 'Die Ill. der Septuaginta,' *Münchener Jahrbuch der bild. Kunst*, III/IV, 1952-53, 96-120; H. L. Hempel, 'Jüdische Traditionen in frühmittelalt. Miniaturen,' *Beiträge zur Kunstgeschichte und Archäologie des Frühmittelalters*, Frühmitt. Kongress, Vienna 1958, Graz-Cologne, 1962, 53-66; K. Weitzmann, 'Zur Frage des Einflusses jüdischer Bildquellen auf die Illustrationen des alten Testamentes,' *Mullus. Festschrift Th. Klauser*, Münster, 1964, 403-15.

90 Cf. Suzanne Spain, *The program of the 5th c. mosaics of Sta Maria Maggiore*, diss. NY University (known to me only from a summary in: *Marsyas*, 1968-69, 85). The hypotheses put forward by N. A. Brodsky, in: *L'Iconographie oubliée de l'arc éphésien de Ste Marie Majeure à Rome*, Brussels, 1966, seem on the whole questionable, see: review *Art Bulletin*, Sept. 1968, 286-87; see also: Grabar, *o.c.* (1969), 47: 'wrongly called the "Ephesian" arch . . .'.

91 St. Waetzoldt, *Die Kopien des 17. Jahrhts nach Mosaiken und Wandmalereien in Rom*, Vienna-Munich, 1964 (Römische Forschungen der Bibliotheca Hertziana, Bd. XVIII), figs. 484-85 (compositional plan of the wall of St. Peter's); H. W. Janson, *History of Art*, London, 1962, fig. 253 (compositional plan of the wall of S. Paolo). The representations were in two zones with prophets and saints between the windows and series of papal portraits below the lower zone. In St. Peter's there was a New Testament cycle from the life of Christ opposite an Old Testament cycle. In S. Paolo the New Testament cycle was taken from the life of Paul. In both cases the Old Testament was depicted on the right-hand wall and the New Testament on the left, that is to say left and right of the Christ figure in the apse (see Christa Ihm, *o.c.*, 22 ff.: St. Peter; 135 ff.: S. Paolo). This

usage can be traced through far into the 12th century, cf. a text concerning the monastery church at Petershausen near Constanz: 'Muri quoque basilicae erant ex omni parte pulcherrime depicti: ex sinistra parte habentes materiam de veteri, a dextra autem de novo testamento' (Schlosser, *Quellenbuch*, 234).

For the symbolic meaning of left and right, north and south, see: Sauer, *Symbolik des Kirchengebäudes* (Index: Links, Rechts, Norden, Süden).

For the continuation of the early-christian roman programmes, see, e.g.: J. Garber, *Wirkungen der frühchr. Gemäldezyklen der alten Peters- und Paulsbasiliken in Rom*, Berlin-Vienna, 1918 and the article by A. Weis in *Tortulae* quoted earlier (see note 82).

92 A. Dempff, *Sacrum Imperium*, Munich-Berlin, 1929; F. X. Seppelt and G. Schwaiger, *Geschichte der Päpste von den Anfängen bis zur Gegenwart*, Munich, 1964, 39-44.
93 Grabar, *o.c.* (1969), 141.
94 *Ibidem*.
95 H. Wentzel, *Meisterwerke der Glasmalerei*, Berlin, 1951, 15-16, Pl. I, figs. 1-6; A. Boeckler, 'Die romanischen Fenster des Augsburger Domes und die Stilwende vom 11. zum 12. Jrh.,' *Zeitschrift des dts. Vereins für KW*, 10, 1943, 153-82.
96 For the Majestas Domini as a quadripartite visual exegetic scheme see Ch. II, pp. 47 ff.
97 See Ch. II, pp. 56 ff. and figs. 47a-d.
98 Cf. O. Demus, *Byzantine mosaic decoration. Aspects of Monumental Art in Byzantium*, London, 1947, 7: 'the image is not a world by itself; it is related to the beholder, and its magical identity with the prototype exists only for and through him ...' (although the use of the term 'magical identity' is not without its dangers).
99 Lange, *o.c.*, 69.
100 See Spiro Kostoff, *o.c.* and the other literature cited in note 69.
101 For an analysis of the programme in the presbytery of S. Vitale, which says nothing, however, about the supplementary rôle of the human being, see: Grabar, *o.c.* (1969), 144 ff.
102 Cf. the 12-century mosaics of the Capella Palatina at Palermo.
The choice of scenes and the way they were positioned on the wall of the south transept has been determined by the need for them to be visible from the royal box, high up in the north transept. Demus so far as I am aware, is the first to have postulated the existence of two axes in court chapels: a 'liturgical axis' from west to east and a 'dynastic axis' from north to south, corresponding to the line of sight from the king's box (cf. O. Demus, *The Mosaics of Norman Sicily*, London, 1949, 53 and n. 233, Plates 12 and 21).

NOTES CHAPTER II

1 Hugh of St. Victor, *In Hier. cael.* 1, 10 (*PL* 175, 1137 C): 'Descendimus quando simplicitati coelestium naturarum multiplicitatem corporalium formationum per significationem aptamus. Ascendimus, quando eamdem multiplicitatem visibilium figurationum ad intelligentiam simplicis veritatis exponendo resolvimus'.
2 See p. 46, note 102.
3 H. I. Marrou, *St. Augustin et la fin de la culture antique*, Paris, 1938, pp. 237 ff., 570 ff. Augustine conceived the plan of writing a handbook on the 'artes liberales' himself: the *Disciplinarum libri*, but only *De grammatica* and six books of *De musica* have survived. The term quadrivium first occurs in Boethius; trivium makes its first appearance in the 9th century; cf. *Lexikon der chr. Kunst*, II, Rome etc., 1970, s.v. Freie Künste.
4 *Cassiodori senatoris Institutiones*, ed. R.A.B. Mynors, Oxford, 1937, 1961², 158 Conclusio 1. and 3.; Marrou, *o.c.*, 377: Abélard, who was the first to aim at creating a single great theological synthesis, still presented this synthesis as an introduction to the Scriptures.

5 The phenomenon of visual exegesis has been noted by various authors:
A. Katzenellenbogen, *Allegories of the virtues and vices in mediaeval art*, New York,
1964², 37: '... the Ratisbon miniaturists ... in comprising for the first time within a
highly developed geometrical design a body of carefully worked out ideas (far beyond
the scope of the then usual themes) such as the teaching of the moral significance of the
creation, of the monastic life and the monarchy. In doing this and in *fusing word and
picture in a unity*, they anticipated in a unique manner the endeavours of succeeding
epochs' (*inter alia* in connexion with the Uta evangeliarum, Munich, Clm. 13601, c.
1002/25); and *o.c.*, 63: (my italics) '... tract illustration ... This type of illustration
provided a new field for the miniaturists of the first half of the 12th century, because
certain figurative conceptions of the authors called for clear *visual representation*, that
the reader in the midst of a complicated world of abstractions might see and grasp the
essentials'.
B. Smalley, *The Study of the Bible in the Middle Ages*, Oxford, 1952², 95: (my italics) '*The
roles of text and picture*, that we are accustomed to, *seem to be reserved* in much of the
twelfth-century educational literature. You begin with your picture, to which the text is
a commentary and illustration. The most abstract teaching must take its starting point
from some concrete shape which the pupil can have visibly depicted for him' (in
connexion with the use of this method by Hugh of St. Victor).
M. Reeves & B. Hirsch-Reich, 'The "Figurae" of Joachim of Fiore,' *Mediaeval and
Renaissance Studies*, 3, 1954, 198: (my italics) 'The figures that the abbot created were in
a real sense general expositions of his system of thought — not illustrations to his text
merely, but *independent designs*, embodying the multitudinous patterns of his thought in
some ways far more adequately than words could do' (in connexion with Joachim da
Fiore's *Liber Figurarum*).
H. Bober, 'In Principio. Creation before Time,' *De Artibus Opuscula XL. Essays in
Honor of Erwin Panofsky*, New York, 1961, 27: (my italics) '... a type of medieval
composition and iconography *which develops in and out of schematic method.* Through
such an example we can see how form and content develop without requiring any single
textual source or combination of texts. The monogram, as a figured schema, develops
visual graphic exegesis in the art of the book in much the same way that verbal exegesis is
practiced by the textual commentators. Our monogram serves ... to call attention to the
unusual importance of Genesis initials as the focus of *visual exegesis* in Bible illustration'
(in connexion with the Genesis IN initials, see p. 40 of this chapter). '... the monogram
does not derive from, illustrate or exactly fit any particular text. Compositional structure
and intellectual content develop perfectly and completely in the formal and visual realm
of which the schemata have been an unrecognized determinant' (he is the first to draw
attention in this connexion to the rôle of the school schemata).
E. Greenhill, *Die geistigen Voraussetzungen der Bilderreihe des Speculum Virginum.
Versuch einer Deutung*, Münster i. W., 1962, 129: (my italics) 'Die Bilder sind dem Text
völlig gleichgeordnet, sind häufig der Exegese näher als der Text selbst, und dürfen als
bildgewordene Exegese zum Hohelied bezeichnet werden'.
6 See respectively pp. 42 ff., 108, n. 51; pp. 98 ff., 123 ff.
7 See Illustrations 46, 47, 58c, 69a, 78b.
8 Cf. the transmigration of the western formula of the Majestas Domini from the
evangeliaria to monumental art (as apse theme) and the adoption of the composition of
the 'quadriga virtutum' for portable altars, see pp. 47 ff. and 52 ff.
9 See for example Marcobius, *Comm. in Somnium Scipionis* I, xxi, 3; II, v, 13 and vii, 3, 5
(ed. Fr. Eyssenhardt, 571, 601, 608).
10 Cassiodorus, *Institutiones*, II, 5 (ed. Mynors, 92); for the primacy of 'sight' among the
senses and the influence of this on the rôle of the image and the prestige of painting, see:
G. Lange, *Bild und Wort. Die katechetischen Funktionen des Bildes in der griechischen
Theologie des 6. bis 9. Jhrts.*, Würzburg, 1969, 19 ff., 24 ff.

137

11 This becomes especially clear in the representation of the 'quadriga', see pp. 48 ff., 51 ff.

12 E. Auerbach, 'Figura,' *Archivum Romanicum*, XXII, 1938, 476.

13 Darmstadt, Hessische Landes- und Hochschulbibl., MS. 1640, fol. 6 v., 7 r., Cologne, c. 1000 (P. Bloch ed., *Der Darmstädter Hitda-Codex*, Frankfurt a. M. — Berlin, 1968, 89).

14 London, Br. Mus., Arundel 44, fol. 83 v., 114 r., 2nd quarter 12th cent.; earliest copy of the *Speculum?* (Greenhill, *o.c.*, 33, fig. 12 (fol. 114 r.) and 114 ff., fig. 9 (fol. 83 v.).

15 Lib. III (*PL* 122, 622-26). Frances Yates, 'Ramon Lull & John Scotus Erigena,' *Journal of the Courtauld and Warburg Institutes,* 1960 (27, 34; appendix 42-44 and fig.) thinks that there may be an allusion here to a meditation technique in use in the Irish monastic tradition: ' . . . perhaps using revolving circles or figures?' For a related use of diagrams for magical practices see also: L. Thorndike, *A History of magic and experimental science,* I, New York, 1923, 366, 673 ff.

16 For the use of diagrams and schemata in late antique schoolteaching, see e.g. the examples mentioned in: Isidore, *Traité de la nature,* ed. J. Fontaine, Bordeaux, 1960, 15-18.

17 M. Roger, *L'enseignement des lettres classiques d'Ausone à Alcuin,* Paris, 1905, 437-48 (conclusion); Marrou, *o.c.,* 291 ff.

18 L. Koep, *Das himmlische Buch in Antike und Christentum,* Bonn, 1952; E. R. Curtius, *European literature and the latin middle ages* (Bollingen Series XXXVI) New York, 1953, 302-47 (The book as symbol).

19 Interest was first focussed on this by H. Bober, 'An illustrated medieval school-book on Beda's "De natura rerum",' *Journal of the Walters Art Gallery,* 1956-57, 65-97; idem, *o.c.* (1961), 13-28.

20 Marrou, *o.c.,* passim.

21 R. S. Brumnaugh, *Plato's Mathematical Imagination,* Bloomington, Indiana, 1945; idem, 'Logical and Mathematical symbolism in the Platonic Scholia,' *Journal of the Warburg and Courtauld Institutes,* 24, 1961, 45-58; *ibidem,* 1965, 1-14; *ibidem,* 1968, 1-11. Bober, *o.c.* (1961), 45: 'Plato's works demonstrate a mind with a fruitful geometrical imagination; his mathematical passages only make sense when one imagines at the same time the diagrams intended to go with them. There are all sorts of possibilities: 'inscriptions, cross-classifications, linear order or linked terms, branching "genealogical" classifications, intersecting cycles, concentric circular constructions'.
By and large these are also the possibilities open to the visual exegetic schemata.
The platonic tradition did not have a series of original platonic diagrams, but operated with the same geometrical inventiveness as was displayed by the original texts. For a list of all the schemata used see: W. C. Greene, *Scholia Platonica, Haverford, 1938, 569 (index schematum).*

22 In particular *Timaeus* 31b-32c with the harmony between the 4 elements discussed there; and 35b: the geometric proportions (1, 2, 4, 8 and 1, 3, 9, 27); and 55d-56c: the relation between the elements and the 4 primary bodies: pyramid (tetrahedron)-fire, octahedron-air, icosahedron-water and cube-earth. Cf. F. M. Cornford, *Plato's cosmology. The Timaeus of Plato,* London, 1956⁴, 43 ff.; 66; 222 ff.

23 See P. Vossen, 'Über die Elementen-Syzygien,' *Liber Floridus. Mittellateinische Studien Paul Lehmann . . . gewidnet,* B. Bischoff & S. Brechter ed., St. Ottilien, 1950, 33-46.

24 Cf. Vossen, *o.c.,* for the doctrine of the 'syzygiae elementorum', the 4 elements related to each other through love and hate, which probably goes back to Empedocles.

25 E.g. *De civitate Dei,* XII, 19, 13-22 (*CCSL* XL, viii, p. 375).

26 See the examples cited by Bober, *o.c.* (1961), 22 n. 43. Characteristic examples of the Chalcidius illustrations are the diagrams in: *Platonis Timaeus Interpretatore Chalcidio cum Eiusdem commentario,* J. Wrobel ed., Leipzig, 1876 (descriptio I-XXVI). A harmony scheme is a scheme in which the components are arranged so as to emphasize the essential harmony of the created universe.

27 Macrobius, *Comm. in Somnium Scipionis* I, vi, 24 (ed. Eyssenhardt, 500). For the sources of Macrobius see: P. Courcelle, *Les Lettres Grecques en Occident. De Macrobe à Cassiodore, Paris, 1948²*, 3-36; W. H. Stahl, *Macrobius, commentary on the dream of Scipio*, New York, 1952, 24-38 (Plotinus (?) and especially Porphyry).

28 For the estimation of sight above hearing see note 10 above; for the illustrations see: Stahl, *o.c.*, 175, 202, 209.

29 In connexion with Macrobius, *Comm.* I, xxi, 3-4; Copenhagen, Ny Kongl. Saml. 218, 4° (M. Mackeprang, V. Madsen & C. S. Petersen, *Greek and Latin Illuminated MSS. in Danish Collections*, Copenhagen, 1917, 47-48, Pl. LXII).

30 London, Br. Mus., Arundel 339, fol. 120 v., 13 th century. Chalcidius' *Timaeus* commentary, Boethius, *Arithmetica*, Macrobius, *Comm. in Somn. Scipionis* and other arithmetical, geometrical, musical and astronomical texts (F. Saxl & H. Meier, H. Bober ed., *Cat. of astrol. & mythol. ill. MSS . . .*, III, London, 1953, 93 ff.; Bober, *o.c.* (1961), fig. 7). The same scheme occurs much earlier in a passage on the mixing of the elements in an 11th-century commentary on Boethius; but it is probably not original; see note 53.

31 Martianus Capella, *De nuptiis Philologiae et Mercurii*, liber I, 1-10 (ed. Fr. Eyssenhardt, Leipzig, 1866, 1).

32 Roger, *L'enseignement*, 127; W. H. Stahl, R. Johnson & E. L. Burge, *Martianus Capella and the 7 Liberal Arts*, vol. I. The quadrivium of Martianus Capella. Latin traditions in the mathematical sciences 50 B.C.-A.D. 1250, New York-London, 1971.

33 See the illustrations in: K. A. Wirth, 'Eine illustrierte Martianus-Capella-Handschrift aus dem 13. Jrh.,' *Städel Jahrbuch*, N.F., 2, 1969, 43-75; Flor. Mütherich, 'De Rhetorica. Eine Illustration zu M.C.,' *Festschrift B. Bischoff . . .*, Stuttgart, 1971, 198-206.

34 Paris, B. N. lat. 3110, fol. 60 r., c. 1100 (Wirth, *o.c.*, 57, fig. 21, with list of the earlier literature). The 3rd figure from the left, 'pastor Oclus' features in the poem on the facing page, but is of no further relevance for the scheme.

35 Cf. Florence, Bibl. Laurenziana, Plut. XII. 17, *De civitate Dei*, fol. 2 v., English, 11th/ 12th century (*New Paleographic Society*, 1903-12, II Pl. 138); Strasbourg, Bibl. de la Ville, Herrad of Landsberg, *Hortus Deliciarum*, fol. 225 v., 12th century (Straub-Keller, Pl. LIX). Schemata for the 7 liberal arts in an architectonic form are uncommon. A late example in Tübingen, MS. M.d.2, fol. 320, gives a comparison between the 7 arts, the planets, and metals.

36 Basle, coll. R. von Hirsch (previously coll. R. Forrer, Strasbourg), Salzburg (?) 12th century (Wirth, *o.c.*, fig. 30).
 A 'rota' scheme of 'Medicina lactans' with her personified subdivisions in a Prudentius MS.: Lyons, Bibl. Pal. des Arts, 22, fol. 1 r., 11th century (R. Stettiner, *Die Ill. Prudentius Hss.*, 1895, Pl. 109. 1) possibly goes back to the same prototype as the 'rota' of Philosophia and the 'artes' in the *Hortus Deliciarum*. The equating of Medicina and Philosophia could have been influenced by Isidore of Seville, *Etym.* IV, xiii, 1 De initio medicinae: '. . . Hinc est quod Medicina secunda Philosophia dicitur . . .'

37 Courcelle, *Lettres grecques*, 198-204; M. Cappuyns, *Jean Scot Erigène*, Louvain-Paris, 1933, 25-26; *Johannes Scotti Annotationes in Marcianum Capellam*, Cora E. Lutz ed., Cambridge Mass., 1939; Cora Lutz, 'Remigius ideas on the origins of the 7 liberal arts,' *Mediaevalia et Humanistica*, X, 1956, 33-34; *Remigii Autissiodorensis, Comm. in Marcianum Capellam*, libri I-IX, 2 vols., Cora E. Lutz ed., Leiden 1962-65.

38 P. Courcelle, *La consolation de Philosophie dans la tradition littéraire. Antecédents et Postérité de Boèce*, Paris, 1967, 269.

39 Cf. I, 44, 18 and 74, 5 (ed. Lutz, 149-50 and 199).

40 See the examples in the following MSS.:
 Munich, Clm. 14271, fol. 11 v., Regensburg, 11th cent. (Wirth, *o.c.*, fig. 39): a complete page of drawings of antique gods; suggestive of a model-book (based on the illustrations of a prototype?). Since the leaf occurs between the end of the two first books of

Martianus Capella and the beginning of the Remigius commentary, it is not clear to which of the two it belongs.

Paris, Bibl. Geneviève, MS. 1041/42, I, fol. 1 v., French, c. 1200: representation of the 'artes' of the trivium, preceding: 'Incipit commentum Remigii in primo libro . . ' (Lutz, o.c., II, Pl. preceding p. 1). Berne, Burgerbibl. Cod. B. 56, e. 9th/b. 10th cent., Martianus Capella MS. with glosses in the margin incorporating portions of the Remigius commentary: fol. 182 v. a variation on the standing figure which also occurs in Munich, Clm. 14271, fol. 11 v.; various diagrams were added at the beginning and end of the manuscript during the 11th and 12th centuries: stemmata composed of circles (fol. 5r., 183 v., 184 r.) accompanying the following concepts: 1. vir bonus, 2. Oratoris spetialis diffinitio, 3. utilitas, 4. Philosophia, 5. causa plenaria VII cir(cum)stantias habet, 6. 7. and 8. large circle containing 3 concentric tapering rings and 8 'spokes' (O. Homburger, *Die ill. Hss. der Burgerbibl. Bern*, Berne, 1962, 164 ff., Pl. 133; 166).

41 Courcelle, *La consolation de Philosophie* (1967).

42 *Anici Manli Severini Boethi. De consolatione Philosophiae,* ed. A. Fortescue & C. D. Smith, London, 1925, 81-85.

43 Cf. the enthusiastic remark: 'summa totius philosophiae in his versibus continetur' in: Paris, B.N., lat. 6401 A, fol. 45 r., placed opposite metrum 9 (Courcelle, *La consolation de Philosophie* (1967), 14, n. 4). For the sources of Boethius see: Courcelle, *Lettres grecques,* 257-312 and idem, *La consolation de Philosophie* (1967), 163.

44 Isidore of Seville, *De natura rerum* (*PL* 83, 963-1018), written c. 612-20, dedicated to Sisebut, king of the Visigoths; *Isidore de Seville, Traité* de la Nature, J. Fontaine ed., Bordeaux, 1960, 15 ff. (origine et valeur des figures).

45 *Etym.* III, iv. 1: 'Ratio numerorum contemnenda non est. In multis enim sanctarum scripturarum locis quantum mysterium habent elucet. Non enim frustra in laudibus Dei dictum est (Sap. 11, 21): Omnia in mensura et numero et pondere fecisti.' For number symbolism and the church fathers see, e.g. J. Fontaine, *Isidore de Séville et la culture classique dans l'espagne wisigotique,* II, Paris, 1959, 370. For the tract formerly, but now no longer, attributed to Isidore: *Liber numerorum qui in sanctis scripturis occurrunt* (*PL* 83, 179) see: B. Bischoff, 'Eine verschollene Einteilung der Wissenschaften,' *Mittelalterliche Studien,* I, Stuttgart, 1966, 273-88 (with bibliography).

For the connexion between number symbolism and exegesis see: Lubac, o.c., II/1, 7-39 and Ch. Butler, *Number Symbolism,* London, 1970, Ch. II (The Early Medieval Period: Biblical Exegesis and Worldschemes, 22-46). A number of as yet unpublished medieval treatises on number symbolism are discussed by: Guy Beaujouan, 'Le symbolisme des nombres à l'époque romane,' *Cahiers de civilisation médiévale,* IV, 1961, 159-69.

46 Marrou, o.c., 449-53.

47 For Carolingian exegesis, cf. Sibylle Mähl, *Quadriga virtutum. Die Kardinaltugenden in der Geistesgeschichte der Karolingerzeit,* Cologne-Vienna, 1969.

48 Ed. Fontaine, 213-17.

49 Ed. Fontaine, fig. p. 212 bis (figura solida), fig. p. 216 bis (rota).

50 Paris, B. N., lat. 6400 G, fol. 122 v.; in the 9th century this MS. was at Fleury (B. Teyssèdre, 'Un exemple de survie de la figure humaine dans les mss. précarolingiens. Les ill. du 'De N. R. d'Isidore',' *Gazette des B.A.,* 102, 1960 II, 19-34, fig. 7).

51 Cf. the thoroughgoing investigation by Bober, o.c. (1956-57), 65 ff. in connexion with a schoolbook of this type at Baltimore, Walters Art Gallery, W. 73, which was put together on the same system, though at a later date. For the 'Nachleben' of the 'rotae' into the 17th century, see: ed. Fontaine, 18 n.l. (obsession de la figure circulaire).

52 E.g. Berlin, Staatsbibl. Maihingensis, I.2.lat.4°, 3, 10th century (Courcelle, o.c. (1967), 49, 272, 404-05). Both on fol. 28 v. in a compilation by Fromund of Tegernsee after the Boethius commentary by Remigius, elucidating Boethius, *Consolatio* III, 9, there is a

'rota' with the macrocosmos-microcosmos comparison, the 4 elements, 4 aetates hominis and 4 seasons.

There is an example of transmigration of the round scheme of the elements in: Munich, Staatsbibl., Clm. 14798, fol. 70 v. (quadripartite 'rota' still vaguely visible) in a work on St. Christopher dedicated by Walther of Speyer to Bishop Balderich of Speyer in 984, cf. P. Vossen, *Der Libellus Scolasticus des Walther von Speyer*, Berlin, 1962, 14.

53 Cf. Paris, B. N., lat. 7361, fol. 51 v., 11th / 12th century: linear scheme of the elements, qualities, number series and 'tetragonus cubus', announced in the text as follows: 'subscribatur figura, ut quibus ad intellectum nostra non sufficit lingua, his ad videndum satisfaciat pictura', in a Boethius commentary by Adalbold of Utrecht (the syzygiae theory taken over from Remigius), see R. B. C. Huygens in: *Sacris Erudiri*, 1954, 409-26, Pl. IV. Same in: Paris, B. N., lat. 15104, compilation of the commentaries of Adalbold of Utrecht (almost word for word), Remigius of Auxerre and Guillaume de Conches. Here, too, the introduction 'Quod ut facilius et alia omnia innotescant quaecumque supra dicta sunt, in subiecta descriptione monstrabitur' is followed by the linear scheme of the elements (according to Courcelle, *o.c.* (1967), 408: 13th century). Transmigration of the linear scheme of the elements e.g. to the end of the text of Boethius' *Consolatio*, where it is strictly speaking irrelevant, but may have served as a summary of the cosmological subject-matter contained in the text, in: Madrid, B. N., MS. Vitr. 20, I, fol. 54 v., late 11th century (Bober, *o.c.* (1961), 22, fig. 5); see our fig. 13b.

54 E.g. Oxford, St. John's College, MS. 17, fol. 13, English, c. 1100, contains, among other things excerpts from Byrhtferth of Ramsey and Bede, *De natura rerum* (Bober, *o.c.* (1961), fig. 6). In addition, on fol. 39 r. the 'figura solida' and on fol. 39 v. the 'rota' of 'mundus, annus, homo', and on fol. 40 r. scheme of the climatic zones.

55 Ed. Mynors, X ff. (survey of the surviving MSS.) and 167.

56 For an extensive discussion see: Bober, *o.c.* (1956-57) and *o.c.* (1961); Fontaine, *Isidore de S. et la culture classique*, 657 ff., considers that the 'figura' may refer back to Isidore himself, since it is the only figure in his *De natura rerum* which he introduces in the first person.

57 Ed. Eyssenhardt, 493; Stahl, *Macrobius Commentary*, 96 ff.

58 Cf. Isidore, *Etym.* III, 12, 3: 'Cubus est figura propria solida quae longitudine, latitudine et altitudine continetur'; see also Augustine, *De quantitate animae*, 6, 10-12, 21 (*PL* 32, 1041-47) on the 3 dimensions of space: longitudo, latitudo, altitudo, cf. Marrou, *o.c.*, 262. Furthermore Cassiodorus, *Institutiones* II, 4, 6 (ed. Mynors, 140) might have played a part here by adding to the description of the 'solidus numerus' a 3-dimensional drawing of the cube: 'solidus numerus est qui longitudine et latitudine vel altitudine continetur, ut sunt pyramides, qui in modum flammae consurgunt, ita (seq. figura) cybi, ut sunt tesserae, ita (seq. figura) spherae, quibus est aequalis undique rotunditas, ita (seq. figura)' which is quoted word for word by Isidore, *Etym.* III, 7.

59 O. K. Werckmeister, 'Three problems of tradition in pre-carolingian figure style. From visigothic to insular illumination,' *Proceedings of the Royal Irish Academy*, Vol. 63, Sect. C, No. 5, Dublin, 1963, 167-89.

60 See note 50: fol. 117 v. (diagram of the months), 121 v. (climatic zones), 122 v. (rota of the elements according to Ambrose).

61 Paris, B. N., lat. 6413, fol. 4 v., 2nd half 8th century (Teyssèdre, *o.c.*; Werckmeister, *o.c.*).

62 Munich, Clm. 16128, Salzburg (?), c. 800, fol. 15 r. (K. Holter & W. Neumüller, *Der Codex Millenarius*, Graz-Cologne, 1959, 157 ff., figs. 54-56).

63 Cf. the figure of 'aer' seated on a bird, on the relief at the east side of the Ara Pacis at Rome, 13-9 B.C. (Th. Kraus, *Das Römische Weltreich*, Berlin, 1963, Propyläen Kunstgeschichte, Bd. 2, fig. 184). See also the medieval representations of elements mounted on animals: small silver plaquettes on the back of the cross of Engelberg, c. 1200 (Ellen Beer, *Die Rose der Kathedrale von Lausanne . . .*, Berne, 1952, fig. 34) and MS. Vienna,

141

(pp. 39-41)

Österr. Nat. Bibl., cod. 12600, fol. 30 r.: Ps. Beda, *De ordine ac positione stellarum et al.*, Prüfening, c. 1200 (M. W. Evans, *Medieval Drawings,* London-Toronto, 1969, fig. 77). The cubus/terra comparison (going back to *Timaeus,* 55e) also occurs in the scheme in the appendix *Excerptum de quattuor elementis* (Cassiodorus, *Institutiones,* ed. Mynors, 167).

64 Anagni, crypt of the cathedral, end 12th/early 13th century (Bober, *o.c.* (1961), fig. 8; O. Demus, *Romanische Wandmalerei,* Munich, 1968, 125-26, Pl. XXII-XXIV, 53, 54 with ground-plan after Toesca).

65 A quadripartite circular scheme with the 4 humours represented simply by heads (L. Pressouyre, 'Le Cosmos platonicien de la cathédrale d'Anagni,' *Mélanges d'archéologie* (Ecole française de Rome), t. 78, 1966, 551-93 with ills.).

66 A. C. Crombie, *Medieval and early modern science,* I, New York (Doubleday Anchor Books), 1959, 163.

67 An earlier building was altered in 1187, so the lost decoration must date from after that time (H. Cornell, *Biblia Pauperum,* Stockholm, 1925, 136: Fr. Wilh. Wittwer (1449-1512) described the decoration in his *Catalogus Abbatum Monasterii S.S. Udalrici et Afrae* (Augsburg, Bischöfl. Ordinats-archiv, No. 78) as 'mystisch astronomische Kreise').

68 E.g. Cologne, Cath. Bibl. 753 b, Cologne, mid-11th cent. (Bober, *o.c.* (1961), 27 and fig. 9) evangeliarium, fol. 178 v.: IN-monogram, preceding St. John's Gospel.
For the Majestas scheme as cosmic harmony scheme, see pp. 47 ff. For IN-initials in general see: H. Jantzen, 'Das Wort als Bild in der frühmitt. Buchmalerei, '*Über den gotischen Kirchenraum . . .*, Berlin, 1951, 53-60 (initial and monogram as iconographic type); H. Dembowski, *Initium Sancti Evangelii,* Cassel, 1959; J. Guttbrod, *Die Initiale in Hss des achten bis dreizehnten Jahrhunderts,* Stuttgart etc., 1965, 74 ff. (Die I-initialen), which does not, however, discuss the IN-initials. Another interesting instance is the adaptation of the IN scheme for visual exegetic purposes in the 13th-century Bible in the cathedral archives at Merseburg, where a parallel is drawn between the knowledge of the ancients respecting the creation and composition of the world and the days of creation; a kind of tree is rooted in the representation of the meeting of 4 of the sages of the ancient world: Ovid, Vergil, Aristotle and Plato (A. Stange, in: *Münchener Jahrbuch,* VI, 1929, 329 and fig. 16).

69 Brussels, Bibl. Royale, MS. II, 1639, fol. 6 v., Meuse area, c. 1070. The inscriptions forming the marginal text round the medallions with the 4 elements run as follows: 'Bis. Bina. Bis VIII (Ignis), Bis. Bina. Ter XII (aer), Ter. Tria. Bis XVIII (Aqua),Ter. Tria. Ter XXVII (Terra)', see Bober, *o.c.* (1961), 24 ff. and fig.

70 Chantilly, Musée Condé, MS. 1632-33, fol. 3 r., Meuse area, c. 1170-80. From the Abbey of St. Truiden. The representations in the medallions can be grouped as follows: inner field: 4 rivers of Paradise, 2 female figures (personifications of O.T. and N.T.?); 8 semicircles arranged as follows: top- Aaron and rain of manna, Abraham's sacrifice; bottom- figure in shroud (Lazarus?), descent to Limbo; left- prophet (or evangelist?), crucifixion; right- prophet (or evangelist?), Ecclesia. See S. Collon-Gevaert et. al., *Romaanse Kunst van het Maasland in de 11de, 12de en 13de eeuw,* Brussels, 1968, 237, fig. p. 239.

71 Paris, B. N., lat. 5047, fol. 2 r., 12th century (Adelheid Heimann, in: *Warburg Journal,* I, 1937-38, 273 ff., Pl. 38a).

72 See the detailed analysis and reconstruction in: Ellen Beer, *Die Rose von Lausanne,* fig. 4, and fig. 23 in the present work.

73 For the relation to the cross quaternity, see Ch. V, pp. 104 ff.

74 One of the matters, for example, that we shall simply have to leave undiscussed is the problem of the origin and significance of the two basic forms in which tree scheme and genealogical tree occur, the one rising from root to crown, and the other descending

142

from top to bottom, (the problem is touched on by, among others, A. Watson, *The early iconography of the Tree of Jesse*, Oxford-London, 1934, 45 and G. Ladner, 'Vegetation symbolism and the concept of Renaissance,' *De Artibus Opuscula XL. Essays in Honor of Erwin Panofsky*, New York, 1961, 309, n. 30.

75 For a detailed discussion see Ch. V, pp. 108 ff.

76 Although Porphyry did not illustrate his *Isagoge* himself, the commentaries on Aristotle's categories written under his influence by, for example, Ammonius and his pupils, did provide illustrations. Boethius may have taken the explanatory diagrams in his *In Categ.* from them (cf. Courcelle, *Lettres grecques*, fig. p. 273, where there is a comparison between the quadripartite logical diagrams of Ammonius and Boethius).

77 Paris, B. N., lat. 6734, 12th century (Marie Thérèse d'Alverny, 'Le cosmos symbolique du 12e siècle,' *Archives d'histoire doctrinale et littéraire du Moyen Age*, 1954, 31-81; Frances A. Yates, 'Ramon Lull and John Scotus Erigena,' *Journal of the Warburg and Courtauld Institutes*, 23, 1960, 1-45).
Vienna, Nat. Bibl. S. n. 3605, 12th century (from Lambach, unpublished). Fol. 12 r., 12 v.: fourfold 'divisio naturae', fivefold ladder of nature; fol. 104 r.: tree scheme with sevenfold division; see also P. Lucentini, 'La Clavis Physicae di Honorius Augustodunensis. Codici e Titoli Marginali,' *Atti e Memorie dell'Accademia Toscana di Scienze e Lettere*. La Colombaria, XXXV, N.S. xxi, 1970, 103-35.

78 D'Alverny, *o.c.* For John Scotus Erigena, *De divisione naturae*, and the description of a revolving (?) scheme found in that work, see also p. 33.

79 Detailed explanation by d'Alverny, *o.c.*

80 For the significance of the 'syndesmos' posture see Ch. V, pp. 97 ff.

81 See d'Alverny, *o.c.* and Yates, *o.c.* for illustrations and detailed descriptions.

82 Darmstadt, Landesbibl. MS. 2282, franz. A, fol. 1 v. (inserted leaf), French, c. 1140 (Cologne, Schütgenmus. exhib. cat. 1964 *Sammlung von Hüpsch*, No. 60, fig. 95).

83 The syndesmos posture and the placing of Dialectica on a pedestal, as the regulating and ruling principle of all, are features related to the scheme of the Christ syndesmos embracing the cosmos which occurs in the representation in the *Tractatus de quaternario* at Cambridge, mentioned in Ch. V, pp. 98 ff.

84 The snake is the customary attribute of Dialectica (cf. Martianus Capella, *De nuptiis*, III, ed. Eyssenhardt, 99: '. . . in laeva quippe serpens gyris inmanibus involutus, in dextra formulae . . .'. Instead of the 'formulae', however, she holds in her right hand the sceptre of Philosophia (see Boethius, *Consolatio* I, pr. I, 21: 'Et dextra quidem eius libellos, sceptrum vero sinistra gerebat'.
The scheme, which forms an 'inverted' tree, and leads from the concepts of 'substantia (corporea, incorporea)' to 'animal rationale (homo, deus)' corresponds to that in: Boethius, *Commentaria in Porphyrium*, lib. L (*PL* 64, 103) with the substitution of mortalis and immortalis for homo and deus.

85 Cf. G. Leff, *Medieval Thought, St. Augustine to Ockham*, Harmondsworth (Pelican Books), 1958, 131, for further commentary on this standpoint and the controversy about it.

86 Chantilly, Musée Condé, cod. 599, 1426, fol. 6 v. Bartolomeo di Bartoli, Cantica de virtutibus et scientiis vulgariz, school of Niccolò da Bologna, c. 1355: Philosophia is shown meditating above a wheel-shaped scheme of planetal spheres and the zodiac; at the corners are Aristotle, Plato, Seneca and Socrates (W. Stammler, 'Aristoteles und die sieben Artes Liberales im Mittelalter,' *Festschrift Lützeler*, 1962, 197); see fig. 26 in the present work.
See also the scheme of Charlemagne with 4 philosophers (including Cato and Seneca) in the so-called Karlsteppich (Halberstadt, cathedral, c. 1200; Betty Kurth, *Die deutschen Bildteppiche des Mittelalters*, I, Vienna, 1926, 22, 38, 50 ff., 207 ff.)

87 Aristotle, *Metaph.* I (ed. Bakker, II, 993, col. B 19-21); Seneca uses the terms 'activa' and

143

'contemplativa' (*Epist.* 95, 10); 'Philosophia autem et contemplativa et activa spectat simul agitque'.

Augustine, *De civ. Dei*, VIII, 4, 17 (*CCSL*, XLVII, 219), links 'vita activa et contemplativa' with the 'studium sapientiae'; he is also familiar with the platonic tripartite division, and does not consider that they clash with each other.

See: L. Bauer, *Dominicus Gundissalinus. De divisione philosophiae*, Münster, 1903, 316-408; J. Mariétan, *Problèmes de la classification des sciences d'Aristote à St. Thomas*, Paris, 1909; M. Grabmann, *Die Geschichte der scholastischen Methode*, Freiburg i. Br., 1909, II, 28-52; Marrou, *St. Augustin, o.c.*, 211 ff.; Fontaine, *Isidore de S. et la culture classique*, II, 609 ff.; E. Bréhier, 'Sur l'ordre des parties de la philosophie dans l'enseignement néoplatonicien,' in: *Etudes de philosophie antique*, Paris, 1955, 212 ff.

88 Ed. Mynors, 110.

89 Courcelle, *Lettres grecques*, 322 ff. (Ammonius, prologue *Comm. In Isagog.*).

90 See p. 31 and n. 10; Cf. the diagrams accompanying *Institutiones* II, ii, 3, 4, 11 (De rethorica). The chapter 'De arithmetica', in particular, contains a variety of diagrams (see *Institutiones* II, iiii, 3, 4, 5, 6).

90a Florence, Bibl. Laurenziana, Am. 1, codex Amiatinus, before 716. See also Ch. IV, p. 74, n. 4.

91 Cf. L. W. Jones, 'The influence of Cassiodorus on medieval culture,' *Speculum*, 20, 1945, 433-42; 22, 1945, 245-56.

91a Munich, Clm. 14456, miscellany, 9th century, fols. 68 v. and 69 r.: schemata of 'divisio sacrae scripturae' (for bibliography see Ch. III, p. 60, n. 6).

92 Bamberg, Patr. 61, fol. 59 v. (accompanying *Institutiones*, II, iv), Monte Cassino (?) 2nd half 8th century (H. Belting, 'Probleme der Kunstgeschichte Italiens im Frühmittelalter', *Frühmittelalterliche Studien*, I, 1967, 103, n. 42, Pl. I, 1).

Paris, Bibl. Mazarine 660, fol. 132 v. (accompaying *Institutiones* II, iv), Nonantola, early 9th century (B. Bischoff, 'Panorama der Handschriftenüberlieferung aus der Zeit Karls des Grossen,' *Karl der Grosse*, II, Düsseldorf, 1965, 250 ff., n. 141; Belting, *o.c.*, 103, n. 43, Pl. I, 2). St. Gall, 855 (Cassiodorus, *Institutiones*; ed. Mynors, XVIII, 104, 144: MS. S), 9th century, unedited. Fol. 276 r.: 'divisio mathematicae'; fol. 287 v.: 'divisio totius numeri'; fol. 305 v.: 'divisio musicae' and fol. 306 r.: 'instrumentorum musicorum genera sunt tria'.

93 See Helga Hajdu, *Das Mnemotechnische Schrifttum des Mittelalters*, Vienna-Amsterdam-Leipzig, 1936; Frances Yates, *The art of memory*, London, 1966.

93a See pp. 39 and 112.

94 Courcelle, *Lettres grecques*, 322 ff., in connexion with Boethius, *In Isagogen Porphyrii Comm.* I, 3.

95 Ed. Fortescue, 3. The moral interpretation of the 7 steps given here in connexion with the 'gradus quidam' can be combined, in my opinion, with an interpretation of the rungs of the ladder in terms of the quadrivium, as suggested by Courcelle, *La consolation de Philosophie*, 26, n. 2; cf. e.g.: Boethius, *Institutio arithmetica* (ed. Friedlein, 9, 28 ff.): 'Hoc igitur illud quadrivium est, quo his viandum sit, quibus excellentior animus a nobiscum procreatis sensibus ad intelligentiae certiora perducitur. Sunt enim quidam gradus certaque progressionum dimensiones, quibus ascendi progredique possit, ut animi illum oculum ... demersum orbatumque corporeis sensibus hae disciplinae rursus inluminent.'

96 For Carolingian adaptations by, e.g., Alcuin and Theodulf of Orleans, see pp. 46 ff.

97 *Platonis Timaeus Commentatore Chalcidio, CCCLV* (ed. Wrobel, 379).

98 Isaiah 11:1-3; offering points of contact with other genealogical schemata such as the tree of virtues and the tree of Jesse.

99 Madrid, B. N. 10109, fol. 2 r., 11th/12th century (Courcelle, *La consolation de Philosophie*, frontispiece).

Sélestat, 93 (98), fol. 74 r., 10th century (P. Courcelle, *Hist. litt. des grandes invasions germaniques*, Paris, 1964³, 367-68, Pl. 39). Vienna, Österr. Nat. bibl., No. 242, fol. 3 r., early 12th century (H. J. Hermann, *Die deutschen roman. Hss.*, Leipzig, 1926, 44; Courcelle, *La cons. de Phil.*, fig. 26.1).

100 Cambridge, Gonville & Caius college, MS. 428, fol. 51 r., *Tractatus de quaternario*, c. 1100 (F. Saxl & H. Meier, H. Bober ed., *Cat. of Astrol. and Mythol. Ill. MSS of the Latin Middle Ages*, III, London 1953, 422.

101 Leipzig, U. B. 1253, fol. 83 v., Boethius, *De cons. phil.*, early 13th century (Courcelle, *La cons. de Phil.*, fig. 27).

102 Roger, *o.c.*, 314 ff.; Riché, *o.c.*, 433 ff.; F. Brunhölzl, 'Der Bildungsauftrag der Hofschule,' *Karl der Grosse*, II, Düsseldorf, 1965, 32 ff.).

103 Courcelle, *La cons. de Phil.*, 29 ff. This was of decisive influence on the views of all subsequent Boethius commentators.

104 Alcuin, *De grammatica* (*PL* 101, 853). The title is misleading; not only grammar but all 7 disciplines are dealt with: some MSS. bear the title 'Disputatio de vera philosophia' (e.g. Munich, lat. 6404, 2nd half century, from the cathedral library of Freising).
Brunhölzl, *o.c.*, 32 ff. sees the 'Disputatio' as normative for the 'Bildungsprogramm der Hofschule',.

105 *De grammatica* (*PL.* 101, 849c), see Courcelle, *La cons. de Phil.*, 38.

106 Alcuin, *Epist. 280 ad Monachos Hibernienses* (*MGH, Epp.* IV, 437), c. 792-804.

107 *De grammatica* (*PL* 101, 852 c); see for its application in exegesis and its relation to genealogical trees and the tree of Jesse: Spitz, *o.c.*, 99-102 (Wurzel-Frucht).

108 J. von Schlosser, *Beiträge zur Kunstgeschichte aus den Schriftquellen des frühen Mittelalters*, Vienna, 1891, 128 ff.; idem, *Schriftquellen zur Geschichte der karol. Kunst*, Vienna, 1892.

109 Schlosser, *Schriftquellen*, No. 1023.

110 Schlosser, *Schriftquellen*, No. 1026. For the problems round Theodulf's 'arbor philosophiae', see my article 'De VII liberalibus artibus in quadam pictura depicta' in: *Album Amicorum J. G. van Gelder*, 1973, 102-13.

111 See Sibylle Mähl, *o.c.*, 64-72.

112 See Spitz, *o.c.*, 95-99 (Blätter-Frucht).

113 F. van der Meer, *Maiestas Domini. Théophanies de l'Apocalypse dans l'art chrétien*, Rome-Paris, 1938, 220 ff. Another carolingian creation in this field is the 'fons vitae' representation, in which a visual summary of the ways of interpretation possible in exegesis is given, e.g. the paradisal fountain with 4 rivers, the Holy Sepulchre, the fountain of baptism, the fountain of life in the world to come, 'refrigerium' (cf. P. A. Underwood, 'The Fountain of Life,' *Dumbarton Oaks Papers*, V, 1950, 67 ff.); Spitz, in the work we have quoted so often already, provides, under the head of 'Deckmetaphorik' (o.c. 109-22: Wasser-Brunnen) various ways of interpreting the fountain, but pays no attention to the fountain of life.

114 Cf. W. Neuss, *Das Buch Ezechiel in Theologie und Kunst bis zum Ende des 12. Jrhs.*, Münster i. W., 1912.

115 *CSEL* 32, I, 272 ff. The ascription of the virtues to the rivers of paradise occurs in various combinations, see Ch. III on the paradise quaternity.

116 Sibylle Mähl, *o.c.*, 11.

117 For other interpretations of the 4 rivers see Ch. III, p. 61 ff.

118 *De Abraham*, II, 9, 65 (*CSEL* 32, I, 620) where Ambrose offers a further comparison of the 4 ages of the world with the 4 ages of man: pueritia, adolescentia, iuventus, maturitas.

119 For the great variety of interpretations, even at a later date, of Ezekiel 1:14, see Neuss, *o.c.* and V. d. Meer, *o.c.*, 223 ff.

120 Irenaeus, *Adv. Haer.*, IV, 20, 10-11 (*Sources Chrétiennes*, 34, F. Sagnard ed., Paris, 1952).

This was incorporated into Latin exegesis, for example the works of Ambrose. The attribution of the various symbols to the evangelists can vary. Generally it takes the following form (after Jerome): man-Matthew, lion-Mark, bull-Luke, eagle-John (cf. *Lexikon der chr. Ikonographie*, I (1968), s.v. Evangelisten, -symbole).

121 *De Abraham*, II, 8, 54 (*CSEL* 32, I, 607); the comparison borrowed from Plato, *Phaedrus*, 264a already occurs in Origen (see Neuss, *o.c.*, 38 ff.; Sibylle Mähl, *o.c.*, 13 ff.).

122 Jerome, *Epist. ad Paulinum*, cap. 8 (*PL* 22, 548).

123 Gregory, *Hom. in Ez. III*, 1; IV, 1, 2 (*PL* 76, 785, 815-16); he adds, furthermore, borrowings from the *Physiologus*.

124 E. Köstermann, 'Neue Beiträge zur Geschichte der lateinischen Handschriften des Irenaeus,' *Zeitschrift f. die neutestamentl. Wissenschaft*, 36, 1937, 1 ff., 5 ff.

125 V.d. Meer, *o.c.*, 227 ff.

126 V.d. Meer, *o.c.*, 316, 351 ff.

127 In opposition to the view held by, among others, Van der Meer, *o.c.*, 351 and Ihm, *o.c.*, who consider that monumental painting was the donor and that miniaturists took the composition over and rang variations on it or condensed it.

128 Cf., e.g., W. Sauerländer, *Gotische Skulptur in Frankreich 1140-1270*, Munich 1970 pp. 24 ff.; H. Schrade, *Die romanische Malerei. Ihre Majestas*, Cologne, 1963.

129 Early tituli dealing with representations in churches (cf. the examples cited by Van der Meer, *o.c.*, 324-25) give no reason for thinking that what we have here is a quadripartite scheme of the unity of the 4 Gospels and not the Enthroned Judge of the Apocalypse.

130 S. Beissel, *Geschichte der Evangelienbücher in der ersten Hälfte des Mittelalters*, Freiburg i. Br., 1906; *Lexikon der chr. Ikonographie*, III (1971), 140 ff., s. v. Maiestas Domini; Frauke Steenbock, *Der Kirchliche Prachteinband im frühen Mittelalter*, Berlin, 1965, 231 (Ikonographisches Verzeichnis, s.v. Christus in der Glorie thronend).

131 See Sibylle Mähl, *o.c.*, 22 ff., 27 ff.

132 Included among the works of Jerome in the Migne edition (*PL* 30, 531 ff.).

132a Cf. the examples in the Carolingian miscellany: Munich, Clm. 14456 (see Ch. III, p. 60, n. 6).

133 Trier, cathedral treasury 61, fol. 1 v., Echternach, c. 730 (E. Zimmermann, *Vorkarolingische Miniaturen*, Berlin, 1916-18, Pl. IV, fig. 267). The representation has apparently been copied from an example that probably had 4 medallions at the ends of the arms of the cross. The symbols of the evangelists do not fit in the compartments; in the representation of 'imago hominis' fragments can still be clearly seen of the throne of a seated figure (cf. Paris, B. N., lat. 9389, fol 18 v., Echternach-evangeliary, Northumbria, end 7th century; Essen 1956, exh. cat. *Werdendes Abendland*, No. 395, fig. 41).

134 Written by the Spaniard Paulus Orosius c. 417/18 at the instigation of Augustine. The history of the world was divided into 7 periods and 4 world-empires from Adam to 417 (*PL* 31, 663-1212).
Laon, Bibl. Mun., MS. 137, fol. 1 v., Laon, mid-8th century; there is an inscription accompanying the Lamb taken from John 1:29 (E. H. Zimmermann, *o.c.*, fig. 222).

135 The 'tria genera animantium' of Ambrose, *Hexaemeron*, V, 12, 37 (*CSEL*, 32, I, 171): 'Tria enim genera animantium esse non dubium est, terrenum volatile aquatile'. Cf. O. K. Werckmeister, *Irisch-northumbrische Spiritualität*, Berlin, 1967, 159 ff.

136 Trier, Stadtbibl., cod. 23 II, fol. 62 r., 1st quarter 9th century; the symbols have to be read clockwise (Essen 1956, exh. cat. *Werdendes Abendland*, No. 288, fig. 29).

137 London, B. M., Roy I E VI, 8th/9th century; the inscription occupies 8 lines and is written in alternating gold and silver letters on purple (Beissel, *o.c.*, 131).
Aschaffenburg, Hofbibl. Ms. 2, lectionary, fol. I V., end 10th century (*Bayerns Kirche im Mittelalter*, exh. cat. Munich, Bayer, Staatsbibl. 1960, cat. nr. 189, fig. 17); see fig. 39 of the present work.
Nancy, cathedral treasury, Arnaldus evangeliarium, fol. 3 v., early 9th century (W.

146

Köhler, *Die karolingischen Miniaturen*, I, Pl. 35) see fig. 40 of the present work; on fol. 2 v. a curious variant depicting the ✗ monogram and the quaternity of the 4 Gospelbooks with the inscription: 'Quattuor Hic Rutilant uno de fonte / fluentes Matthei Marci Lucae Libri atque Iohann.'

138 Paris, Musée de Cluny, inv. No. CL. 1362, book cover, engraved and gilded copper, Meuse area, 3rd quarter 12th century (H. Swarzenski, *Monuments of Romanesque Art*, London, (1954), fig. 422).

139 Darmstadt, Hessische Landes- und Hochschulbibl., MS. 1640, fol. 25 r. (beginning of St. Matthew's Gospel); fol. 170 r. (beginning of St. John's Gospel); for literature see p. 32, n. 13.

140 Based on Ezechiel 5:5 'Ista est Ierusalem, in medio gentium posui eam et in circuiti eius terras'. For the symbolic meaning of the altar see: J. Braun, *Der christliche Altar in seiner geschichtlichen Entwicklung*, Munich, 1924, I, 501 ff. (Ikonographie des Bildwerkes der mittelalt. Portatilien; 502-13: Kardinaltugenden); J. Sauer, *Symbolik des Kirchengebäudes und seiner Ausstattung in der Auffassung des Mittelalters*, Freiburg i. Br., 1924², 155-66; *Lexikon der chr. Ikonographie, I (1968)*, 106-07, s.v. Altar; see also Katzenellenbogen, *Virtues & Vices*, 45 for the comparison of the 4 horns of the Old Testament altar (Exod. 38:2) with the cardinal virtues, following Bede, *De tabernaculo et vasis eius ac vestibus sacerdotum*, II, 11 (*PL* 91, 450).

141 This interpretation occurs fairly late, cf. Pope Innocent III, *De sacro altaris myst.* 2, 14 and Durandus, *Rationale divinorum officiorum*, 1, 2, 4.

142 *PL* 170, 150; see also Honorius August., *Sacram.* 10 (*PL* 172, 745 D).

143 *CCSL* XLVII, xiv, 1, 275; also in Origen, *Contra Celsum*, VIII, 17 (*PG* 11, 1542).

144 Munich, Nationalmuseum, portable altar (bottom), south-German, early 11 th century (Katzenellenbogen, *Virtues & Vices*, 45 fig. 44).

145 Augsburg, Diözesan-Museum, portable altar (bottom), from S. Sebastian, Oettingen, Meuse area, mid-12th century. The top has enamel plaquettes at the 4 corners depicting types of crucifixion and eucharistic sacrifice: Melchisedek, Abel, widow of Sarepta, Moses striking water from the rock (O. von Falke & H. Frauberger, *Deutsche Schmelzarbeiten des Mittelalters*, Frankfurt, 1904, 73, Plates 76, 77).

146 Bucharest, Nationalbibl. Codex Aureus, from S. Nazarius at Lorsch, Charlemagne's palace school c. 810 (the other part: Rome, Bibl. Vat., Pal. lat. 50). Fol. 18 v.: Majestas; fol. 19r.: beginning of St. Matthew's Gospel (W. Köhler, *Die Hofschule Karls des Grossen, Die Karol. Miniaturen*, II, Berlin, 1958, 88 ff.). This Majestas formula was copied at various times:
Darmstadt, Hessische Landesbibl., cod. 1948, Gerocodex, fol. 5 v. Reichenau c. 969 (Aachen 1965, exh. cat. *Karl der Grosse*, No. 473, fig. 76).
Heidelberg, U. B., Sal. IXv, sacramentarium from Petershausen, fol. 41 r., Reichenau c. 980-85 (*ibidem*, No. 474, fig. 77).
Hildesheim, treasury of the cathedral, 33 evangeliarium of Guntbaldus made for Bernward I of Hildesheim, fol. 20 v., dated 1011 (H. Josten, *Neue Studien zur Evangelienhs. No. 18 . . . im Domschatz zu Hildesheim*, 1901, 83, Pl. Va).

147 A comparison is made between the 4 cardinal virtues and the 8 beatitudes in the New Testament exegesis of the Sermon on the Mount; the aim is to explain the incongruity between Luke 6:20 (4 beatitudes) and Matthew 5:3 (8 beatitudes), cf. Ambrose, *Exp. Evang. Sec. Luc.*, V, 49 and 69 (*CCSL* XIV, 152, 158). See for a full discussion: Sibylle Mähl, *o.c.*, 14.

148 Chantilly, Musée Condé, No. 1347 (J. Meurgey, *Les principaux manuscrits à peintures du Musée Condé*, Paris, 1930, Pl. IIIB). The 4 draped figures with books who are placed in the rectangular frame cut by the circle, are personifications of books from the Old Testament (cf. the inscriptions: Exodus, Leviticus, Deuteronomium . . .') contrasting with the 4 Gospels placed at the ends of the 4 arms of the cross in the outermost circle.

147

149 Cf. M. D. Chenu, 'Les deux âges de l'allégorisme,' *Recherches de théologie ancienne et médiévale*, 18, 1951, 19-28.

150 Cf. the thorough investigation by Bober, *o.c.* (1956-57), 65 ff. in connexion with schoolbooks of this type. Another important Carolingian example — not yet published as a schoolbook — is the miscellany already quoted in notes 91a and 132a of this chapter (Munich, Clm. 14456; for the literature see Ch. III, p. 60, n. 6).

151 See Klibansky, *o.c.*

152 Cf. Cologne 1972, exh. cat. *Rhein und Maas. Kunst und Kultur 800-1400*, 249, 297.

153 H. Sedlmayr, *Die Entstehung der Kathedrale*, Zürich, 1950, 330 ff. (Der Platonismus des 12. Jrhts und das typologische Prinzip); Ch. H. Haskins, *The Renaissance of the 12 th century* (1927), New York (Meridian Books) 1958², 343.

154 E. Mâle, *L'art religieux du XIIe siècle en France*, Paris, 1947⁵, 151 ff.

155 A. Weckwerth, for example ('Die Zweckbestimmung der Armenbibel und die Bedeutung ihres Namens,' *Zeitschrift f. Kirchengeschichte*, 4. Folge VI, 68, 1957, 225 ff.) draws attention to the occurrence in Germany, simultaneously with and independent of St. Denis, of a new motif such as 'Christ in the winepress' (e.g. in the Regensburg ceiling, see Ch. IV, p. 85).

156 One must not forget, however, that works of art can get lost, and that the visual exegetical element in various programmes is still not recognized for what it is. There is still much to be done with respect to Italian art for example. The fullest account so far is: H. von der Gabelentz, *Die kirchliche Kunst im italienischen Mittelalter. Ihre Beziehungen zu Kultur und Glaubenslehre*, Strasbourg, 1907.

157 For the contacts of an active centre like, e.g. Regensburg, much interesting material can be found in: B. Bischoff, 'Literarisches und künstlerisches Leben in St. Emmeram (Regensburg) während des frühen und hohen Mittelalters" *Mittelalterliche Studien*, II, Stuttgart, 1967, 77-115.

158 E.g. Cornell, *Biblia Pauperum, o.c.*, 314 ff.

159 See, for example, the 'imitatio' idea in the *Speculum Virginum* and the possibility of the intensive contemplation of schemata as a mystical practice; cf. pp. 32 ff. supra.

160 P. Weber, *Geistliches Schauspiel und kirchliche Kunst . . .*, Stuttgart, 1894, 58 ff., refuted by K. Künstle, *Ikonographie der chr. Kunst*, I, Freiburg, 1928, 78-82. See also: K. Young, *The Drama in the Mediaeval Church*, Oxford, 1933, 2 vols. and W. Seiferth, *Synagoge und Kirche im Mittelalter*, Munich, 1964.

161 First suggested by Weckwerth, *o.c.*, 225 ff. and taken up and worked out further by: F. Röhrig, 'Rota in medio rotae. Ein typologischer Zyklus aus Österreich,' *Jahrbuch des Stiftes Klosterneuburg*, N. F. Bd. 5, 1965, 7-113 (11 ff.)

162 For a parallel in later exegesis cf. Lubac, *o.c.*, II/2, 369 ff.

163 Künstle, *o.c.*, 85 ff., 90 ff. For the attribution of the *Glossa Oridinaria* to the circle of Anselm of Canterbury at Laon, see: B. Smalley, *o.c.*, 56-66.

164 Cf. the possible influence of works by Honorius Augustodunensis on the no longer existent 12th-century ceiling of the abbey church of St. Emmeram, Regensburg, and the influence of Rupert of Deutz's Ezekiel commentary on the programme of the twostoreyed chapel in Schwarzrheinhof (see Ch. IV, pp. 85 ff., 90 ff.).

165 See p. 46, note 108.

166 Schlosser, *Quellenbuch*, 158-81.

167 See Ch. III.

168 For the *Pictor in carmine* see the extensive treatment in: Röhrig, *o.c.*, 21-29, 56-82 (text). The Cistercian abbot, Adam of Dore (near Hereford) c. 1200, has been proposed as its author, but there were also influences from the poet Bernardus Morlanensis (probably a Cluniac monk) who died about the middle of the 12th century, and from the writings of Bernard of Clairvaux.
In addition to the typological contrast between Old Testament and New Testament,

attention has also been paid to multiple exegesis, cf. the prologue and the tituli of the verses which follow it: 'moralis intelligentia, tropologica intelligentia, allegorica ratio, mystica significatio' etc. (see Röhrig, *o.c.*, pp. 56 ff.).
For the types borrowed from the *Physiologus* see: F. Lauchert, Geschichte des Physiologus, Strasbourg, 1889; Fr. Sbordone, *Physiologi graeci . . . recensiones*, Milan, 1936; F. J. Carmody, *Physiologus latinus*, Editions préliminaires. Versio B, Paris, 1939; O. Seel, *Der Physiologus*, Zurich, 1960; M. I. Gerhardt, 'Zoologie médiévale: préoccupations et procédés,' *Miscellanea Medievalia*, 7, Berlin, 1970, 232-35.
For the influence on monumental cycles at Peterborough and Canterbury, see the literature cited by Röhrig, *o.c.*, 15, 22 ff. and C. M. Kaufman, *Romanesque Manuscripts 1066-1190*, London, 1975, p. 42, n. 69.

169 Eton College, MS. 177, 3rd quarter 13th century; fols. 1-7 typological representations; fol. 95 r. the New Jerusalem with the Lamb in the centre (P. Brieger, *English Art*, Oxford, 1957, 37a, 59b; G. Schmidt, *Die Armenbibeln des XIV. Jhrh.*, Graz-Cologne, 1959, 91 ff.; Röhrig, *o.c.*, 18, n. 64; Kauffmann, *o.c.*, p. 42, n. 68).
For an extensive description and the tituli see: M. R. James, *A descriptive catalogue of the MSS. in the library of Eton College*, Cambridge, 1895, 95 ff.
The relation with France and the Meuse area is evidenced not only by the themes but also by the use of a composition with a system of medallions. By that time, this was a somewhat old-fashioned procedure. It was becoming standard practice, whether for miniatures, or for glazed windows or for ceilings, to make use of compositions based on more complicated shapes: squares, circles, lozenges, quadrilobes (cf. Hildesheim, St. Michael, Ceiling).
For the rôle of the prophets as commentators see Ch. I, pp. 25 ff.

170 Worcester cathedral: lost picture cycle with the same ten principal scenes (Cornell, *o.c.*, 133 ff.)
Bury St. Edmunds cycle (M. R. James, 'On the Abbey of St. Edmund at Bury,' *Cambridge Ant. Society Octavo Publications* 28, Cambridge, 1895, 92).

171 Röhrig, *o.c.*, 29-53; 83-113 (text).

172 Cornell, *o.c.*; Weckwerth, *o.c.*; Schmidt, *o.c.*; Röhrig, *o.c.*, 53 ff.

173 Another programme almost as extensive as this one is to be found in Durandus of Mende, *Rationale divinorum officiorum* I, 3, 22, which contains 124 scenes from the Old and New Testaments: 'pro voluntate pictorum'.

174 Known only from drawings. See my article in: *Oud-Holland*, 1955, 219-22.

175 E. Mâle, *L'art religieux de la fin du Moyen âge en France*, Paris (1908) 1949, 231, figs. 124-27.

176 Speculum humanae salvationis, mid-14th century (J. Lutz and P. Perdrizet e.d., Mulhouse, 1907); *Concordantia caritatis*, c. 1351/58 (H. Tietze, 'Die typologischen Bilderkreise des Mittelalters in Österreich,' *Jahrbuch d.k.k. Zentralkommission f. Erforschung und Erh. der Kunst- und hist. Denkmale*, N. F. 2/2, 1904, 20-88; *Defensorium Virginitatis Mariae*, end 15th cent., dedicated to Marian typology (E. Vetter, *Mariologische Tafelbilder des 15. Jhr. und das Defensorium des Franz Retz. Ein Beitrag zur Geschichte der Bildtypen im Mittelalter*, typed dissertation, Heidelberg, 1954.

177 Röhrig, *o.c.*, 55.

178 For an exegesis of an Alciati emblem in terms of the 4 senses, see: R. J. Clements, *Picta Poesis. Literary and Humanistic Theory in Renaissance Emblem Books*, Rome 1960, 127 ff., Pl. VI. For a fourfold exegesis of Pieter Breughel's Parable of the Blind leading the Blind (Matth. 15:14) at Naples, see: H. Sedlmayr, *Pieter Bruegel. Der Sturz der Blinden*, Munich, 1957 (Hefte des kunsthist. Seminars der Universität München 2).

149

NOTES CHAPTER III

1 See Ch. II, pp. 33 ff., 41 ff.
2 See for texts relating to the 'paradisus quadripartitus' Lubac, *o.c.*, II/1, 32 ff. The commonest quartets are: 4 rivers of Paradise, 4 Gospels, evangelists, evangelists' symbols, 4 rings of the ark of the covenant, 4 pillars of the tabernacle, 4 major prophets, 4 great councils, 4 principal church-fathers, 4 cardinal virtues, 4 forms of charity, quadriga of Aminadab, 4 chariots of Zach. 6:1-8.
3 In Augustine, *De Genesi ad Litteram*, c. II, 5; v. III, 6 (*PL* 34, 222), exegesis according to historia, allegoria, analogia, aetiologia, which — as indicated earlier — only partly correspond to the 4 'sensus' of multiple Scriptural exegesis.
 Raban Maurus, *De universo*, XIII (*PL* 111, 334) provides what is apparently a threefold exegesis (historice, mystice, allegorice) but which, through its exegesis of 'ecclesia praesens' as 'terra viventium' (anagogical), and through its explanation of the 4 rivers in terms of the 4 Gospels — also the 4 virtues (tropological) — is in fact fourfold.
 In the *Glossa Ordinaria*, Gen. II, 10-14 (*PL* 113, 87), however, a threefold exegesis is given.
 Honorius August., *Expositio in Cant. cant.* (*PL* 172, 428): 'Sunt ergo quatuor paradisi, scilicet paradisus voluptatis, terrestris; paradisus exaltationis, coelestis; paradisus religionis, Ecclesiarum; paradisus virtutis, animarum.'
 Pope Innocent III, *In comm de evang.* s. 3: de quadruplici acceptatione paradisi (*PL* 217, 605-10) describes the one single fountain: 'Fluvius . . . est evangelica praedicatio, quae de Domino Jesu Christo procedit; qui est fons vitae . . .' and the 4 rivers issuing from it (each of which can be separately interpreted) which fertilize the paradise of Ecclesia (which is itself one of the 4 paradises according to the Scriptures).
4 The ornaments on prehistoric pottery found at Persepolis have been interpreted along these lines, cf. E. Herzfeld, *Iranische Denkmäler*, I, 1932, Pl. XII, fig. 3. Cf. also the Nimrud ivory (Berlin, Staatl. Museen) c. 1243-1207 B. C., where the creator is holding in his hand the vase with 4 rivers (E. Douglas Van Buren, *The Flowing Vase and the God with Streams*, Berlin, 1933).
5 The uncertainty concerning the shape of the cosmos — circular or square — is reflected not only in representations of Paradise (as 'pars pro toto' for the cosmos) but also in maps of the world (see: L. Bagrow, *Die Geschichte der Kartographie*, Berlin, 1951, 28 ff.). Cf. Burgo de Osma, Cathedral library 1, fol. 35 r. *Beatus in Apocalypsin*, ii, 3 with circular map of the world, 1086 (W. Neuss, *Die Apokalypse des hl. Johannes in der altspanischen und altchr. Bibel-ill.* Das Problem der Beatus-Hss., Münster i.W., 1931, I, 63 ff.; II, Pl. XLIX, 71), and New York, Pierpont Morgan Library 644, fols. 35 v., 36 r., 9th/10th c., square map (Neuss, *Apokalypse*, I, 63 ff.); see figs. 48 and 49 of the present work.
6 Munich, Clm. 14456, fol. 74 v., Regensburg, 1st quarter 9th cent. (before 824) contains, inter alia, 'Computus S. Augustini, S. Hieronymi, S. Isidore, S. Dionysii, S. Quirilli Greciae et ceterorum'. G. Swarzenski (*Die Regensburger Buchmalerei des X. und XI. Jrh.*, Leipzig, 1901, 11) considers that the MS. was certainly written in Regensburg, and in his view under Irish influence. He suggests that the MS., which was dedicated to Louis the Pious, must have arrived at the library of St. Emmeram via his son, Louis the German.
 E. Schlee, *Die Ikonographie der Paradiesesflüsse*, Leipzig, 1937, 15, Pl. 102 only illustrates the lower portion of the representation and does not discuss at all the vitally important connexion with the 7 planets. See F. Saxl, 'Beiträge zu einer Geschichte der Planetendarstellungen im Orient und im Okzident,' *Der Islam*, III, 1912, 20, Pl. 9.
7 Bonn, Rheinisches Landesmuseum, inv. No. 27679 (V.H. Elbern, 'Die Stele von

(pp. 60-61)

Moselkern und die Ikonographie des frühen Mittelalters,' *Bonner Jahrbücher*, 155/56, 1955-56, 184 ff.).

8 Cologne, Schnütgenmuseum, inv. No. B 2/b, Cologne c. 980, front of bookcover (H. Swarzenski, *The Berthold Missal*, New York, 1943, 50 with earlier bibliography). For its possible adaptation to a Pentecost representation and the relation between Pentecost and the new Paradise, see my article: 'Cosmos en Theatrum Mundi in de Pinkster-voorstelling', *Nederlands Kunsthistorisch Jaarboek*, 1964, 24, note 17; for the comparison between evangeliarium and Paradise and for the placing of the evangeliarium in the middle of the council (which counts as the continuation of the assembly of the apostles) see: P. Metz, *Das Goldene Evangelienbuch von Echternach ...*, Munich, 1956.

9 See W. F. Volbach, *Die Elfenbeinarbeiten der Spätantike und des frühen Mittelalters*, Mainz, 1952, No. 48 and exhib. cat. Paris, Bibl. Nat. 1958, *Byzance et la France médiévale*, 175 (150): French or Byzantine?

10 See p. 45, note 100.

11 (*PL* 37, 1236) with the idea that the 'fragmented', so to speak, Adam Sparsus was strewn over the whole world, subsequently being collected together and fused in the fire of love. Anatole = E, dysis = W, arktos = N, mesembria = S.
In medieval exegesis the ascription of the letters A.D.A.M. to the 4 cardinal points is extremely frequent, see the texts mentioned in Sauer, *o.c.*, 64. This idea is also incorporated in various medieval maps of the world, with East (and thus also the beginning of the name ADAM) at the top, cf. the mappa mundi in the MS. containing Byrthferth excerpts mentioned earlier on p. 38, note 54: Oxford, St. John's College Library, MS. 17, fol. 7 v., where in addition to the name ADAM, the zodiac, months, seasons, elements, the 4 ages of man, the cardinal points and winds are included in the scheme (M. Evans, *Medieval drawings*, London-Toronto, 1969, Pl. 66; for inscriptions see *Byrthferth's Manual (A.D. 1011) ...*, S. J. Crawford ed., London, 1929, I, 13). See fig. 53 of the present work.

12 The horns of the wind-gods may be a corruption of the wings belonging to the ancient wind-gods (usually attached to the shoulders and less commonly to head and feet), cf. W. H. Roscher, *Ausfürliches Lexikon der griech. u. röm. Mythologie*, 1965, c. 515 s.v. Windgötter.
For horned wind-gods see, e.g., Vienna, Österr. Nationalbibl. 395, Miscellany, Bohemia, mid-12th cent., fol. 34 v.: scheme of the winds (Swarzenski, *Salz. Mal., o.c.*, Pl. CXXI, 409), see fig. 54 of the present work.
For winged wind-gods see, e.g.: Vienna, Erzbischöfl. Dom- und Diözesanmuseum, triangular enamel plaque, Lorraine 2nd half 12th century, personification of Aquilo with 2 minor winds (Heide Lenzen & H. Buschhausen, :Ein neues Reichsportatile,' *Wiener Jahrbuch*, XX, 1965, 21-73).
For the development of the windrose see: J. F. Masselink, *De grieks-romeinse windroos*, Nijmegen, 1956.
Already in Isidore, *Etym.* and *De natura rerum* one can find a moralized explanation of the significance of the winds in terms of their benevolence or malevolence; see also Raban Maurus, *De universo*, IX, 25 (*PL* 111) and Honorius August., *De imagine mundi*, I, 55 (*PL* 172). Hildegard of Bingen, for example, attaches a favourable significance to east and south (H. Liebeschütz, *Das Allegorische Weltbild der Heiligen Hildegard von Bingen*, Leipzig, 1930, 77).
For the relation between the 4 'partes mundi' or the 4 winds and the 4 'sensus' of multiple exegesis see: Lubac, *o.c.*, II/2, 302.

13 For the persistence of the scheme with the figure in the centre see, e.g., the examples in: K. Lehmann, 'The dome of heaven,' *Art Bulletin*, 1945, 1-28.

14 See also Ch. II, pp. 33 ff.

15 *Comm. In Matth.* prologue (*PL* 26, 18).

16 See Ch. II, pp. 48 ff.

151

17 Cf. Sibylle Mähl, *o.c.*, 19 ff.
18 *PL* 78, 809.
19 *PL* 59, 501, Cf. Mähl *o.c.*, 19 ff.
20 *PL* 122, 291.
21 *Hist.* 1. I, c. 1 *MGH. Ser.*, VII, 51-52, ed., G. Waitz). As early as in Augustine, *In Joannis Evangelium*, tr. 118, No. 4 (*CCL* 36, 656) we find mention of this 'divina quaternitas'. For the importance of number symbolism for exegesis, and in particular ot the number 4, see also Ch. II, p. 37 and note 45.
22 See p. 59 and note 2.
23 See Courcelle, *Lettres grecques*, fig. 272 with a comparison between the diagrams of Ammonius and Boethius. See also the scheme in Martianus Capella, *De nuptiis*, IV, ed. Eyssenhart, 126-27.
24 London, Br. Mus., Arundel 44, South-German c. 1140/45 (Eleanor Greenhill, *Die geistigen Voraussetzungen der Bilderreihe des Speculum Virginum*, Münster i.W. 1962, with bibliography of the earlier literature; M. Bernards, *Speculum Virginum*. Geistigkeit und Seelenleben der Frau im Hochmittelalter, Cologne-Graz, 1955; idem, 'Zur Geschichtstheologie des Speculum Virginum,' *Revue Bénédictine*, 75, 1965, 277-303; Eleanor Greenhill, 'Die Stellung der Hs. Br. Mus. Arundel 44 in der Überlieferung des Speculum Virginum,' *Mitt. des Grabmann Instituts der Univ. München*, 10, Munich, 1966. The earliest known MSS. from the first half of the 12th century are: Arundel 44, c. 1140 / 45 and Cologne, Hist. Stadtarchiv, W. fol. 276a, before 1150. Arundel 44 contains the following miniatures (all reproduced by Greenhill (1962): fol. 2 v. tree of Jesse; 13 r. paradise quaternity; 28v. / 29r. trees of the virtues and vices; 34 v. Humilitas conquering Superbia; 46 r. quadriga; 57 v. the wise and foolish virgins; 70 r. tree of the ranks within Ecclesia; 83 v. HOMO TOTUS; 93 v. ladder of virtues; 100 v. Christ, Mary, John and choir of the blessed; 114 r. tree of Jesse in the House of Wisdom.
The dating of Arundel 44 is based by Greenhill partly on the resemblance in method and illustration to the work of Hugh of St. Victor, who began his activities at the school of St. Victor in Paris c. 1125 and died in 1141, and partly on the fact that the *Speculum* must have been known in Hirsau in the early 1140s, since there is an inscription in the dormitory there with 3 lines from the *Speculum* and the name Peregrinus. At all events Arundel 44 served ante 1150 as the example for the *Speculum* MS. from Andernach in the Stadtarchiv at Cologne, which was very probably illustrated in the Rhineland. As regards its style, Greenhill (*o.c.*, 129, 137) relates Arundel 44 to the school of Freising, the stylistic characteristics of which were established by Boeckler (A. Boeckler, 'Zur Freisinger Buchmalerei des 12. Jrhs.,' *Zeitschr. des deutschen Vereins für Kunstwissenschaft*, 8, 1941, 1-16). Although this attempt to link it up with the still fairly hypothetical school of Freising is not particularly convincing, a south-German provenance (Bavaria) appears certain.
25 Munich, Bayer. Nationalbibl., Clm. 14159, Prüfening c. 1170 / 85. In addition to the literature mentioned in the previous note, see: A. Boeckler, *Die Regensburg-Prüfeninger Buchmalerei*, Munich, 1924, 33 ff., Plates XXVI-XXX; B. Bischoff, 'Literarisches und Künstlerisches Leben in St. Emmeram (Regensburg),' *Mittelalterliche Studien* II, Stuttgart, 1967, 77-155.
In addition to the visual exegetic representations on folios 5 r., 5 v., 6 r., and 8 v., and the typological cycle (folios 1 r.-4 v.), which will be discussed in the text, other interesting genealogical tree schemata occur on fol. 46 v.: a logical scheme held by Christ with the concepts 'deus, spiritus, caro' and the 4 categories of 'bonum, qualitas and quantitas, motus, iudicium'; 187 v.: genealogical tree of Noah and description of the 72 languages and peoples stemming from Noah's sons; 188 r.: genealogical tree of the Old Testament, with its roots in Terah, and Christ at the top.
The assumptions by M. Bernards, 'Mittelrheinische Mss. des Jungfrauenspiegels,'

Archiv für Mittelrheinische Kirchengesch. 3, 1951, 362 ff., that Arundel 44 was in the Cistercian monastery at Eberbach (Rheingau, Kreuznach), and by Greenhill (1962), 139, that the writer of the text of *Laudes Crucis* may have seen this MS. in the Rhine area — further supported by the relations this writer had with Mainz (cf. Bischoff, *o.c.*, 139, note 151) — ought to be worked out more closely.

26 Greenhill (1962), 59 ff.; cf. also Katzenellenbogen, *Virtues & Vices*, 69 ff. for the relation to other 'rota' schemes, and in particular to that of the virtues and vices.

27 An exegesis in terms of Ecclesia could go back to the *Speculum* text: 'Christus in medio Ecclesiae' and 'in hoc Ecclesiae paradiso . . .' (Arundel 44, fol. 12 v.). Furthermore the figure is wearing the same sort of crown as Ecclesia on fol. 57 v. (in the representation of the wise and foolish virgins), although this is not a typically female crown (burial crowns of this type were used for both male and female rulers, cf. H. Biehn, *Die Kronen Europas und ihre Schicksale,* Wiesbaden, 1957, No. 9; see also fig. 8, the crown of the Madonna of Essen, end 10th century and the burial crowns in figs. 12 and 13, from the 11th and 12th centuries).

Even in *Speculum* MSS. of a much later date, the centre of the paradise quaternity is occupied by a crowned Ecclesia with a medallion depicting Christ, or by Mary with the infant Christ. See fig. 56c of the present work: Leipzig, U.B. 665, *Speculum Virginum:* Mary and Christchild in centre of quaternity of 4 rivers of Paradise, cardinal virtues, evangelist-symbols and fathers of the Church.

28 For the variants in the exegesis of the text 'si quis sitit, veniat et bibat (et de ventre eius fluent aquae vivae)' John 7:37-38, which can be interpreted in terms of either Christ himself or the human soul, see: H. Rahner, 'De dominici pectoris fonte potavit,' *Zeitsch. f. kathol. Theologie*, 55, 1931, 103-08; idem, 'Flumina de ventre Christi. Die patristische Auslegung von Joh. 7:37, 38,' *Biblica*, 22, 1941, 269-302; 367-403.

Greenhill's hypothesis (1962), 60, 66, 68, that the central figure of the paradise quaternity is supposed to represent the human soul, the 'anima fecunda' from which originate the 'aquae vivae' alluded to in the text of the book held by Christ, seems incorrect to me in view of the crown being worn and the way in which Ecclesia/Mary is portrayed in later *Speculum* representations; see my review of Greenhill's book: *Art Bulletin*, XLVII, 1965, 140-43 (where I also argue that the interpretation of the *Speculum* as an exegesis of the Song of Songs is too one-sided).

29 Fol. 13r.: '. . . ut octo beatitudines cum iiii virtutibus principalibus in quibus omnis spiritualis disciplinae ratio consistit, imitari valeant, sicque celestibus disciplinis delibutae et celestem paradisum per istum mistica ratione complexum perveniant. Attende igitur perfectum habeas ex mistica pictura tardior intueris ex scriptura' (followed by paradise quaternity).

30 Greenhill (1962), 70: difficult to imagine that the representation was designed for the *Speculum;* refers to the parallel drawn earlier by P. E. Schramm, *Sphaira-Globus-Reichsapfel. . . ,* Stuttgart, 1958, 44 ff., with the Majestas as mystical paradise and with cosmos schemata. Schramm calls the representation: 'Darstellung des innermensch-lichen Paradieses mit denjenigen Attributen ausgestattet, wie sonst das Lamm oder Christus'.

31 See p. 62, note 24.

32 See the illustrations in Greenhill (1962).

33 See the examples in: J. Baltrusaitis, 'L'image du monde céleste du IXe au XIIe siècle,' *Gazette d.B.A.*, 1938, II, 137-48 and 'Roses de vents et roses de personnages à l'époque romane.' *ibidem*, 265-76.

34 See the literature given p. 62 in notes 24 and 25.

35 Which in the *Speculum*, however, are grounded in the text, see quotation p. 90 note 29.

36 See p. 62, notes 27 and 28.

37 The relation of the 4 'mysteria Christi' to man and the 'paradise of the soul' derives from

(pp. 65-67)

texts such as: Augustine, *Enchiridion*, XIV, 53 (ed. J. Rivière, 98) in which the whole life of the christian is seen as a 'configuratio' of the 'mysteria Christi', and everything that Christ accomplished through His life, death and resurrection is seen as 'interioris hominis sacramentum'. For the 4 'mysteria Christ' see also, e.g.,: Rupert of Deutz, *In Apoc.* III, iv, vi (*PL* 169, 912 AB, 940) and the same author's *In Cant. cant.*, IV (*PL* 168, 879 C).

38 To the right of Christ is an angel in adoration with the cross as 'vexillum', to the left the other instruments of the Passion, among which the 3 nails are particularly noteworthy (the cross on fol. 5 r. is still a 4-nail type of cross). This is one of the earliest examples of the occurrence of 3 nails (the *Lexikon der chr. Ikonographie*, I, (1968), s.v. Dreinagel-kruzifix quotes an earlier example of 1149).
Representations of Christ with the instruments of the Passion do not appear to have been popular before the last quarter of the 12th century. (see *Reallexikon z.d. KG*, I, s.v. Arma Christi).

39 Up to the 12 th century the list of doctors of the church was still not fixed; Cassiodorus (who could not have known of Gregory as yet) often starts off with Cyprian and Hilary; sometimes Greeks were included as well, e.g. John Chrysostom, Athanasius, Origen. Gregory may have been added to the list in the 1st half of the 7th century (Isidore of Seville, who died in 636, mentions him, as number eight on the list), but right up to the 12th century he often fails to gain inclusion. The Spaniards were fond of including Isidore; the Cistercians, St. Bernard. Bede's name is also sometimes found on the list.
The combination Augustine, Ambrose, Gregory, Jerome, possibly for the first time in Beda Venerabilis, *Ep. dedic. ad Accam* (*PL* 92, 304 D) in a discussion of the 4 evangelists, symbolized by the 4 beings from Revelation (*ibidem*, 305-08). The idea of a quaternity of doctors of the church may have been influenced by the classical lists of 4 roman rhetors, etc.; Jerome, *Ep. 50, c. V (PL* 3, 95) mentions 4 generals, 4 philosophers, 4 poets, 4 orators, acting on the principle that every profession has its principal figures.

40 See p. 62, note 25.

41 This can be found as early as Ambrose (cf. C. Morino, *Il ritorno al Paradiso di Adamo in S. Ambrogio*, Rome, 1952). For the same ideas in eastern exegesis, e.g. in Ephraim the Syrian (306-373?), see: E. Beck, 'Ephraems Hymnen über das Paradies,' *Studia Anselmiana*, XXVI, Rome, 1953.

42 In *Laudes crucis* the letters A.D.A.M. are placed so that they have to be read clockwise, which provides the key to the ascription of the symbols of the evangelists and the virtues to the 4 church fathers. For the relation to the *mappa mundi*, see p. 60, note 11.

43 For the application of the 'mysteria Christi' to mankind, see note 37.

44 The church fathers' particular specializations formed a favourite subject in 12th-century exegesis, e.g. Richard of St. Victor, *Serm. cent.* 10 (*PL* 177, 9200) in connexion with the chraracteristics of the 'complete theologian'. Bonaventura, *De reduct.* 7, 5, names as the grandmasters of allegory Augustine, and later Anselm, who applies it to doctrine; of tropology, Gregory, and later St. Bernard, who applies it to preaching; of anagoge, Dionysius, and later Richard of St. Victor, who applies it to contemplation, while Hugh of St. Victor is eminent in everything.
For the influence of this on the arrangement of medieval libraries see e.g., Lubac, *o.c.*, I / 1, 31, note 6, in connexion with a 12th-century catalogue stating: 'Hieronymus historiae, Ambrosius allegoriae, Gregorius tropologiae appropriatius insudarunt'.

45 For the texts concerned see, e.g.: Greenhill (1962), 101 ff., and Lubac, *o.c.*, I, 30, 654 ff.

46 See note 37.

47 E.g. on fol. 1 r. the 'pre-existing' Ecclesia with the cross, right of Adam and Eve is indicated by the titulus: 'forma ecclesiae, quae post Adae ruinam in sanctis patribus esse probatur, quia nunquam defuerunt, qui errantes ad penitentiam revocarent, quae maxime per fidem crucis ostendebatur. Crux enim a cruciatu nomen accepit, quod

penitentium est' (cf. Boeckler, *o.c.*, 35, Pl. XXVI, fig. 30).

48 *Speculum* (Arundel 44, fol. 83 v.); Greenhill (1962), 115 ff., fig. 9; see fig. 56b of the present work.

49 For an extensive discussion of this exegesis, see Greenhill (1962), 119 ff.

50 'Quia vetus homo noster simul crucifixus est . . . si autem mortui sumus cum Christo, credimus quia simul etiam vivemus cum Christo . . .'.

51 Which is mentioned in the text both of the *Speculum* (Arundel 44, fol. 83 v.) and of *Laudes crucis*, fol. 6 r.: 'draco versutus, qui proprio se mucrone transfodit'.

52 The literature concerning *Imago Dei* is extensive, and we shall confine ourselves to mentioning: W. Dürig, *Imago. Ein Beitrag zur Terminologie und Theologie der Römischen Liturgie*, Munich, 1952: S. Otto, *Die Funktion des Bildbegriffes in der Theologie des 12. Jrhs.*, Münster i.W., 1963; G. B. Ladner, *Ad imaginem Dei. The image of Man in Mediaeval Art* (Wimmer Lecture No. XVI, 1962), Latrobe (Pa.), 1966.

53 The inscription in which this is explained runs: 'figura praesens hoc pretendit quod omnes sancti ab exordio mundi usque adventum Christi in fide Christ pependerunt. crucifixum per figuras quasi ex parte videbant unde facies manus pedes apparent'. See for a more extensive discussion of this representation: Ch. V, pp. 105 ff.

54 For the evaluation of this cycle as a typological compendium, see Ch. II, p. 57.

55 Although the representations related to the *Speculum* on folios 5 v., 6 r. and 8 v. had each been recognized separately as an example of visual exegesis; see: Katzenellenbogen, *Virtues & Vices*, 69 in connexion with the paradise quaternity: 'At the same time the rivers of paradise (historical) correspond with the Evangelists (typological) and the cardinal virtues (moral)'. See also Greenhill (1962) passim.

56 It seems to me incorrect to regard, as Greenhill does, the representation of TOTUS HOMO on fol. 6 r., or, like Boeckler and others, the tree scheme on fol. 8 v. (immediately preceding the discussion proper), as a title-page in which the whole programme has been pictorially summarized, since neither of the representations provides in itself a complete picture of all the possibilities given in the title on fol. 9 r.

57 For the syndesmos posture and ideogram, see Ch. V, pp. 97 ff.

58 Stuttgart, Landesbibl., Brev. 128, fol. 9v., 10r., 10 v., Lectionary mid-12th century (K. Löffler, *Schwäbische Buchmalerei in romanischer Zeit*, Augsburg, 1928, 35-39, Plates 19, 20, 21; p. 37: 'Die Darstellungen der Bilderseiten haben die Aufgabe, das Wesen des Buches, das den Kern des Officiums enthält auszudrücken, was in tiefsinniger Weise geschieht').

59 Related elements in a miscellany MS., Homiliarium with lives of Saints (Verdun c. 1140 / 50). The representation on fol. 1 r. of this Book of Homilies provides a visual exegesis of its function 'per circulum anni' by means of a 'rota' scheme of the 7 days of creation with the Creator and the 7th day as central figure, the whole being placed in a square frame with the 4 seasons. Above and below the 'rota' are Lux as a crowned figure and Tenebrae hiding its face; in medallions at the 4 corners are 4 winged and bearded winds. See: F. Ronig, 'Die Buchmalerei des 11. u. 12. Jrhs. in Verdun,' *Aachener Kunstblätter*, 38, 1969, 52-64; 145-48. fig. 21.

60 A justification for the adaptation of an Annus scheme is provided by, for example, the text of Honorius August., *Speculum Ecclesiae* (PL 172, 956): 'Christus namque est Annus Dei benignitatis factus particeps nostrae mortalitatis. Hujus menses sunt XII apostoli, dies justi, horae vero fideles, noctes adhuc in tenebris infidelitatis aut peccatorum errantes . . .'.

61 The comparison with the 'cardo' (which in addition to being a doorhinge can also mean a pole, or turning-point) made in the inscription, can also have cosmological implications, cf. 'cardo caeli' or 'cardo mundi' and 'quattuor cardines mundi'.
 There is also a possible relation with the text *Glossa ordinaria*, In Paral. 9, 26 (after Raban Maurus), where the 4 doctores are called the 'quattuor principes janitorum', who

via the 4 Gospels open the door of faith to the believers, and who guard it with respect to the 4 cardinal points and summon all peoples from the 'quattuor plagae mundi' to embrace the Faith.

62 See Ch. II, p. 51 and note 138.
63 For the anthropomorphic quaternity scheme and the syndesmos figure, see Ch. V.
64 For the texts see Löffler, *o.c.*

NOTES CHAPTER IV

1 For the conception of the world as a building (palace, temple, fortress, tower or city), sometimes situated on a mountain or at the centre of the creation, see e.g. H. P. L'Orange, *Studies on the iconography of cosmic kingship in the ancient world*, Oslo, 1953. The uncertainty respecting the round or the square shape which we found in the case of the paradise quaternity, is also to be observed in connexion with the city quaternities. In the Greek tradition the city scheme appears to have been predominantly circular, although at least one square ground plan is known, cf. H. Rosenau, *The ideal city in its architectural evolution*, London, 1959, 12 (in connexion with Atlantis). The city as 'imago mundi', with a system of axes in which two main streets cross each other, survives well into modern times in the groundplan of the ideal or utopian city, cf. H. Frankfort, *The art and architecture of the ancient Orient* (Pelican History of Art), Harmondsworth, 1954, 55 and Rosenau, *o.c.*, 159.

2 That it draws upon various traditions is clear from the variants: in Ezekiel we meet with a square Messianic temple in the Holy City of Jerusalem; in II Chronicles 3:8 a square sanctuary is described; I Kings 6 introduces a holy place in the form of a cube; and in Revelation 21:16 the Heavenly Jerusalem is described as a square cosmic city with a system of axes.
There are also numerous variations in the way in which the Heavenly Jerusalem is depicted in Apocalyptic MSS. Usually it is presented in the form of a ground-plan, which can be either square — in agreement with Revelation 21:16: 'et civitas in quadro posita est' — or round (circle = perfect form; possibly influenced by Revelation 4, where the 'antiquus dierum' is described enthroned with the four and twenty elders 'in circuito'). Cf. Valenciennes. Bibl. Publique 99, fol. 38 r., Apocalypse 8th/9th century: circular Heavenly City with the Lamb in the centre (W. Neuss, *Die Apokalypse des hl. Johannes, o.c.*, I, 247-67). Paris, Bibl. Nat., N. acq. lat. 1366, fols. 148 v., 149 r., *Beatus in Apocalypsin*, end 12th century: square city, the corners of which are accentuated by means of gatehouses with angels, and Christ enthroned in the centre (Neuss, *o.c.*, I, 219). Even after eye-witness reports had put people in a position to know better, the city of Jerusalem in the Holy Land continued to be reproduced as the ideal city by means of a circular city quaternity divided into four (cf. Stuttgart, Landesbibl. Fols. 57, 56, 12th century, see fig. 61 of the present work; cf. also the examples in: L. Heydenreich, 'Jerusalemplan aus der Zeit der Kreuzfahrer,' *Miscellanea pro Arte, Festschrift H. Schnitzler*, Düsseldorf, 1965, 83-90).

3 Lubac, *o.c.*, I / 1, 160; II / 2, 41 ff. (symboles architecturaux) even thinks that architectural symbols outnumber all other symbols; see also Spitz, *o.c.*, 201-05 (Strukturmetaphorik).

4 Florence, Bibl. Laurenziana, Am. 1, Codex Amiatinus, fols. 2v., 3r., Jarrow-Wearmouth before 716. For the problems round the Codex Amiatinus itself, and for its relation to the 'Codex Grandior' of Cassiodorus, see e.g.: H. Quentin, *Mémoire sur l'établissement du texte de la Vulgate*, Paris, 1922, 447, fig. 77 (tabernacle), fig. 76 (divisio scripturae divinae, according to Hilary and Epiphanius); Courcelle, *Lettres grecques*, 356 ff.; R.L.S. Bruce-Mitford in: *Evangeliorum Quattuor Codex Lindisfarnensis* 2, ed. T. D. Kendrick et al., Olten, 1960, 143 ff.; B. Fischer, 'Codex Amiatinus und Cassiodor,'

Biblische Zeitschrift, N.F. 6, 1962, 57-59; H. Belting, 'Probleme der Kunstgeschichte Italiens im Frühmittelalter,' *Frühmittelalterliche Studien*, I, 1967, 106 ff.

For the court of the tabernacle with an orientation to the 4 cardinal points and serving as image of the world, see: Rome, Bibl. Vat., gr. 699, *Cosmas Indicopleustes, Topographia Christiana*, fol. 49 r., 9th cent. (C. Stornajolo, *Le miniature della topografia cristiana di C.I.*, Milan, 1908, 32, Pl. 15; Wanda Wolska, *La topographie chrétienne de C.I. Théologie et science au VIe siècle*, Paris, 1962; *Cosmas Indicopleustes, Topographie chrétienne*, Wanda Wolska ed., Vol. I (Livres I-IV), Paris, 1968; Vol. II (Livre V), Paris, 1970. For the later examples in which the indication of the cardinal points is lacking: C. Roth, 'Jewish Antecedents of Christian Art,' *Journal of the Warburg and Courtauld Institutes*, 16, 1953, 28 ff.; P. Bloch, *Nachwirkungen des Alten Bundes in der christlichen Kunst*, reprint from *Monumenta Judaica*. 2000 Jahre Geschichte und Kultur der Juden am Rhein, Handbuch, Cologne 1963.

5 The literature concerning the symbolic significance of the actual church building itself is very extensive. See e.g.: J. Sauer, *Symbolik des Kirchengebäudes*, Freiburg i. Br., 1924², 99 ff.; L. Kitschelt, 'Die frühchr. Basilika als Darstellung des Himmlischen Jerusalem,' *Münchener Beiträge zur KG*, 111, 1938; A. Stange, *Das frühchristliche Kirchengebäude als Bild des Himmels*, Cologne, 1950; G. Bandmann, *Mittelalterliche Architektur als Bedeutungsträger*, Berlin, 1951; A. Weckwerth, 'Das altchr. und das frühmittelalt. Kirchengebäude. Ein Abbild des Gottesreiches,' *Zeitschr. f. Kirchengeschichte*, 69, 1958, 26-78; P. Frankl, *The Gothic. Literary Sources and Interpretations through eight centuries*, Princeton, 1960, 159 ff.; A Stange, *Basiliken, Kuppelkirchen, Kathedralen. Das Himmlische Jerusalem in der Sicht der Jrh.*, Regensburg, 1964; G. Bandmann, 'Die Vorgotische Kirche als Himmelsstadt,' *Frühmittelalt. Studien*, 6, 1972, 67-93; *Lexikon der chr. Ikonographie*, II (1970), 514-29, s.v. Kirche, Kirchenbau.

For the continuance of schematic compositions in ceiling decoration, and for the relation between ceiling and floor decoration, see: K. Lehmann, 'The Dome of Heaven,' *Art Bulletin*, XXXVII, 1945. 1-28 (5: '. . . a persistent interrelationship exists between ceilings and floor decorations. In most cases, we see projected upon floors the schemes which were originally developed on ceilings', see also *o.c.*, 16, note 140 for the use of a city quaternity with caryatids on a mosaic floor).

6 A. Feigel, 'San Pietro in Civate,' *Monatshefte f. KW*, 1909, 206-17; P. Toesca, *Monumenti dell'antica Abbazia di S. Pietro al Monte di Civate*, Florence (1943), 1951²; G. Bognetti and C. Marcora, *L'Abbazia benedettina di Civate*, Civate, 1957; A. Buttafava, 'Nuovi affreschi scoperti a S. Pietro al Monte,' *Arte Cristiana*, Dec. 1962, 274 ff.; F. Mazzini, in: *Arte Lombarda*, VII, 2, 1962, 169, fig. 2 and *Boll. d'Arte*, 1963, 274 ff.;O. Demus, *Romanische Wandmalerei*, Munich, 1968, 112-14 (e.g. the ascription to various hands); Constanza Segre Montel, 'Gli Affreschi della Capella di S. Eldorado alla Novalese,' *Boll. d'Arte*, 1964, 21-40 (on the complex problems of Lombardic painting, its relation to Ottonian and Byzantine art, and the reminiscences of late-antique fresco art noted by various authors, for example in the representation of the Heavenly Jerusalem at Civate).

7 Opinions vary about the radical changes made to the architecture of S. Pietro, although there is general agreement on its having taken place at the end of the 11th century. G. Arslan, 'L'architettura romanica milanese,' in: *Storia di Milano*, III, 430 ff., points out the stylistic similarities to S. Abbondio, Como, which was consecrated by Pope Urban II at more or less the same time (1095).

On the other hand Weckwerth, *o.c.*, 67, considers that the east apse of S. Pietro had been altered as early as 1040. He discusses S. Pietro in connexion with German churches possessing double choirs, wherein possibly both 'sacerdotium' and 'imperium' are symbolized, but contrary to G. Bandmann ('Zur Bedeutung der Romanischen Apsis,' *Wallraf-Richartz Jrb.*, XV, 1953, 31), among others, he thinks that this type of church

plan was already to be found in early-christian times, and that the tradition continued without interruption into the Middle Ages and was not confined to Germany.

The suggestion has been put forward by Bognetti/Marcora, *o.c.*, 126, that the reconstruction at Civate was connected with the hypothetical stay there — shortly before his coronation at Milan— of Conrad (reigned 1093-1101) the son of Henry IV. The argument is that Conrad sought refuge at Civate and, while there, had a sort of equivalent to a westwork built, with a 'loggia imperiale'. This is not really very likely, however. The king's stay in Civate simply could not have been long enough to justify this. Moreover the small 'chapel' with its three bays seems hardly suitable for the purpose suggested (for instance where were the king and his followers supposed to sit?).

Most writers see a parallel between the construction of a narthex on the east side of S. Pietro and the westwork in other churches. The choice of a programme with apocalyptic motifs would seem to corroborate this view. It remains odd, nevertheless, that in S. Pietro the architectural addition and its decoration should be in the east and not in the west. The explanation could lie in the church's situation and the difficulties of the terrain.

8 Bognetti/Marcora, *o.c.*, 174, note 14.
9 Bognetti/Marcora, *o.c.*, 189: in 1571 S. Carlo Borromeo (as Archbishop of Milan) visited Civate and ordered the use of the altars to be discontinued because the officiating priest stood with his back to the main altar.
10 Bognetti/Marcora, *o.c.*, figs. 9-20.
11 For the part played by the light of the rising sun in certain programmes (Regensburg, Schwarzrheindorf, Palermo, Gurk), see: E. Hempel, 'Der Realitätscharakter des kirchlichen Wandbildes im Mittelalter,' *Kunstgeschichtliche Studien. Festschrift D. Frey*, Breslau, 1943, 106-20; W. Krönig, 'Zur Transfiguration der Capella Palatina in Palermo,' *Zeitschrift für Kunstgeschichte*, 1956, 162-79.
12 H. J. Wetzer and B. Welte, *Kirchenlexikon...*, Freiburg i. Br., 1882-1903 (Vol. I, 1883), c. 189 s.v. Begräbnis.
13 For the motif of the 'ascent of the soul' see, e.g., A. Farinelli, 'Der Aufstieg der Seele bei Dante. Über die Vorstellungen von der Himmelsreise der Seele,' *Vorträge Bibliothek Warburg* 1928-29, Leipzig-Berlin 1930, 191-213.
14 See pp. 89 ff., 90 ff., 93 ff. (Perschen, Schwarzrheindorf, Gurk).
15 Toesca, *o.c.*, PL. 43; representations of the 4 winds as birds are uncommon; usually they are depicted as fierce, horned or winged, heads being held in some form of check. In some ways the composition resembles the illustration of Rev. 7:9-17 in *Beatus* MSS.; e.g.: New York, Pierpont Morgan Library, 429, fol. 77 r., where we also find 18 saints depicted (Neuss, *o.c.*, I, 67; II, Pl. LXXXV, 122).
16 This combination of representations of the fight between Michael and the Dragon and the infant Christ being bathed is also found in the apse of St. Pierre les Eglises (Vienne), the dating of which varies widely: Deschamps/Thibout, *o.c.*, 369 ff.: early 9th cent.; Demus (1968), 68, 144, Pl. 114 ff.: 'volkstümlich und jedenfalls altertümlich wenn auch nicht früh' dating it in the 12th century, which seems likelier.
17 For the various interpretations of the Woman as Mary or Ecclesia see: Demus (1968), 113; for a different view: H. Schrade, *Die romanische Malerei*, Cologne, 1963, 79 ff. with an interpretation as Ecclesia only (Schrade, who also notes the difference in colouring between the two children, interprets the child — with reference to Rom. 6:3 — as the human being reborn after baptism).
 In the light of the programme as a whole, an interpretation in terms of Ecclesia seems more probable (although one in terms of Mary undoubtedly is implicitly present). The figure raising up the child is certainly not a woman; perhaps a monk?
 The reference to Rom. 6:3 can be supplemented by Rom. 6:4: 'Consepulti enim sumus cum illo per baptismum in mortem: ut quomodo Christus surrexit a mortuis per gloriam

Patris, ita et nos in novitate vitae ambulemus', which provides the link with the rest of the programme of the 'chapel' culminating in the vision of the Heavenly Jerusalem. Schrade, *o.c.*, 80 adduces the commentary on Revelation by Beatus, where the Woman giving birth is explained as Ecclesia and the child as mankind 'fortis in penetentiae contemplatione', who, born again through baptism and risen from the dead, as it were, through penance, is drawn up from the 'vita activa' to the 'vita contemplativa'. He is immediately granted the 'visio Dei'.

Although Schrade states that the fragmentarily preserved inscription contains no Beatus elements, there is no reason to assume that this well-known commentary was entirely without influence (cf. the similarity, mentioned earlier, between the representation on the inside of the ciborium and the Beatus illustration).

The emphasis on penance and the transition from 'vita activa' to 'vita contemplativa', together with the pessimistic start of the inscription, would have been especially appropriate to the special case represented by Archbishop Arnolfo (not forgetting the exceptional power of absolution possessed by the Abbot of Civate).

For the development of the exegesis and depiction of Rev. 12, see: Lili Burger, *Die Himmelskönigin der Apokalypse in der Kunst des Mittelalters*, Berlin, 1937, 58 ff.; P. Prigent, *Apocalypse 12. Histoire de l'exégèse*, Tübingen, 1959; J. A. Schmoll gen. Eisenwerth, 'Sion-Apokalyptisches Weib-Ecclesia Lactans . . .,' *Miscellanea pro Arte Medii Aevi. Festschrift H. Schnitzler*, Düsseldorf, 1965, 109.

18 Cf. A. Ruegg, *Die Jenseitsvorstellungen vor Dante und die übrigen literarischen Voraussetzungen der 'Divina Commedia'. Ein Quellenkritischer Kommentar*, 2 vols., Cologne, 1945.

Of great importance are the apocryphal *Visio Pauli* (much copied, from the Carolingian period on), the visions described by Gregory the Great and Bede, and the Tundalus vision. One of the richest and most interesting among the visions of Heaven and Hell, before that of Dante (in which much of the earlier material was incorporated, thus giving rise to all sorts of repetitions and parallel versions), is the vision of Alberic of Monte Cassino (1057-88), which Arnolfo may have known.

19 See note 9. The report speaks of a 'finestra' under the principal altar (as in St. Peter's at Rome) where a relic of the arm of St. Peter was preserved. This was supposed to have been brought from Rome, in the time of Pope Hadrian I (772-95) by the Lombard King Desiderius, founder of S. Pietro. The altars mentioned in the report were dedicated to Peter and to James and Philip. There is also mention of an altar to Gregory, which may have something to do with the representation of Gregory on the entrance wall to the right of the door.

The altar in the crypt was dedicated to Mary. Behind it were stucco reliefs with representations of the crucifixion and the dormition of the Virgin.

The crypt also contains remains of a representation of the Wise Virgins, which could indicate that even here the programme had an eschatological bias.

20 The patron may have chosen Pope Marcellus (d. 309) because of the parallel with his own career: exile followed by elevation to a post of the highest dignity. But there may have been some confusion with his predecessor Pope Marcellinus (292-304), whose tongue, according to the legend, was presented to King Desiderius by Pope Hadrian, together with Peter's arm.

21 There are a large number of possible reasons for the choice of Pope Gregory (590-604): for example because he aided the christianization of the Lombards, or because he promoted the welfare of Benedictine monasteries (N.B. it may have been at Civate that Paul the Deacon wrote, in the 8th century, a commentary on the Rule of St. Benedict), or because he was the author of the *Liber regulae pastoralis*. Gregory was also regarded as an authority on descriptions of Heaven and Hell (see note 18), and he did much to propagate the doctrine that the torments of souls in Purgatory could be relieved by the

celebration of masses. In addition, sinners were received back into the Church by the pronouncing of the words in the text appended to the representation of Gregory. A final consideration may have been the fact that Gregory contributed to the spread of the veneration of Peter's keys (and one of these important relics was in S. Pietro di Civate = Clivate).

The choice of Gregory (as pendant to Pope Marcellus, see note 20) could also have been based, possibly, on motifs transferred from the Oedipus story to the Gregory legend: starting life as a foundling, being brought up by foster-parents, searching for his own parents, winning the throne, his recognition and (unlike Oedipus) long penance, being pardoned and elected Pope. I do not know, however, whether these motifs had become transferred to the Gregory legend before the middle of the 12th century.

22 A similar representation in S. Michele di Oleggio, near Novara – a cemetery chapel – is very closely related; cf. Demus (1968) 59. The souls in Abraham's bosom, signifying their being now 'in bono', also represent a generally sanctioned preliminary stage of heavenly bliss. The combination of the representation of Abraham's bosom and the vision of the Heavenly City may, in the case of Civate, have been inspired by Hebr. 11:10, which speaks of the strongly founded city which Abraham was already expecting and of which the builder and maker was God.

23 With inscription: 'Eccle. varios conflictus atque labores'.

24 Christ with the Lamb in his lap in the Heavenly City is only found elsewhere, so far as I know, (see: Index of Christian Art), in a late MS.: London, Br. Mus. Harley 1526-27, fol. 152 r., *Bible Moralisée*, 2nd half 13th cent. (A. de Laborde, *La Bible Moralisée* . . ., IV, Paris, 1921, Pl. 623).

25 Christ enthroned on a globe in the restored paradise is found at a very early date in apse mosaics, e.g. Rome, Sta Costanza, in the representation of the 'traditio clavium' (?) end 4th / 5th cent. (Christa Ihm, *o.c.*, 127 ff., Pl. V. 2) and in the apse of S. Vitale, Ravenna (*ibidem*, Pl. VII.1).

This way of depicting Christ also occurs widely in representations of the creation from early christian times onwards, cf. the roman cycle in S. Paolo f.l.m. – known only from drawings – and later adaptations of it (see Garber, *o.c.*). In the case of Civate it is a true reproduction of Rev. 4:3: 'et vis erat in ciruiti sedis similis visioni smaragdi'. For the significance of the globe and being seated on it, see: P. Schramm, *o.c.*

26 Rev. 22:4: 'Et videbunt faciem eius et nomen eius in frontibus eorum'. These figures can be interpreted in various ways, since they are not distinguished from each other by atributes or inscriptions. In Rev. 21:12 ff. the number 12 occurs various times: 12 angels in the gates, 12 tribes of Israel whose names are on the walls, the 12 apostles who form the foundation of the walls. It could also be an allusion to the chosen who are the building-stones of the Holy City, or who 'per portas intrant in civitatem' (Rev. 22:14). The architecture of heaven forms the subject of numerous speculations in the literature of visions: the blessed are themselves the building-stones, or they take an active part in the task of construction (stones are added by means of good deeds).

27 Starting from Rev. 21:18, descriptions abound in vision-literature of the priceless riches of the walls and gates of paradise, use being made at the same time of all the elements borrowed from medieval *lapidaria*.

28 For the various exegetical possibilities of this text: in terms of Christ, or in terms of the believer himself, see Ch. III, p. 62 and note 28.

The concept of the redemptive effects of baptism coincides in this case with that of a 'locus refrigerii' with 4 streams (cf. A. Stuiber, *Refrigerium interim*, Bonn, 1957).

The linking of a garden paradise to a city paradise occurs frequently in visions of heaven and hell, from the *Visio Pauli* to the vision of Tundalus; it is not however frequent in art, cf.:

Cambrai, Bibl. de la Ville, 386, fol. 43 r., Apocalypse MS., 9th cent. (Neuss, *Apokalypse*,

o.c., I, 248-67) and Ghent, Universiteitsbibl. No. 92, fol. 52 r., *Liber Floridus* by Lambert of St. Omer: city paradise with tree in the middle and the inscription: 'PARADYSUS' (A. Derolez, *Lambertus S. Audomari Canonicus, Liber Floridus*, Ghent, 1968).

29 The combination of the Heavenly Jerusalem and the virtues occurs frequently in the programmes for romanesque chandeliers (cf. Katzenellenbogen, *Virtues & Vices*, 51, note 7). Here, too, Jerusalem is represented as a round or polygonal city.

30 Brioude (Haute Loire) St. Julien, 1st quarter 13th cent. (Demus (1968) fig. 145). In the westwork above the narthex: gallery with two chapels resting on the side aisles and open towards the central nave. On the south: 'chapelle dite chambre St. Michel' (P. H. Michel, *La fresque romane*, Paris, 1961, 165, 206 ff.: consacrée à l'ensevelissement et à l'exposition des chanoines-comtes). Regensburg, Allerheiligenkapelle, see pp. 88 ff. below. Brixen (Bressanone) Liebfrauenkirche, formerly Bishop's Chapel, c. 1214-21 (Demus (1968) 25, 43, 99, 133, figs. 72-73). Above the vaults (of later date), at the top of the walls are the remains of decoration with, on the south wall: Heavenly Jerusalem, and on the north wall: Babylon. Gurk, see pp. 93 ff. and Perschen, see pp. 89 ff. below.
St. Plancard (Haute Garonne) cemetery chapel dedicated to John the Baptist, end 11th / beginning 12th cent. (Demus (1968) 138, fig. 95, who dates it c. 1140 / 60). Two apses, with, in the east apse: Majestas Domini with evangelists and their symbols. Next to John an inscription taken from Sedulius' *Carmen Paschale;* left of Matthew an angel with two richly clothed figures on the battlements of the Heavenly Jerusalem. On the south side of the east apse: representation of hell (?). Rather anorganic distribution of the representations over the walls.

31 Canterbury, Cathedral, St. Gabriel's chapel; belongs to the choir finished in 1130; situated to the south of the crypt (Demus (1968) 189 ff., Plates LXXVII, LXXVIII). Vault of apse: Majestas Domini with 4 angels; next to it in the west: Heavenly Jerusalem.
Hardham (Sussex), St. Botolph, c. 1125 (Demus (1968), 170, fig. 37). The programme in the choir shows the fall and redemption of mankind in two zones; vault: Heavenly Jerusalem.

32 St. Michel d'Aiguilhe, see pp. 81 ff.; Brioude, see note 30; Regensburg, St. Leonhard, see pp. 88 ff.; St. Chef, see pp. 83 ff.; Matrei, see pp. 92 ff.

33 Hersfeld (Reg. bez. Kassel) Abbot's chapel of the Stiftskirche, on the upper floor adjoining the Stift, connected to the southern transept of the church; late 11th cent. / c. 1100 (Demus (1968) 91, 179, fig. 44). Small room with a barrel-vault and a sort of barrel-vaulted apse. Christ enthroned with book, encircled by 9 compartments containing the 9 choirs of angels. Strong byzantine influence translated into western terms. Continuous scroll, cf. Prüfening.
Le Puy, cathedral, gallery in north transept (Demus (1968) 135 ff., Pl. XXXVIII). Evangelists, saints, prophets, the archangel Michael and, inter alia, the Judgment of Solomon.

34 One wonders, for example, whether in the case of the Klosterneuburg retable of Nicholas of Verdun we are not confronted with just such a correction of an out-of-date iconographic representation of the Resurrection of Christ. If so, the original representation of the three Marys at the Tomb has been replaced by one which was becoming much commoner in the 2nd half of the 12th century: Christ ascending from the grave. The impetus in this particular instance may have come from Provost Wernher, whom the inscription names as the founder (died 1195 as Bishop of Gurk).
Cf. the engraved representation (three Marys at the Tomb) now on the back of enamel No. III / 17, representing hell, and the resurrection of Christ represented on enamel No. II / 13, where the 'transitus' from the earthly to the heavenly life is brought into connexion with the 'Agnus Pascalis' (see *Reallexikon z.d. KG*, I, 1230 ff, s.v. 'Auferstehung', and F. Röhrig, *Der Verduner Altar*, Klosterneuburg, 1955, figs. pp. 39 and 53).

161

(pp. 80-82)

This in opposition to: O. Demus, 'Neue Funde an den Emails des Nikolaus von Verdun in Klosterneuburg,' *Österr. Zeitschrift f. Denkmalpflege*, V, 1951, 13-22, who considers that we have to do with a sketch for enamel No. II / 11: 'Sepulcrum Domini' (entombment of Christ, see Röhrig, *o.c.*, fig. 33).

35 For itinerant artists see, e.g., Deschamps/Thibout, *o.c.*, and Demus (1968) 104, note 25. Hugh of St. Victor, *De bestiis et aliis rebus* (*PL* 177, 46) cap. XLV De graculi natura moraliter, brackets itinerant artists together with doctors and jugglers, and compares them to the 'graculus' (magpie) as an image of instability.

For model books see: R. W. Scheller, *A Survey of Medieval Model Books*, Haarlem, 1963; O. Demus, *Byzantine Art and the West*, New York, 1970, 31 ff.

Little is known about how people commissioning works went about it. One of the pleasantest bits of information we have on the matter comes from Gregory of Tours (c. 538-94) *Historia Francorum*, II, 17, where he describes how Ceraunia, the widow of Namatius, Bishop of Clermont (c. 446), seated in the church of St. Etienne, outside the walls of Clermont, gave instructions on the spot to the painters by reading out aloud from a book on her lap the stories of the events which had to be portrayed. The itinerant artists may have been sent to her from Limoges by Rurice, the first bishop of Limoges (together with a moralizing letter of introduction containing a suitable comparison between the colourfulness of the building and the variegated nature of the virtues in the soul which forms the temple of God; see Deschamps/Thibout, *o.c.*, 6).

36 There were excellent opportunities for this at the very time when the decoration of Civate was being created, during the reign of Pope Urban. For example there was the Council of Piacenza in 1095, where in addition to bishops from France and Italy and the bishops from Germany mentioned earlier, who reordained Arnolfo, there was also a Byzantine delegation. It is not known whether Arnolfo attended the Council at Clermont in the same year.

37 Cf. Schlosser, *Quellenbuch*, 184; I. Yoshikawa, *L'Apocalypse de Saint-Savin*, Paris, 1938, 152. According to M. James (*The Apocalypse in Art*, London, 1931, 39-48), the 64 representations on the west facade formed an apocalyptic cycle with 18 themes, the principal scenes being the Last Judgment and the Adoration of the Lamb.

One or two surviving capitals in the porch also show scenes from the Last Judgment and Apocalypse.

Taking into account the relations between Fleury and S. Maria in Ripoll during the time of Gauzelin, and the account in one of the sources of an exchange of MSS. between the two monasteries, it is thought that Fleury must have had a Beatus MS. According to Yoshikawa (*o.c.*, 154 ff.) the themes in Fleury are related both to Apocalypse MSS. of the Cambrai-Trier group and to the Beatus group.

38 Like Fleury, the church of St. Savin had a tower-like westwork, the upper chapel of which was dedicated to Michael (Deschamps/Thibout, *o.c.*, 75 ff.; Yoshikawa, *o.c.*; Demus (1968), 143). All authors indicate the possible connexion with Fleury. Yoshikawa thinks that the Apocalyptic cycle in St. Savin is also derived from various Apocalypse traditions, and that in its turn it formed the prototype for the Anglo-Norman group of Apocalypse illustrations.

39 G. Bandmann, in: *Das Münster*, 1952, 1-19, suggests a date in the 10th century and regards the whole building as a Heavenly Jerusalem: 'Die Bedeutung des Bauwerks als himmlische Stadt und von oben herabgekommenes neues Jerusalem wird an der Fassade anschaulich'; Schrade, *Roman. Mal.*, 52 gives end 11th / early 12th century as a date; R. Martin, *St. Michel d'Aiguilhe*, Le Puy-Lyon, 1958; Demus (1968), 135, dates it end 10th / early 11th century; G. Marinelli, 'New discoveries of the romanesque period in France, 2. Frescoes and Reliquaries at St. Michel-d'Aguilhe,' *The Connoisseur*, 158, No. 635, 1965, 165-68 (including ills. of north and south walls after old drawings). In addition to the chapel the plateau also contained the small abbey of Séguret (Securité)

for the clerics responsible for the services, and on the way up there were chapels dedicated to Gabriel, Raphael and St. Guignefort (saint of Scottish origin with power against epilepsy and rickets).
The sanctuary was enlarged in the 12th century, which resulted in the disappearance of the west apse.

40 The dating of the paintings in the crypt ranges widely between the 9th and the 11th / 12th century. Deschamps/Thibout, *o.c.*, 30, 35, figs. 1, 4, incline towards a date in the late-Carolingian period. What we are confronted with on the walls, is a forerunner of a widespread romanesque programme containing figures under arcades (saints, prophets, apostles, evangelists, virtues) and a vision of heaven with a quaternity composition on the ceiling.

41 The fact that more than one point of view is catered for, i.e. one figure confronting those entering (in St. Michel it is Christ, in Ternand, Mary), and another (Michael and Christ respectively) facing anyone situated in the east and in front of the altar, could be connected with the chapel's possible function as a funerary or memorial chapel, in which case the second of the two observers referred to above could be represented by the dead person for whom the Mass for the Dead was being said.
Again, in the Panteón de los Reyes at León (last quarter 12th cent., entrance hall of the Colegiata San Isidoro, converted into a funerary chapel 1054-67), the Majestas representation on the ceiling is not oriented on those entering but on a spectator near the altar (cf. Demus (1968), 24, 165, fig. 31 — where, in my opinion incorrectly, the suggestion is made that we have to do with clumsiness on the part of the painter).

42 R. Storz, 'Zu den romanischen Wandmalereien in St. Chef,' *Das Werk des Künstlers. Festschrift H. Schrade*, Stuttgart, 1960, 124: 'Transzendentalisierung eines hochgelegenen Raumes ... die architektonische Symbolik wird durch die Malerei zum Bilde'; R. Oursel, 'L'architecture de l'abbaye de St. Chef,' *Bulletin Monumental*, 1962, 49-70; Nurith Cahansky, *Die romanischen Wandmalereien der ehemaligen Abteikirche St. Chef (Dauphiné)*, Berne, 1967; Demus (1968), 136 ff. (3rd quarter 11th cent.).
The building and its decoration have been associated with St. Léger (Leodegar) 1030-70, Archbishop of Vienne, who is considered responsible for the restoration of St. Chef, founded in the 6th century by St. Theudère. The name St. Chef itself, (also St. Chiefz, St. Chier, St. Chief) could be related to a venerated relic of St. Theudère, who was buried in the church (cf. Cahansky, *o.c.*, 11).
An attempt to establish a connexion between the decoration of this church and Montecassino (St. Léger was a contemporary of Desiderius, Abbot of Montecassino) is not supported either by the style of the surviving paintings or by the nature of the programme.
Storz's hypothesis, that the programme of the lower chapel of St. Clement ought to be read together with that of the upper chapel of St. Michel, and that we are in fact dealing with a two-storeyed chapel, seems correct to me, despite Cahansky's counter-argument that the decoration of the upper chapel is entirely based on its function as an 'Engelskapelle' and choir gallery (*o.c.*, 25). The point is, surely, that if one accepts that the whole programme of the two-storeyed chapel reflects an 'ascent of the soul', the choir, singing 'in conspectu angelorum', has its appropriate part to play in this representation of the Heavenly Jerusalem.

43 For the city pictogram see, e.g.: P. Lavedan, *Représentations des villes dans l'art du moyen âge*, Paris, 1954; E. Baldwin Smith, *Architectural Symbolism of Imperial Rome and the Middle Ages*, Princeton, 1956; P. Lampl. 'Schemes of architectural representation in early medieval art,' *Marsyas*, 9, 1961, 6-13.

44 Or St. Clement and St. George? One of the figures is wearing armour.

45 Cf. the accompanying angels in the entrance hall of St. Savin and in the vault of the choir of N. Dame la Grande, Poitiers (see p. 89, note 63).

163

46 In this instance the figures of Mary and Christ are oriented towards someone standing in front of the altar in the east. Oursel (*o.c.*) claims that the Heavenly Jerusalem is situated, in defiance of every tradition, in the west, but this argument fails, since it is the whole ceiling that must be interpreted as the Heavenly Jerusalem (the gatehouse is indeed in the west, but this is only the entrance). Nor can we accept his following statement: 'Infolgedessen begrüsst der Herr mit seinen erhobenen Armen die Auserwählten so unmittelbar nicht wie gemeint worden ist', since the Christ figure faces those entering the chapel and thus can certainly be said to be welcoming them.

47 Storz, *o.c.*, 124, after M. Varille & Loison, *L'Abbaye de St. Chef à Dauphiné*, 1929, who considered that the chapel was intended for the canons of the church; Storz, and others, however, could find no evidence to back this idea up. Nor, on the other hand, could an alternative explanation of the chapel's function be put forward.

48 When the Codex Aureus (Munich, Clm. 14000) made for Charles the Bald in 870 at St. Denis or Aachen, and presented to St. Emmeram, Regensburg, by Arnulf of Carinthia, was restored in 975 / 1009 under Abbot Romuald of St. Emmeram, some miniatures were added which show that the Carolingian method was understood (see: G. Swarzenski, *Die Regensburger Buchmalerei*, Leipzig, 1901, 29 ff.). This comprehension continued to be reflected in the productions of the Regensburger miniature school, cf., for example, the Uta codex produced at roughly the same time (Munich, Clm. 13601; A Boeckler, 'Das Erhardbild im Uta-Kodex,' *Studies in Art and Literature for Belle da Costa Greene*, Princeton, 1954, 219-30, which pays special attention to the relation of fol. 4 to pseudo-Dionysius Areopagita, *Hierarchia ecclesiastica*).
See also the article by B. Bischoff mentioned earlier, in: *Mittelalterliche Studien*, II, 102 ff. (including a discussion of the claim put forward in 1049 that St. Emmeram possessed the body of Dionysius, which had earlier been carried off from St. Denis by Arnulf of Carinthia).

49 J. A. Endres, 'Romanische Deckenmalereien und ihre Tituli zu S. Emmeram,' *Zeitschrift f. chr. Kunst*, XV, 1902, 205 ff.; 235 ff.; 275 ff.; H. Karlinger, *Die Hochromanische Wandmalerei in Regensburg*, Munich-Berlin-Leipzig, 1920; Bischoff, *o.c.*, 139.

50 F. Schwäbl, *Die Vorkarolingische Basilika St. Emmeram in Regensburg...*, Regensburg, 1919 (Sonderdruck *Zeitschr. f. Bauwesen*, Jhrg. 1919, H. 1-19); R. Strobel, *Romanische Architektur in Regensburg*, Neurenberg, 1965.

51 A renewal of interest in this text during mid-12th century; the original exegesis in terms of Babylonia and Chaldea ruled by Nebuchadnezzar; Media by Darius; Persia by Cyrus; Greece, Macedonia by Alexander, becomes the following: Babylonia and Chaldea ruled by Nebuchadnezzar; Media and Persia by Cyrus; Greece and Macedonia by Alexander; Roman Empire by Julius Caesar or Augustus (cf. P. Clemen, *Die romanische Monumentalmalerei in den Rheinlanden*, Düsseldorf, 1916, 323 ff. in connexion with the occurrence of this representation in Schwarzrheindorf).

52 See, e.g., the tituli of Suger for stained glass windows in St. Denis and the representation in Herrad of Landsberg's *Hortus Deliciarum*.

53 For the chandelier as Heavenly Jerusalem see, e.g.: H. Sedlmayr, *Die Entstehung der Kathedrale*, Zürich, 1950, 125 ff.; H. Kreusch, 'Zur Planung des Aachener Barbarossaleuchters,' *Aachener Kunstblätter*, 1960-61, 21-36. The Aachen chandelier presented in 1165 by Barbarossa in honour of Mary, is in the form of a circle with 12 turrets. According to the inscription it depicts the Heavenly City, the 'visio pacis'; on the base of the central turret there is a representation of St. Michael, together with the inscriptions: 'Nunc facta est salus et virtus' (cf. Rev. 12:10-12) and 'Vox magna'; Michael's head is facing east.

54 J. A. Endres, 'Romanische Malerei in Prüfening,' *Christliche Kunst*, I, 1905-06, 160-71; Karlinger, *o.c.*; Schrade, *Rom. Malerei*, 10 ff., 238 ff.; Demus (1968), 187 ff., Pl. 205, fig. 50.

55 See inter alia: O. Casel, *Die Kirche als Braut Christi in Schrift, Väterlehre und Liturgie,* Mainz, 1961; A. Mayer, *Das Bild der Kirche. Hauptmotive der Ekklesia im Wandel der abendl. Kunst,* Regensburg, 1962, 35, fig. 21.
For the influence of the Marian exegesis of the Song of Songs by Rupert of Deutz and Honorius August., which must have been known at an early date in Regensburg: E. Beitz, *Rupert von Deutz . . .,* Cologne, 1930, 109; G. Wellen, 'Sponsa Christi,' *Festschrift F. van der Meer,* 1966, 153. The closest approximation to the Prüfening representation is: Munich, Clm. 16002, fol. 39 v., Lectionary of St. Nikola in Passau, Salzburg, 2nd half 12th cent. (G. Swarzenski, *Die Salzburger Malerei,* Leipzig, 1908-13, Pl. LXXXVIII (299). That we are dealing with what was already a well-known type of the 'Ecclesia Imperatrix', however, is evident from a Carolingian ivory: New York, Metropolitan Museum, early 9th cent. (Aachen 1962, cat. exhib. *Karl der Grosse,* No. 524, fig. 102), and an Ottonian book-cover, known only from a drawing, and previously preserved at Essen, containing the inscription in Greek: 'Theotokos' (Th. Rensin, 'Zwei ottonische Kunstwerke des Essener Münsterschatzes,' *Westphalia,* 40, 1960, 44 ff.). There is no adequate explanation as to why the subject should be wearing military dress.

56 The placing of the figures of a spiritual and a worldly ruler on either side of a central representation is reminiscent of the programme in the Johanneskirche at Pürgg, c. 1160 / 70.
On the wall with the triumphal arch and on either side of Christus Pantocrator we find the founders of the church: left, the spiritual ruler (Abbot Gottfried of Admont?) and right, the worldly ruler (Ottokar III of the Traungauer family?); above them, left, is Cain's sacrifice, and, right, Abel's sacrifice. There are other interesting features in this programme, in particular the representations in the sanctuary with 4 personifications of virtues (after Psalm 84:11-12: Justitia, Pax, Veritas and Misericordia), and the vault with its quaternity scheme of the Lamb of God and the 4 symbols of the Evangelists, borne by 4 figures in Atlas-posture, a representation which, with the aid of the remains of the inscription: 'IXRO dant naciones agnis precones', can be interpreted as the heralds of the Lamb, the 4 nations assembled from the 4 cardinal points at the end of time. As a quaternity scheme this is closely related to the architectural quaternities borne by figures in Atlas-posture at Matrei and Gurk (E. Weiss, 'Der Freskenzyklus der Johanneskirche in Pürgg,' *Wiener Jahrbuch für Kunstgeschichte,* 22, 1969, 7-42; Demus (1968) 208 ff., figs. 233-36, Pl. XLVIII); see fig. 70 of the present work.

57 See also Strobel, *o.c.,* 45, note 275 on the importance of inscriptions in works from St. Emmeram.

58 For this last dating see: Karlinger, *o.c.,* 54. According to some authors the scene of Peter with Pope and Emperor has to be seen as a representation of the two-swords theory (cf. Demus 1968) 187 ff, Pl. 205). The female figure above the arcade appears to be related to the figures of the virtues in: Munich, Clm. 13002, *Glossarium Salomonis,* fol. 4. Prüfening 1158 / 65 (G. Leidinger, *Min. Hss., Munich,* VIII, 1924, Pl. XII).

59 Karlinger, *o.c.,* 20, 54; *Kunstdenkmaler der Oberpfalz,* H. 1, Bez.-Amt Roding, Munich, 1905, 197. It is again worth remarking that the representation here, as in a number of examples mentioned earlier, has been painted on the vault of a chapel situated on a height.

60 For the 'raptus' motif see also the Enoch representation in St. Savin (Demus (1968) fig. 105).

61 J. A. Endres, 'Die Wandgemälde der Allerheiligenkapelle zu Regensburg,' *Zeitschrift f. chr. Kunst,* 1912, 43-52 (e.g. for the relation to the Office of All Saints and to the Apocalypse commentary by Rupert of Deutz). For the way in which Regensburg came to be familiar with Rupert of Deutz via Kuno, Abbot of Siegburg and later of St. Emmeram (1121-31), see Bischoff, *o.c.*
E. Giordani, 'Das mittelbyzantinische Ausschmückungssystem als Ausdruck eines

hieratischen Bildprogrammes,' *Jahrbuch der Österr. Byz. Gesellschaft*, I, 1951, 89 ff.; O. Demus, 'Regensburg, Sizilien und Venedig. Zur Frage des byzantinischen Einflusses in der romanischen Wandmalerei,' *ibidem*, II, 1952, 95-104; Demus (1968) 188 ff., Pl. 206, fig. 51.

For the rôle of the inscriptions see, e.g.: Demus (1952) 96: 'Freude an der Magie des Wortes'; for the spatial function of the scrolls cf. Hempel, *o.c.:* '... der sich in der Verbildlichung des Programmes durch die räumliche Anordnung seiner Teile, ihre Verbindung miteinander, und in der Einbeziehung 'realer' Elemente äussert...'. One of these non-fictive elements is the significance of the light of the sun rising in the east as related to the positioning of the Angel of the Last Judgment standing on the symbol of the sun, in the east, cf. Hempel, *o.c.*, 116. See fig. 71a of the present work.

62 For the role of complementary (real or fictional) elements in works of art, see: D. Frey, 'Der Realitätscharakter des Kunstwerkes,' *Festschrift H. Wölfflin...*, Dresden, 1935, 67 and Hempel, *o.c.*

63 P. Clemen, *Rom. Mon. Mal.*, 357, 765; Karlinger, *o.c.*, 27 ff., 54, 63, 66 ff., 79, Pl. 14 (gives 1161 as date, this being when the Pfarre Perschen was handed over to the Regensburg Cathedral Chapter by Bishop Hartwig II); Schrade, *Rom. Mal.*, 85; Demus (1968) 190, Pl. LXXXVIII, 207-09 ('das Ganze eine Verquickung von Apsis- und Kuppelausstattung, wobei die Arkadenarchitektur des Apsiszylinders und die Majestas der Concha zu einem centrierten Kuppeldekor zusammen geschweisst sind'); F. Hula, *Mittelalterliche Kultmale. Die Totenleuchten Europas, Karner, Schalenstein und Friedhofsoculus*, Vienna, 1970, 39-55 (50).

Arcades as succinct notation for heavenly architecture occur in apse paintings from the Carolingian period onwards, e.g. Müstair (Münster, Grisons), 8th / 9th cent. (B. Brenk, *Die romanische Wandmalerei in der Schweiz*, Berne, 1963, 16 ff.). See also Areines (Loir et Cher), 3rd quarter 12th century (Deschamps/Thibout, *o.c.*, 121, Pl. LVII, 1, fig. 41) and Brixen (see note 30).

In a number of cases this heavenly architectural zone has been continued on into the composition of the ceiling, e.g. at: Poitiers, N. Dame la Grande, vault of choir, c. 1100 (Deschamps/Thibout, *o.c.*, 95, fig. 30; Demus (1968) 139, fig. 15). As in St. Chef, angels accompany souls to the gate of heaven and the Madonna is depicted under the Majestas Domini. Unlike Ternand, St. Michel and St. Chef, there is one uniform direction in which the representation is to be viewed, namely west-east.

In Chalivay-Milon (Cher), middle of the 3rd quarter 12th cent. (Deschamps/Thibout, *o.c.*, 108, Pl. XLVIII, 1) the heavenly architecture has likewise been continued on into the composition of the ceiling, as is also the case at St. Mary's Kempley (Gloucestershire) 1st half 12th cent. (Demus (1968) 171 ff., Pl. LXXVI) where, furthermore, there is a clear west-east orientation, as at Poitiers.

64 Karlinger, *o.c.*, 67: 'Diese Kunst ist keine Illustration für den Laien, kein anschaulich Unterrichten und Darstellen religiöser Inhalte, sie existiert zuerst für den Eingeweihten, der den Zusammenhang der Inhalte, als selbstverständliches Wissen in sich trägt. Was hätte ein bis in die Einzelheiten rein theologisch-ersonnener Inhalte Erschaffenes, wie die Allerheiligenliturgie in der Hartwigskapelle am Domkreuzgang den Laien vermitteln können. Was bedeuten für diesen selbst die allgemeineren Inhalte des Jüngsten Gerichts in der Perschener Totenkapelle mehr wie die lateinisch gesprochenen Begräbnisorationen'.

65 Hempel, *o.c.*, 106-20; A. Verbeek, *Schwarzrheindorf. Die Doppelkirche und ihre Wandgemälde*, Düsseldorf, 1953; J. Kunisch, *Konrad III, Arnold von Wied und der Kapellenbau von Schwarzrheindorf*, Düsseldorf, 1966; Demus (1968) 182 ff., fig. 46 (upper church), Pl. 200 and fig. 47 (lower church).

Verbeek, *o.c.*, XXIII shows that for private chapels such as this the founder's tomb was extremely important, and that this may also have determined the cruciform plan at

Schwarzrheindorf (the suggestion has been made that it was an import from Constantinople, where Arnold von Wied had gone in 1149, in connexion with the abortive crusade of 1147 / 49). As regards two-storeyed constructions of this sort, there was some influence from the type of the castle chapel. In the long run this private castle chapel goes back to the palace chapel at Aachen (where two altars were for the first time placed one above the other (cf. Kunisch, *o.c.*, 91 ff.).

For the relationship to mausolea and martyria, cf. A. Grabar, *Martyrium. Recherches sur le culte des reliques et l'art chrétien antique*, Paris, 1946, I, 577 ff. (where attention is drawn, inter alia, to the tradition of the martyria in connexion with Goslar). A similar design, in which the functions of being representative and serving as funerary church for the founder are combined, occurs in: Mainz, Gothardkapelle, built on to the north side of the west transept of the Cathedral to serve both as court chapel and funerary chapel for Archbishop Adalbert I and dedicated in 1137 (Kunisch, *o.c.*, 106, 116); Goslar, Ulrichskapelle, c. 1100 (Kunisch, *o.c.*, 113; H. Reuther, 'Studien zur Goslarer Pfalzkapelle St. Ulrich,' *Niederdeutsche Beiträge z. KG*, VII, 1968, 65-84); Bonn, Cyriakuskapelle on the east wing of the cloister attached to the Münsterkirche, containing the tomb of Provost Gerhard von Are, died 1169 (*Reallexikon z.d.KG*, IV, 208, s.v. Doppelkapelle).

66 Kunisch, *o.c.*, 56 ff. calls Arnold von Wied a new type of bishop, more of a statesman than a cleric. Verbeek, *o.c.*, II, and especially Kunisch, *o.c.*, 94 ff. go into the question of the possible connexion with the text and illustrations of Otto von Freising's *Chronicon*, but come to the conclusion that the origin of the Schwarzrheindorf programme is not to be found there, although the programme is related to the other's 'resignierte Zeitbilder . . . düsteres Daseinsgefühl . . . pessimistisches Gegenwartsbewusstsein', and although in both cases there is an attempt to understand the contemporary world 'in ihrem Bestand und ihrer heilsgeschichtlichen Lage, ihren Aufgaben und Pflichten und dem Weg ihrer letzten zukünftigen Erfüllung zu erfassen . . .'.
For Wibald of Stavelot's commission for the Remaclus retable, see e.g. exh. cat. Cologne 1972, '*Rhein und Maas. Kunst und Kultur 800-1400,*' 249.

67 For a comparison with the programme of the Capella Palatina at Palermo (especially the transfiguration) see: W. Krönig, 'Zur Transfiguration der Capella Palatina in Palermo, '*Zeitschrift f. Kg.*, 1956, 162-79. For the Ezekiel programme see: Clemen, *Rom. Mon. Mal.*, 278; Neuss, *Das Buch Ezechiel . . .*, 265ff.; E. Beitz, *Rupert von Deutz. Seine Werke und die bildende Kunst* (Veröffentl. des Kölner Geschichtsvereins 4) Cologne, 1930, 233 ff.; W. Kahles, *Geschichte als Liturgie. Die Geschichtstheologie Rupert's von Deutz*, Münster, 1960. Ezekiel programmes are infrequent in monumental art; see, for example, the decoration of the chapel above the entrance-hall of the cathedral at Hildesheim, c. 1130 / 53 (?), destroyed in 1841 (Demus (1968), 90) and a badly preserved example in the castle chapel of the Count of Hainault at Mons, 2nd half of 12th century (Clemen, *o.c.*, 290, fig. 210).

68 For a succinct and helpful account of the programme of the upper and lower churches see the little guide to Schwarzrheindorf in the *Rheinische Kunststätten* series, compiled by A. Verbeek, 1966.

69 I. Hänsel-Hacker, 'Die Fresken der Kirche St. Nikolaus bei Matrei in Ost-Tirol. Das Werk einer Paduaner Malerschule,' *Jahrbuch d.Österr. Byz. Gesell.*, 3, 1954, 109-22 (ascription to the Venetian-Byzantine tradition of a 'Wanderkünstler' from Padua; contacts with Padua are possible since the reigning Archbishop at Salzburg — to which Matrei belonged — was at that time Vladislaz, 1265-70, who had earlier studied at Padua); W. Frodl & D. Talbot Rice, *Österr. mittelalt. Malerei*, New York-Munich, 1964, Pl. XVII, XX; Demus (1968) 211 ff., Plates 237-40, XCIX, fig. 73.

70 Demus (1968), 211 draws attention to the fact that representations in glass-painting are similarly framed.

71 For the motif of the Jacob's ladder see, among others, Clemen, *Rom. Mon. Mal.*, 127-30; *Lexikon der chr. Ikonographie*, II, 1970, 373-75, s.v. Jakob's Traum.

72 Demus (1968) 212, with bibliography of the earlier literature. In 1211 / 13 the chapel was still unfinished. It was probably consecrated in 1214 by the bishop elect, Otto I, and seems to have been damaged by fire towards the middle of the century. Work was started on its restoration, and this must have been completed by 1264, since in that year the church was dedicated by Bishop Dietrich II (1253-78) to St. Paul and St. Florian. The 'episcopus electus', Otto, and the 'consecrator secundus' are both portrayed above the arch of the original apse in the east wall of the chapel; three other founders are depicted in a kneeling position on the west wall; they are Ulricus, 'canonicus secundus', and, on the underside of the arch of the southern window, an anonymous man and woman.
The latest researches indicate that the 'Heinricus pictor de Gurk', repeatedly mentioned in the sources between 1191 and 1226, has no connexion with these paintings.

73 This forms a parallel with the orientation of the programme in Civate. It is tempting to postulate that this may have been because the bishop lay in state with his head away from the altar (and thus, as it were, looking towards the transfiguration).

74 Cf. Ch. Michna, 'Das Salomonische Thronsymbol auf Österr. Denkmälern,' *Alte und Moderne Kunst*, 6, 1961, 2 ff.

75 Earth with sheaf; fire with solar disc; water with fish and trident; air now no longer extant.

76 Cf. Hempel, *o.c.*, 106 ff.; Krönig, *o.c.*, 174 ff. (where we read that the transfiguration occurs rather infrequently in 12th- and 13th-century monumental art; an example is the 12th-century ceiling of the St. Martin's church at Zillis (Graubünden) where this representation is spread over three fields, cf. Demus (1968) 179. See also: *Lexikon der chr. Ikonographie*, IV, 1972, 416-21, s.v. Verklärung Christi.
Of the original stained-glass windows, only the central round disc with the deposition from the cross has survived. This is linked by means of an aureole held by flying angels with the mandorla of Christ in the representation of the transfiguration.
Above the window: a medallion with a half-length figure of Christ, or God the Father (?); the inscription speaks of 'Vox patris' and 'Filius dilectus', but the figure wears a cruciform nimbus.
The other representations in glass may also have been devoted to the Passion; the relation between the windows and the rest of the programme is not clear.

77 In the southern segment are Peter and John, in priestly garments, as Bishops of Rome and Jerusalem.

78 Ezekiel with inscription: 'Video quasi rotam in medio rotae' (Ez. 1:16); Jeremiah, accompanied by a potter with a wheel and inscription: 'Descendi in domum figuli, ipse fecit opus super rotam' (Jer. 18:3); Jeremiah again, now together with a girl sitting down and the inscription: 'Virgam vigilantem ego video' (Jer. 1:11); John writing Revelation, with inscription: 'Vidi portam civitatis ad orientem positam'.

79 W. Frodl, *Die romanische Wandmalerei in Kärnten*, Klagenfurt, 1942, 49, 70 ff., Pl. XIV, figs. 69, 70; Hula, *o.c.*, 39-55.

80 B. Brenk, 'Ein Zyklus romanischer Fresken zu Taufers im Lichte der byz. Tradition,' *Jahrbuch der Österr. byz. Gesell.*, 13, 1964, 119-35; Demus (1968) 132 and fig. 70. According to tradition the hospice of the Knights of St. John on the south side of the Ofen Pass has been in existence since 1218, but originally there was a Benedictine monastery here which in Carolingian times was connected with Müstair. Brenk, *o.c.*, 122 regards the paintings as being dependent on Salzburg and considers that as regards their composition they are related to the early-byzantine period, e.g. Ravenna (Archbishop's chapel, vault-composition with 4 angels as caryatids); J. Weingartner, *Die Kunstdenkmäler Südtirols*, II, 1961[4], thinks that it is the work of a painter from the Vintschgau, inspired by the mosaics in S. Marco, Venice.

It is possible that the north wall, like the other three, also contained a theophany. The combination of transfiguration and city quaternity has already come up for discussion in connexion with the programmes at Schwarzrheindorf and Gurk.

81 The frame within which the Deesis is depicted is remarkable, resembling as it does the form of a triptych. This central section of the ceiling has little organic connexion with the quaternity composition as a whole. The Deesis may have to be regarded here as a Last Judgment in abbreviated form.

82 J. H. Klamt, *Die Mittelalterlichen Monumentalmalereien im Dom zu Braunschweig*, diss. Berlin, 1968 (with bibliography of the earlier literature); Demus (1968) 193-95. Plates 220, 221, figs. 55, 56. In Klamt's opinion (*o.c.*, 184) the whole decorative programme was the work of one large atelier in which a number of artists were working fairly independently. He suggests that work proceeded without interruption and was completed within a fairly short space of time, c. 1250. Furthermore he considers that the artist's signature, 'Johannes Wale' (Gallicus), refers to an artist who was a native of Lower Saxony. Demus, on the other hand, (*o.c.*, 195) thinks that the artist concerned must have come from the west.

83 Cf. G. Swarzenski, 'Aus dem Kunstkreis Heinrichs des Löwen,' *Städel Jahrbuch*, 7-8, 1932, 241-397 (243 'aber das Programm des Zyklus kann schon bei dem Neubau unter Heinrich dem Löwen festgelegt worden sein').

84 For the 7-branched candlestick see the article by P. Bloch in: *Wallraff-Richartz Jahrbuch*, 23, 1961, 55-190.

85 According to Klamt, *o.c.*, 191, the scenes in the vault of the crossing can be taken to represent the principal feasts of the liturgical year. Another possibility is to explain them as the Gifts of the Holy Spirit (after Bernard of Clairvaux); e.g. the women at the tomb = timor Dei, Christ explaining the law = spiritus scientiae, etc.

NOTES CHAPTER V

1 For the syndesmos posture and the all-embracing gesture of the spreading of the arms, see the relevant literature in my article in: *Album Discipulorum J. G. van Gelder*, 1963, 5-15. For the syndesmos gesture as cosmogonic gesture see also: Barbara Bronder, 'Das Bild der Schöpfung und Neuschöpfung der Welt als orbis quadratus,' *Frühmittelalterliche Studien*, 6, 1972, 188-210.

2 Cf. E. Walter, *Christus und der Kosmos. Eine Auslegung von Eph.* 1:10, Stuttgart, 1948.

3 Cambridge, Gonville & Caius College, cod. 428, fol. 10r. *Tractatus de quaternario*, c. 1100 (F. Saxl & H. Meyer, *Cat. of Astrological and Mythological Ill. MSS. of the Latin Middle ages*, III, MSS. in English Libraries, H. Bober ed., London, 1953, 422; R. Klibansky, E. Panofsky & F. Saxl, *Saturn and Melancholy. Studies in the History of Natural Philosophy, Religion and Art*, London, 1964, 292 ff., 303-15, Pl. 75).

4 Firmicus Maternus, *De err. prol. rel.* 24, 4 (ed. K. Ziegler, 1907, 56); Jerome, *Comm. in ep. ad Ephes.* (PL 26, 522); see also Hildebert of Lavardin (1056-1133), *Sermo 71. In exaltatione S. Crucis* (*PL* 171, 685): 'hinc (crux) quadrifaria est, quasi amplectens quatuor mundi partes . . .'

5 Linz, Bundesstaatliche Studienbibl., MS. qu. No. 14, fol. 13 v., 12th cent. (H. Vollmer, *Mater. zur Bibelgeschichte*, I, Berlin, 1912, Pl. 3). A variant with minimal differences (A and Ω lacking) in: Vienna, Österr. Nationalbibl., cod. 378, fol. 1 v., Heiligenkreuz (?) early 13th cent. (H. J. Hermann, *Ill. Hss. Oesterreich*, VIII, pt. 2 (1926), N.F. 2, 334-36, Pl. XXXVII).

An item of information concerning another variant on a loose leaf, in the photographic archives of the Warburg Institute, London, refers to a leaf which was c. 1951 / 52 in the Heinrich Rosenthal Collection, Lucerne.

6 Petrus Pictaviensis, *Sententiae*, c. 1 (ed. Ph. S. Moore & Marthe Dulong. Publ. in

169

Mediaeval Studies, The University of N. Dame, Indiana, VII, 1943). In this *Sententiae* he thrice makes use of schemata (admittedly non-figurative): 'ut . . . subiecta oculis figura, quod dictum est, declaretur' (*o.c.* intr. p. XXI).

7 For the use of a scheme hung up in the classroom and containing a parallel between the alphabet and the figure of the crucified Christ fastened with 4 nails to the cross, see B. Bischoff, 'Elementarunterricht und Probationes Pennae in der ersten Hälfte des Mittelalters,' *Mittelalterliche Studien*, I, Stuttgart, 1966, 75 and note 9 (the 5 vowels are compared in such schemes to the 'quinque vulnera').

8 Honorius August., *De inventione S. Crucis* (*PL* 172, 946).

9 Hannover, Hist. Ver. für Niedersachsen (destroyed 1943). Probably made in Lower Saxony, somewhere near Lüneburg. Considered by some to have been designed c. 1235 by Gervase of Tilbury, provost of Ebstorf.
 Largest known medieval map, perhaps going back to a type from late-roman times. Other details are taken from the Bible and from Isidore of Seville. There is an allusion in the text to a map of the world said to have been made by Julius Caesar. The towns are reproduced as 'city-pictographs' (particular attention being paid to Germany, especially to Lower Saxony); Jerusalem is at the centre (*Mappemondes A.D. 1200-1500 . . .*, M. Destombes ed., Amsterdam 1964, Vol. I Mappaemundi-Imago Mundi. Suppl. No. IV, section 52.2; *Scriptorium*, 1967, 331).

10 K. Miller, *Mappaemundi*. Die ältesten Weltkarten, IV, Stuttgart, 1895; J. K. Wright, *The Geographical Lore of the Time of the Crusades . . .*, A *Study in the History of Medieval Science and Tradition in Western Europe*, New York (Dover Publications), 1965, 276-77, fig. 8; *The World Map of Richard Haldingham in Hereford Cathedral*, with a memoir by G. R. Crone, London, 1954, pl. 6. For the interpretation of the cross as one of the Signs of the Son of Man appearing on the Day of Judgment, in connexion with the gesture of the outspread hands, see: E. Stommel, 'Σημεῖον ἐκπέτασεως (Didache 16, 6),' *Röm. Quartalschrift*, XLVIII, 1953, 26.

11 This is also a common representation in the tympanum of French cathedrals, cf. St. Denis, west portal, before 1140 (W. Sauerländer, *Gotische Skulptur in Frankreich 1140-1270*, Munich, 1970, 63 ff., fig. 1).

12 London, Br. Mus. Add. 28681, folios 9 r., 9 v. (*Mappemondes A.D. 1200-1500, o.c.*, I, Suppl. No. IV, 168, No. 8; Annalina & Mario Levi, *Itineraria picta. Contributo allo Studio della Tabula Peutingeriana*, Rome, 1967, 61, note 112, fig. 31). Fol. 3 v. adoration of the Magi, 4 r. birth, 5 v. ascension, 6 r. crucifixion, 7 v. annunciation, 8 r. Christ in oval mandorla between the 4 evangelists; followed by two blank folios between folios 8 and 9; folios 10 v. and 11 r. contain computational tables and a calendar; the text then follows.

13 Berne, Burgerbibl., cod. 120, fol. 140, Petrus de Ebulo, *De rebus Sicilis, C. 1195-97* (see my article in *Festschrift Van Gelder*, 1963, 13, note 45 and fig. 10): 'Sapientia continens omnia' with mappa mundi.
 Brussels, Bibl. Royale, MS. 9005, fol. 287 f. Augustine, *De civate Dei*, French version in 2 volumes, Flemish c. 1420 / 35 (C. Gaspar & F. Lyna, *Les principaux manuscrits à peintures de la Bibliothèque royale de Belgique*, t. II, Paris, 1945, 40-45): Philosophia in syndesmos posture embracing the cosmos, with at the centre the earth, surrounded by the planetary spheres.
 Zwickau, Ratschulbibl., *Deucz practica Baccalaurii Johannis Craconiensis von Hasfurt, 1499* (H. Straus, *Der astrologische Gedanke in der deutschen Vergangenheit*, Munich, 1926, 66, fig. 55): Saturn, the ancient ruler of the outermost planetary sphere in syndesmos posture, half-length, at the top of the earth encircled by the zodiac.

14 Washington, The Folger Shakespeare Library, John Case, *Sphaera Civitatis . . .*, Oxford, 1588 title-page verso, woodcut (E. M. W. Tillyard, *The Elizabethan World Picture*, New York (Vintage Books), 1961, 8): Elizabeth Regina as primum mobile embracing the

Sphaera Civitatis in syndesmos posture; the 7 planetary spheres correspond to the seven princely virtues: Justitia Immobilis, Ubertas Rerum, Facundia, Clementia, Religio, Fortitudo, Prudentia, and Maiestas.

15 Rome, Vat. Bibl., Cod. Palat. Lat. 1993 (R. Salomon & Adelheid Heimann, *Opicinus de Canistris. Weltbild und Bekenntnisse eines Avignoneser Klerikers des 14. Jahrh.*, Studies of the Warburg Institute, London, 1936, 200 ff., Pl. 18; E. Kris, 'A psychotic artist of the middle ages,' *Psychoanalytic Explorations in Art*, New York, 1952, 118-27; R. Salomon, 'A newly discovered ms. of O.d.C.,' *Journal of the Warburg and Courtauld Institutes*, XVI, 1953, 45-57; G. B. Ladner, 'Homo Viator. Mediaeval Ideas on alienation and order,' *Speculum*, 1967, 252-59).

For a curious 'survival' of the idea that stretching out over the map of the world is a sign of power, cf. Franz Kafka, *Hochzeitsvorbereitungen auf dem Lande und andere Prosa aus dem Nachlass*, Frankfurt a.M. (S. Fischer), 1953, 162: '. . . Manchmal stelle ich mir die Erdkarte ausgespannt und Dich (his father) quer über sie hin ausgestreckt vor. Und es ist mir dann, als kämen für mein Leben nur die Gegenden in Betracht, die Du entweder nicht bedeckst oder die nicht in Deiner Reichweite liegen. Und das sind entsprechend der Vorstellung, die ich von Deiner Grösze habe, nicht viele und nicht sehr trostreiche Gegenden . . .'

16 R. Allers, 'Microcosmos from Anaximandros to Paracelsus,' *Traditio*, II, 1944, 319-407.

17 See, for example, H. Liebeschütz, *Das Allegorische Weltbild der H. Hildegard von Bingen, o.c.*, 95 with bibliography.

18 See for the controversy over the possible relationship between the figure of the crucified Christ and Vitruvius' scheme of proportions, my article in *Festschrift Van Gelder*, 1963, 9, note 26 and the literature mentioned there. But in my opinion the question requires a positive answer. An investigation of the relationship between 11th- and 12th-century crucifixes and crucifixion representations of a schematic nature, such as can be fitted into a square or a circle, and Vitruvius' scheme, would undoubtedly be rewarding.

19 Vienna, Österr. Nationalbibl., 12600, fol. 29 r. (A. Boeckler, *Die Regensb.- Prüfen. Buchmalerei*, Munich, 1924, 72 ff.; H. J. Hermann, *Ill. Hss. Oesterreich*, VIII, pt. 2 (1926) N.F. 2, 72-81, fig. 37). The elements on fol. 30 r. are represented as sitting on various mounts: aer on an eagle, ignis on a lion, aqua on a griffon, and terra on a centaur (aer and ignis are male, aqua and terra female). D. Tselos, who in *Art Bulletin* 1952, 274, mentions various examples of elements riding on mounts, thinks that this particular example could go back to an 11th-century Anglosaxon prototype; which of course does not imply that the prototype of the microcosmos representation also has to be sought there.

20 East and west wind are 'triceps', north and south wind 'biceps'; the secondary winds are in profile turned towards the principal winds. For the inscriptions see: Boeckler, *o.c.*, who indicates that this is almost word for word the same as Honorius August., *Imago mundi*, I, 55, where, furthermore, the unusual designation 'Euronotus' also occurs.

For the relation between the scheme of the winds and the microcosmos scheme, see, e.g., the examples in: J. Baltrusaitis, 'Roses des vents et Roses des personnages à l'époque romane,' *Gaz. d. B.A.*, 1938/II, 265 ff.; E. Beer, *Die Rose der Kathedrale von Lausanne*, Berne, 1952.

21 The way the elements are depicted is striking. Ignis is a sort of upturned torch; aqua a six-part leaf, coloured blue, held in the figure's left hand; aer is a sort of green flabel-lum (?) in the figure's right hand, and terra is a red socle on which the figure is standing.

22 As early as in the *Dialogus* ascribed to Archbishop Egbert of York (8th cent.; J. D. Mansi, *Sacrorum Conciliorum collectio . . .*, XII, 487) both the quaternity of the 'homo exterior' and that of the 'homo interior' occur, together with a comparison between the 4 rivers of Paradise and the 4 Gospels.

23 Honorius August., *Speculum Ecclesiae* (*PL* 172, 833-34) allocates the cardinal points to

the Evangelists as follows: north — Matthew 'a quo divinitas Christi sub carne latuisse describitur'; west — Luke 'a quo sol Christus occubuisse moriendo describitur'; south — John 'a quo sol aeternus in maiestate clarescere exponitur'; east — Mark 'a quo sol iustitia . . . resurrexisse traditur' (cf. Sauer, *o.c.*, 64, n. 1.).

24 Munich, Clm. 13002, fol. 7 v. (Boeckler, *Regensb.-Prüf. Buchmalerei*, 20, 91, Pl. XIV (18); XV (19).

The last leaf of the first gathering is missing; this was the leaf immediately following the microscosmos representation and probably contained the model for the music representations which a copy made at Scheyern in 1247 possesses (Clm. 17403, fol. 5 v.). The MS. contains the following miniatures: fol. 6 r. microcosmos (originally the first miniature), folios 1 v. — 3 r. medical tracts, folios 3 v. — 4 r. two series of virtues and vices, fol. 4 v. Jerusalem, fol. 5 r. blank, fol. 5 v. inventory of the church treasure at Prüfening, fol. 6 r., catalogue of the Prüfening library. The date 1165 refers to these folios. They are quite unconnected with the *Glossarium Salomonis* which bears the date 1158 at its beginning (folios 8 v. — 171 v.).

Boeckler, *o.c.*, draws attention to the similar composition of a loose leaf in the Forrer collection (which he considers to have been produced in Weingarten during the last quarter of the 12th century), where 'Locus' is shown in relation to the 4 elements (R. Forrer, *Unedierte Federzeichnungen, Miniaturen und Initialen des Mittelalters*, Strasbourg, 1907, II, Pl. 3).

The microcosmos scheme discussed here was much copied over a long period of time. A late and somewhat degenerate example (placed in a circle instead of a square) is Vienna, Österr. Nationalbibl. cod. 2357, fol. 65 r., Austrian (Aggsbach) 1st half 14th cent. (F. Saxl, *Verz. Astrol. u. Mythol. Ill. Hss. des lat. Mittelalters*, II, *o.c.*, 41, 45, 47 ff., 82, 90 ff., Pl. XII, fig. 20). The inscriptions more or less match those in Clm. 13002; the vegetation serving to indicate terra has now become a trifoliate leaf, and the inscription runs: 'Flos molem sustentat'.

25 Text and illustrations known (if incompletely) from transcriptions by, among others, Count Auguste de Bastard, who owned the MS. for a time (Paris, B.N. n.acq. fr. 6045, 636). The Ms. of the 'Hortus' once in the Strasbourg Bibl. de la Ville was destroyed during the war of 1870 (*Herrade de Landsberg, Hortus Deliciarum*, A. Straub & G. Keller, eds., Strasbourg, 1879-99; O. Gillen, *Ikonographische Studien zur 'Hortus Deliciarum' der Herrad von Landsberg*, Berlin, 1931; J. Walter, 'Quelques miniatures inédites de l'Hortus Deliciarum', *Cahiers d'archéologie et d'histoire d'Alsace*, III, 1921, 1300; *Herrade de Landsberg, Hortus deliciarum*, Strasbourg-Paris, 1952, 58 (for the mnemotechnic verses see 63-64); G. Camès, *Allégories et symboles dans l'Hortus Deliciarum*, Leiden, 1971, 11-12. Pl. I, 1 and 2). A new edition of the text and miniatures is in preparation at the Warburg Institute, London.

26 G. Camès, 'A propos de deux monstres dans l'Hortus Deliciarum,' *Cahiers de civ. méd.*, 1968, 587-603.

27 Munich, Staatsbibl. Clm. 2655, fol. 104 v., 105 r., c. 1295, originally from the Cistercian monastery of Aldersbach:

fol. 1 ff. *Liber de naturis rerum visibilium* (the books are bound in the order: 16, 17, 18, 4, 5, 6, 7, 8, 9, 10, 11, 12, 14, 15, 13, 1; the miniatures belong to book 1).

fol. 95-104 r. *Figurae animalium aliquaeque cum discriptione et explicatione mystica* (latin Physiologus); fol. 104 r. portrait of Abbot Hugh of Aldersbach (1295-1308).

fol. 109 Guilelmi de Conchis, *Summa de naturis videlicet totius philosophiae*.

Ellen Beer, *Rose von Lausanne, o.c.*, 22, 27 suspects a French model, since virtually all richly illustrated MSS. of Thomas of Cantimpré are Northern French; but there can be no question of a single model: the material in the two schemata, both verbal and visual,

had long been exegetically commonplace; M. d'Alverny, 'Le cosmos symbolique du XIIe siècle,' *Archives d'histoire doctrinale et littéraire du Moyen Age*, XXVIII, 1953, 79, fig. facing p. 47; G. J. J. Walstra, 'Thomas van Cantimpré, De naturis rerum,' *Vivarium*, V, 2, Nov. 1967, 146-71.

28 Cf. the transcription after MS. Utrecht, U.B., No. 710, fol. 1 r., see Walstra, *o.c.*

29 This in disagreement with Clm. 13002, where fire is connected with sight, 'aer superior' with hearing, and 'aer inferior' with smell; 'auditus' and 'olfactus' are here linked with 'aer superior' and placed within the circle of the planets.

30 Allusions to the titles of the other books are also possible, e.g. to books 16 and 17: *De vii regionibus et humoribus aeris* and *De spera et vii planetis et eorum virtutibus*, and to book 18: *De passionibus aeris scilicet fulgure, tonitruo et consimilibus*, and also, of course, to book 1: De partibus et membris corporis humani.

31 The winds are here reproduced as half-length figures with 'wind-heads' in their hands; the German names are given as well as the Latin ones.
The elements are depicted as half-length female figures. Their placing differs from that on the facing page: ignis is at the top with 2 birds (phoenix?) and the qualities calidus and siccus; aer is below, with 2 birds (doves?) and the qualities humidus and calidus; aqua is left, suckling two heads and surrounded by fishes, with the qualities frigida and humida; terra on the right, also suckling two heads, on the left of which is a four-footed creature and on the right a snake (cf. book 8: *De serpentibus*) and the qualities sicca, and frigida.

32 For a discussion of the syndesmos figure combined with the cardinal virtues see, e.g., H. von Einem, *Der Mainzer Kopf mit der Binde*, Cologne-Opladen, 1954, 28; G. Bandmann, 'Zur Deutung des Mainzer Kopfes mit der Binde,' *Zeitschr. f. Kunstw.*, X, 1956, 153-75.
It is striking that the group of fortitudo and the lion is here depicted analogously to the Virgin and the unicorn.

33 See the texts in: Photima Rech, *Inbild des Kosmos. Ein Symbolik der Schöpfung*, 2 vols., Salzburg, 1966. The identification of man with a tree occurs earlier (Ezek. 17:22-24; Daniel 4:7-14).

34 See for a detailed discussion: Eleanor Greenhill, 'The child in the tree,' *Traditio*, X, 1954, 323-73.

35 The division of world history into these 3 periods goes back to Augustine (e.g. his *Enchiridion*, ed. J. Rivière, 98). See also note 46 infra.

36 Cf. Greenhill, *Speculum Virginum, o.c.*, 346, fig. 8 in connexion with a tree scheme alluding to the rewards of the degrees of coniugati, viduae, and virgines (based on the parable of the thirty-, sixty- and hundredfold yields of fruit, Matth. 13:3-15).
For the cross-tree as 'scala coeli' with various 'gradus' of merit, see *De catachysmo ad cathechumenos* (*PL* 40, 696), possibly written by Quodvultdeus and previously ascribed to Augustine. Raban Maurus, too, *De laud. S. Crucis* 2, 17 (*PL* 107, 282), speaks of the cross as 'via . . . justorum, ascensus ad coelum, rota de infima ad superiora nos trahens , , ,', where the 'rota' possibly ought to be interpreted in the sense of 'machina', a sort of mechanism that 'raises' the just. For the use of the 'quadriga' in this sense, see Chap. III, p. 66.

37 See Chap. III, p. 69.

38 It is not clear whether Ecclesia is holding the cross or being supported by it. This last interpretation also occurs, e.g. in Maximus of Turin: 'Ecclesia sine cruce stare non potest, ut sine arbore navis infirma est' (quoted from Jacob Gretser, *De Cruce Christi*, Ingolstadt, 1600, an inexhaustible source of texts on the symbolic significance of the cross and crucifixion).

39 Cf. e.g. Walafrid Strabo, *In Ps. LXXI* (*PL* 113, 956A): 'Christus in David et in Abraham sed occultus; ut fructus est in radice sed non apparet; noverunt autem pauci prophetae

173

et Christum et N. Testamentum, sc. in occulto et pronuntiaverunt revelandum'.

40 See the literature cited in Ch. IV, p. 89, note 62.

41 Cf. G. E. Pazaurek, *Alte Goldschmiedearbeiten aus Schwäbischen Kirchenschätzen*, Leipzig, 1912, Pl. 1; A. Andersson, *Abendmahlsgeräte in Schweden aus dem XIV. Jrh.*, Uppsala, 1956 (who dates it in the 11th cent.); H. Schnitzler, 'Zur Regensburger Goldschmiedekunst,' *Wandlungen Christl. Kunst im Mittelalter*, Baden-Baden, 1953, 171-85 (does not mention the reliquary). The foot and the top are a later reconstruction (Augusburg, 1625).

42 *Oesterreichische Kunsttopographie*, III, 1909, p. 115, fig. 141.

43 Andersson, *o.c.*, Pl. 79 (90).

44 K. Richstätter, *Die Herz-Jesuverehrung des Deutschen Mittelalters*, Munich-Regensburg, 1924²; R. Bauerreis, *Pie Jesu. Das Schmerzensmannbild und sein Einfluss auf die mittelalterliche Frommigkeit*, Munich, 1931, 121.
Cf. also the possibilities for visual exegesis in the use of the so-called Hungertücher with the 5-wounds scheme, which were hung up during the Lenten fast (originally in front of the high altar and later above it) and then let down at the words 'et velum templi scissum est medium'. The concealment took place for three reasons: the unworthiness of the faithful to see the altar during a time of penance; the concealment of Christ's godhead during his suffering; and the comparison with the veil of the Temple which was rent (see: P. Engelmeier, *Westfälische Hungertücher vom 14. bis 19. Jrh.*, Munich, 1960; H. Appuhn, 'Der Auferstandene und das Heilige Blut zu Wienhausen,' *Niederd. Beiträge*, I, 1961, 84 ff.).

45 Richstätter, *o,c.*, 332; a second (?) edition came out at Antwerp in 1618. The syndesmos angel with the scheme of the 5 wounds can also be found in woodcuts to which indulgences had been attached. These depict two angels holding up a cloth containing a reproduction of the wounded Sacred Heart. One angel with the scheme of the 5 wounds on a cloth (a parallel with the Sacred Countenance on Veronica's veil occurs sometimes as well, e.g. Calkar, Pfarrkirche, ceiling painting above the chancel, 1469 (Richstätter, *o.c.*, 240).
For the exegesis of the text John 7:37-38 'qui sitit veniat' and the source of the 'aquae vivae' see Chr. III, p. 62, note 28.

46 Schulpforta, Bibl. der Landesschule, A. 10, fol. 2 v. and 3 r., from the monastery of Bosau near Zeitzen (Lübeck area), written and probably also illustrated by the monk Erkenbert, c. 1180 (A. de Laborde, *Les MSS. à peintures de la Cité de Dieu*, III, Paris, 1909, Pl. 11). For the ages of the world see: R. Schmidt, 'Aetates mundi. Die Weltalter als Gliederungsprinzip der Geschichte,' *Zeitsch. f. Kirchengesch.* 67, 1955-56, 292 ff.

47 Called John the Baptist by Laborde. Identification is difficult, however, since the scrolls accompanying both this figure and Peter are blank. Another possibility is that John the Evangelist is meant; from Augustine onwards (*In Johannis Evangelium*, tract. CXXIV, 5-7, *PL* 35, 3, 2, 1974) Peter and John had been regarded by exegetes as representatives of the 'vita activa' and 'vita contemplativa'.

48 Matthew being the writer of the Gospel which begins with the genealogy of Christ, from Abraham to David (14 generations).
Left and right of Varro the following ancient authors are depicted: Plato, Apuleius, Virgil, Hermes Trismegistus (or Ennius).

49 Thus it forms an example of the 'inverted tree', with its head = the root, in heaven, see Ch. II, p. 41, note 74.

50 This is indicated extremely subtly by permitting the eye to see, behind and through the surface on which the 6 ages of the world are depicted, a background strewn with stars, against which the syndesmos ideogram and the two figures of the Apostles stand out.

51 Augustine, *De civitate Dei*, XV, 26-27; *Glossa Ordinaria*, Lib. Gen. c. vi. For an interpretation in terms of the various categories of souls, see: Peter Damian, *De bono religiosi*

status et variorum animantium tropologia (*PL 145, 763-92*). *Laborde, o.c.*, explains the medallions with animals as an allusion to the Creation.

For an exegesis of the ark of Noah in terms of the 4 'sensus', see the texts cited by Lubac, *o.c.*, II / 1, 317 ff. Christ as a spiritual Noah is the 'architectus Ecclesiae', the central column of the ark is compared with the Tree of Life in the middle of the world; the ark is 'quadrata' and is compared with the 4 dimensions of the cross (the door is the wound in Christ's side), the various compartments are explained as the 'mansiones' in the Father's house (John 14:2), the different floors are comparable with various 'sensus' of Scriptural exegesis (see also Lubac, *o.c.*, I / 2, 550 and Spitz, *o.c.*, 209 ff.: Gebäude). For an interesting description of a visual exegetic scheme (pictura) of Noah's ark, unfortunately no longer extant, see: Hugh of St. Victor, *De arca Noe morali* (*PL* 176, 678 CD), an extensive analysis of which appeared in: F. Ohly, 'Die Kathedrale als Zeitraum. Zum Dom von Siena,' *Frühmittelalt. Studien*, 6, 1972, 94-158; H. Boblitz, 'Die Allegorese der Arche Noahs in der frühen Bibelauslegung,' *ibid.*, 159-70; J. Ehlers, 'Arca significat ecclesiam,' *ibid.*, 171-87.

52 For the development of the 'arbor consanguinitatis' from the 'arbor iuris' see: G. Haenel, *Lex romana Visigothorum*, 1849; O. Lorenz, *Lehrbuch der gesammten wissenschaftl. Genealogie*, Berlin, 1898, 90, 93-94; K. Conrat, *Geschichte der Quellen und Literatur des römischen Rechts im Frühen Mittelalter*, 1891, I, 240, note 5, 316-18, 631-37; idem, 'Arbor Iuris des frühen Mittelalters,' *Abh. der Preuss. Akad. phil. hist. Kl.*, 1909, 27, note 3, 28; F. Calasso, *Il medioevo del diritto. Le fonti*, Milan, 1954; J. Gaudemet, *La formation du droit séculier et du droit de L'Eglise aux 4e et 5e siècles*, Paris, 1957, 210; idem, 'Le droit romain dans la pratique et chez les docteurs aux XIe et XIIe siècles,' *Cahiers de civ. méd.*, VIII, 1965, 365-80; E. Champeaux, 'Jus Sanguinis. Trois façons de calculer la parenté au Moyen Age,' *Revue Historique de droit français et étranger*, 4e ser. XII, 1933, 241-90; Evelyne Patlagean, 'Une représentation byzantine de la parenté et ses origines occidentales,' *L'Homme. Revue française d'anthropologie*, VI, oct.-dec. 1966, No. 4, 59-81.

Only a few indications in art-historical literature, e.g. in: A. Watson, *The early iconography of the tree of Jesse*, Oxford-London, 1934, 39-42, 164-65; *Reallexikon z.d.KG*, II, 74-78, s.v. Baum; *Lexikon der chr. Ikonographie*, I, 1968, 266 ff., s.v. Baum (schema). According to Lorenz, *o.c.* (fig. p. 91) there are indications that at an early stage architectonic details such as bases, columns and capitals were added to the scheme.

53 Julius Paulus, *Sententiae. Tit. XI. De gradibus. Iurisprudentiae Anteiustinianae quae supersunt*, Ph. E. Huschke ed., Leipzig, Teubner, 1879, 505-08.

54 *Imp. Iustiniani Institutionum Libri Quattuor*, Ph. E. Huschke ed., Leipzig, Teubner, 1868, 115. A cruciform scheme to the sixth degree in, e.g., Paris B.N. lat. 12448, *Lex romana canonice compta*, fol. 113 r., 10th cent. — with instruction: 'Hec crux hic fieri debuit'. Conrat, *o.c.*, 631 thinks that a scheme of this sort could go back to that of Justinian. The oldest surviving MS. of the *Institutiones:* Turin, cod. Taurin. D III, 13, fol. 67 v., 10th cent. (Conrat, *o.c.*, 318) puts Adam at the top of the scheme, as highest degree on the vertical axis, and thus already provides an exegetical adaptation of the juridical scheme.

55 Mansi, *Sacr. Concil. Nova et Ampl. Coll.* XVII, 285.

56 Conrat, *o.c.* (1909).

57 For the authenticity of these schemata see: Champeaux, *o.c.*, 274, notes 1, 2, 3.

58 See the examples discussed on p. 113.

59 For, inter alia, the relation to the roman patrician 'stemma' see E. H. Wilkins, 'The Trees of the "Genealogia Deorum",' *Modern Philology*, XXIII, 1925-26 (Aug. 1925), 61-65.

60 Berne, Burgerbibliothek, cod. 101, fol. 88 r. (Homburger, *o.c.*, fig. XXVIII.72).

61 Berne, Burgerbibliothek, cod. 36, fol. 57 v. (Homburger, *o.c.*, fig. XXIX.73).

62 Paris, B.N., lat. 10292, fol. 93 (Patlagean, *o.c.*, 67, Pl. 7).

63 For Alaric's breviary, an adaptation of Roman Law, see: Haenel, *o.c.*, IV, 408, e.g., Paris, B.N. lat. 4412, fol. 76 v., 77 r. (Patlagean, *o.c.*, 70, Pl. 12).

(pp. 111-14)

64 Paris, B.N., lat. 4410, Breviarium of Alaric, fol. 2 (Patlagean, *o.c.*, 67, Pl. 6). Schemes formed of medallions are familiar from another tradition working with genealogical trees, that of the Biblical genealogical tables (dealing with, for example, Noah and his sons) which occur frequently in Beatus MSS., among other places (Neuss, *Die Apok. des Joh.*, I, 119-25, cf. Paris, B.N., lat. 8878, Apocalypse of St. Sever, 11th cent. (Watson, *Jesse tree*, 42 ff., Pl. XXXVII).

65 Conrat, *o.c.* (1909) 14.

66 See Ch. II, p. 34, note 19. See also: Vienna, Österr. Nat. bibl., cod. 67, Isidore, *Etymologiae*, fol. 85 v., 2nd half 12th cent.: stemma III with 6 degrees, inscription 'stemma stirpis humane' (*Reallexikon z.d.KG* II, 77).

67 Wolfenbüttel, Herzog August bibl., cod. 64, Weiss, Isidore, *Etymologiae*, fol. 141 r., beginning or middle 8th cent. (*Reallexikon z.d.KG* II, 75).

68 Brussels, Bibl. royale, II, 4856, fol. 265 v. (Watson, *Jesse tree*, 40, Pl. XXV).

69 Berne, Burgerbibl. cod. 263, fol. 14 r. (Homburger, *o.c.*, 25-27, fig. 14).

70 Munich, Clm. 18192, Isidore, *Etymologiae*, 1st half 11th cent. Left and right, Pater and Mater, below them the Isidore quotation: 'Haec consanguinitas . . .' (E. Bange, *Bayer. Malerschule*, 1932, 13, Pl. I. 2).

71 Paris, B.N. lat. 10293, fol. 99v. (Patlagean, *o.c.*, 69, Pl. 10).

72 Modena, Mutin. Ord. I. 2, fol. 4 v. (Patlagean, *o.c.*, 69, Pl. 11).

73 See note 54.

74 Calasso, *o.c.*, 282. For a comparison of the degrees of relationship with the parts of the human body in early German law, see, e.g., *Sachsenspiegel* I, 3, with reference to the *Decretum Gratiani*, but going back to an older tradition (Patlagean, *o.c.*, 67 ff. and the literature cited there).

75 Paris, B.N. lat. 2169, fol. 195 (Patlagean, *o.c.*, 67, Pl. 8).

76 Munich, Clm. 13031, fol. 102 v. (Boeckler, *Regensb.-Prüf. Buchmalerei*, 15 ff., Pl. IV, fig. 6). The linking of the two triangles to the tree scheme would appear to be an anticipation of the 'arrow'-shaped scheme occurring in very many MSS. of the *Decretum Gratiani* (see p. 115).

77 This is indicated by the 'renascetur' and 'renovando' of the inscriptions.

78 Burchard of Worms, *Decretum Burchardi*, VII.10 De incestu (*PL* 140, 781; P. Fournier & G. Le Bras, *Histoire des collections canoniques en Occident depuis les fausses décrétales jusqu'au décret de Gratien*, 2 vols., Paris, 1931-32). Paris, B.N. lat. 9630, *Decretum Burchardi*, fol. 118, 11th c. (Patlagean, *o.c.*, 67, Pl. 9). Related schemata in other 11th- and 12th- c. Burchardus-MSS., see Patlagean, *o.c.*, figs. pp. 69, 87; *Reallexikon z.d.KG* II, fig. p. 78 and E. Garrison, *Studies in the history of mediaeval italian painting*, IV, 2, Florence, 1960-62, 199, fig. 151.

79 W. Plöchl, *Das Eherecht des Magisters Gratianus*, Leipzig-Vienna, 1953, 13 ff.; Jacqueline Rambaus-Buhot, 'L'étude des MSS. du Décret de Gratien conservés en France,' *Studia Gratiana*, I, Bologna, 1953, 121-45; Rosy Schilling, 'The Decretum Gratiani formerly in the C. W. Dyson Perrins collection,' *The Journal of the British Archaeological Association*, 3, XXVI, 1963, 27-40; J. Gaudemet, 'Le droit romain dans la pratique et chez les docteurs au XIe et XIIe s.,' *Cahiers de civ. méd.*, VIII, 1965, 376-80. Gratianus (died after 1150) was a Camaldolese (?) monk, jurist and theologian who taught at the monastic school of SS. Felix and Nabor at Bologna and possibly also belonged to a school working at Rome. Opinions are divided about where he acquired his method. Some commentators claim to see a French influence (similarity to, e.g., the methods of Abelard, Anselm of Laon and Hugh of St. Victor), which raises the problem of whether he had studied in Paris. His approach is not new: the same method was followed in earlier collections of canons, for example in those of Ivo of Chartres (c. 1040-1116). According to legend, Peter Lombard and Peter Comestor were his brothers. Dante places him in Paradise: 'Quall'altro fiammeggiar esce del riso de Grazian, che l'uno e l'altro foro Aiuto si, che piace in Paradiso (*Paradiso*, X, 103 ff.).

176

Very soon after the completion of his *Decretum* copies were circulating north of the Alps (Schilling, *o.c.* (1963), 31).

80 Schilling, *o.c.* (1963), 31 thinks that the anthropomorphic 'arbor consanguinitatis' scheme is of Italian origin and goes back to the collections of canons made before the time of Gratianus. The question of origin had better be left open, however, until more is known about both the illustrations to these early canon collections and the illustrations to Isidore's *Etymologiae.*

81 This holding of tendrils is related to the gesture made by Jesse in various representations of the Tree of Jesse (see, e.g., illustrations IV, VI, X in Watson, *Jesse tree*).

82 Auxerre, Bibl. Mun. 265 (Schilling, *o.c.* (1963), Pl. XIX.3). The same headdress is worn, in medieval representations, by Adam and by Old Testament priests and prophets, see, e.g., the jamb statues of the west portal of St. Denis, known to us from the drawings in: Bernard de Montfaucon, *Monumens de la monarchie française,* Paris, 1729 (see Sauerländer, *Gothische Skulptur . . .,* figs. p. 64, 65).

83 Munich, Clm. 13004, fol. 308 v., 309 r. (Boeckler, *Regensb.-Prüfen. Buchmalerei,* 17, Plates 171, 172).

84 Admont, Stiftsbibl. lat. 35, fol. 296 v., 1st half 13th c., Austrian or German (Hermann, *Ill. Hss. Oesterreich,* IV, 1, 1911, 87, fig. 90); Munich, Clm. 4505 (Schilling, *o.c.,* 32, Pl. XIX.1).

85 New York, Glazier collection, 37, Northern France, 13th c., with the inscription: 'Gautier Lebaube Fit Labre' (*Exhib. Cat. Pierpont Morgan Library, Glazier Coll.,* 1959, No. 22, Pl. 20). Probably illustration to Decretals of Raymundus de Pennaforte (died 1275).
See also the examples reproduced in the articles by Rosy Schilling mentioned above.

86 New York, H. P. Kraus collection, from the Dyson Perrins collection, dating c. 1180 (Schilling, *o.c.* (1963), Pl. XVI).
Florence, Bibl. Laurenziana, Plut. 4. sin. I, fol. 280 (Garrison, *o.c.,* IV, 3-4, 337, fig. p. 342).

87 Admont, Stiftsbibl. lat. 43, fol. 342 v. *Decretum Gratiani* pars II and III and *Partes codicis Justiniani,* Admont, 2nd half 12th c. (Hermann, *Ill. Hss. Oesterreich,* IV, 1, 1911, 47, fig. 41); Vienna, Österr. Nationalbibl., cod. 428, miscellany from Salzburg (?), 2nd half 12th cent. (Hermann, *Die deutschen roman. Hss.,* N.F. VIII.2, 140–41, Pl. XVI).

88 Cf. Raymundus de Pennaforte, *Summa,* fol. 1 v., 13th c., from the Stiftsbibl. of Lambach (L III), present whereabouts unknown. Anthropomorphic stemma II with 4 figures in the corners, left 2 men, and right, 2 women (*Oesterr. Kunsttopographie,* XXXIV, 1959, 210, fig. 253).

89 Admont, Stiftsbibl., lat. 12, fol. 41 v. (Hermann, *Ill. Hss. Oesterreich,* IV, 1, 1911, 133, fig. 142; J. Trummer, 'Bigamie als Irregularitätsgrund nach der Lehre der alten Kanonistik,' *Festschrift W. Plöchl,* 1967, 393-409).

90 Brussels, Bibl. Royale, 19546, fol. 2 r. (*Bibl. Roy. Mss.,* I, 1937, Pl. LIX.b).

91 Madrid, Biblioteca Nacional, Hb. 51 (Watson, *Jesse tree,* 42, Pl. XXXVI).

92 H. Abert, *Die Musikanschauung des Mittelalters und ihre Grundlagen,* Halle, 1964 (reprint of the edition of 1905); G. Pietzsch, *Die Klassifikation der Musik von Boethius bis Ugolino von Orvieto,* Halle, 1929; Th. Gérold, *Les Pères de l'Église et la musique,* Paris, 1931; idem, *La Musique au Moyen Âge,* Paris, 1932; G. Pietzsch, *Die Musik im Erziehungs- und Bildungsideal des ausgehenden Altertums und frühen Mittelalters,* Halle, 1932; R. Hammerstein, *Die Musik der Engel. Untersuchungen zur Musikanschauung des Mittelalters,* Berne-Munich, 1962; L. Spitzer, *Classical and christian ideas of world harmony. Prolegomena to an Interpretation of the word 'Stimmung',* Baltimore, 1963; Spitz, *o.c.,* 223-33 (Übereinstimmung-Leier: Holzkörper und Saiten).
For additional information concerning medieval instruments and musical practice (see notes 119, 124 and p. 127), I am gratefully indebted to Professor Hélène Wagenaar-Nolthenius of Utrecht University.

177

93 Of importance for the use of a musical instrument as a quadripartite harmony scheme for visual exegesis, is the age-old idea — one which is already present in the Pythagorean tradition — of the omnipresent fourfold harmony in the world. For the history of this idea from Plato (especially the *Timaeus*) to the Middle Ages, see, e.g., Spitzer, *o.c.*, 8.

94 Cf. Plato, *Phaedo*, 85E, where Socrates questions Simmias the Pythagorean about his idea of the body as a lyre.

95 Philo also used another cosmic symbol, the 7-branched candle-stick: for this comparison, see Spitzer, *o.c.*, 223 ff.

96 Basing himself on Plato, *Symposium*,211E; this made its way by various routes into medieval mysticism, see Abert, *o.c.*, 41, 109, 212 ff.

97 H. Steger, *David rex et propheta*, Nuremberg, 1961.

98 This was incorporated into the visual exegetic scheme of the cosmic crucifixion in the Uta Gospel book (Munich, Clm. 13601, fol. 3 v.; G. Swarzenski, *Die Regensb. Buchmalerei* (1901), Pl. XIII.30).

99 Quite at variance with antique teaching, however, is the penentential element introduced into the singing of the psalms, cf. the 'compunctio cordis', in the passage cited from the Rule of St. Benedict.

100 The cithara as standing for caritas in John Chrysostom, *Homil. in Act. Apost.* 40:4 and for the symphony of the virtues in his *In ps. 98:2*. The cithara as image of good works is also found in Gregory the Great, *Moralia in Job*, 29.

101 Bonaventura, *In Hexaemeron*, collat. XIX, 7 (*Opera omnia*, ed. Quaracchi, 189, V, 421): 'Tota scriptura est quasi una cithara et inferior chorda per se non facit harmoniam, sed cum aliis, similiter unus locus scripturae dependet ab alio, immo unum respiciunt mille loca'.

102 The symbolism of the cithara and psaltery, based on the difference in their form, probably occurs for the first time in Hippolytus, *Comm. in ps.*, c. 6, where the psaltery is compared to the 'corpus Christi' and the saints, on the grounds that it possesses the highest degree of completeness, is the only instrument with no bent or curved lines, and, unlike the cithara, has its 'soundboard' on top and not below. This was taken over by Eusebius, *Comm. in ps.*, init. and Basil, *Hom. in ps. 32:2*, where we also find an account of the symbolic relation of the psaltery and cithara to the soul and body respectively. This made its way to the west via Hilary of Poitiers, *Prol. in Libr. Psalmorum*, c. 7. The comparison between the psaltery and the cithara is found in Augustine, *In ps. 32:2* (*PL* 36, 286) and also in Cassiodorus, *Expositio psalmorum*, praef., c. 4 (*PL* 70, 15).

103 As early as Origen, *In Matth. X, 16* we find the musical instrument being used as an image of the agreement between the various parts of Scripture (see also the Bonaventura text cited in note 101).
Unlike most writers, John Chrysostom, *Comm. ps.* LXXX (*PG* 55, 728) designates the psaltery as Old Testament and the cithara as New Testament.

104 Dublin, Library of A Chester Beatty (E. G. Millar, *The Library of A. Chester Beatty*, Oxford, 1927, I, 109, 111 ff., Pl. 83; Ch. de Tolnay, 'The music of the Universe.' *Journal of the Walters Art Gallery*, VI, 1943, 83-104; Greenhill, in: *Traditio* 1954, 361 ff., Pl. I; Steger, *David rex et propheta*, 68 ff., 232 ff., Plates 27, 53a; Spitz, *o.c.*, 228 ff.; H. Steger, *Philologia Musica. Bild und Sache im Literarischen Leben des Mittelalters: Lire, Harfe, Rotte und Fidel*, Munich, 1971.
Not only the style but also the independent rôle played by the texts argue for a provenance in Regensburg/ Prüfening.
David occurs frequently as the type of Christ, of the Ecclesia and of the concordia of the Civitas Dei, cf. Augustine, *De civ. Dei*, XVII, (*CCSL*, XLVIII, 578): 'Diversorum enim sonorum rationabilis moderatusque concentus concordi varietate compactam bene ordinatae civitatis insinuat unitatem' and *Enarrationes in Psalmos*, In ps. 59:1 (*PL* 36, 713): 'David rex unus homo fuit, sed non unum hominem figuravit; quando scilicet

figuravit ecclesiam ex multis constantem, distentam usque ad fines terrae; quando autem unum hominem figuravit, illum figuravit qui est mediator Dei et hominum, homo Christus Jesus'.

105 The great significance attached to the number 4 in this instance goes back to the Pythagorean tradition. The antique cithara originally had 4 strings, to which according to tradition, Terpander added another three, cf. Gerold, *o.c.,* 6.

The 'quaternarius mysticus', in connexion both with the Scriptures and with the world harmony of the elements and seasons and music, is already to be found in: Ambrose, *De XLII mansionibus filiorum Israel* (*PL* 17, 11).

The 'quaternarius' is also found in connexion with the 'syzygiae elementorum' and the 3 'musicae genera' (mundana, humana, instrumentalis) in Berno of Reichenau, *Prol. in Tonarium* (*PL* 142, 1102-03: '. . . Satis claret non sine magno divini muneris nutu hanc vim quaternario esse ingenitam ut totius harmoniae concentus ab eo oriatur et in eundem velut ad principii sui originem revertatur'.

Cf. also an anonymous tract on 'musica quadrata': *De musica theorica* (*PL* 90, 191; *Sacris Erudiri* III, 1961, N 1384, p. 311, Bede, *Dubia et Spuria*).

106 See the literature mentioned in note 1 of this chapter.

107 Augustine, *Tractatus in Joannis Evangelium,* No. 118, 5 (*PL* 35, 1949) and *De Doctrina Christiana* 2. 41 (*PL* 34, 64); Raban Maurus, *De laudibus S. Crucis,* I, 271 (*PL* 107, 157-58); Ps. Augustine (Quodvultdeus?) *Sermo 7, De catachysmo ad catechumenos PL* 40, 699); Peter Damian, *En. in Epp. S. Pauli* (*PL* 112, 424).

108 Jerome, *Comm. in Ep. ad Ephes.* (*PL* 26, 522).

109 Isaiah 9 : 6: 'Parvulus . . . natus est nobis . . . et factus est principatus super humerum ejus'. *Glossa Ordinaria,* In Isaiam, IX.6: 'Principatus super humerum (Hieronymus) Dum duceretur ad patibulum, portavit crucem in qua meruit principatum'.

An interpretation in the sense of an 'imitatio Christi', in other words an inducement to take up the cross, the four extremeties of which are interpreted mystically, is to be found in, for example, the *Stimulus Amoris* (*PL* 184, 953; incorrectly ascribed to Anselm or St. Bernard): 'portabo infatigabiliter eam, quae ab inimicis est, crucem post te . . . cujus latitudo est charitas, cujus longitudo est aeternitas, cujus sublimitas est omnipotentia, cujus profundum est inscrutabilis sapientia'.

110 Cf. the text by Peter Damian cited in note 107: 'latitudo vero extensio est charitatis, quae etiam non solum ad amicos, qui dextra significantur, sed etiam ad inimicos, qui in sinistra intelliguntur . . .' and Hildebert of Lavardin (1056-1133) *Sermo 71, In exaltatione S. Crucis* (*PL* 171, 685): 'hinc (crux) quadrifaria est, quasi amplectens quatuor mundi partes, . . . altitudo spem salutis, quam habemus in coelestibus, significat; latitudo caritatem, quae extensa est usque ad inimicos; longitudo perseverantiam bonorum operum; profunditas, id est illa pars, quae latet, profunda mysteria judiciorum Dei . . .'.

111 Possibly an adaptation of Jeremiah 23:23: 'Putasne Deus e vicino ego sum, dicit Dominus, e non Deus de longe'.

112 Cf. the text by Peter Damian cited in note 107, where the 3 theological virtues are linked to the dimensions of the cross. The same author (*Carmen, PL* 107, 174) also connects the latter with the 4 cardinal virtues (with 'profundum crucis' incorporating both 'fides' and 'fortitudo').

Rupert of Deutz, *De divinis officiis* 6, 9 (*PL* 170, 159) also follows up an exegesis of the 4 extremities of the cross in terms of the 4 cardinal points with an interpretation based on the 3 theological virtues, to which he adds 'perseverantia'.

113 Vilma Fritsch, *Links und Rechts in Wissenschaft und Leben,* Stuttgart (Urbanbücher 80), 1964; E. J. Zwaan, *Links en rechts in waarneming en beleving,* diss. Utrecht, 1965.

114 For the perfection of the number 3, See, e.g., Augustine, *De musica,* I, 12 (*PL* 32, 1081-1194): '. . . in ternario numero quandam esse perfectionem vides, quia totus est, habet enim principium medium et finem'.

179

115 This classification of music – Greek in origin – came down to the Middle Ages largely through the influence of Boethius, cf. Abert, *o.c.*, 165. Other tripartite divisions also occur, e.g., Raban Maurus, *Comm. in paralip.* I, 5 (*PL* 109): '. . . rationalis pertinebat ad humanam vocem, irrationalis ad instrumenta musica, communis autem de utriusque partibus aptatur . . .' and Absalom of Springiersbach (end 12th, beginning 13th century) *Sermones Festivales*, Sermo XX In Annunciatione B. Mariae (*Pl* 211, 121): musica animalis (comparison with 5 vocales, diapente, 5 sensus corporis) musica spiritalis (in profecto virtutum; comparison with diatesseron, fortitudo, justitia, temperantia, perseverantia) and musica coelestis.
One also comes across a twofold division, into: musica naturalis (given by God, e.g. the movement of the heavens or of the human voice) and musica artificialis (invented by man and produced on 3 sorts of instruments: wind, percussion and stringed instruments), see Abert, *o.c.*, 166 for an appropriate text by Regino of Prüm.

116 Honorius August. *Exp. in Ps.* (*PL* 172, 271).

117 Raban Maurus, *Comm. in paralip.* (*PL* 109) calls the cithara triangular and an image of the Trinity.

118 The description of the cithara or psaltery (the names keep on being used interchangeably) as delta-shaped goes back to Jerome's commentary on the Psalms, which is repeatedly quoted by later writers, cf. Cassiodorus, *Expositio psalmorum*, praef. 4 (*PL* 70, 15): 'Psalterium est, ut Hieronymus ait, in modum Δ litterae formati ligni sonora concavitas . . .'. See also Isidore *Etymologiae*, III, xxiii, 7 and *Glossa Ordinaria*, Prothemata in Psalterium.
One instance of a comparison between 'corpus Christi', 'psalterium decemchordarum' and the harmony of the Old and New Testaments, can be found in: Arnold of Bonneval, *De VII verbis Domini in cruce*, tr. 4 (*PL* 189, 1701B): '. . . et extensa in cruce pelle corporis sui, in psalterio decachordo, Veteris et Novi Instrumenti concutit consonantiam'.

119 This reproduces the normal position in which the psaltery was held for performance, i.e. with the point downwards (see Hammerstein, *Musik der Engel*, figs. 61, 62).

120 See note 98.

121 Cf. Abert, *o.c.*, 37 ff., and Gérold, *o.c.*, 59.

122 The exegesis of instrumental playing in terms of 'vita practica' and of song in terms of 'vita contemplativa' was highly popular both among eastern exegetes (cf. the commentaries on the Psalms by Didymus, Eusebius, Basil the Great and Gregory of Nyssa, the last of whom was the only one to use the term 'philosophia practica et theoretica') and among those of the west (e.g. Hilary and Ambrose), see Abert, *o.c.*, 110.
The cithara and psaltery were also compared with, respectively, the 'vita activa et contemplativa', where the cithara usually stood for the earthly and the psaltery for the heavenly, cf. Gérold, *o.c.*, 125 ff.

123 Cf. *Glossa Ordinaria*, In Cant. cant., II, 6.

124 The 'vertical' position of the 'pendant' strings differs from the actual practice. In reality the instruments had horizontal stringing; cf. Hammerstein, *Musik der Engel*, figs. 61, 62).
The comparison between the 'psalterium 10 chordarum' and the 10 Commandments occurs in the exegesis of both east and west, e.g. in the commentaries on Psalm 32:2 by Basil and by Augustine (where, incidentally, the symbolism of the numbers 3, 7, and 10 has also been worked in). This was probably taken over directly from Augustine by Isidore of Seville, cf. Fontaine, *Isidore de Seville et la culture classique*, I, 438. This interpretation occurs frequently in western exegesis, e.g., in Raban Maurus, *Comm. in Ecclesiast.* VIII, 18 and in the *Glossa Ordinaria*, In Ps. XXXII, 2: *Cithara* (Aug.) a inferiori sonat, et ex terra est, unde laudemus, id est, prosperitas et adversitas, quae ab eo sunt nobis. *In psalterio.* Dum attendit superiora quae tibi dedit, coelestem doctrinam.

Per *citharam* caro per *psalterium* charitas intelligitur: ad quae decem praecepta legis pertinent: tria in prima tabula ad Deum, septem in secunda ad proximum'.

125 See also the text on the left, referring to the psaltery 'obesum habens ventrem . . .'; cf. *Glossa Ordinaria, In Isaiam,* XVI, 11: '*Venter meus.* Propheta, qui tanquam cithara, musica arte compositus, et de Dei timore concipiens, multos liberos generat, ut omnis chorda sonum suum reddat. *Et viscera.* Sicut cithara sonum compositum non emittit, etc.'

The term 'Ecclesia-venter' occurs in the *Glossa Ordinaria, In Cant.* cant., V, 4 in connexion with the Sponsus-Sponsa relationship.

126 The texts provided by Abert, *o.c.* 121, note 219 and Gérold, *o.c.,* 126 ff. in this connexion are all taken from commentaries on the Psalms by Greek church fathers (Origen, Athanasius) who, under neoplatonic influence, compare the 'psalterium decem chordarum' with the 5 senses of the body and the 5 energies of the soul.

127 *Glossa Ordinaria, In Cant.* cant. II, 9: '. . . *prospiciens per fenestras,* id est, per quinque sensus sollicite contuetur; ubi enim non prospicit sponsus, mors ascendit: unde Jeremias: *Ecce mors ascendit* per fenestras nostras (Jer. 9) . . . *Per fenestras.* Sicut sol intrans per fenestras illuminat domum, ita Christus exemplo et admonitione apostolorum nos illuminavit. Sicut *per cancellos,* id est per parva foramina parva lux intrat, sic obscura cognitio per prophetas'.

The 'obscura cognitio' of the prophets as against the 'illuminatio' of the apostles, is an important point (the same in Honorius August. *In Cant. cant.* 2,9 (*PL* 172, 391) and Durandus, see Sauer, *Symbolik des Kirchengebäudes,* 120 ff.). See also Alanus de Insulis, *Dist.* XX, 787d (*PL* 210), where Ecclesia is depicted as a temple with the 12 apostles as windows.

128 The term 'imperiti' possibly refers here to those who are not skilled in exegesis according to the 4 'sensus' and for whom the scheme could serve as a useful aid.

129 Hugh of St. Victor, *Didascalicon,* v, ii, De triplici intellegentia (*PL* 176, 789).

130 Joachim of Fiore (c. 1132-1202) a mystic and an apocalyptic writer, was founder of the order of Fiore (a branch of the Cistercians) and of the monastery of the same name in Calabria. Joachim projects the 3 persons of the Trinity onto the various periods of world history: the age of the Father (from the Creation up to and including the Old Testament period); the age of the Son (Incarnation to the end of the 12th century) and the age of the Holy Ghost (the eternal kingdom, where with the arrival of the 'evangelium aeternum', the true spirit of Christ's teaching will reign and the Church will be reformed). His teaching greatly influenced the following century, especially among the Franciscans, but also among heretical movements, particularly those in the south of France. His followers, however, went far further than Joachim himself. At the 4th Lateran Council (1215) Joachim's doctrine concerning the Trinity (set forth in his *Liber de vera et falsa philosophia*), was rejected, whereas the Trinitarian teaching of his opponent Peter Lombard (in his *Sententiae*) which Joachim had attacked, was declared orthodox. For the Trinitarian controversy between Joachim and Peter Lombard, see infra: Reeves/Hirsch (1972), s.v. 'Lombard, Peter'.

H. Grundmann, *Studien über J. von Floris,* Leipzig, 1927; J. Bignami-Odier, 'Notes sur deux mss. de la Bibl. du Vatican contenant des traités inédits de J.d.F.', *Mélanges d'Archéologie et d'histoire,* LIV, 1937, 213 ff.; L. Tondelli, *Il Libro delle figure dell'Abate Gioachino da Fiore,* vol. I, Turin, 1953²; H. Grundmann, *Neue Forschungen über J.v.F.,* Marburg, 1950: M. E. Reeves, 'The Liber Figurarum of Joachim of Fiore,' *Mediaeval & Renaissance Studies,* II, 1951, 57-81; M. Reeves & B. Hirsch-Reich, 'The Figurae of J. of F.', *ibidem,* V, 1954, 170-79; M. Bloomfield. 'J. of Flora. A critical survey of his canon, teachings, sources, biography and influence,' *Traditio,* XIII, 1957, 249 ff.; A. Crocco, *Simbologia Dantesca. Nuove Prospettive d'interpretazione della Divina Commedia,* Naples, 1961²; Lubac, *o.c.,* I/2, 437ff.; M. Reeves & B. Hirsch-Reich, *The Figurae of Joachim of Fiore,* Oxford, 1972.

181

(pp. 123-28)

131 Cf. *Psalterium decem chordarum* and *Expositio in Apocalypsim*, printed ed. Venice 1527, fol. 228 r.

132 The name *Liber Figurarum* derives from Salimbene's designation of it, see Reeves/ Hirsch, *o.c.* (1972), V, 112.

133 Reeves/Hirsch, *o.c.* (1972), 23, 75-98.

134 For a table of figures belonging or related to the *Liber Figurarum* see: Reeves/Hirsch, *o.c.* (1972), XXII, XXIII.

135 Oxford, Bodleian Library, Corpus Christi College 255A, ca. 1200.
Dresden, Sächs. Landesbibl. A 121, 1st qu. 13th c.; Reggio Emilia, Lib. Seminario Vescovile, 2d half 13th c. For a list of MSS. relating to the *Liber Figurarum*, see Reeves/Hirsch, *o.c.* (1972), XXI.

136 E.g. Roger Howden (Tondelli, *o.c.*, I, 24 ff.; Reeves/Hirsch *o.c.* (1972), 87, n. 64 on the problem of the veracity of these accounts).

137 Tondelli, *o.c.*,I, 22.

138 Bignami-Odier, *o.c.*, 31.

139 For an extensive discussion of the scheme of the psalterium, see Reeves/Hirsch, *o.c.* (1972), 199-211.

140 See note 135.

141 For the parallel with the rose = Ecclesia in Dante, *Paradiso*, XXXI, 1:3, cf. Crocco, *o.c.*; see also the comparison of the cross to a musical instrument in *Paradiso*, XV. For a further discussion of possible relations to Dante's symbolism, see Reeves/Hirsch, *o.c.* (1972), 316-29 (Joachim's *Figurae* and Dante's symbolism).

142 On the development of Joachim's interpretation of the psaltery and on the possible influences and sources, cf. Reeves/Hirsch, *o.c.* (1972), 59 ff., 201 ff.

143 The inscription, added by a somewhat later hand at the base, within the triangular scheme: 'Decem . . . corde decem precepta legis/ Alio modo in tribus cordis inferioribus congrue accipimus/ Tres ordines primi status: in tribus aliis tres ordines/ secundi in tribus aliis tres ordines tertii: / in corda superiori naturam angelicam', starts with an allusion to the time-honoured patristic interpretation of the psaltery's 10 strings as the 10 Commandments (an interpretation adopted by Joachim himself in his earlier exegesis). After that, however, the inscription proceeds to a historical interpretation in terms of the 3 status and the 3 ordines, subordinating the human historical element to the angelic nature, which is in contradiction with the further development of Joachim's exegesis, as manifested in the scheme (cf. Reeves/Hirsch, *o.c.* (1972), 58, 202, n. 8).

144 See list of works: Reeves/Hirsch, *o.c.* (1972), xxi.

145 Vienna, Österr. Nationalbibl., cod. 1400 (Theol. 71), fol. 24 v., South-Italian, Naples (?), 1st half 14th c. (H. J. Hermann, *Die Ital. Hss. des Dugento und Trecento*, I, Bis zur Mitte des XIV Jrh., N.F. V.1, Leipzig, 1928, 16-19).
The facing page, fol. 25 r., contains a visual-exegetic scheme of the 'rota Ezechielis', and the prologue begins on fol. 26.

146 London, British Museum, Add. 11439, f. 102 v. (Reeves/Hirsch, *o.c.* (1972), 283, fig. 45). This miniature, illustrating Pseudo Joachim da Fiore's *Praemissiones*, simply adds a bust of Christ with a cruciform nymbus – His right hand raised in benediction, in His left hand a globe surmounted by a cross – thus missing the point of the special meaning of the syndesmos figure.

147 See notes 119 and 124.

148 Th. Gérold, *o.c.* (1931), 176; idem, *o.c.* (1932), 9 ff.

149 Smalley, *o.c.*, 288, 292.

150 See, e.g., the example mentioned on pp. 106 ff. of the perpetuation of the scheme of the 'quinque vulnera' in religious emblemata.

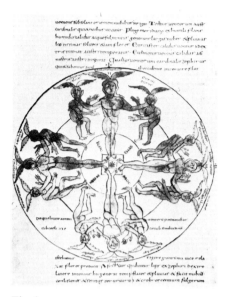

Fig. 1a.

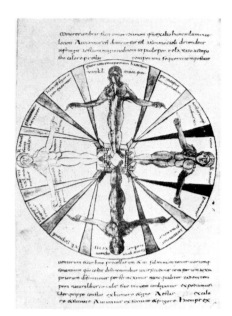

Fig. 1b.

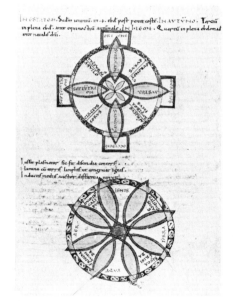

Fig. 2.

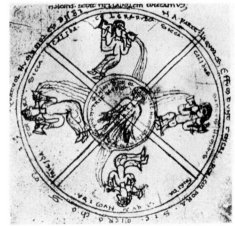

Fig. 3.

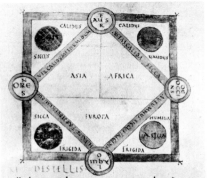

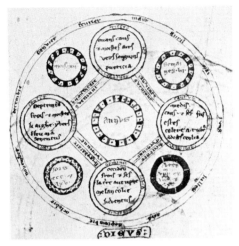

Stelle lumen asole muruanter cum mundo uesti utpote
uno loco fixae & nonstante mundo uagae ferri dicun
tur exceptis hir que planetae idē erranter uocantur.
Eatqi dici aduertu celari necumquā caelo decidere
fulgor pleni luni & solis pbat diliquium · quamuis uide
amur ignitulos exa&here lapsos postari uerter uagiqi
lumen sideris imitari tru cis ẽcto coorientibi uentir

Fig. 4.

Fig. 5.

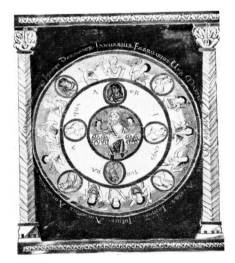

Fig. 6.

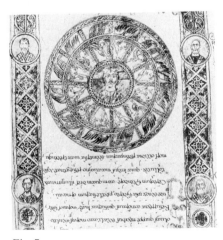

Fig. 7.

184

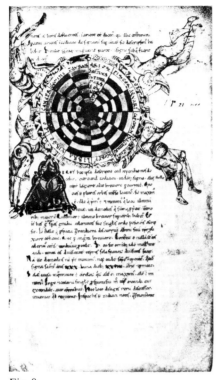

Fig. 8.

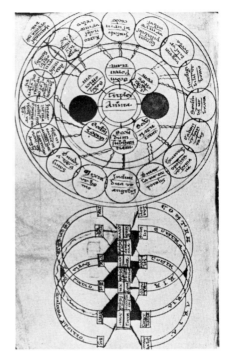

Fig. 9.

Fig. 10.

Fig. 11.

185

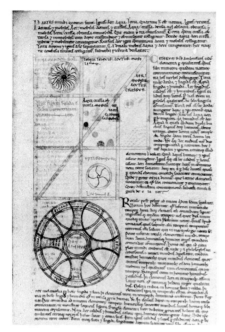

Fig. 12.

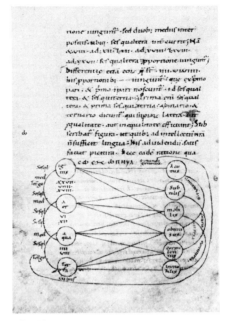

Fig. 13a.

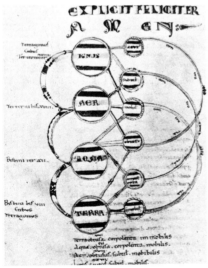

Fig. 13b.

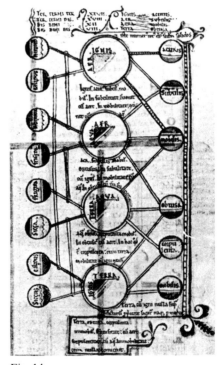

Fig. 14.

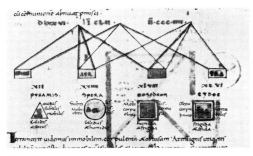

Fig. 15.

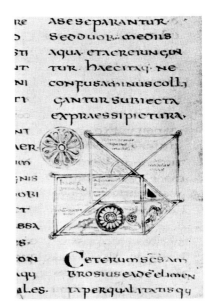

Fig. 16.

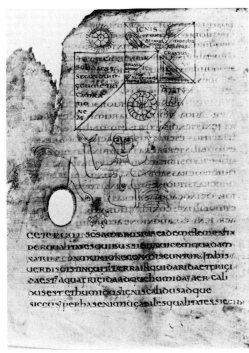

Fig. 17.

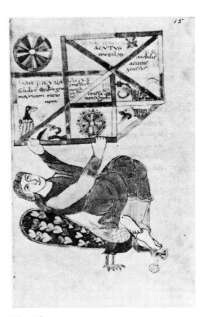

Fig. 18.

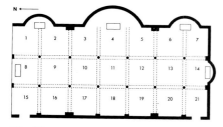

Fig. 19a.

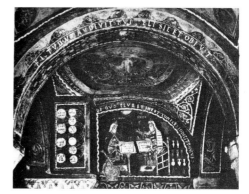

Fig. 19c.

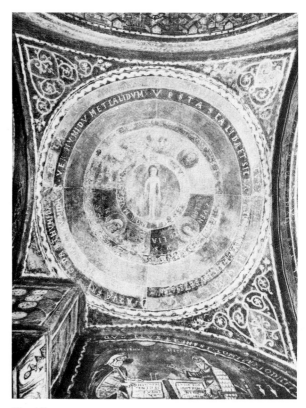

Fig. 19b.

188

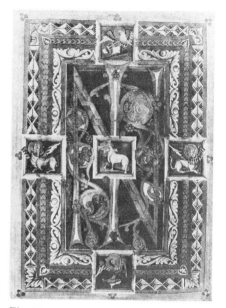

Fig. 20.

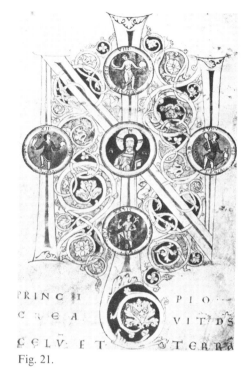

Fig. 21.

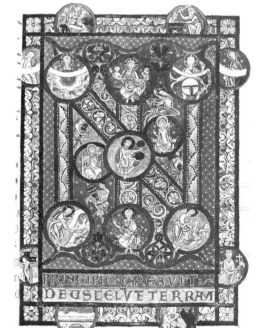

Fig. 22.

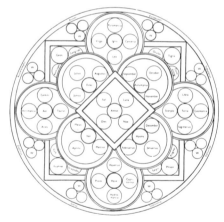

Fig. 23.

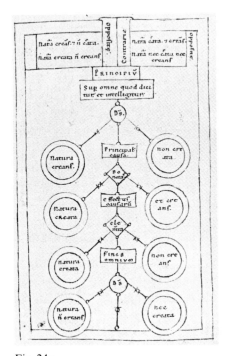

Fig. 24a.

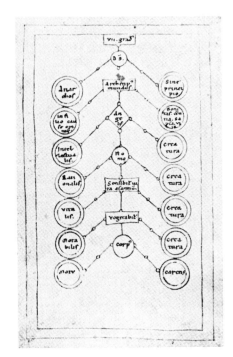

Fig. 24b.

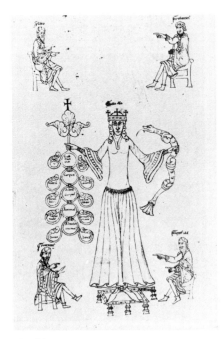

Fig. 25.

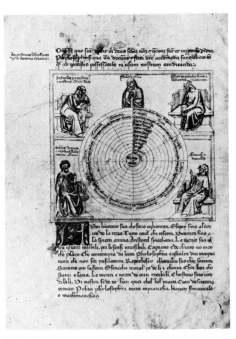

Fig. 26.

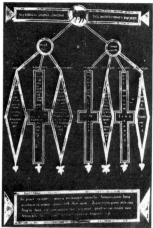

Fig. 27a.

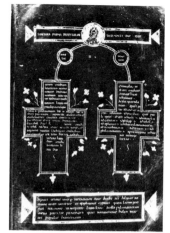

Fig. 27c.

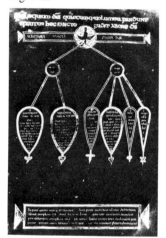

Fig. 27b.

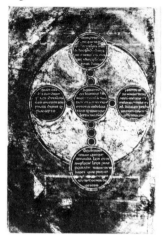

Fig. 27d.

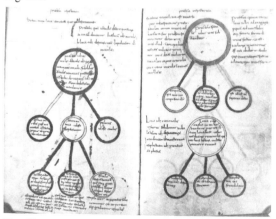

Fig. 28.

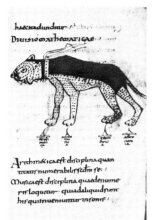

haec traduntur (...)
DIVISION MATHEMATICAE

Arithmetica est disciplina quam
tractat numerabilis secundum se
Musica est disciplina quae de nume-
ris loquitur quae aliquid sunt
hi qui inveniuntur insonis

Fig. 30a.

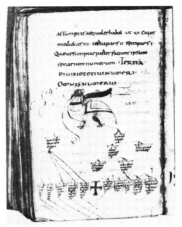

assumptus ad quaderhabet ut ui cuius
medica in tota parte ti tota parti
quae assum prae patet facium ipsam
senarium numerum TERTIA
divisio totius numeri
Omnis numerus

Fig. 30b.

Armonica est secunda musicae quae dici-
tur insonorum: armo-
nicum est quae qui educantur sonorum
animalis in ...
est ... qui ... tam vocalis temp-
et ... hujusmodi lambicon
... in area

Instrumentorum omnium musicorum genesis (...)

Percussionalia sunt acetabula ae ...
... celluminato quimmo ... tabule are
... de aere quemmo ... phitiano
... acutum de ... in ... brium sorum ...
... it regla est semplex stratum ...
... rale fulani, organa pandu ... pecto-
... ... iai ... ad simphoni ... debemus (...)

Fig. 29a.

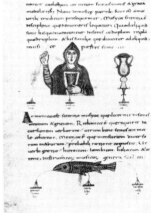

natur caelestium un cursum secundum est & gratia
modulatur; Nunc demusice partibus sicut est ama-
toribus eruditum prosequamur; Musica est enim
disciplina quae de numeris loquitur quae aliquid
sunt hi qui inveniuntur insonis induplum triplo
quadruplum & his similia quae dicuntur adaliquid
musi(...)ae partes sunt iii

Armonica est facultas musicae quae dicitur insonum
acutum & gravem. Rythmica est quae requirit in
earumdem verborum: utrum bene teneat an ma-
le adhereat. Metrica est quae mensuram diver-sa-
rum naturam: probabili ratione cognoscit. Ut
verbo graeco: hieroicon iambicon helicon &ce-
tera. Instrumentorum musicorum genera sunt iii

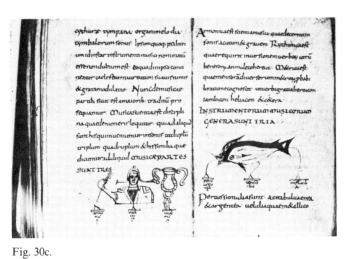

cythare tympana organa melo dia
cymbalorum sonat: Ipsum quoque psalteri
um idinstar instrumenta musica nominati
esse non dubium est: eo quod impso cona
natur caelestium curuam suaui sonum
& graui modulatio. Nunc de musicae
partibus sicut est amatoribus tradita pro
sequamur. Musica etenim est discipli
na quae de numeris loquitur quae aliquid
sunt hi qui inveniuntur insonis unduplum
triplum quadruplum & his similibus quae
dicuntur adaliquid MUSICE PARTES
SUNT TRES

Armonica est facultas musica quae de certa nam
sonit acutum & gravem. Rythmica est
quae requirit in earum sione uerbouru utru
bene tonat an male coheret ea. Metrica est
quae mensura diversorum sonorum numeros probati
brationecognoscit utuerbigratiae heroicon
iambicon helicon &cetera.

Instrumentorum musicorum
GENERA SUNT TRIA

Percussionalia sunt acetabula aenea
& argentea uel illis quaeaenea & illico

Fig. 30c.

Fig. 29b.

Fig. 31.

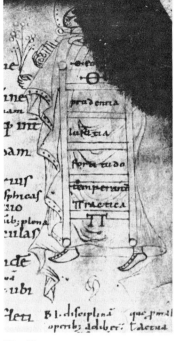

Fig. 32.

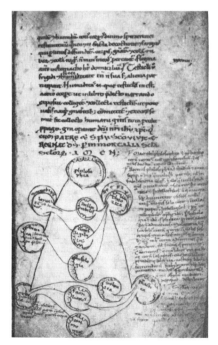

Fig. 33.

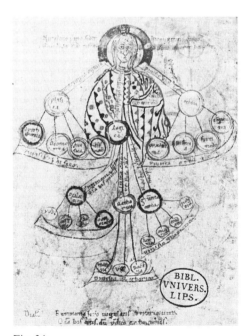

Fig. 34:

193

 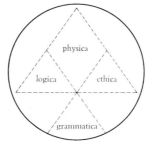 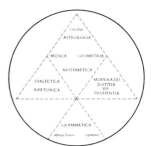

Fig. 35.

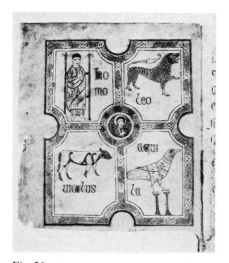

Fig. 36.

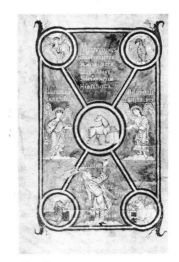

Fig. 37.

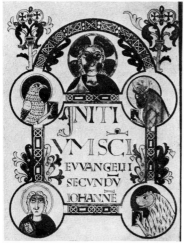

Fig. 38.

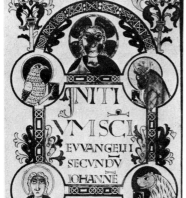

Fig. 39.

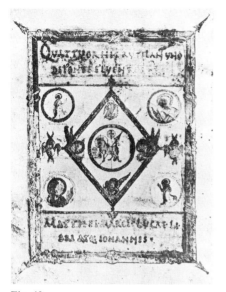

Fig. 40.

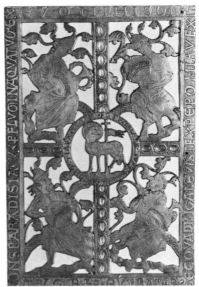

Fig. 41.

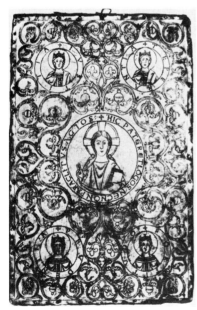

Fig. 42.

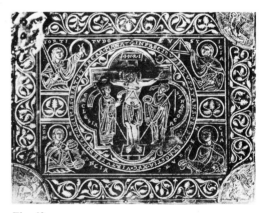

Fig. 43.

195

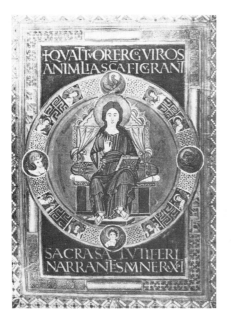

Fig. 44.

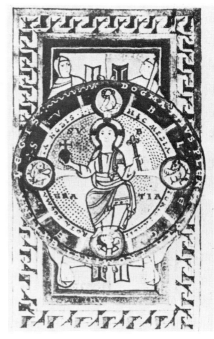

Fig. 45.

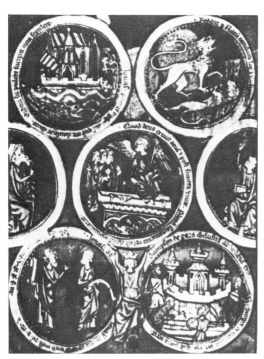

Fig. 46.

196

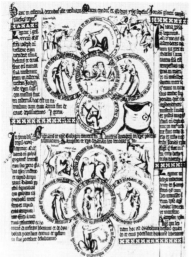

Fig. 47a.

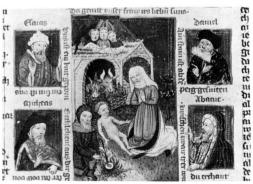

Fig. 47b.

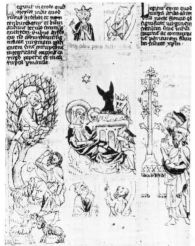

Fig. 47c.

Fig. 47d.

Fig. 48.

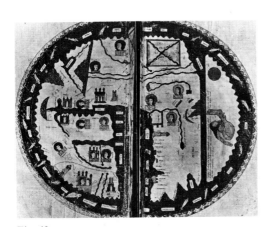

Fig. 49.

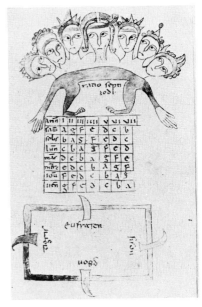

Fig. 50.

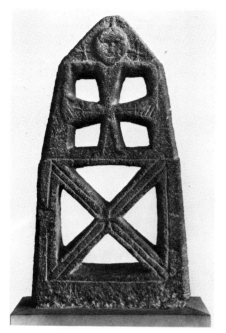

Fig. 51.

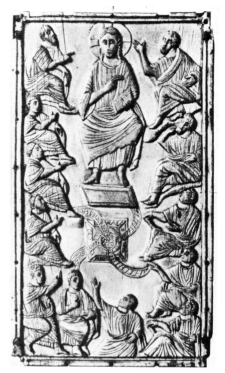

Fig. 52.

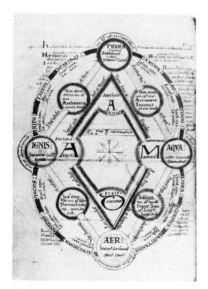

Fig. 53.

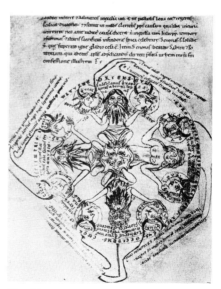

Fig. 54.

199

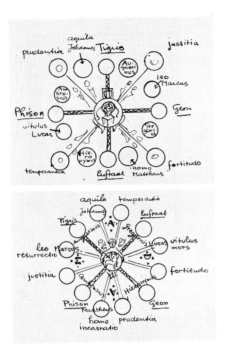

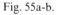

Fig. 55a-b.

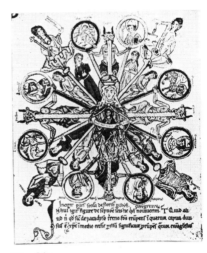

Fig. 56a.

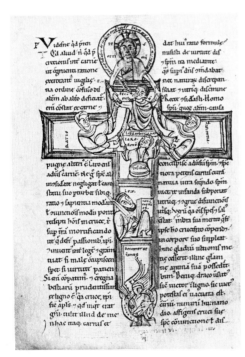

Fig. 56b

Fig. 56c.

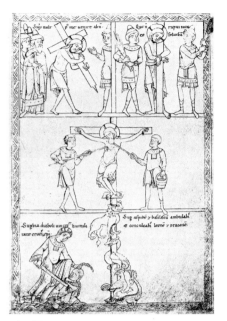

Fig. 57a.

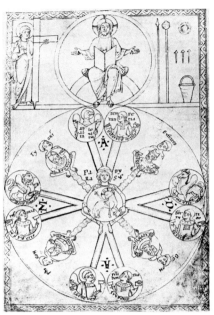

Fig. 57b.

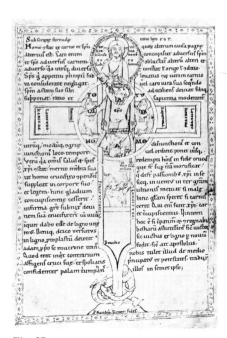

Fig. 57c.

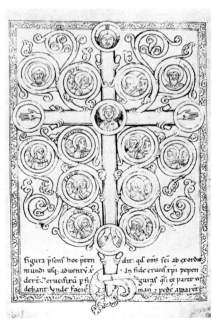

Fig. 57d.

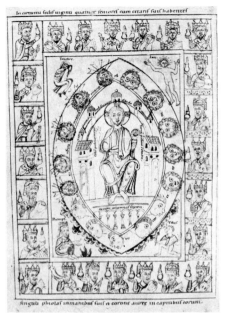

Fig. 58a.

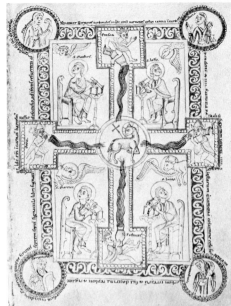

Fig. 58b.

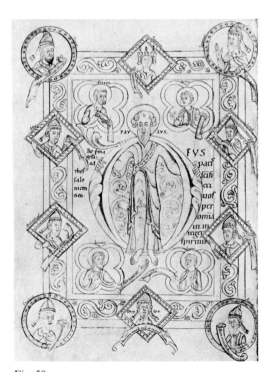

Fig. 58c.

202

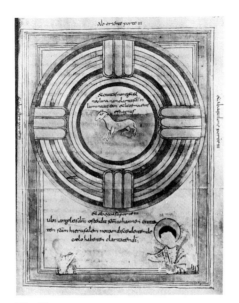

Fig. 59.

Fig. 60.

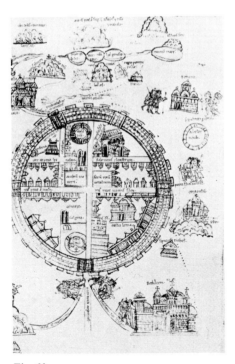

Fig. 61.

Fig. 62.

Fig. 63.

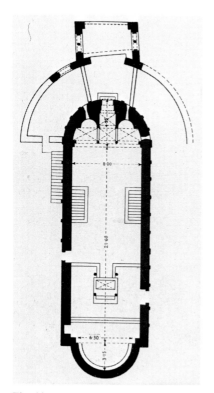

Fig. 64a.

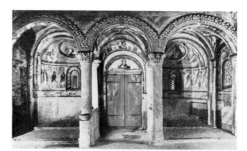

Fig. 64b.

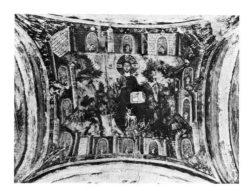

Fig. 64c.

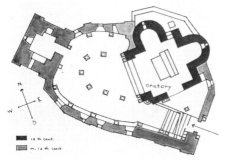

Fig. 65a.

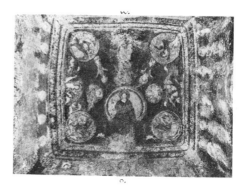

Fig. 65b.

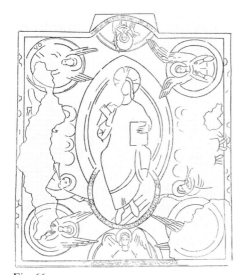

Fig. 66.

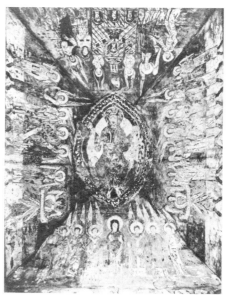

Fig. 67.

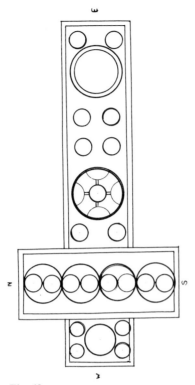

Fig. 68.

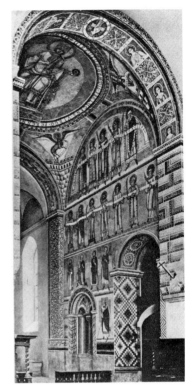

Fig. 69a.

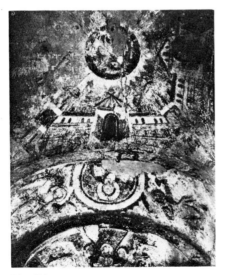

Fig. 69b.

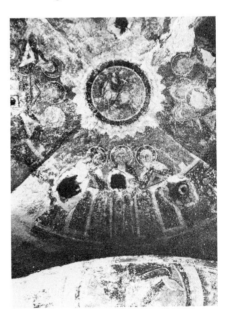

Fig. 69c.

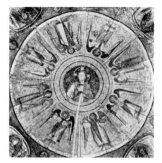

Fig. 71b.

Fig. 70. Fig. 71a.

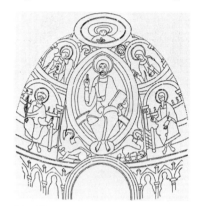

Fig. 72.

Fig. 73.

207

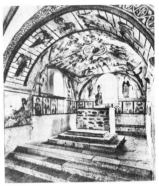

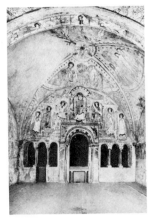

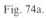
Fig. 74a. Fig. 74b.

Fig. 75a.

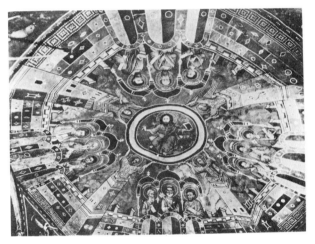

Fig. 74c.

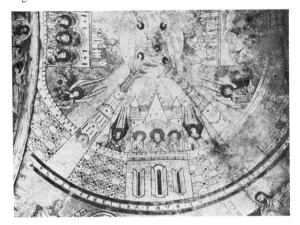

Fig. 75b.

208

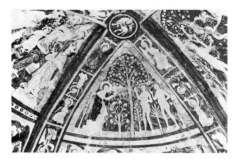

Fig. 76.

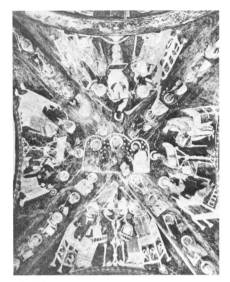

Fig. 77.

Fig. 78a.

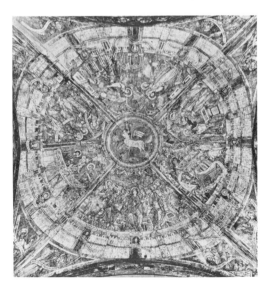

Fig. 78b.

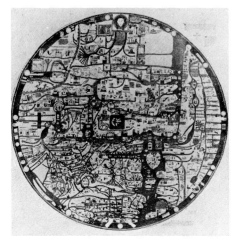

Fig. 80a.

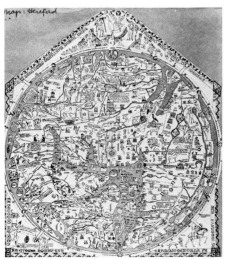

Fig. 80b.

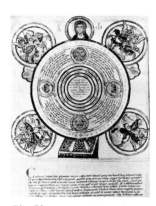

Fig. 79.

Fig. 81a.

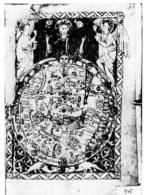

Fig. 81b.

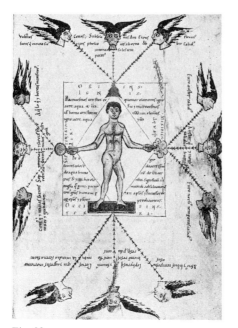

Fig. 82.

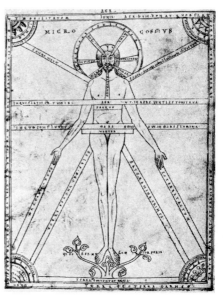

Fig. 83.

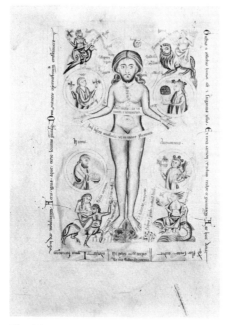

Fig. 84a.

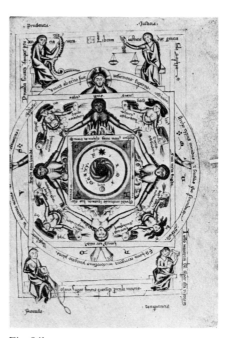

Fig. 84b.

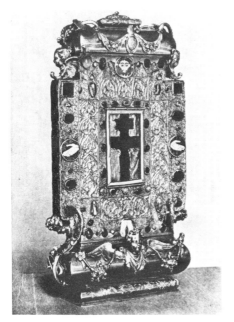

Fig. 85. Fig. 86.

Fig. 87.

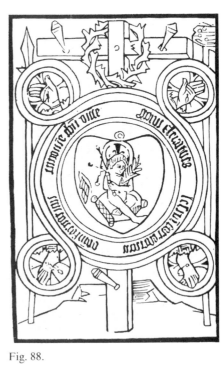

Fig. 88.

212

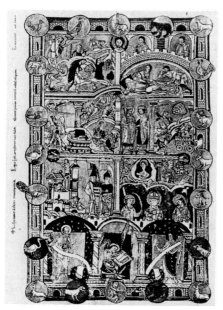

Fig. 89.

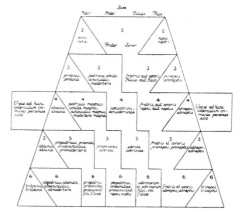

Fig. 90a.

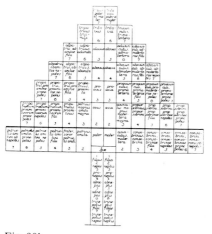

Fig. 90b.

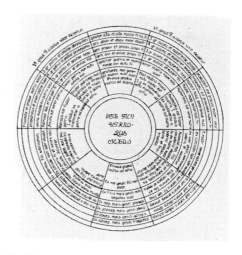

Fig. 90c.

213

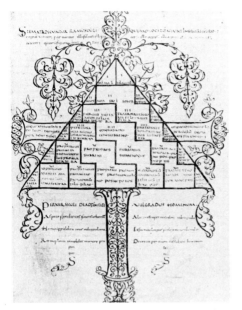

Fig. 91.

Fig. 92.

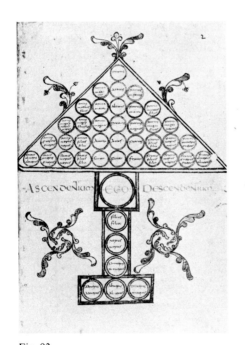

Fig. 93.

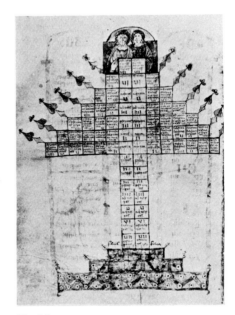

Fig. 94.

214

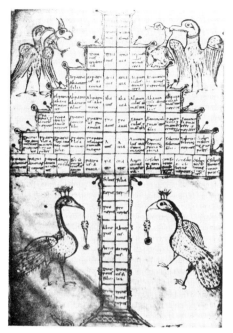

Fig. 95.

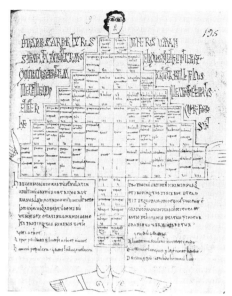

Fig. 96.

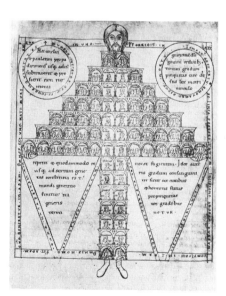

Fig. 97.

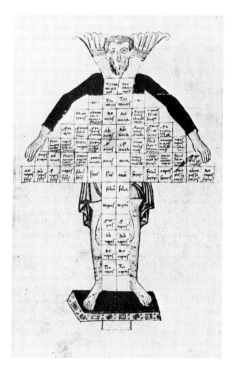

Fig. 98.

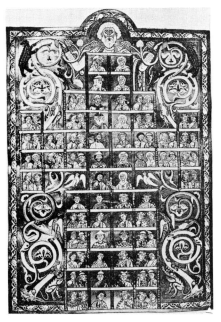

Fig. 99a.

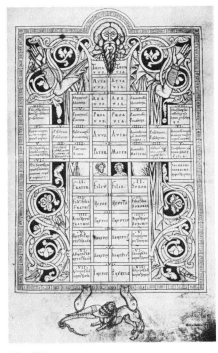

Fig. 99b.

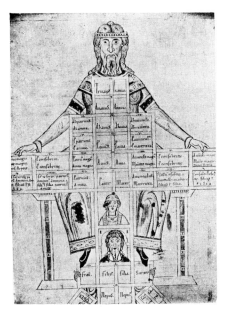

Fig. 100.

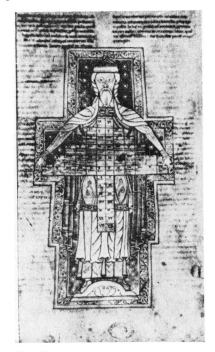

Fig. 101.

216

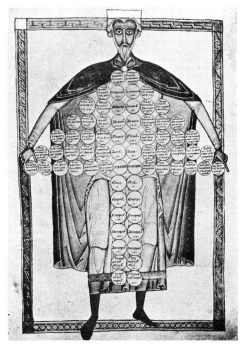

Fig. 102.

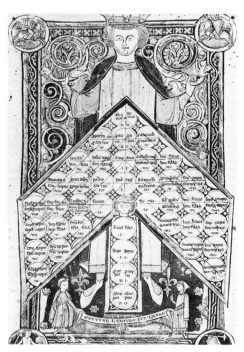

Fig. 103.

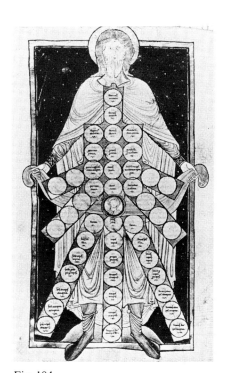

Fig. 104.

217

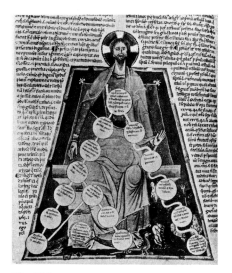

Fig. 105.

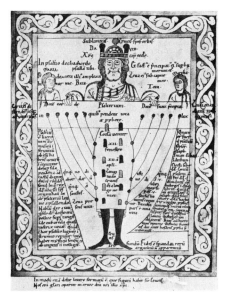

Fig. 106.

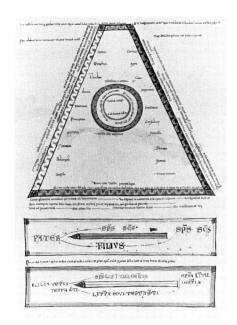

Fig. 107.

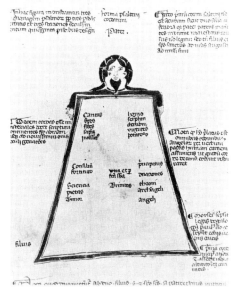

Fig. 108.

218

LIST OF ILLUSTRATIONS

219

21. Brussels, Bibl. Royale, MS. II, 1639, bible from St. Hubert, c. 1070; fol. 6 v: Genesis initial with Christ and four elements.
22. Chantilly, Musée Condé, MS. 1632-33, Flavius Josephus, *Antiquitates Judaicae*, c. 1170/80; fol. 3 r.: IN-monogram with Creator and six days of creation.
23. Lausanne, cathedral, reconstruction of rose window (after E. Beer, 1952).
24. a-b Paris, Bibl. Nat., lat. 6734, Honorius Augustodunensis, *Clavis Physicae*, 12th.; fols. 2 r.: fourfold 'divisio naturae'; 2 v.: fivefold ladder of nature.
25. Darmstadt, Hessische Landesbibl., MS. 2282, Porphyrius, *Isagoge*, et al., c. 1140; fol. 1v.: Dialectica with tree schema of logical principles.
26. Chantilly, Musée Condé, cod. 599, 1426, Bartolomeo di Bartoli, *Cantica de virtutibus et scientiis vulgariz*, school of Niccolò da Bologna, c. 1355; fol. 6 v.: Philosophia with wheel of planetary spheres and four philosophers.
27. a-d Florence, Bibl. Laurenziana, Am. I, Codex Amiatinus, before 761; four schemata of visual exegesis.
28. Munich, Bayer. Staatsbibl., Clm. 14456, miscellany, 9th cent.; fols. 68v., 69r.: schemata of 'divisio Sacrae Scripturae'.
29. a Bamberg, Staatsbibl., Patr. 61, Cassiodorus, *Institutiones*, 2nd half 8th cent.; fol. 59 v.: schemata of threefold 'divisio musicae' and of threefold division of musical instruments.
29. b Paris, Bib. Mazarine, 660, Cassiodorus, *Institutiones*, early 9th cent.; fol. 132 v.: schemata of threefold 'divisio musicae' and of threefold division of musical instruments.
30. a-c St. Gall, Abbey Library, 855, Cassiodorus, *Institutiones*, 9th cent.; fols. 276r.: 'divisio mathematicae'; 287v.: 'divisio totius numeri'; 305v.: threefold 'divisio musicae'; 306r.: threefold division of musical instruments.
31. Sélestat, MS. 93(98), Boethius, *De consolatione Philosophiae*, 10th cent.; fol. 74 r.: Philosophy bearing ladder of seven Gifts of the Holy Ghost.
32. Vienna, Nat. Bibl., No. 242, Boethius, *De consolatione Philosophiae*, early 12th cent.; fol. 3 r.: Philosophy bearing ladder of four cardinal virtues.
33. Cambridge, Gonville & Caius College, MS. 428, *Tractatus de quaternario*, c. 1100; fol. 51 r.: tree schema of division of philosophy.
34. Leipzig, U.B., 1253, Boethius, *De consolatione philosophiae*, early 13th cent.; fol. 83 v.: Philosophy bearing tree schema of threefold philosophical division.
35. Theodulf of Orleans, 'arbor philosophiae' (reconstruction).
36. Trier, Cathedral Treasury, 61, evangeliarium, c. 730; fol. 1 v.: Majestas Domini.
37. Laon, Bibl. Mun. MS. 137, Paulus Orosius, *Historiarum ad paganos libri VII*, 8th cent.; fol. 1 v.: Majestas of the Lamb of God.
38. Trier, Stadtbibl., cod. 23 II, evangeliarium, 1st quarter 9th cent.; fol. 62 r.: Majestas Domini.
39. Aschaffenburg, Hofbibl., MS. 2, lectionary, end 10th cent.; fol. 1 v.: Majestas of the Lamb of God and Ecclesia.
40. Nancy, Cathedral Treasury, Arnaldus evangeliarium, early 9th cent.; fol. 3 v. Majestas of the Lamb of God.
41. Paris, Musée de Cluny, inv. No. Cl.1362, book cover, 3rd quarter 12th cent.; Majestas of the Lamb of God and four rivers of Paradise.
42. Munich, Nationalmuseum, portable altar (bottom), early 11th cent.; schema of Christ and four cardinal virtues.
43. Augsburg, Diözesan-Museum, portable altar (bottom), mid-12th cent.; Crucifixion and four cardinal virtues.
44. Bucharest, Nat. Bibl., Codex Aureus from Lorsch, c. 810; fol. 18v.: Majestas Domini.
45. Chantilly, Musée Condé, No. 1347, lectionary, 12th cent.; Majestas Domini.
46. Eton College, MS. 177, *Figurae bibliorum*, 3rd quarter 13th cent.; fol. 5 v.: Resurrection of Christ with Old Testament types and prophecies.

220

47. a-d *Biblia Pauperum* MSS., schemata containing New Testament antitype and Old Testament types and prophecies.
48. New York, Pierpont Morgan Library, 644, *Beatus in Apocalypsin*, 9th/10th cent.; fols. 35 v. and 36 r.: map of the world.
49. Burgo de Osma, Cathedral library, 1, *Beatus in Apocalypsin*, 1086; fols. 34 v. and 35 r.: map of the world.
50. Munich, Bayer. Staatsbibl., Clm. 14456, miscellany, 9th cent.; fol. 74 v.: Paradise pictogram and seven planets.
51. Bonn, Rheinisches Landesmuseum, stele from Moselkern, c. 700 Christ syndesmos and Paradise pictogram.
52. Cologne, Schnütgenmuseum, Inv.No.B 2/b, front of book cover, c. 980; Christ enthroned above Paradise pictogram.
53. Oxford, St. John's College, MS. 17, Byrhtferth of Ramsey et al., c. 1100; fol. 7 v.: schema of macrocosmos and microcosmos.
54. Vienna, Nat. Bibl. 395, miscellany, mid-12th cent.; fol. 34 v.: windrose.
55. a London, Br. Mus., Arundel 44, *Speculum Virginum*, c. 1145/55; fol. 13 r.: schema of Paradise quaternity.
55. b Munich, Bayer. Staatsbibl., Clm. 14159, *De Laudibus S. Crucis*, c. 1170/85; fol. 5 v.: schema of Paradise quaternity.
56. a-b London, Br. Mus., Arundel 44, *Speculum Virginum*, c. 1145/55; fols. 13 r.: Paradise quaternity; 83 v.: Homo Totus.
56. c Leipzig, U.B., 655, *Speculum Virginum*, end 14th cent.; Paradise quaternity.
57. a-d Munich, Bayer. Staatsbibl., Clm. 14159, *De Laudibus S. Crucis*, c. 1170/85; fols. 5 r.: Crucifixion; 5 v.: Paradise quaternity; 6 r.: Homo Totus; 8 v.: tree schema with syndesmos ideogram.
58. a-c Stuttgart, Landesbibl., Brev. 128, lectionary, 12th cent.; fols. 9 v.: Christ and twenty four elders; 10 r.: Paradise quaternity; 10 v.: St. Paul as syndesmos figure in initial D.
59. Valenciennes, Bibl. Publ., 99, Apocalypse, 8th/9th cent.; fol. 38 r.: circular Heavenly City.
60. Paris, Bibl. Nat., N. acq.lat. 1366, *Beatus in Apocalypsin*, end 12th cent.; fols. 148v. and 149 r.: square Heavenly City.
61. Stuttgart, Landesbibl., fols. 57, 56, 12th cent.; Jerusalem as a circular city.
62. Rome, Bibl. Vat., gr. 699, *Cosmas Indicopleustes*, 9th cent.; fol. 49 r.: court of the Tabernacle.
63. Florence, Bibl. Laurenziana, Am. I, Codex Amiatinus, before 716; fols. 2 v. and 3 r.: court of the Tabernacle.
64. a-c Civate, S. Pietro in Monte, end 11th c.; groundplan (after Bognetti/Marcora); narthex; ceiling decoration of narthex: Christ in Heavenly City.
65. a-b St. Michel d'Aiguilhe, 10th cent. and after; groundplan (after R. Martin); ceiling decoration: heavenly vision of Christ, four evangelists' symbols and St. Michael.
66. Ternand (Rhône), 10th cent.; ceiling decoration of crypt: heavenly vision of Christ, angels and Virgin Mary (after Deschamps/Thibout).
67. St. Chef (Dauphiné), Notre Dame, Chapelle St. Michel, 11th/12th cent.; ceiling decoration: Christ in Heavenly City.
68. Regensburg, St. Emmeram, 12th cent.; reconstruction of schema of ceiling decoration.
69. a-c Prüfening, Monastery church, m. 12th cent.; main choir: Ecclesia Imperatrix in Heavenly City; north choir: square Heavenly City; south choir: circular Heavenly City.
70. Pürgg, Johanneskirche, c. 1160/70; ceiling of sanctuary: Lamb of God in quaternity schema.
71. a-b Regensburg, Allerheiligenkapelle, m. 12th cent.; Angel standing on sun-symbol; ceiling decoration: Christ Pantocrator in rota schema of angels.

221

72. Perschen (Oberpfalz), Karner, 3rd quarter 12th cent.; heavenly vision of Christ and Maria-Ecclesia.
73. Schwarzrheindorf, middle 12th cent.; decoration of lower church: Ezekiel's vision.
74. a-c Windisch Matrei (Eastern Tirol), Nikolauskirche, c. 1250; choir; upper choir: Jacob's ladder and city quaternity; detail of ceiling decoration: Heavenly Jerusalem.
75. a-b Gurk, Cathedral, bishop's chapel, c. 1260/70; east vault with throne of Solomon and Paradise quaternity; west vault: city quaternity.
76. Pisweg (Carinthia), Karner, 13th cent.; detail of ceiling decoration: Paradise quaternity and Jacob's ladder.
77. Taufers, chapel of Knights of St. John, c. 1200/20; ceiling decoration: Deesis and quaternity of church fathers.
78. a-b Brunswick, Cathedral; choir; ceiling decoration, 13th cent.: city quaternity.
79. Linz, Bundesstaatliche Studienbibl., MS. Qu.No.14, Petrus Pictaviensis, *Compendium historiae in genealogia Christi*, 12th cent.; fol. 13 v.: Christ syndesmos with schema of the winds.
80. a-b Ebstorf map of the world, c. 1235; Hereford cathedral, map of the world, c. 1290.
81. a-b London, Br. Mus., Add. 28681, psalter, c. 1200/50; fols. 9v: Christ syndesmos with mappa mundi; 9 r.: mappa mundi.
82. Vienna, Nat. Bibl., 12600, miscellany, late 12th cent.; fol. 29 r.: microcosmos.
83. Munich, Bayer. Staatsbibl., Clm. 13002, miscellany, c. 1158/68; fol. 7 v.: microcosmos.
84. a-b Munich, Bayer. Staatsbibl., Clm. 2655, Thomas of Cantimpré, *De naturis rerum*, c. 1295; fols. 104 v.: microcosmos; 105 r.: Christ syndesmos with machina mundi.
85. Zwiefalten, former abbey church, treasury, cross reliquary with syndesmos ideogram, c. 1130.
86. Albrechtsberg a.d. Pillach, castle chapel, portable altar (?) with syndesmos ideogram, 1st half 14th cent.
87. Vårdsberg, church, silver-gilt paten with syndesmos ideogram, 14th cent.
88. 15th cent. woodcut of the 'quinque vulnera'.
89. Schulpforta, Bibl. der Landesschule, A.10, Augustine, *De Civitate Dei*, end 12th cent.; fol. 2 v.: Civitas Dei with syndesmos ideogram.
90. a-c Isidore of Seville, *Etymologiae*, stemmata I, II, III.
91. Paris, Bibl. Nat., lat. 10292, Isidore, *Etymologiae*, 9th cent.; fol. 93; stemma consanguinitatis.
92. Paris, Bibl. Nat., lat. 4412, *Breviarium* of Alaric, end 9th/b. 10th cent.; fol. 77 r.: stemma consanguinitatis with Theodosius rex (detail).
93. Paris, Bibl. Nat., lat. 4410, *Breviarium* of Alaric, 9th cent.; fol. 2: stemma consanguinitatis.
94. Brussels, Bibl. Royale, II. 4856, Isidore, *Etymologiae*, c. 800; fol. 265 v.: stemma consanguinitatis crowned by figures of Pater and Mater.
95. Modena, Mutin. Ord. I.2, lombardic edict, late 9th cent.; fol. 4 v.: stemma consanguinitatis with four birds.
96. Paris, Bibl. Nat., lat. 2169, Isidore, *Etymologiae,* 1072; fol.195: anthropomorphic stemma consanguinitatis.
97. Munich, Bayer. Staatsbibl., Clm. 13031, Isidore, *Etymologiae*, c. 1150/65; fol. 102 v.: anthropomorphic stemma consanguinitatis.
98. Paris, Bibl. Nat., lat. 9630, *Decretum Burchardi*, 11th cent.; fol. 118: anthropomorphic stemma consanguinitatis.
99. a-b Munich, Bayer. Staatsbibl., Clm. 13004, *Decretum Gratiani*, c. 1160/70; fols. 308 v. and 309 r.: anthropomorphic stemma consanguinitatis.
100. Admont, Stiftsbibl., lat. 43, *Decretum Gratiani*, 12th cent.; fol. 342: seated figure holding stemma consanguinitatis.
101. Auxerre, Bibl. Mun., 265, *Decretum Gratiani*, c. 1170; standing figure holding stemma consanguinitatis.

102. Admont, Stiftsbibl., lat. 35, *Decretum Gratiani*, 1st half 13th cent.; fol. 296 v.: standing figure holding stemma consanguinitatis.

103. New York, Glazier collection, vellum leaf, 13th cent.; crowned figure with stemma consanguinitatis.

104. New York, H. P. Kraus collection, *Decretum Gratiani*, c. 1180; nimbed figure holding stemma consanguinitatis.

105. Admont, Stiftsbibl., 109(12), Henricus de Segusio, *Aurea Summa*, b. 14th cent.; fol. 41 v.: Christ with 'arbor bigamiae'.

106. Dublin, Chester Beatty collection, Petrus Lombardus, commentary on the Psalms, 12th cent.; fol. 1 r.: David Rex holding 'psalterium decem chordarum'.

107. Oxford, Corpus Christi college, 255 A, Joachim da Fiore, *Liber Figurarum*, c. 1200; fol. 8 r.: 'psalterium decem chordarum'.

108. Vienna, Nat. Bibl., 1400 (Theol. 71), ps. Joachim da Fiore, *Comm. super Esaiam*, first half 14th cent.; fol. 24 v.: anthropomorphic 'psalterium decem chordarum'.

SELECTED BIBLIOGRAPHY

ABBREVIATIONS

CCSL	CORPUS CHRISTIANORUM . . ., Series Latina, Turnhout-Paris 1953 ff.
CSEL	CORPUS SCRIPTORUM ECCLESIASTICORUM LATINORUM, Vienna 1866 ff.
Lex.d.chr.Ikon.	LEXIKON DER CHRISTLICHEN IKONOGRAPHIE, E. Kirschbaum ed., 8 vols., Rome-Freiburg-Basle-Vienna 1968 ff.
LC	LIBRI CAROLINI (*PL* 98).
NT	NEW TESTAMENT.
OT	OLD TESTAMENT.
PG	PATROLOGIA GRAECA, ed. J. P. Migne, 162 vols., Paris 1857-66.
PL	PATROLOGIA LATINA, ed. J. P. Migne, 221 vols., Paris 1878-90.
RAC	REALLEXIKON FÜR ANTIKE UND CHRISTENTUM, Stuttgart 1950 ff.
RBK	REALLEXIKON ZUR BYZANTINISCHEN KUNST, Stuttgart 1963 ff.
RDK	REALLEXIKON ZUR DEUTSCHEN KUNSTGESCHICHTE, Stuttgart 1937 ff.

BIBLIOGRAPHY

H. Abert, *Die Musikanschauung des Mittelalters und ihre Grundlagen,* Halle 1964 (reprint of the edition of 1905).

R. Allers, 'Microcosmos from Anaximandros to Paracelsus,' *Traditio,* II, 1944, 319-407.

Marie-Thérèse d'Alverny, 'La sagesse et ses sept filles: Recherches sur les allégories de la philosophie et des arts libéraux du IXe au XIIe siècle,' *Mélanges dédiés à la mémoire de Felix Grat I,* Paris 1946, 245-78.

—, 'Le cosmos symbolique du XIIe siècle,' *Archives d'histoire doctrinale et littéraire du Moyen Age,* 20, 1954, 31-81.

A. Andersson, *Abendmahlsgeräte in Schweden aus dem XIV. Jahrhundert,* Uppsala 1956.

H. Appuhn, 'Der Auferstandene und das Heilige Blut zu Wienhausen,' *Niederdeutsche Beiträge zur Kunstgeschichte,* I, 1961, 75-138.

G. Arslan, 'L'architettura romanica milanese,' in: *Storia di Milano,* III, 430 ff.

E. Auerbach, 'Figura,' *Archivum Romanicum,* XXII, 1938, 436-89 (reprinted in: *Neue Dante-Studien.* Istanbuler Schriften, No. 5, 1944).

—, *Typologische Motive in der Mittelalterlichen Literatur* (Schriften und Vorträge des Petrarca-Instituts Köln 11), Krefeld 1953.

Augustine, *Sancti Aurelii Augustini, De Civitate Dei,* 2 vols. (CCSL 47, 48), Turnhout 1955.

L. Bagrow, *Die Geschichte der Kartographie,* Berlin 1951.

J. Baltrusaitis, 'L'image du monde céleste du IXe au XIIe siècle,' *Gazette des Beaux Arts,* 20, 1938/II, 137-48.

—, 'Roses des vents et Roses des personnages à l'époque romane,' *ibidem,* 265-76.

G. Bandmann, *Mittelalterliche Architektur als Bedeutungsträger,* Berlin 1951.

—, 'Ein Fassadenprogramm des 12. Jahrhunderts und seine Stellung in der christlichen Ikonographie,' *Das Münster,* 5, 1952, 1-19.

—, 'Zur Bedeutung der romanischen Apsis,' *Wallraf-Richartz Jahrbuch,* XV, 1953, 28-47.

—, 'Zur Deutung des Mainzer Kopfes mit der Binde,' *Zeitschrift für Kunstwissenschaft,* X, 1956, 153-75.

—, 'Die Vorgotische Kirche als Himmelsstadt,' *Frühmittelalterliche Studien,* 6, 1972, 67-93.

R. Bauerreis, *Pie Jesu. Das Schmerzensmannbild und sein Einfluss auf die mittelalterliche Frommigkeit,* Munich 1931.

L. Baur, *Dominicus Gundissalinus. De divisione philosophiae* (Beiträge zur Geschichte des Mittelalters Bd. 4, 2-3), Münster 1903.

G. Beaujouan, 'Le symbolisme des nombres à l'époque romane,' *Cahiers de civilisation médiévale,* IV, 1961, 159-69.

E. Beck, 'Ephraems Hymnen über das Paradies,' *Studia Anselmiana,* XXVI, Rome, 1953.

Ellen Beer, *Die Rose der Kathedrale von Lausanne und der Kosmologische Bilderkreis des Mittelalters,* Berne 1952.

S. Beissel, *Geschichte der Evangelienbücher in der ersten Hälfte des Mittelalters,* Freiburg i. Br. 1906.

E. Beitz, *Rupert von Deutz. Seine Werke und die bildende Kunst* (Veröffentl. des Kölner Geschichtsvereins 4), Cologne 1930.

H. Belting, 'Probleme der Kunstgeschichte Italiens im Frühmittelalter,' *Frühmittelalterliche Studien,* I, 1967, 94-143.

M. Bernards, 'Mittelrheinische HSS. des Jungfrauenspiegels,' *Archiv für Mittelrheinische Kirchengeschichte* 3, 1951, 357-64.

—, *Speculum Virginum. Geistigkeit und Seelenleben der Frau im Hochmittelalter* (Forschungen zur Volkskunde 36 / 38), Cologne-Graz 1955.

—, 'Zur Geschichtstheologie des Speculum Virginum,' *Revue Bénédictine,* 75, 1965, 277-303.

H. Biehn, *Die Kronen Europas und ihre Schicksale,* Wiesbaden 1957.

J. Bignami-Odier, 'Notes sur deux MSS. de la Bibl. du Vatican contenant des traités inédits de Joachim de Fioris,' *Mélanges d'Archéologie et d'Histoire,* LIV, 1937, 211-41.

L. Birchler, 'Zur karolingischen Architektur und Malerei in Münster-Müstair,' *Frühmittelalterliche Kunst in den Alpenländern* (Intern. Kongr. f. Mittelalterforschung 3), Olten-Lausanne 1954, 167-252.

B. Bischoff, 'Panorama der Handschriftenüberlieferung aus der Zeit Karls des Grossen,' *Karl der Grosse. Lebenswerk und Nachleben* II, Das geistige Leben, Düsseldorf 1965, 233-54.

—, 'Elementarunterricht und Probationes Pennae in der ersten Hälfte des Mittelalters,' *Mittelalterliche Studien,* I, Stuttgart 1966, 75-87.

—, 'Eine verschollene Einteilung der Wissenschaften,' *ibidem,* 273-88.

—, 'Literarisches und künstlerisches Leben in St. Emmeram (Regensburg) während des frühen und hohen Mittelalters,' *Mittelalterliche Studien,* II, Stuttgart 1967, 77-115.

P. Bloch, 'Siebenarmige Leuchter in christlichen Kirchen,' *Wallraf Richartz Jahrbuch,* 23, 1961, 55-190.

—, *Nachwirkungen des Alten Bundes in der christlichen Kunst,* reprint from: *Monumenta Judaica. 2000 Jahre Geschichte und Kultur der Juden am Rhein,* Handbuch, Cologne 1963.

—, 'Das Apsismosaik von Germigny-des-Prés. Karl der Grosse und der Alte Bund,' *Karl der Grosse. Lebenswerk und Nachleben* III, Düsseldorf 1965, 234-61.

—, *Der Darmstädter Hitda-Codex,* Frankfurt a.M.-Berlin 1968.

M. Bloomfield, 'Joachim of Flora. A critical survey of his canon, teachings, sources, biography and influence,' *Traditio,* XIII, 1957, 249 ff.

H. Bober, 'An illustrated medieval school-book on Beda's "De natura rerum",' *Journal of the Walters Art Gallery,* 19-20, 1956-57, 65-97.

—, 'In Principio. Creation before Time,' *De Artibus Opuscula XL. Essays in Honor of Erwin Panofsky,* New York 1961, 13-28.

H. Boblitz, 'Die Allegorese der Arche Noahs in der frühen Bibelauslegung,' *Frühmittelalterliche Studien,* 6, 1972, 159-70.

A. Boeckler, *Die Regensburg-Prüfeninger Buchmalerei des 12. und 13. Jahrhunderts,* Munich 1924.

—, 'Zur Freisinger Buchmalerei des 12. Jahrhunderts,' *Zeitschrift des deutschen Vereins für Kunstwissenschaft,* 8, 1941, 1-16.

—, 'Die romantischen Fenster des Augsburger Domes und die Stilwende vom 11. zum 12. Jahrhundert,' *ibidem,* 10, 1943, 153-82.

—, 'Das Erhardbild im Uta-Kodex,' *Studies in Art and Literature for Belle da Costa Greene,* Princeton 1954, 219-30.

Boethius, *Boethius Anicius Manlius Torquatus Severinus, De institutione arithmetica libri duo. De institutione musica libri quinque. Accedit geometria quae fertur Boetii,* G. Friedlein ed., Leipzig 1867.

—, *Anicii Manlii Severini Boethii, De consolatione Philosophiae,* A. Fortescue & G. D. Smith eds., London 1925.

G. Bognetti & C. Marcora, *L'Abbazia benedettina di Civate,* Civate 1957.

J. Braun, *Der christliche Altar in seiner geschichtlichen Entwicklung,* Munich 1924.

E. Bréhier, 'Sur l'ordre des parties de la philosophie dans l'enseignement néoplatonicien,' in: *Études de philosophie antique,* Paris 1955, 212 ff.

B. Brenk, *Die romanische Wandmalerei in der Schweiz* (Basler Studien zur Kunstgeschichte, N.F., Bd. V), Berne 1963.

—, 'Ein Zyklus romanischer Fresken zu Taufers im Lichte der byzantinischen Tradition,' *Jahrbuch der Österreichischen byzantinischen Gesellschaft.* XIII, 1964, 119-35.

P. Brieger, *English Art* (The Oxford History of English Art IV), Oxford 1957.

Anna-Dorothee v. den Brincken, '. . . Ut describetur universus orbis. Zur Universalkartographie des Mittelalters,' *Methoden in Wissenschaft und Kunst des Mittelalters* (*Miscellanea Mediaevalia.* Veröffentl. des Thomas-Instituts der Univ. zu Köln, Bd. 7), Berlin 1970, 249-78.

Barbara Bronder, 'Das Bild der Schöpfung und Neuschöpfung der Welt als orbis quadratus,' *Frühmittelalterliche Studien,* 6, 1972, 188-210.

R. S. Brumbaugh, *Plato's Mathematical Imagination,* Bloomington, Indiana, 1954.

—, 'Logical and Mathematical symbolism in the Plato Scholia,' *Journal of the Warburg and Courtauld Institutes,* 24, 1961, 45-58; *ibidem,* 28, 1965, 1-14; *ibidem,* 31, 1968, 1-11.

F. Brunhölzl, 'Der Bildungsauftrag der Hofschule,' *Karl der Grosse, Lebenswerk und Nachleben* II, Das Geistige Leben, Düsseldorf 1965, 28-41.

L. de Bruyne, 'La décoration des baptistères paléochrétiens,' *Miscellanea liturgica L. C. Mohlberg,* I, 1948, 191-220.

E. Douglas Van Buren, *The Flowing Vase and the God with Streams,* Berlin 1933.

Lili Burger, *Die Himmelskönigin der Apokalypse in der Kunst des Mittelalters,* Berlin 1937.

Ch. Butler, *Number Symbolism,* London 1970.

A. Buttafava, 'Nuovi affreschi scoperti a S. Pietro al Monte,' *Arte Christiana,* Dec. 1962, 274 ff.

Byrhtferth of Ramsey, *Byrhtferth's Manual (A.D. 1011) . . .,* S. J. Crawford ed., 2 vols., London 1929.

Nurith Cahansky, *Die romanischen Wandmalereien der ehemaligen Abteikirche St. Chef, Dauphiné* (Basler Studien zur Kunstgeschichte N.F., Bd. VII), Berne 1967.

F. Calasso, *Il medioevo del diritto. Le fonti,* Milan 1954.

G. Camès, *Allégories et symboles dans l'Hortus Deliciarum,* Leiden 1971.

—, 'A propos de deux monstres dans l'Hortus Deliciarum,' *Cahiers de civilisation médiévale,* XI, 1968, 587-603.

H. Caplan, 'The four senses of scriptural interpretation and the medieval theory of preaching,' *Speculum,* IV, 1929, 282-90.

M. Cappuyns, *Jean Scot Erigène: Sa vie, son oeuvre, sa pensée,* Louvain-Paris 1933.

F. J. Carmody, *Physiologus latinus.* Éditions préliminaires. Versio B, Paris 1939.

O. Casel, *Die Kirche als Braut Christi in Schrift, Väterlehre und Liturgie,* Mainz 1961.

Cassiodorus, *Cassiodori senatoris Institutiones,* R. A. B. Mynors ed., Oxford 1961².

Chalcidius, *Platonis Timaeus Interpretatore Chalcidio cum Eiusdem commentario,* J. Wrobel ed., Leipzig 1876.
—, *Calcidius, Timaeus a Calcidio translatus commentarioque instructus,* J. H. Waszink ed., London-Leiden 1962.
E. Champeaux, 'Jus Sanguinis. Trois façons de calculer la parenté au Moyen Age,' *Revue Historique de droit français et étranger,* 4e ser. XII, 1933, 241-90.
Gretel Chapman, 'The Bible of Floreffe. Redating of a romanesque manuscript,' *Gesta,* X / 2, 1971.
Elis. Chatel, 'Scènes marines des fresques de St. Chef,' *Synthronon* (Bibl. des Cahiers archéologiques II), Paris 1968, 177-87.
F. Chatillon, 'Vocabulaire et prosodie du distique attribué à Augustin de Dacie sur les quatre sens de l'écriture,' *L'Homme devant Dieu. Mélanges offerts au Père Henri de Lubac,* II, Lyons 1963, 17-28.
M. D. Chenu, 'Les deux âges de l'allégorisme,' *Recherches de théologie ancienne et médiévale,* 18, 1951, 19-28.
—, *La théologie au douzième siècle* (Études de Philosophie médiévale 45), Paris 1957.
P. Clemen, *Die romanische Monumentalmalerei in den Rheinlanden* (Publikationen der Gesellschaft für rheinische Geschichtskunde 25), Düsseldorf 1916.
R. J. Clements, *Picta Poesis. Litterary and Humanistic Theory in Renaissance Emblem Books* (Tesi e Testi 6), Rome 1960.
S. Collon-Gevaert et al., *Romaanse Kunst van het Maasland in de 11e, 12e en 13e eeuw,* Brussels 1968.
M. Conrat, *Geschichte der Quellen und Literatur des römischen Rechts im frühen Mittelalter,* 1891.
—, 'Arbor Iuris des frühen Mittelalters,' *Abh. der Preuss. Akademie phil. hist. Kl.,* 1909, 27 ff.
H. Cornell, *Biblia Pauperum,* Stockholm 1925.
F. M. Cornford, *Plato's cosmology. The Timaeus of Plato,* London 1956[4].
Cosmas Indicopleustes, *Cosmas Indicopleustes, Topographie chrétienne,* Wanda Wolska ed. vol. I (Livres I-IV), Paris 1968; vol. II (livre V), Paris 1970.
P. Courcelle, *Les Lettres Grecques en Occident. De Macrobe à Cassiodore* (Bibl. des écoles françaises d'Athène et de Rome 159), Paris 1948[2].
—, *Histoire littéraire des grandes invasions germaniques,* Paris 1964[3].
—, *La consolation de Philosophie dans la tradition littéraire.* Antécédents et Postérité de Boèce (Études Augustiniennes), Paris 1967.
A. Crocco, *Simbologia Dantesca.* Nuove Prospettive d'Interpretazione della Divina Commedia, Naples 1961[2].
A. C. Crombie, *Medieval and early modern science,* I, New York (Doubleday Anchor Books) 1959.
E. R. Curtius, *European Literature and the latin middle ages* (Bollingen Series XXXVI), New York 1953.
J. Daniélou, *Sacramentum futuri. Études sur les origines de la typologie biblique* (Études de théologie historique), Paris 1950.
R. Delbrueck, *Probleme der Lipsanothek in Brescia* (Theophaneia 7), Bonn 1952.
H. Dembowski, *Initium Sancti Evangelii,* Cassel 1959.
A. Dempff, *Sacrum Imperium,* Munich-Berlin 1929.
O. Demus, *Byzantine mosaic decoration. Aspects of Monumental Art in Byzantium,* London 1947.
—, *The Mosaics of Norman Sicily,* London 1949.
—, 'Neue Funde an den Emails des Nikolaus von Verdun in Klosterneuburg,' *Österr. Zeitschrift für Denkmalpflege,* V, 1951, 13-22.
—, 'Regensburg, Sizilien und Venedig. Zur Frage des byzantinischen Einflusses in der romanischen Wandmalerei,' *Jahrbuch der Österr. Byzant. Gesellschaft,* II, 1952, 95-104.
—, *Romanische Wandmalerei,* Munich 1968.
—, *Byzantine art and the West,* New York 1970.

A. Derolez, *Lambertus S. Audomari Canonicus, Liber Floridus,* Ghent 1968.

P. Deschamps & M. Thibout, *La peinture murale en France. Le haut moyen âge et l'époque romane,* Paris 1951.

Dionysios of Phurna, *Ermeneia tès zographikès technès. Malerbuch des Malermönchs Dionysios vom Berge Athos,* G. Schäfer ed., (reprint from the edition Trier 1855), Munich 1960.

Durandus, *Rationale Divinorum officiorum . . .,* Antwerpen 1614.

W. Dürig, *Imago. Ein Beitrag zur Terminologie und Theologie der römischen Liturgie* (Münchener Theol. Studien II. Systemat. Abt. 5. Bd.), Munich 1952.

J. Ehlers, 'Arca significat ecclesiam,' *Frühmittelalterliche Studien,* 1972, 171-87.

H. von Einem, *Der Mainzer Kopf mit der Binde* (Arbeitsgem.f.Forschung des Landes Nord-rhein-Westfalen. Geistesw., H. 37), Cologne-Opladen 1954.

V. H. Elbern, 'Die Stele von Moselkern und die Ikonographie des frühen Mittelalters,' *Bonner Jahrbücher,* 155 / 56, 1955-56. 184 ff.

—, 'Theologische Spekulation und die Gestaltungsweise frühmittelalterlicher Kunst,' *Früh-mittelalterliche Studien,* I, 1967, 144-55.

W. Elliger, *Die Stellung der alten Christen zu den Bildern in den ersten vier Jahrhunderten,* Leipzig 1930.

J. A. Endres, 'Romanische Deckenmalereien und ihre Tituli zu S. Emmeram,' *Zeitschrift für christliche Kunst,* XV, 1902: I, 205-210; II, 235-240; III, 275-82.

—, 'Romanische Malerei in Prüfening,' *Christliche Kunst,* I, 1905-06, 160-71.

—, 'Die Wandgemälde der Allerheiligenkapelle zu Regensburg,' *Zeitschrift für christliche Kunst,* 25, 1912, 43-52.

P. Engelmeier, *Westfälische Hungertücher vom 14. bis 19. Jahrhundert,* Munich 1960.

A. C. Esmeijer, 'Een raam in de Utrechtse Mariakerk naar ontwerp van Scorel,' *Oud Holland,* LXX, 1955, 219-22.

—, 'La Macchina dell'Universo,' *Album Discipulorum J. G. van Gelder,* Utrecht 1963, 5-15.

—, 'Cosmos en Theatrum Mundi in de Pinkstervoorstelling,' *Nederlands Kunsthistorisch Jaarboek,* 15, 1964, 19-44.

—, 'De VII liberalibus artibus in quadam pictura depicta. Een reconstructie van de arbor philosophiae van Theodulf van Orleans,' *Album Amicorum J. G. van Gelder,* The Hague 1973, 102-13.

R. L. S. Bruce-Mitford & T. D. Kendrick et al., *Evangeliorum Quattůr Codex Lindisfarnensis,* 2 vols., Olten 1956, 1960.

M W. Evans, *Medieval Drawings,* London-Toronto 1969.

P. Fairbarn, *The typology of Scripture,* 2 vols., Michigan 1952.

A. Farinelli, 'Der Aufstieg der Seele bei Dante. Über die Vorstellungen von der Himmels-reise der Seele,' *Vorträge der Bibliothek Warburg 1928-29,* Leipzig-Berlin 1930, 191-213.

A. Feigel, 'San Pietro in Civate,' *Monatshefte fur Kunstwissenschaft,* II, 1909, 206-17.

B. Fischer, 'Codex Amiatinus und Cassiodor,' *Biblische Zeitschrift,* N.F. 6, 1962, 57-59.

J. Fontaine, *Isidore de Séville et la culture classique dans l'espagne wisigotique,* 2 vols. (Études Augustiniennes), Paris 1959.

R. Forrer, *Unedierte Federzeichnungen, Miniaturen und Initialen des Mittelalters,* Strasburg 1907.

P. Fournier & G. Le Bras, *Histoire des collections canoniques en Occident depuis les fausses décrétales jusqu'au décret de Gratien,* 2 vols., Paris 1931-32.

H. Frankfort, *The art and architecture of the ancient Orient* (the Pelican History of Art), Harmondsworth 1954.

P. Frankl, *The Gothic. Literary Sources and Interpretations through eight centuries,* Princeton 1960.

D. Frey, 'Der Realitätscharakter des Kunstwerkes,' *Festschrift H. Wölfflin zum siebzigsten Geburtstage,* Dresden 1935, 30-67.

Vilma Fritsch, *Links und Rechts in Wissenschaft und Leben* (Urbanbücher 80), Stuttgart 1964.

W. Frodl, *Die romanische Wandmalerei in Kärnten,* Klagenfurt 1942.

—, & D. Talbot Rice, *Österreichische mittelalterliche Malerei,* New York-Munich 1964.

H. v.d. Gabelentz, *Die kirchliche Kunst im italienischen Mittelalter.* Ihre Beziehungen zu Kultur und Glaubenslehre, Strasburg 1907.

J. Garber, *Wirkungen der frühchristlichen Gemäldezyklen der alten Peters- und Paulsbasiliken in Rom,* Berlin-Vienna 1918.

E. Garrison, *Studies in the history of mediaeval italian painting,* IV, 2, Florence 1960-62.

C. Gaspar & F. Lyna, *Les principaux manuscrits à peintures de la Bibliothèque royale de Belgique,* II, Paris 1945.

J. Gaudemet, *La formation du droit séculier et du droit de l'Église aux 4e et 5e siècles,* Paris 1957.

—, 'Le droit romain dans la pratique et chez les docteurs aux XIe et XIIe siècles," *Cahiers de civilisation médiévale,* VIII, 1965, 365-80.

M. I. Gerhardt, 'Zoologie médiévale: préoccupations et procédés,,' *Miscellanea Medievalia,* 7, Berlin 1970, 231-39.

Th. Gérold, *Les Pères de l'Église et la musique,* Paris 1931.

—, *La Musique au Moyen Âge,* Paris 1932.

O. Gillen, *Ikonographische Studien zur 'Hortus Deliciarum' der Herrad von Landsberg* (Kunstwiss. Studien IX), Berlin 1931.

E. Giordani, 'Das mittelbyzantinische Ausschmückungssystem als Ausdruck eines hieratischen Bildprogrammes,' *Jahrbuch der Österreichischen Byzantinischen Gesellschaft,* I, 1951, 103-34

R. C. Goldschmidt, *Paulinus' Churches at Nola. Texts, translations and commentary,* Amsterdam 1940.

L. Goppelt, *Typos. Die typologische Deutung des Alten Testaments im Neuen* (Beiträge zur Förderung christlicher Theologie XLIII), Darmstadt 1966 (reprint of the edition Gütersloh 1938).

A. Grabar, *Martyrium. Recherches sur le culte des reliques et l'art chrétien antique,* 2 vols., Paris 1946.

—, *Christian iconography. A study of its origins* (A. W. Mellon Lectures in the fine Arts, 1961. The National Gallery of Art, Washington D.C.), London 1969.

M. Grabmann, *Die Geschichte der scholastischen Methode,* Nach den Gedruckten und Ungedruckten Quellen dargestellt, 2 vols., Darmstadt 1956 (reprint of the edition Freiburg i. Br. 1909-11).

W. C. Greene, *Scholia Platonica* (Philological Monographs 8), Haverford 1938.

Eleanor Greenhill, 'The child in the tree,' *Traditio,* X, 1954, 323-73.

—, *Die geistigen Voraussetzungen der Bilderreihe des Speculum Virginum.* Versuch einer Deutung (Beiträge zur Geschichte der Philosophie und Theologie des Mittelalters, Bd. XXXIX, H.2)), Münster i.W. 1962.

—, 'Die Stellung der Handschrift Br. Mus. Arundel 44 in der Überlieferung des Speculum Virginum,' *Mitt. des Grabmann Instituts der Univ. München,* 10, Munich 1966.

Jacob Gretser, *De Cruce Christi,* Ingolstadt 1600.

Ursula Grossmann, 'Studien zur Zahlensymbolik des Frühmittelalters,' *Zeitschrift für Katholische Theologie,* 76, 1954, 19-54.

H. Grundmann, *Studien über Joachim von Floris,* Leipzig 1927.

—, *Neue Forschungen über J. von Fiore,* Marburg 1950.

J. Gutbrod, *Die Initiale in HSS. des achten bis dreizehnten Jahrhunderts,* Stuttgart-Berlin-Cologne 1965.

G. Haendler, *Epochen Karolingischer Theologie. Eine Untersuchung über die karolingischen Gutachten zum byzantinischen Bilderstreit* (Theologische Arbeiten X), Berlin 1948.

G. Haenel, *Lex romana Visigothorum,* 1894.

I. Hänsel-Hacker, 'Die Fresken der Kirche St. Nikolaus bei Matrei in Ost-Tirol. Das Werk einer Paduaner Malerschule,' *Jahrbuch der Österr. Byzant. Gesellschaft,* III, 1954, 109-22.

Helga Hajdu, *Das Mnemotechnische Schrifttum des Mittelalters,* Vienna-Amsterdam-Leipzig 1936.

R. Hammerstein, *Die Musik der Engel. Untersuchungen zur Musikanschauung des Mittelalters,* Berne-Munich 1962.

Ch. H. Haskins, *The Renaissance of the 12th century*(1927), New York (Meridian Books), 1958[2]

Adelheid Heimann, 'The six days of creation in a twelfth century manuscript,' *Journal of the Warburg and Courtauld Institutes,* I, 1937-38. 269-75.

E. Hempel, 'Der Realitätscharakter des kirchlichen Wandbildes im Mittelalter,' *Kunstgeschichtliche Studien. Festschrift D. Frey,* Breslau 1943, 106-20.

H. L. Hempel, 'Jüdische Traditionen in frühmittelalterlichen Miniaturen,' *Beiträge zur Kunstgeschichte und Archäologie des Frühmittelalters,* Akten zum VII. Intern. Kongress f. Frühmittelalterforschung 1958, Graz-Cologne 1962, 53-65.

A. Hermann, 'Der Nil und die Christen,' *Jahrbuch für Antike und Christentum,* 2, 1959, 30-69.

H. J. Hermann, *Die Illuminierten Handschriften und Inkunabeln der Nationalbibliothek:* Die deutschen romanischen HSS., N.F. VIII. 2, Leipzig 1926.

—, *Die Italienischen Handschriften des Dugento und Trecento.* I. Bis zur Mitte des XIV. Jahrhunderts, N.F., V.1, Leipzig 1928.

Herrad of Landsberg, *Herrade de Landsberg, Hortus Deliciarum,* A. Straub & G. Keller eds., Strasburg 1879-99.

L. Heydenreich, 'Jerusalemplan aus der Zeit der Kreuzfahrer,' *Miscellanea pro Arte, Festschrift H. Schnitzler,* Düsseldorf, 1965, 83-90.

B. Hirsch-Reich, 'The Symbolism of Musical Instruments in the Psalterium X Chordarum of Joachim of Fiore and its Patristic Sources,' *Studia Patristica,* IX, 1966, 540-51.

K. Hoffmann, 'Sugers 'Anagogisches Fenster' in St. Denis,' *Wallraf-Richartz Jahrbuch,* 30, 1968, 57-88.

K. Holter & W. Neumüller, *Der Codex Millenarius,* Graz-Cologne 1959.

O. Homburger, *Die illustrierten Handschriften der Burgerbibliothek Bern,* Berne 1962.

V. F. Hopper, *Medieval Number Symbolism. Its sources, meaning and influence on thought and expression,* New York 1938.

F. Hula, *Mittelalterliche Kultmale. Die Totenleuchter Europas, Karner, Schalenstein und Friedhofsoculus,* Vienna 1970.

R. C. B. Huygens, 'Mittelalterliche Kommentare zum 'O qui perpetua . . .',' *Sacris Erudiri,* 6, 1954, 373-427.

Christa Ihm, *Die Programme der christlichen Apsismalerei vom vierten Jahrhundert bis zur Mitte des achten Jahrhunderts* (Forschungen zur Kunstgeschichte und Christlichen Archäologie 4), Wiesbaden 1960.

Isidore of Seville, *Isidorus Hispalensis. Etymologiarum sive originum libri XX,* W. M. Lindsay ed., 2 vols., Oxford 1957.

—, *Isidore de Séville. Traité de la Nature,* J. Fontaine ed., Bordeaux 1960.

E. von Ivánka, *Plato Christianus. Übernahme und Umgestaltung des Platonismus durch die Väter,* Einsiedeln 1964.

E. Iversen, *The myth of Egypt and its Hieroglyphs in European Tradition,* Copenhagen 1961.

M. R. James, *A descriptive catalogue of the manuscripts in the library of Eton College,* Cambridge 1895.

—, 'On the Abbey of St. Edmund at Bury,' *Cambridge Antiquarian Society Octavo Publications* 28, Cambridge 1895, 92 ff.

—, *The Apocalypse in Art* (The Schweich Lectures of the British Academy), London 1931.

H. Jantzen, 'Das Wort als Bild in der frühmittelalterlichen Buchmalerei,' *Über den gotischen Kirchenraum und andere Aufsätze,* Berlin 1951, 53-60.

Joachim da Fiore, *Il Libro delle Figure dell'abbate Gioachino da Fiore,* L. Tondelli, M. Reeves, B. Hirsch-Reich eds., 2 vols., Turin 1940, 1953[2]

John Scot Erigena, *Johannes Scotti, Annotationes in Marcianum Capellam,* Cora E. Lutz ed., Cambridge Mass. 1939.

—, *Jean Scot, Homélie sur le prologue de Jean* (Sources Chrétiennes 151), E. Jeanneau ed., Paris 1969.

L. W. Jones, 'The influence of Cassiodorus on medieval culture,' *Speculum*, 20, 1945, 433-42; 22, 1945, 245-56.

Julius Paulus, *Sententiae, Tit. XI. De gradibus. Iurisprudentiae Anteiustinianae quae supersunt*, Ph. E. Huschke ed., Leipzig (Teubner) 1879.

Justinian, *Imperatoris Iustiniani Institutionum Libri Quattuor*, Ph. E. Huschke ed., Leipzig (Teubner) 1868.

W. Kahles, *Geschichte als Liturgie. Die Geschichtstheologie Ruport's von Deutz*, Münster 1960.

U. Kamber, *Arbor Amoris der Minnebaum. Ein Pseudo-Bonaventura Traktat* (Philol. Studien und Quellen H. 20), Berlin 1964.

H. Karlinger, *Die Hochromanische Wandmalerei in Regensburg*, Munich-Berlin-Leipzig 1920.

H. Karpp, *Die frühchristlichen und mittelalterlichen Mosaiken in Santa Maria Maggiore zu Rom*, Baden-Baden 1966.

A. Katzenellenbogen, *Allegories of the virtues and vices in art from early christian times to the thirteenth century*, New York 1964[2]

L. Kitschelt, 'Die frühchristliche Basilika als Darstellung des Himmlischen Jerusalem,' *Münchener Beiträge zur Kunstgeschichte*, III, 1938.

E. Kitzinger, 'The mosaics of the Capella Palatina in Palermo. An Essay on the Choice and Arrangement of Subjects,' *Art Bulletin*, XXXI, 1949, 269-92.

—, 'The cult of images in the age before iconoclasm,' *Dumbarton Oaks Papers*, VIII, 1954, 83-150.

J. Ch. Klamt, *Die Mittelalterlichen Monumentalmalereien im Dom zu Braunschweig*, diss. Berlin 1968.

R. Klibanski, *The continuity of the platonic tradition. Outlines of a corpus platonicum Medii Aevi* (Warburg Institute Publications), London 1939.

—, E. Panofsky & F. Saxl, *Saturn and Melancholy*. Studies in the History of Natural Philosophy, Religion and Art, London 1964.

W. Köhler, *Die Karolingischen Miniaturen* I: Die Schule von Tours, Berlin 1930; II: Die Hofschule Karls des Grossen, Berlin 1958.

L. L. Koep, *Das himmlische Buch in Antike und Christentum* (Theophaneia. Beitrage z. Religions- u. Kirchengeschichte des Altertums 8), Bonn 1952.

E. Köstermann, 'Neue Beiträge zur Geschichte der lateinischen Handschriften des Irenaeus,' *Zeitschrift für die Neutestamentliche Wissenschaft*, 36, 1937, 1-34.

Sp. Kostoff, *The Orthodox Baptistery of Ravenna*, New Haven-London 1965.

R. Krautheimer, 'Introduction to an "Iconography" of Mediaeval Architecture,' *Journal of the Warburg and Courtauld Institutes*, V, 1942, 1-33.

F. Kreusch, 'Zur Planung des Aachener Barbarossaleuchters,' *Aachener Kunst-Blätter*, 19 / 20, 1960-61, 21-36.

E. Kris, 'A psychotic artist of the middle ages,' *Psychoanalytic Explorations in Art*, New York 1952, 118-27.

W. Krönig, 'Zur Transfiguration der Capella Palatina in Palermo,' *Zeitschrift für Kunstgeschichte*, 19, 1956, 162-79.

J. Kunisch, *Konrad III, Arnold von Wied und der Kapellenbau von Schwarzrheindorf* (Veröffentl. des hist. Ver. f. den Niederrhein insbes. das alte Erzbistum Köln 9), Düsseldorf 1966.

Betty Kurth, *Die deutschen Bildteppiche des Mittelalters*, 3 vols. Vienna 1926.

A. de Laborde, *Les Manuscrits à peintures de la Cité de Dieu de Saint Augustin*, 3 vols., Paris 1909.

—, *La Bible Moralisée conservée à Oxford, Paris et Londres*. Repr. intégral du MS. du XIIIe · siècle, 5 vols., Paris 1911-27.

G. B. Ladner, 'Some recent publications on the classical tradition in the middle ages and the renaissance and on Byzantium,' *Traditio*, X, 1954, 578-94.

231

—, 'Vegetation symbolism and the concept of Renaissance,' *De Artibus Opuscula XL. Essays in Honor of Erwin Panofsky*, New York 1961, 303-22.

—, *Ad imaginem Dei. The image of Man in Mediaeval Art* (Wimmer Lecture No. XVI, 1962), Latrobe Pa., 1966.

—, 'Homo Viator. Mediaeval Ideas on Alienation and Order,' *Speculum*, XLII, 1967, 252-59.

P. Lampl, 'Schemes of architectural representation in early medieval art,' *Marsyas*, 9, 1961, 6-13.

G. Lange, *Bild und Wort. Die katechetischen Funktionen des Bildes in der griechischen Theologie des 6. bis 9. Jahrhunderts* (Schriften zur Religionspaedogogik und Kerygmatik 6), Würzburg 1969.

F. Lauchert, *Geschichte des Physiologus*, Strasburg 1889.

G. Leff, *Medieval Thought. St. Augustine to Ockham*, Harmondsworth (Pelican Books), 1958.

K. Lehmann, 'The dome of heaven,' *Art Bulletin*, XXXVII, 1945, 1-28.

G. Leidinger, *Miniaturen aus Handschriften der bayerischen Staatsbibliothek*, Munich 1924.

Heide Lenzen & H. Buschhausen, 'Ein neues Reichsportatile,' *Wiener Jahrbuch*, XX, 1965, 21-73.

Annalina & Mario Levi, *Itineraria picta. Contributo allo Studio della Tabula Peutingeriana*, Rome 1967.

H. Liebeschütz, *Das Allegorische Weltbild der Heiligen Hildegard von Bingen* (Studien der Bibliothek Warburg XVI), Leipzig-Berlin 1930.

K. Löffler, *Schwäbische Buchmalerei in romanischer Zeit*, Augsburg 1928.

O. Lorenz, *Lehrbuch der gesammten wissenschaftlichen Genealogie*, Berlin 1898.

H. de Lubac, *Exégèse mediévale. Les quatre sens de l'écriture*, I / 1.2, II/1.2, Paris 1959-64.

P. Lucentini, 'La Clavis Physicae di Honorius Augustodunensis. Codici e Titoli Marginali,' *Atti e Memorie dell'Accademia Toscana di Scienze e Lettere.* La Colombaria, XXXV, N.S. xxi, 1970, 103-35.

P. Lundburg, *La typologie baptismale dans l'ancienne église* (Acta Seminarii Neotestamentici Upsaliensis X), Lund 1942.

Cora E. Lutz, 'Remigius' Ideas on the Origins of the Seven Liberal Arts,' *Mediaevalia et Humanistica*, X, 1956, 32-49.

M. Mackeprang, V. Madsen & C. S. Petersen, *Greek and Latin Illuminated Manuscripts in Danish Collections*, Copenhagen 1917.

Macrobius, *Macrobius, Commentarium in Somnium Scipionis*, Fr. Eyssenhardt ed. Leipzig.

—, *Macrobius, commentary on the dream of Scipio*, W. H. Stahl transl. and introd. (Records of civilisation, sources and studies, Columbia University, A. P. Evans ed.), New York 1952.

Sibylle Mähl, *Quadriga virtutum. Die Kardinaltugenden in der Geistesgeschichte der Karolingerzeit* (Beihefte z. Archiv f. Kulturgeschichte 9), Cologne-Vienna 1969.

J. L. Maier, *Le baptistère de Naples et ses mosaïques. Étude historique et iconographique* (Paradosis. Études de littérature et de théologie anciennes XIX), Fribourg 1964.

E. Mâle, *L'art religieux de la fin du Moyen âge en France*, Paris (1908), 1949.

—, *L'art religieux du XIIe siècle en France*, Paris (1922), 1947⁵.

G. D. Mansi, *Sacrorum Conciliorum Nova et Amplissima Collectio*, 31 vols., Florence 1758-98.

M. Destombes ed., *Mappemondes A.D. 1200-1500*, Catalogue préparé par la Commission des cartes anciennes de l'Union géographique intern., Monumenta Cartographica Vetustioris Aevi, vol. 1. Mappaemundi-Imago Mundi. Suppl. nr. IV, sect. 52.2, Amsterdam 1964.

J. Mariétan, *Problèmes de la classification des sciences d'Aristote à St. Thomas*, Paris 1909.

G. Marinelli, 'New discoveries of the romanesque period in France, 2. Frescoes and Reliquaries at St. Michel-d'Aighuilhe,' *The Connoisseur*, 158, No. 635, 1965, 165-68.

H. I. Marrou, *St. Augustin et la fin de la culture antique* (Bibl. des écoles françaises d'Athène et de Rome 145), Paris 1938.

Martianus Capella, *De nuptiis Philologiae et Mercurii*, Fr. Eyssenhardt ed., Leipzig 1866.

232

—, *De nuptiis Philologiae et Mercurii*, A. Dick ed., Leipzig 1925.

R. Martin, *St. Michel d'Aighuilhe*, Le Puy-Lyon 1958.

J. F. Masselink, *De grieks-romeinse windroos*, Nijmegen 1956.

A. Mayer, *Das Bild der Kirche. Hauptmotive der Ekklesia im Wandel der abendländischen Kunst.* Regensburg 1962.

F. van der Meer, *Maiestas Domini, Théophanies de l'Apocalypse dans l'art chrétien.* Étude sur les origines d'une iconographie spéciale du Christ (Studi di Antichità Cristiana 13), Rome-Paris, 1938.

P. Metz, *Das Goldene Evangelienbuch von Echternach im Germanischen National-Museum zu Nürnberg. Codex Aureus Epternacensis*, Munich 1956.

K. Michel, *Gebet und Bild in frühchristlicher Zeit* (Studien über christliche Denkmaler 1), Leipzig 1902.

Ch. Michna, 'Das Salomonische Thronsymbol auf österreichischen Denkmälern,' *Alte und Moderne Kunst*, 6, 1961, 2 ff.

K. Miller, *Mappaemundi. Die ältesten Weltkarten*, 6 vols., Stuttgart 1895-98.

C. Morino, *Il ritorno al Paradiso di Adamo in S. Ambrogio*, Rome 1952.

Florentine Mütherich, 'De Rhetorica. Eine Illüstration zu Martianus Capella,' *Festschrift B. Bischoff zu seinem 65. Geburtstag*, Stuttgart 1971, 198-206.

W. Neuss, *Das Buch Ezechiel in Theologie und Kunst bis zum Ende des XII. Jahrhunderts.* Mit besonderer Berücksichtigung der Gemälde in der Kirche zu Schwarzrheindorf. Ein Beitrag zur Entwicklungsgeschichte der christlichen Kunst, Münster i.W. 1912.

—, *Die Apokalypse des hl. Johannes in der altspanischen und altchristlichen Bibelillustration. Das Problem der Beatus-HSS.*, 2 vols., Münster i.W. 1931.

F. Ohly, 'Die Kathedrale als Zeitraum. Zum Dom von Siena,' *Frühmittelalterliche Studien*, 6, 1972, 94-158.

H. P. L'Orange, *Studies on the iconography of cosmic kingship in the ancient world*, Oslo 1953.

— & P. J. Nordhagen, *Mosaics. From Antiquity to the Early Middle Ages*, London 1966.

S. Otto, *Die Funktion des Bildbegriffes in der Theologie des 12. Jahrhunderts* (Beiträge zur Geschichte der Philosophie und Theologie des Mittelalters 40 / 1), Münster i.W. 1963.

R. Oursel, 'L'architecture de l'abbaye de St. Chef,' *Bulletin Monumental*, 120, 1962, 49-70.

E. Panofsky, 'Note on a controversial passage in Suger's "De Consecratione Ecclesiae Sancti Dionysii",' *Gazette des Beaux Arts*, 86, 1944, II, 95-114.

—, *Abbot Suger on the Abbey Church of St. Denis and its Art Treasures*, Princeton 1946.

—, 'Postlogium Sugerianum' *Art Bulletin*, XXXIX, 1947, 119-21.

—, *Tombsculpture. Its changing aspects from ancient Egypt to Bernini*, New York 1964.

Evelyne Patlagean, 'Une représentation byzantine de la parenté et ses origines occidentales,' *L'Homme. Revue française d'anthropologie*, VI, oct.-dec. 1966, No. 4, 59-81.

G. Pazaurek, *Alte Goldschmiedearbeiten aus Schwäbischen Kirchenschätzen*, Leipzig 1912.

J. Pépin, *Mythe et Allégorie. Les origines grecques et les contestations judéo-chrétiennes*, Paris 1958.

Peter of Poitiers, *Petrus Pictaviensis, Sententiae*, Ph. S. Moore & Marthe Dulong eds. (Publ. in Mediaeval Studies, The University of N. Dame, Indiana, VII), 1943.

G. Pietzsch, *Die Klassifikation der Musik von Boethius bis Ugolino von Orvieto*, Halle 1929.

—, *Die Musik im Erziehungs- und Bildungsideal des ausgehenden Altertums und frühen Mittelalters*, Halle 1932.

W. Plöchl, *Das Eherecht des Magisters Gratianus* (Wiener Staats- und Rechtsw. Studien, N.F., Bd. XXIV), Leipzig-Vienna 1953.

L. Pressouyre, 'Le Cosmos platonicien de la cathédrale d'Anagni,' *Mélanges d'archéologie et d'histoire* (École française de Rome) 78, 1966, 551-93.

P. Prigent, *Apocalypse 12. Histoire de l'exégèse* (Beiträge zur Geschichte der biblischen Exegese 2), Tübingen 1959.

Prudentius, *Tituli Historiarum (Dittochaeon)* in: *Prudentius*, H. J. Thomson transl., II, London-Cambridge Mass. (Loeb Classical Library) 1961, 346-75.

H. Quentin, *Mémoire sur l'établissement du texte de la Vulgate* (Collectanea Biblica Latina VI), Paris 1922.

233

H. Rahner, 'De dominici pectoris fonte potavit,' *Zeitschrift für kathol. Theologie*, 55, 1931, 103-08.
—, 'Flumina de ventre Christi. Die patristische Auslegung von Joh. 7:37, 38,' *Biblica*, 22, 1941, 269-302; 367-403.
Jacqueline Rambaus-Buhot, L'étude des MSS. du Décret de Gratien conservés en France,' *Studia Gratiana*, I, G. Forchielli & A. M. Stichler eds., Bologna 1953, 121-45.
Photima Rech, *Inbild des Kosmos. Ein Symbolik der Schöpfung*, 2 vols., Salzburg-Freilassing 1966.
M. E. Reeves, 'The Liber Figurarum of Joachim of Fiore,' *Mediaeval & Renaissance Studies*, II, 1951, 57-81.
—, & B. Hirsch-Reich, 'The "Figurae" of Joachim of Fiore. Genuine and spurious collections,' *ibidem*, III, 1954, 170-99.
— & —, *The 'Figurae' of Joachim of Fiore*, Oxford 1972.
Remigius of Auxerre, *Remigii Autissiodorensis, Commentum in Marcianum Capellam*, libri I-IX, 2 vols., Cora E. Lutz ed., Leiden 1962-65.
H. Reuther, 'Studien zur Goslarer Pfalzkapelle St. Ulrich,' *Niederdeutsche Beiträge zur Kunstgeschichte*, VII, 1968, 65-84.
P. Riché, *Éducation et culture dans l'occident barbare VIe-VIIIe siècles* (Patristica Sorbonensia 4), Paris 1962.
K.Richstätter, *Die Herz-Jesuverehrung des Deutschen Mittelalters*, Munich-Regensburg 1924[2].
F. Röhrig, *Der Verduner Altar*, Klosterneuburg 1955.
—, 'Rota in medio rotae. Ein typologischer Zyklus aus Österreich,' *Jahrbuch des Stiftes Klosterneuburg*, N.F., Bd. 5, 1965. 7-113.
M. Roger, *L'enseignement des lettres classiques d'Ausone à Alcuin*, Paris 1905.
F. Ronig, 'Die Buchmalerei des 11. und 12. Jahrhunderts in Verdun,' *Aachener Kunstblätter*, 38, 1969, 7-212.
H. Rosenau, *The ideal city in its architectural evolution*, London 1959.
E. W. Rosien, 'Die Ebstorfer Weltkarte,' *Veröffentl. des Niedersächs. Amtes f. Landesplanung und Statistik, Reihe A*, II, Bd. 19, Hannover 1952, 44 ff.
C. Roth, 'Jewish Antecedents of Christian Art,' *Journal of the Warburg and Courtauld Institutes*, XVI, 1953, 24-45.
A. Ruegg, *Die Jenseitsvorstellungen vor Dante und die übrigen literarischen Voraussetzungen der 'Divina Commedia'. Ein Quellenkritischer Kommentar*, 2 vols., Cologne 1945.
Fr. Russo, *Bibliografia Gioachimita*, Florence 1954.
R. Salomon, 'A newly discovered MS. of Opicinus de Canistris,' *Journal of the Warburg and Courtauld Institutes*, XVI, 1953, 45-57.
— & Adelheid Heimann, *Opicinus de Canistris, Weltbild und Bekenntnisse eines Avignoneser Klerikers des 14. Jahrhunderts* (Studies of the Warburg Institute), London 1936.
J. Sauer, *Symbolik des Kirchengebäudes und seiner Ausstattung in der Auffassung des Mittelalters*, Freiburg i.Br. 1924[2].
W. Sauerländer, *Gotische Skulptur in Frankreich 1140-1270*, Munich 1970.
F. Saxl, 'Beiträge zu einer Geschichte der Planetendarstellungen im Orient und im Okzident,' *Der Islam*, III, 1912, 20 ff.
—, *Verzeichnis astrol. und mythol. HSS. des lat. Mittelalters* II. Die HSS. der Nationalbibliothek in Wien (Sitzungsberichte der Heidelberger Akademie der Wissenschaften, Philos.-hist. Klasse 1925 / 26, 2. Abh.), Heidelberg 1927.
—, 'A Spiritual Encyclopedia of the later Middle Ages,' *Journal of the Warburg and Courtauld Institutes*, V, 1942, 82-142.
—, 'Macrocosm and Microcosm in Medieval Pictures,' *Lectures I*, London 1957, 58-72.
— & H. Meier, H. Bober ed., *Catalogue of Astrological and Mythological Ill. MSS. of the Latin Middle Ages*, III, MSS. in English libraries, London 1953.
Fr. Sbordone, *Physiologi graeci ... recensiones*, Milan 1936.
H. Schade, 'Die Libri Carolini und ihre Stellung zum Bild,' *Zeitschrift für kathol. Theologie*, 79, 1957, 69-78.

R. W. Scheller, *A Survey of Medieval Model Books,* Haarlem 1963.

Rosy Schilling, 'The Decretum Gratiani formerly in the C. W. Dyson Perrins collection,' *The Journal of the British Archaeological Association,* 3, XXVI, 1963, 27-40.

E. Schlee, *Die Ikonographie der Paradiesesflüsse* (Studien über christliche Denkmäler, J. Ficker ed., N.F., H. 24), Leipzig 1957.

J. von Schlosser, *Beiträge zur Kunstgeschichte aus den Schriftquellen des frühen Mittelalters,* Vienna 1891.

—, *Schriftquellen zur Geschichte der Karolingischen Kunst* (Quellenschrifte für Kunstgeschichte und Kunsttechnik des Mittelalters und der Neuzeit, N.F., Bd. 4), Vienna 1892.

—, *Quellenbuch zur Kunstgeschichte des Abendländischen Mittelalters* (Quellenschrifte für Kunstgeschichte und Kunsttechnik des Mittelalters und der Neuzeit, N.F., Bd. 7), Vienna 1896.

G. Schmidt, *Die Armenbibeln des XIV. Jahrhunderts,* Graz-Cologne 1959.

R. Schmidt, 'Aetates mundi. Die Weltalter als Gliederungsprinzip der Geschichte,' *Zeitschrift für Kirchengeschichte,* 67, 1955-56, 292 ff.

J. A. Schmoll gen. Eisenwerth, 'Sion-Apokalyptisches Weib-Ecclesia Lactans. Zur ikonografischen Deutung von zwei romanischen Mater-Darstellungen in Metz und Pompierre,' *Miscellanea pro Arte Medii Aevi. Festschrift H. Schnitzler,* Düsseldorf 1965, 91-110.

H. Schnitzler, 'Zur Regensburger Goldschmiedekunst,' *Wandlungen Christlicher Kunst im Mittelalter* (Forschungen zur Kunstgeschichte und Christlichen Archäologie II), Baden-Baden 1953, 171-85.

H. Schrade, *Vor- und Frühromanische Malerei.* Die karolingische, ottonische und frühsalische Zeit, Cologne 1958.

—, *Die romanische Malerei. Ihre Majestas,* Cologne 1963.

P. E. Schramm, *Sphaira-Globus-Reichsapfel.* Wanderung und Wandlung eines Herrschaftszeichens von Caesar bis zu Elizabeth II. Ein Beitrag zum Nachleben der Antike, Stuttgart 1958.

F. Schwäbl, *Die Vorkarolingische Basilika St. Emmeram in Regensburg* (Sonderdruck Zeitschrift für Bauwesen, Jhrg. 1919, h. 1-19), Regensburg 1919.

H. Sedlmayr, *Die Entstehung der Kathedrale,* Zürich 1950.

—, Pieter Bruegel. Der Sturz der Blinden. Paradigma einer Strukturanalyse (Hefte des kunsthist. Seminars der Universität München 2), Munich 1957.

O. Seel, *Der Physiologus,* Zürich 1960.

Constanza Segre Montel, 'Gli Affreschi della Capella di S. Eldorado alla Novalese,' *Bollettino d'Arte,* XLIX, S. IV, 1964, 21-40.

W. Seiferth, *Synagoge und Kirche im Mittelalter,* Munich 1964.

F. X. Seppelt & G. Schwaiger, *Geschichte der Päpste von den Anfängen bis zur Gegenwart,* Munich 1964.

B. Smalley, *The Study of the Bible in the Middle Ages,* Oxford 1952².

E. Baldwin Smith, *Architectural Symbolism of Imperial Rome and the Middle Ages,* Princeton 1956.

Suzanne Spain, *The program of the 5th c. mosaics of Sta Maria Maggiore,* diss. NY University (summary in: *Marsyas,* XIV, 1968-69, 85).

Speculum hum.salv., *Speculum humanae salvationis,* J. Lutz & P. Perdrizet eds., Mulhouse 1907.

C. Spicq, *Esquisse d'une histoire de l'exégèse latine au moyen âge* (Bibliothèque thomiste XXVI), Paris 1944.

H. J. Spitz, *Die Metaphorik des geistigen Schriftsinns.* Ein Beitrag zur allegorischen Bibelauslegung des ersten christlichen Jahrtausends (Münstersche Mittelalter-Schriften 12), Munich 1972.

L. Spitzer, *Classical and christian ideas of world harmony.* Prolegomena to an interpretation of the word 'Stimmung', Baltimore 1963.

W. H. Stahl, R. Johnson & E. L. Burge, *Martianus Capella and the seven Liberal Arts,* vol. I:

The quadrivium of Martianus Capella. Latin traditions in the mathematical sciences 50 B.C.-A.D. 1250 (Records of Civilisation: Sources and Studies LXXXIV), New York-London, 1971.

W. Stammler, 'Aristoteles und die sieben Artes Liberales im Mittelalter,' *Der Mensch und die Künste. Festschrift H. Lützeler*, Düsseldorf 1962, 196-214.

A. Stange, *Das frühchristliche Kirchengebäude als Bild des Himmels*, Cologne 1950.

—, *Basiliken, Kuppelkirchen, Kathedralen. Das Himmlische Jerusalem in der Sicht der Jrh.*, Regensburg 1964.

Frauke Steenbock, *Der kirchliche Prachteinband im Frühen Mittelalter*, Berlin 1965.

H. Steger, *David rex et propheta*. König David als vorbildliche Verkörperung des Herrschers und Dichters im Mittelalter nach Bilddarstellungen des 8. bis zum 12. Jahrhunderts (Erlanger Beitr.z.Sprach- und Kunstw. 6), Nürnberg 1961.

—, *Philologia Musica*. Bild und Sache im Literarischen Leben des Mittelalters: Lire, Harfe, Rotte und Fidel, Munich 1971.

H. Stern, 'Le décor des baptistères paléochrétiens en particulier des pavements et des cuves,' *Actes du Ve congrès intern.d'archéologie chrétienne. Aix en Provence 1954*, Rome-Paris 1957, 381-90.

—, Les mosaiques de l'église Sainte-Costance à Rome,' *Dumbarton Oaks Papers*, XII, 1958, 157-218.

R. Stettiner, *Die Illustrierten Prudentius-Handschriften*, 2 vols., Berlin 1895-1905.

E. Stommel, 'Σημεῖον ἐκπέτασεως (Didache 16,6),' *Römische Quartalschrift*, XLVIII, 1953, 21-42.

C. Stornajolo, *Le miniature della topografia cristiana di Cosma Indicopleuste*: Codice Vaticano greco 699, Milan 1908.

R. Storz, 'Zu den romanischen Wandmalereien in St. Chef,' *Das Werk des Künstlers. Festschrift H. Schrade*, Stuttgart 1960, 108-25.

H. Straus, *Der astrologische Gedanke in der deutschen Vergangenheit*, Munich 1926.

R. Strobel, *Romanische Architektur in Regensburg*, Nürnberg 1965.

J. Strzygowski, *Der Bilderkreis des griechischen Physiologus . . .*, (Byzant. Archiv 2), Leipzig 1899.

A. Stuiber, *Refrigerium interim*, Bonn 1957.

G. Swarzenski, *Die Regensburger Buchmalerei des X. und XI. Jahrhunderts*. Studien zur Geschichte der deutschen Malerei des frühen Mittelalters, Leipzig 1901.

—, *Die Salzburger Malerei von den ersten Anfängen bis zur Blütezeit des romanischen Stils*. Studien zur Geschichte der deutschen Malerei und Handschriftenkunde des Mittelalter, Leipzig 1908-13.

—, 'Aus dem Kunstkreis Heinrichs des Löwen,' *Städel Jahrbuch*, 7-8, 1932, 241-397.

H. Swarzenski, *The Berthold Missal*, New York 1943.

—, *Monuments of Romanesque Art*, London (1954).

E. H. Swift, *Roman sources of christian art*, New York, 1951.

B. Teyssèdre, 'Un exemple de survie de la figure humaine dans les MSS. précarolingiens. Les ill. du "De Natura Rerum d'Isidore",' *Gazette des Beaux Arts*, 102, 1960, II, 19-34.

L. Thorndike, *A History of magic and experimental science during the first thirteen centuries of our era*, 8 vols., New York 1923-58.

H. Tietze, 'Die typologischen Bilderkreise des Mittelalters in Österreich,' *Jahrbuch d.k.k. Zentralkommission f. Erforschung und Erh. der Kunst- und hist. Denkmale*, N.F. 2 / 2, 1904, 20-88.

E. M. W. Tillyard, *The Elizabethan World Picture*, New York (Vintage Books) 1961.

P. Toesca, *Gli affreschi della Cattedrale di Anagni* (Le Gallerie Nazionali Italiane 5), 1902.

—, *Monumenti dell'antica Abbazia di S. Pietro al Monte di Civate*, Florence (1943), 1951².

Ch. de Tolnay, 'The music of the Universe,' *Journal of the Walters Art Gallery*, VI, 1943, 83-104.

J. Trummer, 'Bigamie als Irregularitätsgrund nach der Lehre der alten Kanonistik,' *Festschrift W. Plöchl*, 1967, 393-409.

236

P. A. Underwood, 'The fountain of life,' *Dumbarton Oaks Papers*, V, 1950, 41-138.
A. Verbeek, *Schwarzrheindorf. Die Doppelkirche und ihre Wandgemälde*, Düsseldorf 1953.
E. Vetter, *Mariologische Tafelbilder des 15. Jahrhunderts und das Defensorium des Franz Retz.* Ein Beitrag zur Geschichte der Bildtypen im Mittelalter, diss. typewritten, Heidelberg 1954.
W. F. Volbach, *Die Elfenbeinarbeiten der Spätantike und des frühen Mittelalters*, Mainz 1952.
P. Vossen, 'Über die Elementen-Syzygien,' *Liber Floridus. Mittellateinische Studien Paul Lehmann . . . gewidmet . . .*, B. Bischoff & S. Brechter eds., St. Ottilien 1950, 33-46.
—, *Der Libellus Scolasticus des Walther von Speyer*, Berlin 1962.
St. Waetzoldt, *Die Kopien des 17. Jahrhunderts nach Mosaiken und Wandmalereien in Rom* (Forschungen der Bibliotheca Hertziana, Bd. XVIII), Vienna-Munich 1964.
G. J. J. Walstra, 'Thomas van Cantimpré. De naturis rerum,' *Vivarium*, V, 2, 1967, 146-71.
E. Walter, *Christus und der Kosmos. Eine Auslegung von Eph. 1:10*, Stuttgart 1948.
J. Walter, *Herrade de Landsberg, Hortus deliciarum*, Strasburg-Paris 1952.
A. Watson, *The early iconography of the Tree of Jesse*, Oxford-London 1934.
P. Weber, *Geistliches Schauspiel und kirchliche Kunst in ihrem Verhältnis erläutert an einer Ikonographie der Kirche und Synagoge*, Stuttgart 1894.
A. Weckwerth, 'Die Zweckbestimmung der Armenbibel und die Bedeutung ihres Namens,' *Zeitschrift für Kirchengeschichte*, 4. Folge VI, 68, 1957, 225 ff.
—, 'Das altchristliche und das frühmittelalterliche Kirchengebäude. Ein Abbild des Gottesreiches,' *ibidem*, 69, 1958, 26-78.
A. Weis, 'Die Verteilung der Bildzyklen in der Basilika des H. Paulinus in Nola,' *Römische Quartalschrift*, LII, 1957, 1-17.
—, 'Der römische Schöpfungszyklus des 5. Jahrhunderts im Triklinium Neons zu Ravenna,' *Tortulae. Festschrift J. Kollwitz (Römische Quartalschrift*, Suppl. H. 30), Rome 1966, 300-16.
E. Weiss, 'Der Freskenzyklus der Johanneskirche in Pürgg,' *Wiener Jahrbuch für Kunstgeschichte*, 22, 1969, 7-24.
K. Weitzmann, *Illustrations in Roll and Codex.* A Study of the origin and method of textillustration, Princeton 1970^2.
—, 'Die Illustration der Septuaginta,' *Münchener Jahrbuch der bildenden Kunst*, III/IV, 1952-53, 96-120.
—, 'Zur Frage des Einflusses jüdischer Bildquellen auf die Illustrationen des alten Testamentes,' *Mullus. Festschrift Th. Klauser*, Münster i.W. 1964, 403-15.
G. Wellen, 'Sponsa Christi. Het absismozaïek van de Santa Maria in Trastevere te Rome en het Hooglied,' *Festschrift F. van der Meer*, Amsterdam-Brussels 1966, 148-60.
O. K. Werckmeister, 'Three problems of tradition in pre-carolingian figure style. From visigothic to insular illumination,' *Proceedings of the Royal Irish Academy*, Vol. 63, Sect. C, nr. 5, Dublin 1963.
—, *Irisch-northumbrische Spiritualität*, Berlin 1967.
F. Wickhoff, 'Das Speisezimmer des Bischofs Neon von Ravenna,' *Repertorium für Kunstwissenschaft*, 17, 1894, 10-17.
E. H. Wilkins, 'The Trees of the "Genealogia Deorum",' *Modern Philology*, XXIII, 1925-26 (Aug. 1925), 61-65.
K. A. Wirth, 'Eine illustrierte Martianus-Capella-Handschrift aus dem 13. Jahrhundert,' *Städel Jahrbuch*, N.F. 2, 1969, 43-75.
Wanda Wolska, *La topographie chrétienne de Cosmas Indicopleustes.* Théologie et science au VI siècle (Bibliothèque Byzantine. Études 3), Paris 1962.
F. Wormald, *The miniatures of the Gospel of St. Augustine*, Cambridge 1964.
J. K. Wright, *The Geographical Lore of the Time of the Crusades.* A Study in the History of Medieval Science and Tradition in Western Europe, New York (Dover Publications) 1965.
Frances A. Yates, 'Ramon Lull and John Scotus Erigena,' *Journal of the Warburg and Courtauld Institutes*, XXIII, 1960, 1-45.

—, *The art of memory*, London 1966.

I. Yoshikawa, *L'Apocalypse de Saint-Savin*, Paris 1938.

K. Young, *The Drama in the Medieval Church*, 2 vols., Oxford 1933.

E. Zimmermann, *Vorkarolingische Miniaturen*, Berlin 1916-18.

O. Zöckler, *Das Kreuz Christi*. Religionshistorische und kirchlich-archäologische Unter-
suchungen, Gütersloh 1875.

E. J. Zwaan, *Links en rechts in waarneming en beleving*, diss. Utrecht 1965.

238

INDEX

Aachen, palatine chapel, 29, 46, 167[65]

abbot's chapel, decoration programme, 80, 161[33]

Abel, 28, 147[145]; /ante legem, 120; /prudentia, 48; and Cain, 165[56]

Abelard, 136[4], 176[79]

Abraham and 3 angels, 9; 's bosom, 78, 102, 160[22]; /Christ, 173[39]; sacrificing Isaac, 2, 23, 28; scenes, 25; /temperantia, 48; and worldhistory, 107

Absolom of Springiersbach (c. 1200), 180[115]

absolution, 75ff.

Acts 10:11-16 (Peter's vision), 23

Adalbert I, Archbishop of Mainz, 167[65]

Adalbold of Utrecht, 141[53]

Adam, 177[82]; /Christ, 9, 22ff., 113, 135[82]; creation, 22, 102; and Eve, 17, 92-94; expulsion from Paradise/Good Thief introduced into Paradise, 19, 23; fall, 154[47]; genealogy, 110, 112, 175[54]; imago Dei, 22; macrocosmos, 60ff., 64ff.; microcosmos, 102; Sparsus, 150[11]; in syndesmos posture, 97; Vetus and Novus, 21, 23, 64ff., 69, 74, 100, 102ff., 112ff., 114ff.; and world history, 50ff., 107, 146[34]

A.D.A.M./4 cardinal points, 60ff., 64ff., 67ff., 98, 151[11], 154[42]; 4 virtues, 66

Adam of Dore (c. 1200), 148[168]

Adamus de Parvo Ponte (12th cent.), 43

adaptation of schoolschemata, 13, 30-58, 59ff., 65, 70ff., 74, 96, 102, 108-16, 137[5]

Admont, Stiftsbibl., lat. 12 (Henricus de Segusio, *Aurea Summa*), 115, 177[89], fig. 105; lat. 35 *(Decretum Gratiani)*, 115, 177[84], fig. 102; lat. 43 *(Decretum Gratiani)*, 115, 177[87], fig. 100

adoration (latreia) of images, 3-4, 7, 129[3]

aestas and hiems, 60

ages of man, 4/ages of the world, 145[118]; /elements, 141[52], 151[11]

ages of the world, 107, 174[46,50]; /ages of man, 145[118];/days of creation, 123; /degrees of relationship, 110, 112-13, 133[63];/virtues, 48

Agnes of Rome, 107

air/number 12, 41

Alanus de Insulis (1128?-1202), *Dist.XX*, 181[127]

Alaric, breviary, 111, 114, 175[63], 176[64]

Alberic of Montecassino (1057-88), 159[18]

Albrechtsberg a.d. Pillach, 106, fig. 86

Alciati, emblems, 149[178]

Alcuin (c. 735-804), on artes liberales, 33, 45; book-metaphor, 14; ladder of Philosophia, 144[96]; schoolreform, 30, 46, 53, 145[104]; tituli, 24, 26; *Epist. 280, 145*[106]; De Grammatica, 45, 145[104,105,107]

Alexander IV, Pope (1254-61), 124

Alexandria, 10, 17, 132[40]

All Saints-liturgy, 88ff., 165[61]

allegoria, 9, 11-13, 21, 28, 47, 52, 59, 60, 67-69, 71, 73, 77, 79, 87, 89, 108, 113, 118, 123, 126, 130[26], 132[56]; antique roots, 10; jewish roots, 10; Augustine as specialist in, 154[44]

allegorization, 10

Alpha & Omega, 51, 98

alphabet/crucified Christ, 170[7]; 7 letters/ planets, 60; 5 vowels/quinque vulnera, 170[7]

altar ciborium, decoration programme, 75-76

altar, portable, 52, 106, 137[8], 147[140,144,145]; symbolic meaning, 52

altitudo >dimensions, 3 of space

Ambrose (c. 339-97), 63, 66, 117, 141[60], 146[120], 154[41], 180[122]; in quaternity of churchfathers, 154[39]; specialized in

Aristotle, 43, 123, 128, 142[68], 143[86]; with genealogical tree of authors, 116; *Categoriae*, 143[76]; *Logica Vetus*, 42; *Metaph. I*, 143[87]
arithmetica, 144[90]
ark of Covenant, 14, 21, 85, 150[2]
ark of Noah, 134[78]; architectural symbol, 73; /baptism, 108, 175[51]; /civitas Dei, 107; /corpus Christi or cross, 108; /Ecclesia, 9, 50, 108, 175[51]; exegesis, fourfold, 108, 175[51]; exegesis, visual, 175[51]; /Peter's vision, 23; /proportions of human body, 108; /quadriga of Aminadab, 15; quadrata, 175[51]; and stemma cognationum, 109
Arma Christi, 154[38]
Arktos >cardinal points
Arnold of Bonneval, *De VII verbis Domini in cruce*, 180[118]
Arnold of Wied, Archbishop of Cologne (d. 1156), 90-91
Arnolfo III, Archbishop of Milan (d. 1097), 75-79
Arnulf of Carinthia, 164[48]
arrowshaped schemata, 114ff., 176[76]
ars memorativa, 39, 44, 54
art, religious, attacked and defended, 1ff.; erroneous ways of representation, 3, 20; pious deception, 3; rules for artists, 5
artes liberales, 33, 35ff., 43, 45-46; in arbor philosophiae, 46ff., 134[80], 145[110]; in architectonic schema, 35, 139[35]; Carolingian representations, 46; daughters of Philosophia, 35ff.; greek and latin tradition, in ladder schema, 12, 30, 44ff., 144[95]; as propaedeutics for exegesis, 13, 30ff., 37, 44, 53; in tree schema, 41ff.; in tripartite system of philosophy, 12-13, 31, 43, 47, 144[87]; leading from visibilia to invisibilia, 46
artist/gracula (magpie), 162[35]; itinerant, 80, 162[35]; rules, 5
ascending and descending order in tree schemata >inverted tree
ascent, on ladder of artes liberales, 12, 44ff., 144[95]; on ladder of perfection, 126ff.; to illuminatio, 45-46, 78; from image to prototype, 3; from materialia to immaterialia, 2, 6, 12, 30-31; of soul, 3, 7, 80, 84, 88ff., 90ff., 92ff., 96, 158[13], 163[42]; to spiritual perfection, 12-13, 30, 44ff.; from

visibilia to invisibilia, 6, 8, 12, 30, 31; from vita activa to vita contemplativa, 121-23; see also: anagoge
Aschaffenburg, Hofbibl., MS.2 (lectionary), 51, 146[137], fig. 39
Athanasius (295-373), among doctors of the Church, 154[39]; *Comm. in Ps.*, 181[126]
Atlantis, 156[1]
Atlas-posture, 57, 92, 94, 165[56]
attribute(s) as aid to identification, 5
Augsburg, Bischöfl. Ordinatsarchiv, No. 78, 142[67]; cathedral (prophet-windows), 26; Diözesan-Museum (portable altar), 52, 147[145], fig. 43; St. Ulrich and Afra, decoration programme, 40
Augustine (354-430), 3, 1-13, 37, 43, 46, 63, 66, 72, 107ff., 119, 146[134]; artes liberales as propaedeutics, 30, 33; on erroneous ways of representation, 3, 20; in quaternity of churchfathers, 154[39]; specialized in allegoria, 154[44]; on study of numbers, 37; *De civitate Dei*, 23, 35, 73, 107ff., 133[63], 138[25], 144[87], 146[134], 174[51], 178[104]; *De consensu Evangelistarum*, 117; *De doctrina christiana*, 179[107]; *In ps. 32*, 178[102], 180[124]; *In ps. 59*, 178[10]; *In ps. 95*, 60; *In ps. 149*, 117; *Enchiridion*, 67, 173[35]; *Epist. 55 ad Januarium*, 30; *De Genesi ad Litteram*, 34, 61, 132[56], 150[3]; *De Grammatica*, 136[3]; *In Joannis Evangelium*, 152[21], 174[47], 179[107]; *De Musica*, 136[3], 179[114]; *De quantitate animae*, 30, 141[58]; *Retractationes*, 30
ps. Augustine (Quodvultdeus?), *De catachysmo ad cathechumenos*, 119, 173[36], 179[107]
Augustine of Canterbury (d. 604), 129[12]
Augustine of Dacia (d. 1285), *Rotulus Pugillaris*, 129[1]
Auxerre, Bibl. Mun. 265 *(Decretum Gratiani)*, 114, 177[82], fig. 101

Babel, tower of, 23, 74; /Pentecost, 23
Babylon/Heavenly Jerusalem, 161[30]
Balderich, Bishop of Speyer (10th cent.), 141[52]
Baltimore, Walters Art Gallery, W 73 (Isidore of Seville, *De natura rerum*), 111, 138[19], 140[51], fig. 12
Bamberg, Staatsbibl., Patr. 61

9005 *(De civ. Dei)*, 170[13]; 19546 (Jacob v. Maerlant), 177[90]
building of heavenly city by elect, 160[26]
Bucharest, Nat. Bibl., *Codex Aureus*, 53, 147[146], fig. 44
Burchard, Bishop of Worms (c. 965-1025), *Decretum*, 113ff., 176[78]
Burgo de Osma, Cath. library *(Beatus in Apocalypsin)*, 59, 150[5], fig. 49
Burgundio of Pisa (12th cent.) latin transl. of John of Damascus, 7
burial chapel >funerary chapel
Bury St. Edmunds, pictorial cycle, 57, 149[170]
Byrhtferth of Ramsey, Manual (A.D. 1011), 141[54], 151[11]
byzantine influence on western art, 88ff., 157[6], 161[33], 166[61]

Caesar, Julius, 170[9]
Cain and Abel, sacrifice, 17, 165[56]
Calkar, Pfarrkirche, ceiling, 174[45]
Cambrai, Bibl. de la Ville, 386 (Apocalypse), 160[28], 162[37]
Cambridge, Corpus Christi College (evangeliary), 129[12]; Gonville & Caius College, MS. 428 *(Tractatus de quaternario)*, 45, 60, 143[83], 145[100], figs. 3, 33
Cana, marriage at, 14
candelabrum, 7-branched, 95, 169[84], 178[95]
canon law, 42, 108ff., 113ff., 115
Canterbury, cathedral, pictorial cycle, 149[168]; St. Gabriel's chapel, 80, 161[31]
Canticum Canticorum >Song of Songs
canticum vetum et novum, 118
Cappadocian Fathers, on word and image, 2ff.
Capua Vetere, Basilica Suricorum (c. 430), 135[81]
cardinal points, 4 (Anatole, Dysis, Mesembria, Arctus), 48, 60, 74, 98, 151[11], 156[61], 157[4], 165[56]; A.D.A.M., 64, 74; Adam Vetus, 64, 100; altar, 52; dimensions, 4, of cross, 97ff., 99, 119, 179[112]; elements, 101; evangelists, 48, 50, 78, 171[23]; kingdoms 4, 91; 4 virtues, 61
cardo, 155[61]
caritas, 125; and cithara or psalterium, 117, 178[100], 181[124]; and 4 dimensions of cross, 119ff.
Carlo Borromeo, Archbishop of Milan, 78, 158[9]

caro and spiritus, 68ff.
Carolingian art and iconoclastic controversy, 6ff.; school reform, 30, 46, 53, 145[104]
caryatids, 35, 76, 157[5], 168[80]
Cassian, John (c. 360-435), *Collationes*, 13, 73
Cassiodorus (c. 490-583), 12, 33, 37, 46; among doctors of the church, 154[39]; artes liberales as propaedeutics, 46; teaching with visual aids, 31, 43; *Codex Grandior*, 43, 73ff., 156[4]; *Expositio psalmorum*, 74, 178[102], 180[118]; *Institutiones*, 30-31, 38ff., 43-44, 74, 137[10], 141[58], 142[63], 144[90,92]
catacombs, iconography, 16
catalogue, of medieval library, 12, 154[44], 172[24]
catechesis and image-based instruction, 1
Cathars, 55
Cato, 143[86]
ceiling decoration, 74, 77ff., 96, 149[169], 166[63]; relation to floor decoration, 157[5]
celestial harmony >harmony, celestial
cemetery chapel, decoration programme, 76, 78[22], 80, 89ff., 160[22], 168[76], 174[45]
Centcelles, 134[70]
central figure ruling schema, 60, 151[13], 153[27]; see also Annus & 4 seasons, Christ, Creator, Ecclesia, Lamb of God, Homo Totus, Mary, Paulus
centre emphasized: Jerusalem, 52, 100; Majestas Domini composition, 48, 50ff.
centurion's servant healed, 17, 23
La Chaise Dieu, tapistries, 58
Chalcidius (4th cent.), Timaeus commentary, 34, 44
Chalivay-Milon (Cher), 166[63]
chandelier, as Heavenly Jerusalem, 86, 161[29], 164[53]
Chantilly, Musée Condé. cod. 599 (Bartolomeo di Bartoli, *Cantica de virtutibus)*, 143[86], fig. 26; cod. 1347 (lectionary), 53, 147[148], fig. 45; MS. 1632-33 (Flavius Josephus), 41, 142[70], fig. 22
chariot of Aminadab, 15, 48, 150[2]; chariots, 4 (Zachariah 6:1-8), 150[2]
Charlemagne, 12; and *Libri Carolini*, 6-7; and 4 philosophers, 143[86]
St. Chef (Dauphiné), 80, 81, 83-84, 92,

243

cruciform posture >syndesmos
crusade of 1147-49, 167[66]
crux quadrifaria, 169[4], 179[110]
crystal sea, 134[70]
cube, 141[53,58], 156[2]; /earth, 39, 138[22], 142[63]; /number 8, 38; tetragonus, 35
cupola, radiating system of decoration, 88, 161[33]
curative power of music, 117
Cyprian, Bishop of Carthago (d. 258), among doctors of the church, 154[39]
ps. Cyprianus, 16, 28

Daniel, 71; Daniel 4:7-14, 173[33]; 7:22, 85
Dante, 159[18]; *Paradiso*, 176[79], 182[41]; symbolism, 182[141]
Darmstadt, Landesbibl., MS. 1640 (Hitda-codex), 32, 52, 138[13], 147[139]; cod. 1948 (Gerocodex), 147[146]; MS. 2282 (logical treatises), 42ff., 143[82], fig. 25
David, 21; /Christ, 118, 122, 173[39], 178[104]; /Ecclesia, 178[104]; and Goliath, 16; playing to Saul, 117, 178[104]; /psalterium, 118-28; syndesmos, 97, 118-28
David, S. J., Johannes, *Paradisus Sponsi et Sponsae*, 107
day, 7th, personification, 155[59]; days, 7 of creation, 41, 142[68], 155[59]
decoration programme, early christian, 3-6, 8, 18-19, 20ff., 30ff.; and exegesis, 1, 20, 39ff., 74ff., 80ff., 88, 142[64], 161[33], 162[35]
Decretum Gratiani, 113-16, 176[74,76,78,79]
Deesis, 94, 169[81]
Defensorium Virginitatis Mariae, 58
degrees of relationship, 108, 110, 112-13, 133[63]
delta, 180[118]
St. Denis, abbey library, 130[22]; church, west portal, 120ff., 170[11], 177[82]; windows, 15, 148[155], 164[52]
Desiderius, Abbot of Montecassino, 163[42]
Desiderius, King of Lombards, 159[19,20]
diagonal division of quaternity, 47, 50-51, 59, 63, 65-66, 73, 79, 82, 93-94, 98, 101, 104
diagrams and teaching, 30ff.
Dialectica domina, 35; and 4 philosophers, 42
dialogue, based on images, 5, 32, 62ff., 102
diapente, diatesseron, 180[115]
didactic function of image >image . . .
Didymus, comm. on the Psalms, 180[122]

dimensions, 3, of space (longitudo, latitudo, altitudo), 97, 141[58]; 4 dimensions of cross >cross . . .
Dimo of Salzburg, 75
Dionysius the Pseudo-Areopagite (c. 500?), 6-8, 85, 130[22], 131[28], 133[66]; *Hierarchia ecclesiastica* and translations, 164[48]; specialized in anagoge, 154[44]
Dionysius of Phurna, 130[19]
disc, held by syndesmos figure, 97-100; and arbor philosophiae, 47
divina quaternitas, 61, 152[21]
divisio mathematicae, 44, 144[92]; musicae, 44, 120; naturae, 42, 43, 143[77]; totius numeri, 44, 144[92]; philosophiae, 41ff., 60, 61 (see also: philosophy . . .); Scripturae Divinae, 60, 74, 144[91a], 156[4]
division, tripartite of man, 12, 13; of music, 44, 120; of musical instruments, 144[92]; of philosophy, 12, 13; of psalter, 120
docti, 3, 21
doctors of the church, 11; quaternity of, 154[39]; as 4 principes janitorum, 155[61]
door, 155[61]; of ark/Christ's sidewound, 175[51]
double chapel (church), 76, 81, 83ff., 88, 90-92, 163[42]
Doura Europos, baptistery, 16ff.
doves, 7/gifts of Holy Ghost, 89
dragon, red, 124; threatening Woman and Child, 77
Dresden, Sachs. Landesbibl. A 121 (Joachim da Fiore, *Liber Figurarum*), 182[135]
Dublin, Library of A. Chester Beatty (Petrus Lombardus, comm. on psalms), 118ff., 178[104], fig. 106
Durandus, Bishop of Mende (1230-96), *Rationale divinorum officiorum*, 7ff., 147[140], 149[173], 181[127]
Dyon, Museum (ivory plaque), 60
Dysis >cardinal points, 4

eagle, tree-, 123
earth/cube, 39, 142[63]; /number 27, 38, 41
east, special value attached to, 76; at top of mediaeval map, 151[11]
Ebstorf map, 52, fig. 80a
Ecclesia, 48, 52, 69, 78-79, 89, 105, 123, 126; /altar, 52; in architectonic schema, 35, 86ff., 90; ark of Noah, 9,

Heavenly City, 84; and Christchild in paradise quaternity, 64ff., 153[27], seated in tree, 135[81]; Theotokos, 25; typology, 58, 165[55]; /Woman threatened by dragon, 77, 158[17]

Marys, 3 at the Tomb, 16, 161[34], 169[85]; and O.T. types, 57; /timor Dei, 169[85]

materialia/immaterialia, 2, 6, 12

mathematical world view, 3

matrimoniae vinculum, 110, 114, 115ff.

Matthew 1:17, 50, 174[48]; 4:18, 50; 5:3, 147[147]; 13:3-15, 173[36]; 15:14, 149[178]

mausoleum, 17, 167[65]

Maximus of Turin (c. 580-662), 119, 173[38]

meadow, church decoration compared to, 6

medallion-composition, 51, 52ff., 57ff., 111, 114ff., 142[70], 146[133], 148[169], 155[59], 175[51], 176[64]

Medicina/Philosophia, 139[36]

meditation-technique, 32ff., 138[15]

Melchisedek, 9, 147[145]

"in mensura, numero et pondere", 97, 140[45]

memoria, perpetuated by image, 1-2

memorial chapel or church, decoration, 75ff., 90ff., 95ff., 163[41]

memory, art of, 39, 44, 54

mercy acts, 117

Mercy-seat type, 15

Merseburg, Cath. archives (bible), 142[68]

Mesembria >cardinal points

Messiah, 10, 25

Michael II, byzantine emperor, 130[22]

Michael, Archangel, 77ff., 81ff., 83, 161[33], 164[53]; fighting dragon, 77, 81; St. Michael's chapel, 80-81, 161[30], 162[38]

St. Michel d'Aiguilhe, decoration programme, 80ff., 82, 84, 161[32], 162[41], 166[63], figs. 65a-b

S. Michele d'Oleggio, 160[22]

microcosmos, 33, 40, 60, 172[24]; /Adam, 102; /macrocosmos, 61, 64, 66, 68, 70, 97, 100-04, 113, 120, 122, 141[52], 171[20]

Milan, S. Ambrogio, 76; S. Aquilino, 20; baptistery, 17, 19-20

mill of St. Paul, 15

milling (duae molentes), 86

miracles of salvation in O.T. & N.T., 16-18, 23ff.

miraculous properties of images, 4

mission and image-based instruction, 4

mnemotechnics, 1, 132[47]; and school-diagrams, 44; verses, 1, 102

modelbook, 56ff., 80, 92, 95, 139[40], 162[35]

Modena, Mutin. Ord. I, 2 (Lombardic edict), 112, 176[72], fig. 95

monogram, 78; of Christ, 137[8], 142[68], 147[137]

Mons (Bergen), castle chapel (Ezekiel programme), 167[67]

Montecassino, 163[42]

Montfaucon, Bernard de, Monumens de la monarchie française, 177[82]

months, 151[11]; -diagram, 39, 141[60]; /apostles, 155[60]

moral implication of music, 117-118; interpretation of ladder schema, 144[95]

mortuary chapel, 89ff.

Mosan art, 54ff., 57ff., 86, 90, 149[169]

Moses, 71, 120; 5 books of, 122; /fortitudo, 48; giving law, 94; miracle of water/baptism, 9, 16-18; /Christ, miracles, 23-24; scenes, 25; unveiling of, 14-15; and world history, 107

moving power of image, 1-2, 7-8

Müstair (Münster, Grisons), 166[63], 168[80]

mundus-annus-homo, 37, 141[54], fig. 12; -circle, 98, 103; quadripartite/4 sensus, 61; -sensibilis, 103; -square, 101, 103ff.

Munich, Bayer. Staatsbibl., Clm. 2655 (Thomas of Cantimpré, De naturis rerum, 102ff., 172[27], figs. 84a-b; Clm. 4505 (Decretum Gratiani), 115, 177[84]; Clm. 6404 (Alcuin, De grammatica), 145[104]; Clm. 13002 (Glossarium Salomonis), 102ff., 165[58], 172[24], 173[28], fig. 83; Clm. 13004 (Decretum Gratiani), 114, 177[83], figs. 99a-b; Clm. 13031 (Isidore, Etymologiae), 113, 176[76], fig. 97; Clm. 13601 (Uta Gospels), 117[98], 121, 137[5], 164[48], 178[98]; Clm. 14000, Codex Aureus of St. Emmeram, 152[25], 164[48]; Clm. 14159, Laudes Crucis, 62ff., 105ff., figs. 55b, 57a-d; Clm. 14271 (Martianus Capella), 139[40]; Clm. 14456 (computistic excerpts), 59, 144[91a], 148[50], 150[6], figs. 28, 50; Clm. 14798 (Libellus Scolasticus), 141[53]; Clm. 16002 (lectionary), 165[55]; Clm. 16128 (Isidore, De summo bono), 39, 141[62]; Clm. 17403 (Isidore, Etymologiae), 172[24]; Clm. 18192 (Isidore, Etymologiae), 176[70]; Nationalmuseum, portable altar, 52, 147[144], fig. 42

music, anagogic power, 118, 165; curative

power, 117; moral implication, 117; as propaedeutics for philosophy, 121; musica quadrata, 117, 179[105]; theory, 116ff.; threefold division, 44, 119-20, 179[105], 180[115]; vocal, 2fold division/ vita activa et contemplativa, 121

musical instrument, anthropomorphic schema, 118-28; cosmic, 104, 116ff.; /corpus Christi, 117; /cross, 117, 182[141]; delta shaped, 120; in exegesis, 116ff.; in visual exegesis, 116-26; /Scriptures, 117; tripartite division, 44, 120, 180[115]; welltuned/harmony of soul, 116ff., 125ff.

musical practice, 177[92], 180[119,124]

muta praedicatio, painting as, 2

mysteria Christi, 4 >Christ, mysteries

mystical function of images >image . . .

mysticism, medieval, 131[28]; and typological art, 55, 69; practice, 42, 138[15], 148[159]

Nancy, cathedral treasury (Arnaldus evangeliarium), 51, 146[137], fig. 40

Naples, S. Giovanni in Fonte, 17

nations, 4, 165[56]

Neon, Bishop of Ravenna (451-473/4), 22ff.

neoplatonism, 2ff. 117; influence, 181[126], on visual exegesis, 2-4, 8, 15, 54, 85

New Testament scenes in early christian art, 16, 18

New York, coll. Glazier, 37 (leaf from Decretals), 115, 177[85], fig. 103; coll. H. P. Kraus (Decretum Gratiani), 115, 177[86], fig. 104; Metropolitan Museum (ivory), 165[55]; Pierpont Morgan Library 429 (Beatus in Apocalypsin), 158[15]; 644 (Beatus in Apocalypsin), 150[5], fig. 48

Nicephorus I, Patriarch of Constantinople (c. 758-829), 18

Nicetas, Bishop of Remesiana (c. 400), 21

St. Nicolas, scenes, 92

Nicolas de Lyra, prologue to Glossa Ordinaria, 129[1]

Nicolas of Verdun, Klosterneuburg retable, 57, 161[34]

Nicomachus of Gerasa (c. 100 A.D.), 37

Nile landscape of Alexandrian art, 17

Nilus Bishop of Ancyra (d. ca. 43), Epist. LXI to Olympiodorus, 19

Nimrud ivory, 50[4]

Noah, ark of >ark of Noah; /Christ,

175[51]; genealogy, 152[25], 176[64]; /prudentia, 48; and Terah, 114, 152[25]; and world history, 107

north/south, 136[91]

number, series, 38, 41, 138[22], 141[53]; symbolism in exegesis, 10, 21, 37, 49, 121, 140[45], 152[21]; and worldharmony, 3, 33, 34, 36ff.

number 3, 120, 179[114], 180[124]; see also: grades of spiritual perfection, strings of cithara; virtues, theological

number 4, 37ff., 40, 61, 152[21], 179[105]; see also: beatitudines, cardinal points, cross, dimensions, elements, gospels, partes mundi, prophets, sensus of exegesis, towers of heavenly city, virtues, winds

number 5 >Moses, books, 5; nodi of psalterium; quinque vulnera; senses of man; vowels, world zones

number 6 >ages of the world; degrees of relationship

number 7, 180[124]; see also: ages of the world; angels; artes liberales; 7-branched candelabrum; columns of House of Wisdom; days of creation; degrees of relationship; generations in ark; Gifts of Holy Spirit; letters of alphabet; planets; seals of Book; strings of world instrument; virtues, princely

number 8 >beatitudines; cube; fire; winds

number 9 >angelic choirs

number 10 >commandments, 10; strings of psalterium

number 12 >angels; apostles; air; gates of heavenly city; prophets; tribes of Israel; winds

number 14 >generations in genealogy of Christ

number 18 >water; number 27 >earth; number 30-60-100, yields of fruit (Matth. 13:3-15), 173[36]

numerus solidus, 141[58]

Octateuch-scenes, 24

Odysseus, 10

Office of the Dead, 89; of All Saints, 88ff., 165[61]

Oidipous-legend, 160[21]

Old Testament books, personifications, 53, 147[148]; illustrations, 135[89]; O.T.

scenes predominating in early christian art, 16

O.T./N.T., concordance, 14-15, 104, 123; consonantia, 28; typological relationship, 9, 11, 14-16, 19ff., 54ff., 149[168]; in decoration programme, 16-19, 20ff., 22ff., 28ff.; historical continuity, 24ff.; serialization, 24ff.; rota in medio rotae, 53

Oleggio, S. Michele, 166[22]

Olympiodorus, 19

Opicinus de Canistris (c. 1320-40), 100, 171[15]

opinatio, 47

ordine quadrato, 26

organum, virtutum, 117, 123ff.; as world-instrument, 117

orientation of decoration programme, 27ff., 74-79, 82, 89, 91, 93ff., 162[41], 164[46,53], 168[73]

Origen (c. 185-254), 10-12, 14, 73; among doctors of the church, 154[39]; fall and penance, 11ff.; and 3fold exegesis, 11; influence, 11ff.; latin translations of his work, 11; *Comm. in Ps.*, 181[126]; *In cant. prol.*, 12, 132[52]; *Contra Celsum*, 146[121], 147[143]; *In Joh.*, 61; *In Matth.*, 178[103]; *De principiis*, 130[25]

Orosius, Paulus (5th cent.), *Historiarum ad paganos libri VII*, 50, 146[134]

orthogonal division of schemata, 37, 47, 50-51, 59, 63, 65, 66, 70, 73, 98, 101, 104

Otto, Bishop of Bamberg (d. 1139), 87

Otto, Archbishop of Freising (c. 1114-58), *Chronicon*, 90, 167[66]

Oxford, Bodleian Library, Corpus Christi College, 255A (Joachim da Fiore, *Liber Figurarum*), 125ff., 182[135], fig. 107; St. Johns College, MS. 17 (Byrthferth of Ramsey excerpts), 141[54], 151[11], figs. 14, 53

Ovid, 142[68]

pagans and images, 4

painters, manual, 130[19]; and rhetors, 2

painting, 137[10]; as muta praedicatio, 2

palace chapel, 15, 27, 29, 46ff., 136[102], 158[11], 167[65,67]

Palermo, Capella Palatina, 136[102], 167[67]

paradise, 10; circular or square, 150[5]; of Ecclesia, 9; /evangeliarium, 151[8]; exegesis 4fold, 9, 59-72, 150[1]; -garden, 33, 59ff., 82, 92; and Majestas Domini, 153[30]; -personification, 64, 66; -pictogram, 59ff.; -quaternity, 59-73, 93, 94; and 4 rivers, 9, 29, 32, 59-73; of the soul, 153[37]; -tree, 104

Paris, Bibl. de l'Arsenal, MS. 3516, 33, fig. 5; Bibl. Geneviève, MS. 1041/42, I (Martianus Capella comm.), 140[40]; Bibl. Mazarine, 660 (Cassiodorus, *Institutiones*), 144[92], fig. 29b; Bibl. Nat., lat. 1 (Vivianus bible), 26, 133[66]; lat. 2169 (Isidore, *Etymologiae*), 112[71], 176[75], fig. 96; lat. 3110, 35, 139[34], fig. 10; lat. 4410 (breviary of Alaric), 111, 114, 176[64], fig. 93; lat. 4412 (breviary of Alaric), 111, 175[63], fig. 92; lat. 5047 (Flavius Josephus), 41; lat. 6400 G (Isidore, *De natura rerum*), 37, 140[50], fig. 16; lat. 6401A (Boethius, *De cons. phil.*), 140[43]; lat. 6413 (Isidore, *De natura rerum*), 141[61], fig. 17; lat. 6734 (Honorius Aug., *Clavis Physicae*, 42, 143[77], figs. 24a-b; lat. 7361 (Boethius comm.), 141[53], fig. 13a; lat. 8850 (evangeliary from St. Médard de Soissons), 134[70]; lat. 8878 (Apocalypse of St. Sever), 176[64]; lat. 9389 (evangeliarium from Echternach), 146[133]; lat. 9630 *(Decretum Burchardi)*, 113, 176[78], fig. 98; lat. 10292 (Isidore, *Etymologiae*), 111[62], fig. 91; lat. 10293 (Isidore, *Etymologiae*), 175[62], 176[71]; lat. 12448 (Lex romana), 175[54]; lat. 15104 (Boethius comm.), 141[53]; n. acq. fr. 6045, 636 (Bastard MS. of *Hortus Deliciarum*), 172[25]; n. acq. lat. 1366 (Beatus, *In Apoc.*), 156[2], fig. 60; suppl. gr. 1286 (Sinope fragment), 26; Musée de Cluny (book cover), 51, 71, 147[138], fig. 41

partes mundi/4 sensus of exegesis, 151[12]; /4 virtues, 61

partial concealment, 98, 105ff.; partial revelation, 108, 174[39]

Paschasius Radbertus (d. 860), 50

passion of Christ, scenes, 18; see also: Christ, mysteries

paten, 106

patientia/Job, 18

patristic tradition, continuity in exegesis, 14, 55, 59, 62, 81, 86

patrons, commissioners of church decoration, 55ff., 74-79, 80-96 (passim)

Paul, method of exegesis, 11; 's mill, 15;

256

and ars memorativa, 44, 112, 132[47]; of
artes liberales, 41ff.; of divisio natu-
rae, 42, 43, 143[77]; of divisio philo-
sophiae, 41, 60-61; of logical prin-
ciples, 41ff., 61, 143[76], 152[23]; of
Scriptural exegesis, 60, 74, 144[91a],
156[4]; of virtues and vices, 144[98],
152[24]; with syndesmos-ideogram, 69,
99, 104ff., 113, 174[50]; and teaching
methods, 13, 99
triangular, musical instrument/Trinity,
180[117,118]
tribes, 12 of Israel, 74, 88, 157[4], 160[26];
sealed, 88ff.
Trier, Cathedral treasury, 61 (evangelia-
rium), 50, 146[133], fig. 36; Stadtbibl.,
cod. 23 II (evangeliarium), 51, 146[136],
fig. 38
Trinity, 120, 123ff.; /cithara, 120,
180[117,118]; colour symbolism, 125ff.;
/psalterium, 120ff., 124ff.; /world
history, 181[130]; Trinitarian circles, 123
tripartite division, of man, 12-13; of phi-
losophy, 12-13, 31, 43, 47, 144[87]; of
psalms, 120, 126, /Trinity, 132[50]; of
Scriptures, 132[50]
triumph-motif: standing on 2 animals, 68,
99
trivium, 30, 136[3]
tropologia in exegesis, 9-10, 12-13, 21,
27ff., 47, 52, 59, 60, 63, 66, 69, 71, 73,
77, 87, 89, 108, 113, 118, 123, 126,
131[28]; Bernard of Clairvaux as
specialist, 154[44]
Truannus (10th cent.), 82
tuba, exegesis of, 125
Tübingen, Libr., MS. M.d.2., 139[35]
Tundalus vision, 159[18], 160[28]
two-storeyed chapels and churches, 76, 81,
83ff., 88, 90-91, 92, 163[42], 167[65]
Turin, Libr., Cod. Taurin. D. 111.13 (Jus-
tinian, Institutiones), 175[54]
type (umbra, figura, praefiguratio,
forshadowing), 9-11, 21, 54, 56
typological method, 22-23; compendium,
56ff., 155[54]; relation O.T./N.T., 22ff.,
24ff., 26ff., 54ff., 67ff., 85ff.; series,
149[169], 152[25]; typology (bibliogra-
phy), 148[153]; Marian typology, 58

Ulrich of Passau, 75
unicorn and Virgin, 173[32]
unveiling of Moses, 14
Urban II, Pope (1088-99), 75, 157[7]

Utrecht, Mariakerk, windows, 58; U.B.,
No. 710 (Thomas of Cantimpré, De
naturis rerum), 173[28]

Valenciennes, Bibl. Publ. 99 (Apocalypse),
156[2], fig. 59
Vårdsberg, church (paten), 106, fig. 87
Varro, 43, 107, 174[48]
vegetative elements, added to schemata,
41, 45, 54, 108, 111ff., 113-115
vegetation symbolism, 143[74], 173[39]
vehiculum, image as, 31-32, 34, 51-52, 98
veil of Moses, 14-15; of Temple, 174[44];
letter of text as veil of deeper mean-
ing, 6, 8, 130[25], 133[66]
veiling of altar, 174[44]
velatio/revelatio, 15
veneration of images (timè), 4
Venice, S. Marco (mosaics), 168[80]
Verdun, Bibl. Mun., MS. I, f. J.
(homiliarium), 155[59]
Vergil, 142[68], 174[48]
vertical or horizontal development of dec-
oration programme, 73-96
St. Victor, abbey, 12, 132[57]; school, 152[24]
Victorinus of Pettau (d. ca. 304), 133[61]
Vienna, Erzbischöfl. Dom- und Diöze-
sanmus. (enamel), 151[12]; Nat. Bibl.,
cod. 67 (Isidore, Etym.), 176[66]; cod.
242 (Boethius, De cons.), 45, 145[99], fig.
32; cod. 378 (Petrus Pictaviensis,
Compendium), 169[5]; cod. 387 (astro-
nomical treatise), 33, fig. 4; cod. 395
(miscellany), 151[12], fig. 54; cod. 428
(miscellany), 115, 177[87]; cod. 1400
(Theol. 71) (ps. Joachim, Comm. super
Esaiam), 127, 182[145], fig. 108; cod.
2357, 172[24]; S. n. 3605 (Honorius
August., Clavis Physicae), 42, 143[77];
cod. 12600 (miscellany), 101, 142[63],
171[19], fig. 82
vinculum >syndesmos
virgins, 5, wise, 89, 159[10]; and foolish,
152[24], 153[27]
virtues, 3 (fides, spes, caritas), 88ff., 120,
125, 126ff., 179[112]; /dimensions of
cross, 119; /strings of cithara, 125
virtues, 4 (fortitudo, justitia, prudentia,
temperantia), 47, 86, 104, 161[29];
/A.D.A.M., 66; /ages of the world,
48; /altar, 52, 147[140]; /animals enter-
ing ark of Noah, 50; and arbor philo-
sophiae, 45, 46ff., 61, 63, 145[115];
/beatitudines, 53, 147[147]; /cardinal

262

DATE DUE